BERNARD MAYBECK

VISIONARY ARCHITECT

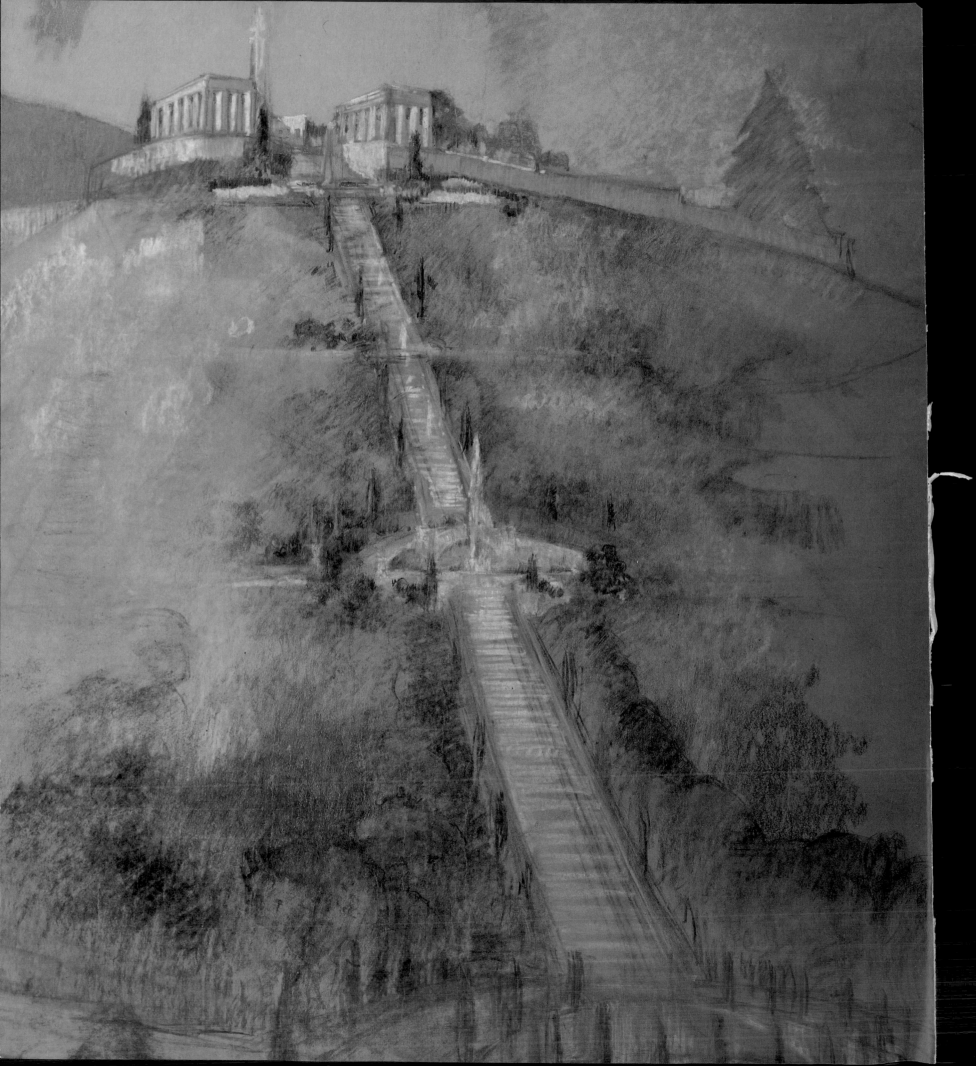

BERNARD MAYBECK

VISIONARY ARCHITECT

TEXT BY

SALLY B. WOODBRIDGE

PHOTOGRAPHY BY

RICHARD BARNES

ABBEVILLE PRESS PUBLISHERS

New York London

Front cover: Stairwell, Andrew C. Lawson house,
Berkeley, 1907
Back cover: Palace of Fine Arts, San Francisco, 1913–15, illuminated at dusk
Endpapers: Detail of stenciled painting on the
underside of the boxed trusses in the First Church of
Christ, Scientist, Berkeley, 1910
Frontispiece: Colored-chalk drawing by Maybeck of a
proposed approach from Market Street to Twin Peaks, San Francisco, c. 1935.
Documents Collection, College of Environmental Design,
University of California, Berkeley

Editor: Nancy Grubb
Designer: Joel Avirom
Production Supervisor: Hope Koturo
Production Editor: Sarah Key
Plans drawn by Diana Woodbridge

First hardcover edition
ISBN-13: 978-1-55859-280-3
ISBN-10: 1-55859-280-6
6 8 10 9 7 5
First paperback edition, 1996
ISBN-13: 978-0-7892-0132-4
ISBN-10: 0-7892-0132-1
2 4 6 8 10 9 7 5 3

Library of Congress Cataloging-in-Publication Data
Woodbridge, Sally Byrne.
Bernard Maybeck : visionary architect / text by Sally B. Woodbridge ;
photography by Richard Barnes.
p. cm.
Includes bibliographical references (p.) and index.
ISBN 0-7892-0132-1 (paperback)
ISBN 1-55859-280-6 (cloth)
1. Maybeck, Bernard R.—Criticism and interpretation. 2. Architecture, Modern—
19th century United States. 3. Architecture, Modern—20th century—United States.
I. Title.
NA737.M435W66 1992
720'.92—dc20
92-12633

For bulk and premium sales and for text adoption procedures, write to Customer Service Manager,
Abbeville Press, 137 Varick Street, New York, NY 10013 or call 1-800-ARTBOOK.

CONTENTS

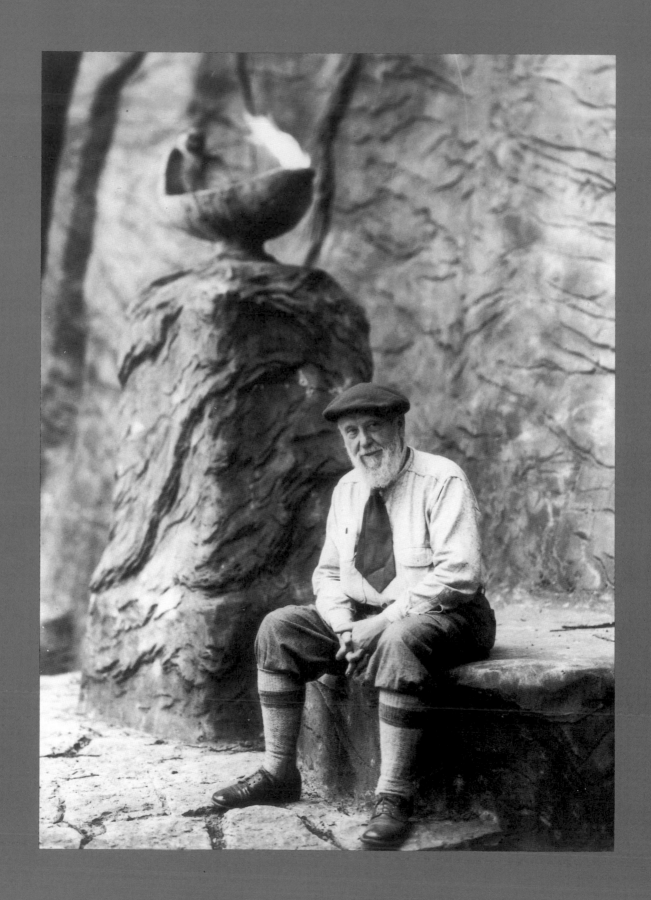

INTRODUCTION

early everyone who has written about Bernard Maybeck has described him as naive, even calling him the Great Naïf, as though he had reached a pinnacle of otherworldliness. Yet this benign genie, regarded by even his fellow architects as a crank and a dreamer, instigated and achieved projects with a lasting value that eluded more grounded and practical men. Other talented architects, who were nobody's fools and who did not spare themselves in pursuit of influence and fame, gained relative obscurity for their pains while the insouciant and world-resigned Maybeck has become ever more luminous. Is this simply the luminosity that accrues to genius in spite of itself? Was serene self-confidence at the root of Maybeck's inclination to wait for the world to come to his door?

That Maybeck enjoyed playing the role of a carefree bohemian was evident in his life-style, his clothing, and his delight in all forms of theater and pageantry. His family celebrated holidays and birthdays in costumes that he designed, and he would transform the house into a make-believe world with backdrops of colored paper. The amateur theatrical productions at the Hillside Club (a mainstay of the Maybecks' social life) and at the Bohemian Club (to which he belonged for over fifty years) provided slightly more public occasions for him to create sets and costumes. Maybeck also designed clothing for his wife, Annie White Maybeck, and himself, drawing the patterns on blueprint paper. For Annie he favored subdued earth tones in simple cuts; for his own everyday wear he designed high-waisted trousers that did away with the need for a vest. After he grew bald in middle age, he wore a beret or tam-o'-shanter to ward off colds, and at home he donned a flowing red-velvet robe. Yet he also appreciated good tailoring and bought fine suits when he could afford them. When he could not, he improvised. In 1897, when he and Annie were on their way to Europe to coordinate Phoebe A. Hearst's international architectural competition for the University of California in

1. *Maybeck at Bohemian Grove, 1932*

Berkeley, they were invited to Washington, D.C., to attend Mrs. Hearst's birthday party. The invitation became a daunting challenge when they discovered that Maybeck's old dress suit no longer fit. Lacking the money to purchase new formal attire, they bought a length of red silk instead. When wrapped around Maybeck's middle like a cummerbund, this vivid sash not only covered the gap but intensified his artistic aura.

Maybeck never lost his flair for such improvisation. He turned mishaps such as the malformed surface of the concrete Reader's desk in the First Church of Christ, Scientist, into art by transmuting the creases into a frieze of painted irises. He liked to make inexpensive industrial materials serve aesthetic ends as, for example, when he used metal factory-sash in that same church but used a tinted, textured glass and had an extra muntin leaded in to refine the windows' proportions. Maybeck's understanding of materials enabled him to use them in unconventional ways that others could not imitate. Although his ideas pervaded the local Arts and Crafts movement, his hyper-individuality inevitably set him apart from all movements. His students benefited from his teaching but not even the most devoted of them, Julia Morgan and Henry Gutterson, captured his wit and ingenuity in their work. During most of his lifetime Maybeck's fame, like that of the Greene brothers and Irving Gill in southern California, remained more or less regional. As the Arts and Crafts movement declined nationwide after World War I, the local allegiance to its principles waned and then vanished almost completely when the 1923 fire in Berkeley destroyed most of its artifacts. After World War II, under the influence of the European International Style, all other movements lost their luster. Like Gill and the Greene brothers, Maybeck was rediscovered in the postwar years, when California boomed and architects from all over the country rushed there to practice. Admiration for these regional geniuses was focused mainly on aspects of their work—structural expression and cubistic form, for example—that could be linked to the aesthetics of the modern movement. Yet, in spite of the romantic eclecti-

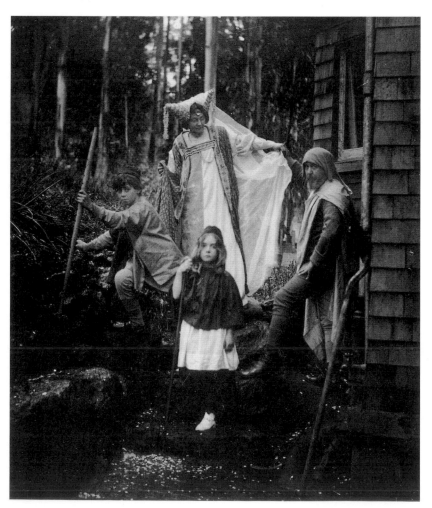

2. Annie, Ben, Wallen, and Kerna Maybeck in costumes designed by Maybeck for a family pageant

cism evident in many of his buildings (and conveniently overlooked), Maybeck's fame began to increase. After he received the American Institute of Architects' highest honor, the Gold Medal, in 1951, his national reputation was secure; and with the rise of pluralism in architectural taste in recent decades, the appreciation of Maybeck's work has spread around the world.

The destruction in the 1923 Berkeley fire of at least thirteen buildings from Maybeck's most active years has destroyed the continuity of his work, which would have promoted a better understanding of how his ideas had evolved. Only 150–60 of Maybeck's designs for individual buildings were ever built (there were about 50 unbuilt projects), and only a few were outside the Bay Area. Despite his having had an office in San Francisco for most of his career, which lasted for fifty-three years or so, only about a dozen buildings that Maybeck designed for clients there were built, and several of those have been destroyed or altered. A half-dozen or so of his buildings were constructed in southern California (most of them for Earle C. Anthony), and a few survive in locations north of the Bay Area. Of the several plans for college campuses, company towns, and other large-scale develop-

ments that Maybeck designed, the only one that was carried out was for the campus and buildings of Principia College in Elsah, Illinois, which he worked on at the end of his career, from 1930 to 1938, in association with Julia Morgan. After reorganizing his office in 1921 to limit his responsibility to the design phase of projects, Maybeck associated with other architects who took charge of the construction process. Thus he no longer intervened personally in the crafting of the buildings he designed, as he had early in his career, and although it cannot be said that he cared less about them, the delightful improvisations that appear in his earlier buildings are absent from the later ones, except those executed for his family.

Color played an increasingly painterly role in Maybeck's work; indeed, few architects have used color more expressionistically. He stained wooden structural members with orange, red, or green; mixed pigments with stucco for walls; and liked to

paint doors and window sashes Prussian blue, sometimes tinting the shaded parts with purple to deepen the tone of the shadow. He also liked to use vivid colors as decorative accents—for example, in the red backing for some of the light fixtures and the doorbell surround in the Roos house (plate 4) and in the gold and bright blue stenciled motifs on the structural members of the First Church of Christ, Scientist, in Berkeley (plate 5). In talking to Dorothy Joralemon about the design of the Joralemons' house in 1923, Maybeck said that too much architecture was sober and drab, and he asked if she would prefer "a white house resembling a bird that has just dropped down on your hilltop, or an earth-colored one that seems to rise out of it."[1] When she chose the latter, Maybeck invited her to participate in the process of spattering the walls with colored stucco. Four pails of wet stucco were prepared, each tinted with a different hue—pale chrome yellow, deep ocher, Venetian red, and gray—and each painter was given a whisk broom with which to flick the stucco onto the walls. Maybeck directed the operation like a maestro: "Red here. Ochre there. Now lighten with yellow. Now soften with gray." When the job was finished, he announced approvingly that the walls vibrated.

Another source of color that Maybeck considered important in designing buildings was landscaping, in which flowering plants, shrubs, and trees were prominent, and lamentably fugitive, components. The planters and trellises that he attached to his buildings testify to his desire to integrate his structure into the landscape, but almost no evidence remains of his intentions for the landscaping of

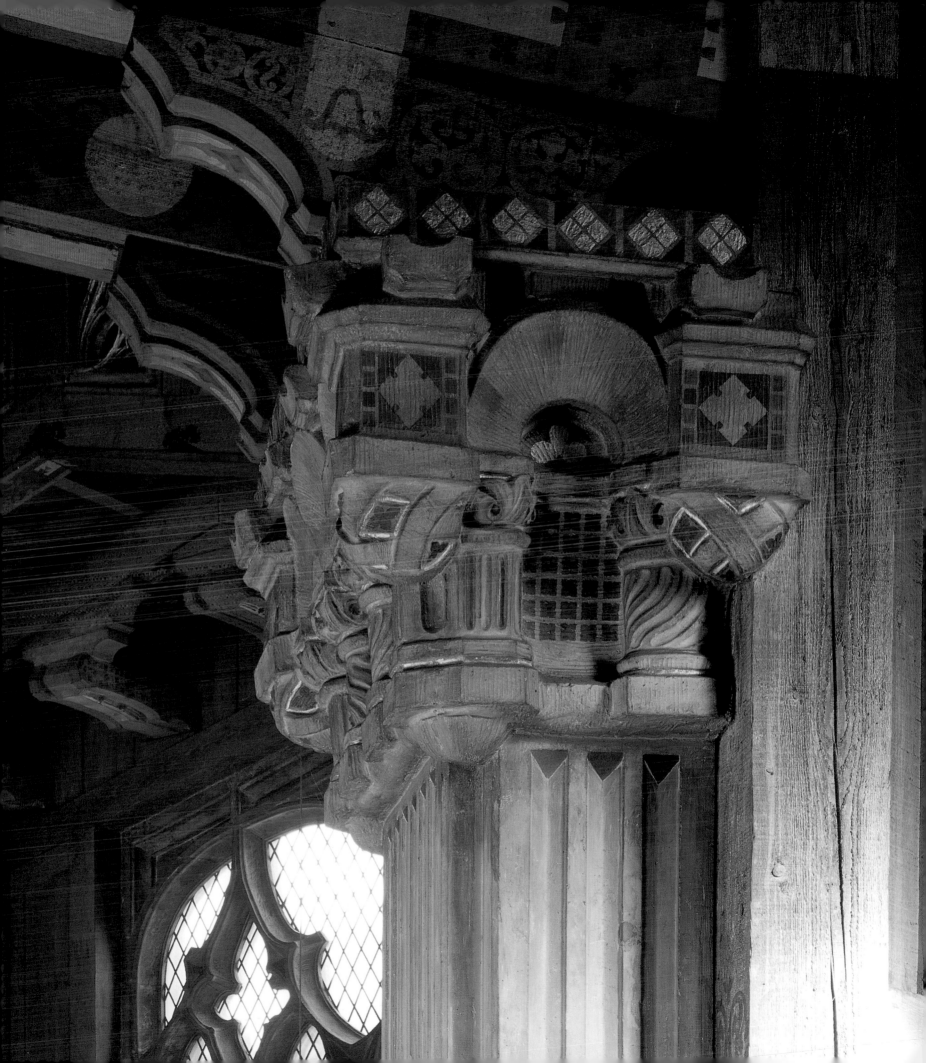

his buildings. Although, for example, he specified pink geraniums for the rooftop planters of the First Church of Christ, Scientist, and bougainvillea and blue hydrangeas for its garden, only the wisteria that covers the trellis outside the great west window has survived (plate 79). In his 1906–7 booklet on hillside building, written for the Hillside Club, Maybeck recommended neighborhood cooperation in landscaping so that blocks were systematically planted: "not fifty feet of pink geraniums, twenty-five of nasturtiums, fifty of purple verbena, but long restful lines, big, quiet masses,—here a roadside of grey olive topped with purple plum, there a line of willows dipped in flame of ivy covered walls,—long avenues of trees with houses . . . hidden behind a foreground of shrubbery."[2]

Maybeck's concern for architecture focused on a larger scale than the individual building. His training at the Ecole des Beaux-Arts nurtured his belief that architecture made its greatest contribution to art and life at the level of urban or civic design, and throughout his career he pursued commissions for major developments. He entered several competitions—the largest of which was for a city plan for Canberra, Australia, in 1911—but without success. Nor did he manage to build the major parts of his plan for the company town of Brookings, Oregon, or to realize his general plan for Mills College. That Maybeck is known chiefly for residential design says more about the opportunities that came his way than about any preference he had for domestic architecture. As for designing large buildings for office use, he appears never even to have been considered for such a commission. The aspects of his personality that endeared him to the proponents of the Arts and Crafts movement doubtless had the opposite effect on the business community. But if Maybeck's bohemianism alarmed those who had commissions for corporate buildings to dispense, he seems not to have been embittered by this lack of notice. When he could not test his ideas through commissions, Maybeck often realized them on smaller projects of his own by mustering up a crew and doing the work himself. Or he committed his dreams to paper in the beautiful drawings that he delighted in doing until the end of his life.

Maybeck launched his practice by designing a series of innovative houses located in a highly visible scenic setting in the Berkeley hills not far from where he lived. The client for the first of these houses (and later his ardent protégé and publicizer) was Charles Keeler, someone he had met by chance on the commuter ferry from Berkeley to San Francisco. Another fortuitous event, Maybeck's presentation to Phoebe Apperson Hearst of a hastily executed sketch for the Hearst Memorial Mining Building on the Berkeley campus, led to his supervising the international competition to select a campus plan for the university. An equally capricious process led to one of Maybeck's greatest commissions: the Palace of Fine Arts at the 1915 Panama-Pacific International Exposition (plate 90). The palace was not only everyone's favorite while the fair was in progress, it was the only building complex to be preserved after the fair closed. Such achievements must have helped to balance the disappointments that Maybeck suffered in most of his large-scale projects.

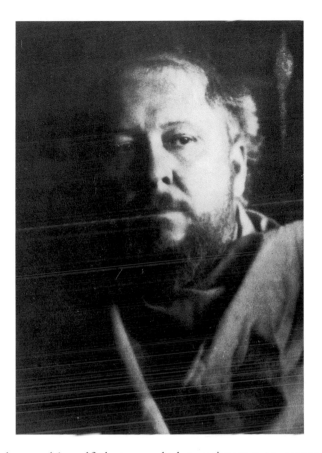

By telling tales on himself that revealed a resistance to conventional ways of learning and a preference for intuition, Maybeck cheerfully contributed to his reputation as a dreamer. In a memoir written in 1949 William Gray Purcell recalled that Maybeck "seemed to be proceeding from within his own emotions and acquired skills of mind and to be crystallizing his experience in an insouciant and non-egoistic spirit. It was Maybeck's mission to establish an architecture of spiritual and emotional feelings."[3] Remarkably resistant to cynicism, Maybeck remained "a long-distance dreamer," as he put it, for life. In 1923, at the age of sixty-one, he wrote: "There is something bigger and more worthwhile than the things we see about us, the things we live by and strive for. There is an undiscovered beauty, a divine excellence, just beyond us. Let us stand on tiptoe, forgetting the nearer things and grasp what we may."[4]

Those who met Maybeck when he was in his eighties and nineties were most taken with his childlike charm and buoyant spirit, perhaps because he had come to terms with disappointment and loss or because his quest for beauty had taken on a mystical quality. But accounts of him in his prime make it clear that Ben Maybeck was a master of savoir-faire. When chance provided him with great opportunities, he was quick to take charge of the ensuing process. More than once in his memoir of Maybeck, Charles Keeler said, "Mr. Maybeck knew what he would do."[5]

6. *Bernard Maybeck, c. 1910*

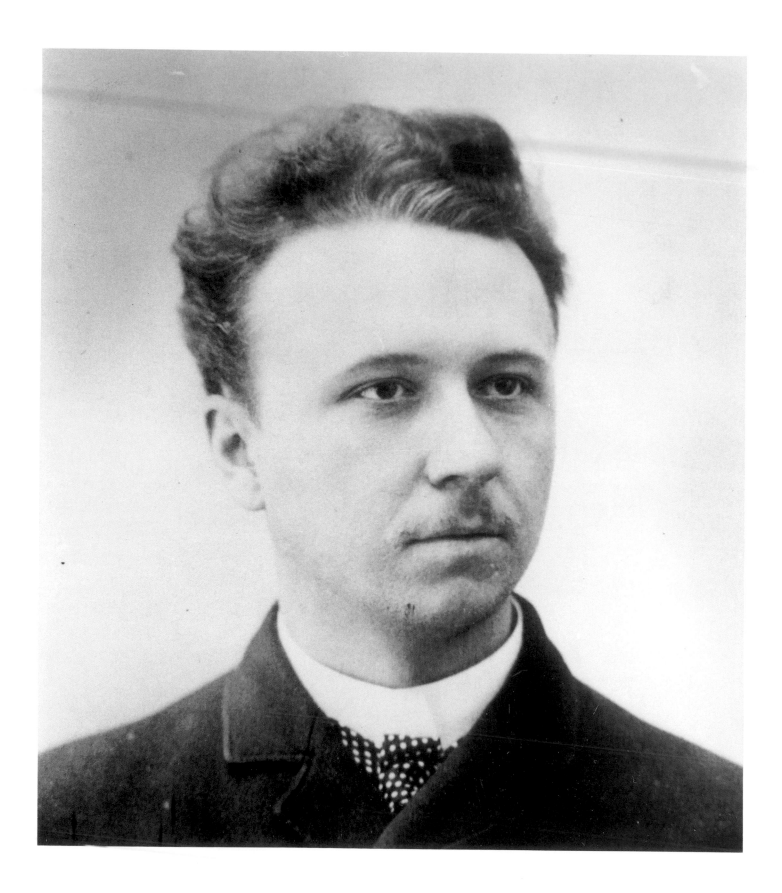

1
FOUNDATIONS

A ccounts of Maybeck's family background suggest that his independence of mind was partly a result of his heritage and upbringing. Later in life he recalled that his father had talked to him from childhood about the importance of doing what he wanted to do and of giving art the highest place in his mind and heart. "That was the finest lesson my father taught me," he said. "It has become my religion."[1]

Maybeck's father, Bernhardt Maybeck, was the son of a master builder in Oelde, in western Germany. Because of political turmoil following the revolutionary events of 1848, their father sent Bernhardt and his brother, Henry, to the new world to pursue opportunities that were lacking at home. Maybeck's maternal grandfather, Christian Kern, had been imprisoned in 1849–50 for his political beliefs and activities. Upon his release Kern, a widower, took his five daughters to the United States, where they settled in the heavily German area of Manhattan known as Yorkville. Meanwhile, Bernhardt and Henry Maybeck had apprenticed themselves to a Staten Island cabinetmaker from whom they learned the craft of Flemish and Dutch furniture making. As educated expatriates, they had a social life revolving around such centers of German-American culture as the Kern home, where Bernhardt met and married one of Kern's daughters, Elisa.

The newlyweds moved into a house on MacDougal Street in Greenwich Village, and there Bernard Ralph Maybeck was born in 1862. With Joseph Reinal, Bernhardt opened a shop on nearby Broadway, where he carved parts of the custom-made furniture they produced. After Elisa's sudden death when Bernard was three years old, father and son moved to Kern's house in Yorkville. Although Bernhardt remarried—his union with Elizabeth Weiss produced two daughters, Irene and Julia—the family continued to live in the Kern house. This cross-cultural environment, where art, politics, and philosophy were vital topics of discussion, expanded Maybeck's horizons beyond those of the typical American

7. Bernard Maybeck, c. 1881

15

boy. His early memories included having to draw while other boys played sports and enjoying the art lessons his father gave him during their Sunday outings. He attended two private schools, the Benjamin Franklin School and the Deutsche-Americanische Schule, where he improved his knowledge of German and studied French, philosophy, and mathematics. In 1875, the year Bernard entered public high school, his father closed his business and became a foreman in charge of some fifty wood-carvers at the large firm of Pottier and Stymus, manufacturers of custom-designed furniture and architectural carving.

After finishing high school Bernard (or Ben, as he was called by family and friends throughout his life) attended the College of the City of New York. He left before graduating because, as he later recalled, he could not cope with memorizing formulas in order to pass a mandatory course in chemistry.[2] However, he had already acquired a broad liberal-arts education at home and in his private schooling. The writings of Ralph Waldo Emerson, introduced to him by an important high-school teacher, particularly impressed Maybeck, probably because Emerson's high-minded seriousness echoed discussions that he had heard at home. Put off by formal education, Maybeck began an apprenticeship with Pottier and Stymus but, as in his chemistry course, he soon balked at doing unrewarding tasks. Rather than challenge his foreman, whom he remembered as a thoroughly disagreeable man, he quit the apprenticeship. He did get a chance to try out his problem-solving talents on the design of a reversible seat for the Pullman Company, for which Pottier and Stymus designed parlor-car furnishings. But even though his solution worked, Maybeck was out of the company, and so it came to nothing.[3] Having enjoyed this taste of designing, he persuaded his father to send him to work with Mr. Pottier's brother in his Paris studio. Also about this time Maybeck was impressed by the stylishness of a young man who came to the shop wearing a silk hat and kid gloves—the latter particularly struck him—and carrying a cane. That man, he said with emphasis, was an *architect*.[4]

Pottier's studio was not far from the Ecole des Beaux-Arts. Maybeck saw other fine young men wearing "pot hats" and capes around the Ecole and learned that they too were architects. Whether or not the appeal of their high style influenced his decision, Maybeck asked his father for permission to take the entrance examination for the Ecole. Despite insufficient funds for the private tutoring or the cram courses in special ateliers that most foreigners took, he passed the formidable examination in March 1882. His standing was twenty-second out of 250 applicants, only fifty of whom were admitted. Maybeck's innate talent, his drawing skills, and his shop experience probably made up for the specific schooling he lacked. His physical strength was also an important asset because of the great size of some of the drawings that students were required to execute. Both mentally and physically, Maybeck was ready for the challenge of the Ecole's rigorous programs.

The Ecole that Maybeck enrolled in was no longer dedicated to a doctrine of pure classicism. Not only had the historical diversity of classicism been revealed,

but the idea that the architecture of the Greco-Roman period should dictate the design of buildings for the present was questioned. The issue of what constituted a living tradition had been forcefully addressed more than a generation earlier by two major theorists, John Ruskin and Eugène-Emmanuel Viollet-le-Duc. In his 1853 Edinburgh lectures on architecture and painting, Ruskin had fumed: "Of all the wastes of time and sense which modernism has invented . . . none are so ridiculous as the endeavor to represent past history. What do you suppose our descendants will care for our imaginations of the events of former days? Suppose the Greeks, instead of representing their own warriors as they fought at Marathon, had left us nothing but their imaginations of Egyptian battles. . . . What fools we should have thought them!" Viollet-le-Duc echoed this sentiment in the preface to his ten-volume *Dictionnaire raisonné de l'architecture française du XIe au XVIe siècle,* the first volume of which was published in 1854. "Supposing," he wrote, "that an architect of [the twelfth or thirteenth century] were to return among us . . . he would not erect a building of the time of Philippe Auguste or of Saint Louis because he would thereby trespass the first law of his art, which is to conform to the needs and to the customs of the moment: to be rational."[5] In making such statements neither man was advocating trashing history. Rather, they argued for an architecture that was modern because it was logically rooted in its own time and place.

By the 1880s, architectural education at the Ecole reflected an eclectic approach to the design of buildings that offered freedom to address contemporary needs. Beauty was no longer believed to inhere in forms simply because they were based on abstract ideals drawn from history. The mechanical reuse of forms to recall the past was taken as a sign of spiritual decay, whereas eclecticism was viewed as a step toward the creation of a new and vigorous architecture. Advances in technology, such as the use of structural steel, were considered important; making function a legible part of each structure was considered a crucial task of architecture.

Although the principles and methods he learned at the Ecole sustained Maybeck throughout his career, we know little of his actual experiences there. In an interview near the end of his life,[6] he recalled those who had inspired him; foremost among them was Jules-Louis André, whose atelier Maybeck entered after passing his entrance examinations in 1882. André favored designing buildings to reflect their origins, and he was apparently pleased that H. H. Richardson, who had been in his atelier, returned home to create an architecture that was more American than European. For his part, Maybeck was always proud that his master was one of the Forty Immortals, as those elected to the Institut de France were called. Maybeck also spoke enthusiastically about Henri Lemmonier's lectures on medieval architecture. According to Maybeck's recollections, Lemmonier gave his students a vivid sense of history by discussing personalities and the life of the times. Particularly dramatic was his account of how French culture had been reinvigorated by the collective sense of relief when the world did not

end in the year 1000. Maybeck often referred to the fifty cathedrals begun thereafter as having "sincerity" because people from all classes participated in their construction.

One of these twelfth-century churches, Saint-Germain-des-Prés, was on his way to the Ecole from the restaurant where Maybeck ate every day. At first he never entered the church because he had not been raised in a churchgoing family. But as he passed its doors one day, the sound of beautiful singing lured him inside. Seated in the dim interior illuminated only with light colored by the stained glass of the windows, he listened enthralled to the music. He returned again and again in hopes of hearing the singing once more, but with no luck. Yet as he sat in the pew waiting, he recalled, "I got a *feeling* of something going on."[7] The affective power of the music had become part of the building, leaving him convinced that architecture, like music, was emotive. Maybeck also remained envious of the sincerity of the medieval man and, as he expressed it, longed to "put himself in the boots of the fellow of the twelfth century." His mystical experience in the church, coupled with Lemmonier's lectures, prompted Maybeck to visit the medieval churches of Paris during his student days, and later to visit the great churches of Europe. He always entered with the expectation of being moved by their sincerity.

At the core of the Ecole's instruction in architecture was a concept of composition that required the design of buildings to be delineated in plan (the arrangement of rooms for each floor); section (usually a longitudinal cut through the building showing the vertical arrangement of spaces); and elevation (the profile of the exterior walls and the roof). These three aspects of the composition were presented on one sheet to show the form in its fundamental aspects. Thus the students were taught to think through their designs in a way that promoted the integration of the interior and exterior—making the plan was the first step—and ensured against simply packing a preconceived form with rooms. Maybeck affirmed the importance of the plan many times, referring to it as a noble, logical diagram that generated the final form. More often than not in his buildings, the primacy of the horizontal and vertical spatial arrangements produced asymmetries in the exterior form. Other architects might think it important to resolve these irregularities in favor of a formal composition that made the building's exterior appear more rational, but for Maybeck such a goal was a violation of the primacy of the plan. Another very important design principle was *caractère,* the aspect of a building that expressed its use, preferably in an ennobling way.[8] Maybeck's experience in Saint-Germain-des-Prés convinced him that the most important purpose of *caractère* was to give buildings a spiritual content. Never satisfied with straightforward expressions of practicality, he always wanted his architecture to have both intimacy and grandeur.

Regrettably, Maybeck's student work from the Ecole has vanished. One anecdote that he repeated on several occasions in his old age concerned a revelation that came to him while executing one of his first assignments in André's atelier.

Having affixed a sheet of beautiful white Whatman paper to his board, he approached the problem of designing a base for a sculptured bust by neatly drawing one parallelogram perpendicular to another with a pencil, T-square, and triangle. Having finished what was supposed to be a two-month problem in about two hours, he was particularly pleased that the paper bore no trace of his labor—there was not a smudge on it. When André saw the work, he said (referring sarcastically to the paper itself): "Very good. Believe me, sir, you will never do better. Now study it!" Thoroughly confused, Maybeck asked his Florentine friend Enrico Ristori what André had meant. Ristori took a charcoal pencil and a gum eraser and began making lines and then rubbing them out and making new lines until the beautiful paper was thoroughly smudged. But Maybeck could see that Ristori was hunting for lines that would harmonize with the bust and that out of the mess of strokes and erasures was emerging the character lacking in his first effort. Years later the memory of the incident caused him to remark cryptically that he had never been an architect, he had only liked one line better than another.[9]

His fellow students in the atelier considered Maybeck a country bumpkin and made him stand on a ladder to sing "The Bullfrog on the Bank." Such hazing was typical of atelier life; Maybeck's good nature must have made the experience easier.[10] He made several new friends within the large group of foreigners at the Ecole. Among those who later figured in his career were Thomas Hastings, with whom he lived on the boulevard Saint-Michel, and John Carrère, Hastings's future partner. Maybeck left Paris in 1886, the year before the Ecole began to award diplomas to foreigners. For Americans, the training that the Ecole provided was the most important thing; the diploma was more important to architects who intended to practice in France. Maybeck certainly considered himself a man of the Ecole. After, as he put it, "passing certain examinations" (it is not clear which), he dressed up in his pot hat, black coat, light trousers, and patent-leather shoes with worn-out soles, and he walked up the Champs-Elysées smoking a corncob pipe. "And that is the kind of man whose ideas other men appreciate,"[11] he said.

Back in New York in 1886, Maybeck went to work for Carrère and Hastings. The young firm had an important commission from the millionaire Henry Flagler to design two hotels in Saint Augustine, Florida. Construction on the Ponce de Leon Hotel had started during the summer of 1885, the year before Maybeck joined the office. He may have helped design its interiors, but he probably participated more in the Alcazar Hotel, across the street.[12] Both projects feature an exuberance of detail and an innovative use of a local material, coquina (fossilized coral and shells), as the aggregate for the concrete. Although Maybeck's contributions cannot be identified with certainty, the inventive details and material were more characteristic of his work throughout his career than of the more academic work by Carrère and Hastings. Maybeck left the firm in 1889, at a time when the so-called battle of the styles was raging in American architecture. Since Carrère, the senior partner, backed classicism as the national style, Maybeck's devotion to medievalism may have made him the odd man out.

The recession that set in at the end of the decade may have been what prompted Maybeck to go to Kansas City with another classmate from the Ecole, Ambrose J. Russell. The economy there initially appeared to be stronger, but the recession deepened in 1889, and Maybeck found no work. However, he did meet his future wife, Annie White, through her brother Mark, a friend of Russell's. Mark White was also a friend of Willis Polk, an architect who became a lifelong friend of Maybeck's.[13] It was a time when architects were on the move, criss-crossing the country in search of the good times that created work. One place that seemed to promise continued growth and prosperity was California. With the arrival of the transcontinental railroads in the late 1880s, Los Angeles had boomed spectacularly. Willis Polk, Ernest Coxhead, and John Galen Howard, who later became prominent architects in San Francisco, all went to Los Angeles first. Although reports through the architectural grapevine may have attracted Maybeck to San Francisco, another factor that influenced his decision to go there rather than to Los Angeles was doubtless the proximity of a cousin near his age, a son of his uncle Henry, who had settled in the Bay Area.[14]

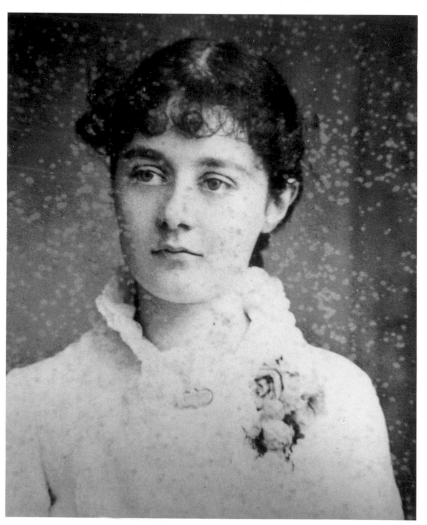

8. *Annie White, c. 1888*

Maybeck was twenty-eight when he arrived in California in 1890. He seems to have spent his time in the usual way of a young, well-trained designer, looking for work and getting to know his peers in the offices and social clubs. He was interviewed by A. Page Brown, who had moved to San Francisco from New York and opened an office on the strength of commissions from the wealthy Crocker family. Brown did not have enough work to hire Maybeck, but he promised him a job when he did. Willis Polk and A. C. Schweinfurth, who had both worked for Brown back east, were already in the office. They were about Maybeck's age and, to judge by their work, were enthusiastic about seeking inspiration for their designs in the regional climate and materials. In the two years before a position opened up in Brown's office, Maybeck filled the time working for the established firm of Wright and Sanders and for the Charles M. Plum

Company, an interiors and custom furniture design firm with a wealthy clientele. In May 1890 Maybeck apparently went to Salt Lake City to supervise construction of an unknown building for the firm of Wright and Sanders. Later that year he went to Kansas City, where he married Annie White on October 29.[15]

In 1892 Maybeck entered two competitions. The first, for the California Building at the World's Columbian Exposition in Chicago, was with a young designer from Norway, Joachim Mathisen, who was the architect of record. By then Maybeck was working for Brown, who won the competition. Maybeck was equally unsuccessful in the second competition, for the French Hospital in San Francisco. In 1893 he apparently worked for Ernest Coxhead; in 1894 he was a draftsman for Julius Krafft and spent some time back in Brown's office. Maybeck seems to have been in several places at once during his first years in California, responding to the many opportunities that architecture on the western frontier offered. There was, for example, a crying need for architectural education. His training at the Ecole had given Maybeck a better grasp of theory and a greater interest in exploring ideas than most of his fellow designers. This interest led to his attempt to start a school of architecture based on the activities of the Sketch Club of the local chapter of the American Institute of Architects. The school was announced in the June 20, 1891, issue of the magazine *Wave*, but it apparently never opened.

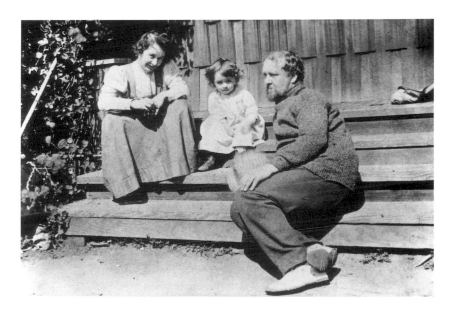

9. *Annie, Wallen, and Ben Maybeck at their house on Berryman Street, Berkeley, 1900*

The Maybecks lived in Oakland until 1892, when they managed to buy a small house on Berryman Street in Berkeley, north of the University of California in the farmlands between the campus and the bay. Whether or not the presence of the university influenced the Maybecks' move to Berkeley is not known, but Ben could hardly have chosen more fertile ground in which to sow the ideas he had assimilated at the Ecole. By the 1890s the university had become "The Athens of the West," attracting not only scholars of growing repute but also men who would help make conservation of the natural environment a subject of national concern.

Although the landscape architect Frederick Law Olmsted and the conservationist John Muir were not members of the university faculty, they were familiar figures in Berkeley. Olmsted, most famous for his design of New York City's Central Park, first visited California in August 1863. The spectacular landscape of Yosemite enthralled him, and it was largely because of his efforts that President Lincoln signed the bill deeding Yosemite Valley and the Mariposa Big Tree Grove to the state of California in June 1864; in 1890 this and the surrounding area

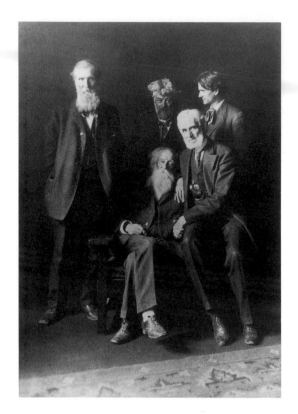

10. *Group portrait (clockwise from left): John Muir, William Keith, Charles Keeler, Francis Brown, and John Burroughs (seated at center), c. 1900*

became the country's first national park. While carrying out this work, Olmsted also found time to advise the City of San Francisco on its plans for a park (which later evolved into Golden Gate Park) and, in 1865, to work on a plan for the grounds of the College (later the University) of California.[16] John Muir, whose name is forever linked with California's Sierra, wrote tirelessly about the natural glories of the state. His writings were imbued with the transcendentalism of Emerson and Henry David Thoreau; he even succeeded in getting Emerson to visit him in Yosemite, "to join me in a month's worship with Nature in the high temples of the great Sierra Crown beyond our holy Yosemite."[17]

The urge to save nature in California came none too soon. Much hyperbole was being published about the climate and the scenery of California, and the real-estate industry was so successful that it began to threaten the natural resources that had brought the state its fame. The Sierra Club was founded in 1892 with the mission "to explore, enjoy, and render accessible the mountain regions of the Pacific Coast; to publish authentic information concerning them; to enlist the support and cooperation of the people and the government in preserving the forests and other natural features of the Sierra Nevada."[18] John Muir was the club's first president, and the 162 charter members included a large number of faculty from the University of California. With few academic burdens and considerable autonomy, faculty members were relatively free "to worship with nature," as Muir recommended. Professors hiked in the Sierra, summered at the Bohemian Club's encampment in its grove of redwoods on the Russian River, and wrote poetry extolling nature's gifts. The yearning for "real life" untainted by the ills of overcivilization and consumerism that afflicted eastern urban centers was easily satisfied even in Berkeley itself, where members of the university community lived near the parklike campus with its stands of oaks and its creeks vaulted with redwood-log bridges.

The reverence for nature was reflected in the aesthetic of the Arts and Crafts movement, which strongly influenced the life-style of the Berkeley community. The movement had originated in England and had gained early momentum in American cities far from Berkeley; Arts and Crafts societies were founded in Boston and Chicago in 1895 and 1897, respectively. In those industrial cities the movement took up the revolt against the unnatural condition of urban man working in mechanized factories. In suburban Berkeley the spokesman for the Arts and Crafts philosophy was Charles Keeler, Maybeck's first client. Arriving in Berkeley with his family in 1887, at age sixteen, Keeler became a precocious student of the natural sciences. Two years later, while still in high school, he was hired by the United States Department of Agriculture to study the migration of birds and mammals in the Lake Tahoe region, and two years after that, at just

twenty years old, Keeler became the director of the California Academy of Science's natural history museum. It was during the next year, 1892, that he met Maybeck, a fellow commuter on the ferry from Berkeley to San Francisco. In Keeler's unpublished memoirs of the illustrious men he had known, the chapter on Maybeck is entitled "A Gothic Man in the 20th Century." His description of their meeting gives a vivid picture of Maybeck at the beginning of his career:

> My attention had been attracted by a man of unusual appearance whom I often encountered on this boat. I was about twenty at the time, and he was perhaps nine or ten years older. He was of a solid build with a round face and chin and cheeks more or less covered with whiskers. His complexion was ruddy like an outdoorsman's, although he evidently worked in an office. His eyes were dark and his expression was benign. He seemed to me like a European rather than an American, and . . . I imagined he might be Italian. Instead of a vest he wore a sash, and his suit seemed like homespun of a dark brown color. I cannot remember who introduced us, if indeed anyone did, but presently we began to meet and converse on the ferry. Perhaps we were both sufficiently unusual in appearance to attract one another. In those days I used to wear an old-fashioned broadcloth cape that belonged to my step-father, and I carried his gold-headed cane. For a long time after those ferry boat conversations began, I did not know the name of my chance friend. I do not recall when I first learned that he was not Italian, and that his name was Maybeck. Such strange ideas this man seemed to hold. He was provocative and would make challenging statements for me to combat. . . . The serenity and self-possession of his manner was disarming, his unique point of view so confidently held, was at once irritating and stimulating. Here was a benign young Socrates on the ferryboat.[19]

The stimulating effect of these talks on this bright and receptive young man lasted the rest of his life. He became an advocate of Maybeck's ideas, perhaps the best publicist a retiring man of genius could have found. Maybeck appears to have sensed the nature of their future relationship. According to Keeler: "One day he told me he heard I owned a lot up in the hills north of the University. How he found this out I have no idea. . . . It was near the rim of a charming little canyon and commanded a superb view of the San Francisco Bay. . . . Maybeck told me that when I was ready to build a home he would like to design it. He would make no charge because he was interested in me."[20]

After Keeler married Louise Bunnell in 1893, he was ready to build. By then the Maybecks had bought their house on Berryman Street and had started to remodel it. Keeler watched Maybeck's "distinctively handmade house" acquire its new form, which he described as "something like a Swiss Chalet. The timbers showed on the inside and the walls of knotted yellow pine had no finish."[21] For

heat and cooking Maybeck had made a stove of sheet iron that sat on a platform of tiles and was open in the front. He had also made all the furniture. Charles helped out, and they discussed the design of the Keelers' house as they worked. He described their talks as a "liberal education in architecture, not in conventional architecture, but in underlying and eternal principles."

These principles concerned sincerity and honesty in construction and the use of materials. Keeler said that Maybeck detested "sham, veneers, and things done for sheer effect. If the material used was wood, it should look like wood, not stone." Here Maybeck took aim at "white-painted houses with nailed-on ornament," a description that, with some variation in color, fit nearly all the housing stock in the Bay Area. The Queen Anne style, which had reached the apogee of fashion, was often ridiculed. Maybeck later said that the style died of a "dreadful absence of beauty."[22] He shared this opinion with the small band of architects who made up the local avant-garde, many of whom worked in A. Page Brown's office. The architecture that these Young Turks championed was inspired by the Arts and Crafts movement. Their heroes were William Morris and John Ruskin; their mentor was the Reverend Joseph Worcester, a Swedenborgian minister who had moved to San Francisco from Boston to improve his health.

A well-informed amateur, Worcester shared his architectural enthusiasms and information with the artists and architects who gathered around him. His library contained many architectural publications with articles on H. H. Richardson; McKim, Mead and White; and others. He also clipped articles for his scrapbooks that ranged over the history of architecture, encompassing photographs of English cathedrals and cottages, Venetian palaces, and French farm buildings. Among the clippings were magazine editorials lauding Viollet-le-Duc's *Habitations of Man in All Ages,* and Worcester kept all the articles from *California Architecture and Building News,* which serialized this work in 1876.

More than just an arbiter of taste, Worcester was also a builder. His first constructed work, in which he lived from late 1877 to fall 1890, was a cottage in the hills of Oakland—a low, one-story structure with a gently sloping roof that extended well beyond the shingle-clad walls. William Keith, California's most famous artist, painted the house in 1883, depicting it as a rustic aerie. Jack and Charmian London apparently stayed in the house, which Charmian later described as having a squat, weathered shingle roof sheltering a large, beamed living hall, a small dining room, and three or four bedrooms. The kitchen, laundry, and other service rooms rambled up and down the sloping site.

One source for the unconventional design may have lingered in Worcester's mind from his first visit to Yosemite, in 1866. He had stayed in a cabin that John Muir had built for himself near Yosemite Falls. Muir described the cabin's construction: "I dug a small ditch and brought a stream into the cabin, entering at one end and flowing out the other with just current enough to allow it to sing and warble in low, sweet tones, delightful at night while I lay in bed. The floor was made of rough [handhewn white-cedar] slabs, nicely joined and embedded in the

ground. In the spring, the common pteris ferns pushed up between the joints of the slabs, two of which, growing slender like climbing ferns on account of the subdued light, I trained on threads up the sides and over my window in front of my writing desk in an ornamental arch. . . . My bed was suspended from the rafters and lined with libocedrus plumes, altogether forming a delightful home in the glorious valley at a cost of only three or four dollars, and I was loathe to leave it."[23]

Worcester was no longer living in his Oakland hills house when the Maybecks discovered it while renting their place nearby. According to Keeler, when Ben peered into the windows, "He saw that the interior of the cottage was all of unpainted redwood boards. It was a revelation."[24] The subsequent popularity of natural wood makes Maybeck's astonishment seem odd now, but at the time unpainted interiors were exceptional in dwellings inhabited by those of the Reverend Worcester's social status; it was an inspiring departure from the norm.

11. *A. C. Schweinfurth, Church of the New Jerusalem, San Francisco, 1894. Photograph by Morley Baer, 1975*

Worcester's other building project, the Church of the New Jerusalem (plate 11), assumed an importance way out of proportion to the small size of the commission because of the reverend's influence on his little group of devotees, which included Willis Polk, Ernest and Almeric Coxhead, A. C. Schweinfurth, and Maybeck.[25] Most of them worked on the Church of the New Jerusalem in one way or another, and one gets the impression that its design was the subject of many informal discussions. The work was executed in the office of A. Page Brown, with A. C. Schweinfurth the principal designer. As was his habit, Maybeck probably joined in discussions that Worcester hosted or encouraged about the church, and he often visited Brown's office even when he was not employed there. The informality of the architectural community and the strong sympathies of its elite with Worcester's goals probably made the design of the church something of a group effort. Still, it is important to keep in mind that it was the product not of an informal atelier but of an office directed by an architect with high professional standing.

With its L-shaped plan and its bell tower facing a walled courtyard, the church conveys the impression of a Mediterranean building, more Italian than Hispanic. In the interior Schweinfurth fulfilled Worcester's ideal of rustic simplicity by using unbarked madrone tree trunks, cut for him in the Santa Cruz Mountains, for the columns and arched roof supports; the walls were made of

stucco and redwood boards and battens (narrow wooden strips that covered the gap between boards). Early photographs show the columns wreathed in fresh pine boughs with feathery needles. Leafy branches, shrubs, and small trees were set around the church and hung on the brick chimney of the fireplace to create the effect of worshipping in nature. William Keith's paintings of the California landscape in different seasons were hung at window height along one wall. Instead of pews there were chairs with seats of woven tule grass, which looked as though they might have come from one of the missions. (Although these chairs have been attributed to Maybeck, no evidence exists that he designed them. The strong resemblance between them and others that he did design for the Rieger house and for Wyntoon is not conclusive because Schweinfurth would likely have designed furniture with the same character.) Just outside the church door was a garden, possibly designed by the gifted landscape designer and artist Bruce Porter, that Worcester planned as a version of Eden, with plants symbolic of spiritual values.

Behind Joseph Worcester loomed the éminence grise of John Ruskin, whose writings Keeler and Maybeck discussed (Keeler founded the Ruskin Society in Berkeley in 1895). Ruskin's *Seven Lamps of Architecture* (1849) provided a gospel for those who believed that sincerity was a cardinal virtue in architecture. In "The Lamp of Truth," Ruskin cited as deceits "the suggestion of a mode of support other than the true one, the painting of surfaces to represent some other material, and the use of cast or machine-made ornament of any kind." Ruskin's contemporary, Viollet-le-Duc, made similar statements. For both Ruskin and Viollet-le-Duc, medieval architecture exemplified architectural truth because it was made by craftsmen who used materials according to their inherent qualities. Maybeck explained to Keeler that architects, in the modern sense of the term, had emerged during the Renaissance and were businessmen who did not produce sincere buildings. Keeler wrote in his manuscript that Maybeck "did not mind how crude a thing was if it was sincere and expressed something personal." Maybeck also shared Viollet-le-Duc's interest in structural expression and thought that important structural elements should be emphasized as ornament. He explained to Keeler that the repetition of exposed columns and rafters in Gothic architecture was like the beat in music or the metrical accents in poetry. "That is why," he said, "Ruskin speaks of architecture as frozen music."[26]

Although Maybeck sympathized with Ruskin's and Viollet-le-Duc's principles, the man whose ideas may have struck deeper in his psyche was the German architect and theorist Gottfried Semper. After fleeing to London from Germany following the 1848 revolution, Semper became keenly interested in the application of art to industrial design when he was put in charge of designing four exhibition stands for the Great Exhibition of 1851. During his design and construction work on the Crystal Palace, Semper had the opportunity to study the crafts of the "half-civilized societies," as they were then called, of Lapps, American Indians, Tibetans, and Africans. He became convinced that these societies produced art

that was technically superior to anything in Europe. His major work, *Der Stil in den technischen und tektonischen Künsten*, which appeared in two volumes published from 1860 to 1863, advanced the theory, based on his study of non-Western cultures, that art originated in techniques that depended on the nature of the materials used.

The only proof that Maybeck knew Semper's principles of design comes from *Architectural News*, a San Francisco journal started by Willis Polk; a list of future articles in the January 1891 issue includes a forthcoming translation by Maybeck of Semper's *Der Stil*. Maybeck could have read *Der Stil* in the original German, and since it was one of the century's most influential studies of the origins of art and architecture, a strong demand for a translation may have inspired him to undertake the work. Unfortunately, only three issues of Polk's journal appeared, and no other evidence exists that Maybeck ever even began the translation. Semper's intuitive approach was more congenial to Maybeck than Viollet-le-Duc's emphasis on the rational process of thought as the basis for design. Unlike Viollet-le-Duc, Semper did not seek a universally applicable rationale for design. "Style," he wrote, "is the accord of an art object with its genesis, and with all the preconditions and circumstances of its becoming. Every work of art should reflect in its appearance . . . the material as physical matter. Thus, for example, the Greek temple in marble differs in style from an otherwise almost identical Greek temple in porous stone."[27]

Semper believed that architectural styles had evolved from a few primitive types in conformance with laws of natural selection, heredity, and adaptation. "The domestic hearth of the nomads with its primitive, protective roof structure has remained at all times the sacred symbol of civilization," he wrote. "If we add to these elements the spatial enclosure and the hearth-protecting substructure, then we have expressed with these few primordial motives, borrowed as it were from the first human couple, everything that architecture has invented."[28] Semper emphasized four elements: the hearth (synonymous with the altar or spiritual center); the mound (the raised foundation on which the hearth was set); the roof (which protected the hearth from the weather); and the enclosing fence or walls (which kept out intruders). These architectural touchstones provided the telluric basis of true form. Used with sincerity, they yielded authentic style, as opposed to the fickle styles based on novelty that the rootless modern city-dweller recognized.

Semper's four elements may well have been the "underlying and eternal principles" that Maybeck spoke about to Keeler. If so, the challenge of applying them to his own work inspired a highly personal vision for Maybeck's first buildings. He began his practice more than a decade later than his peers Willis Polk and Ernest Coxhead, but he made up for lost time by designing in his first five years seven houses and two clubhouses that were remarkable for their structural innovations and rigorous application of theory.

2
SIMPLE HOMES AND CLUBHOUSES

The ideals of the Arts and Crafts movement are now so enshrined that their originally avant-garde position in turn-of-the-century culture is easily forgotten. Enclaves of artists and artisans throughout the state of California felt the exhilaration of charting a fresh aesthetic course that touched life as well as art. Working in the Bay Area, Maybeck and Keeler were in the thick of this adventure. Not only did Maybeck design a number of houses for Berkeley's northside neighborhood between 1895 and 1910, but that neighborhood became a laboratory for their shared ideas.

Local homeowners organized Arts and Crafts guilds for the production of furniture, pottery, metal, and leatherwork for their own homes. Charles and Louise Keeler had such a guild in their house, in which they made their own furniture and sold their designs to others. This craftsmanly activity was certainly congenial to Maybeck, who designed furniture (see plate 121) and other interior furnishings for family use and for clients. Unfortunately, whatever he may have produced for his houses on Berkeley's northside, including his own, did not survive the sweeping 1923 fire.

Nature walks, gardening, running around the block (as jogging was then called), and sleeping on open porches were also part of the daily round. Cedric Wright, a well-known photographer and amateur musician, even incorporated an indoor-outdoor bed into his Maybeck house. The bed was on a track and could be rolled into a screened enclosure in good weather, then rolled back inside when the weather turned bad.

12. *George H. Boke house, Berkeley, 1902. View of the living room from the entrance hall*

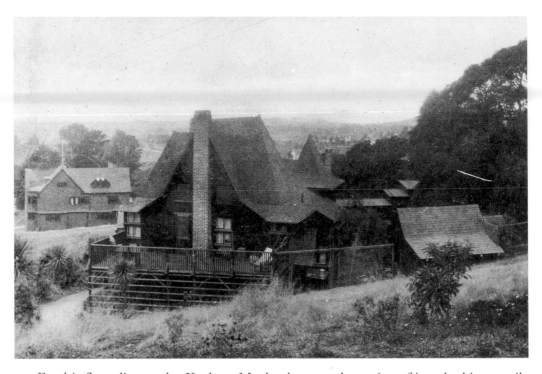

13. *Charles Keeler house, Highland Place, Berkeley, 1895. View from the east, looking toward the bay, c. 1900*

For his first clients, the Keelers, Maybeck created a series of interlocking pavilions with steeply pitched gable roofs with flaring eaves (plate 13). He tagged the house "Gothic," by which he meant something more than just a style. According to Keeler, Maybeck's goal was to return to forgotten first principles and think the whole process through as though for the first time. In this Maybeck may have drawn on his memory of medieval buildings seen during his student days in Europe. He may also have been inspired by a building in the north Berkeley hills that his friend Ernest Coxhead designed for the Beta Theta Pi fraternity (plate 14). He may even have been working in Coxhead's office in 1893 when the building was under construction. Built on a site downhill from Keeler's property, the fraternity house had a picturesque roofscape and was composed of separate blocks that stepped forward and backward to convey the image of a row of houses built over time in a European village. Although the similarity between Coxhead's building and the Keeler house hardly seems accidental, the latter is far from a copy of the former. Both buildings were situated in a rolling terrain; their architects, both trained in Europe, naturally sought sources there for ways of expressing a harmonious relationship between the manmade structures and their sites.

The structural frames for the sections of the Keeler house were made of four-by-four-foot redwood posts clad in one-by-eight-foot boards nailed horizontally to the outside of the posts and left exposed on the inside. Both the roofs and the walls were shingled (plate 15). The timbers that supported the roofs were exposed on the inside to create the kind of rhythmic, modular system that Maybeck admired in Gothic buildings. Completed in 1895, the house caused a sensation in the small, close-knit, university-dominated community of which the Keelers were well-known

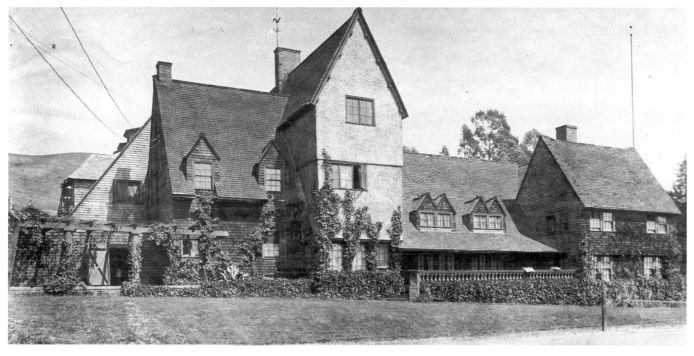

▦ *14. Ernest Coxhead, Beta Theta Pi fraternity house, Berkeley, 1893*

▦ *15. Charles Keeler and his children by their house, c. 1910*

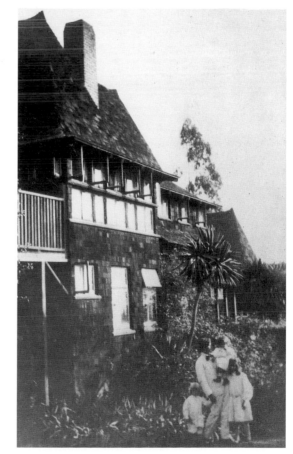

members. This picturesque, rustic house that, in photographs, seems to us so wedded to its setting was then considered "queer," a reaction that testifies to its radical departure from the norm of eastern-influenced house types. Keeler himself was so pleased with the unconventional design that he began to worry that the neighboring parcels of land on Highland Place would be built with "stupid white-painted boxes." He voiced his concern to Maybeck. " 'You must see to it,' Ben replied in his quiet, earnest tones, 'that all the houses about you are in keeping with your own.' "[1]

Thus directed, Keeler went out to find buyers for the adjacent lots. His search among friends yielded Maybeck's next two clients, Laura G. Hall and Williston W. Davis, for whom houses were built in 1896 and 1897, respectively. In 1899 Maybeck designed a house for William P. Rieger that was the last of the group. Isolated against the grassy hillside that swept up to a high ridge, the rustic houses with their walls and high-peaked roofs clad in redwood shingles were a signpost of change (plate 16). Meanwhile, the hillside community had attracted other members of the bohemian counterculture: Fanny Osbourne, widow of Robert Louis Stevenson, had acquired an old house behind the Keelers' and had it shingled; William Keith bought, but never built on, a nearby corner lot.

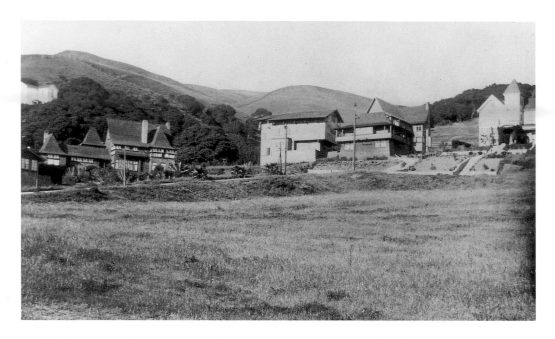

16. *The Highland Place houses, c. 1900. The Keeler house is to the left of the William P. Rieger and Laura G. Hall houses.*

Keeler, ever the propagandist, said that the shingled hillside houses masked with vines were evidence of "an architecture of taste." But for Maybeck they may have represented the more deeply rooted concepts of Semper's four elements. Aspects of all four houses suggest tents, which Semper had cited as a logical first type of dwelling. The shingled roofs, particularly of the Davis and Keeler houses, seemed to be draped over the structure, descending past the dormers to merge with the shingled walls. In places along the eaves the roofs are pulled up, like tent flaps, to allow windows. Maybeck dramatized the smallness of the rooms in Keeler's house by bringing the struts supporting the roofs down into the human domain. In the Rieger house, he expressed the separation of roof from enclosure in a different way: instead of dropping down toward the ground like a hood, the roof is held up and away from the shingled walls by outriggers. In the Davis house, the only one for which a construction drawing survives (plate 17), the structural framework is clearly separated from the exterior skin of the house and articulated in a commanding way that made it a replacement for the nailed-on ornament that Maybeck and Keeler deplored. The drawing shows two tentlike forms set on a braced wooden platform—the equivalent of the hearth-protecting mound that Semper had identified as one of the four elements. The dominant hearths in these houses would recur in a variety of monumental forms throughout Maybeck's work.

The Highland Place houses looked so odd that curiosity-seekers came to the northside area just to see them. If they happened by at the right time, the antics of the residents might have struck them as even stranger. Arrayed in flowing robes and garlands of flowers, the Keelers and their friends staged pageants on the grassy slopes (plate 18). A genteel counterculture *à la Grecque* developed in Berkeley, where it seemed that nearly everyone wrote poetry and attended read-

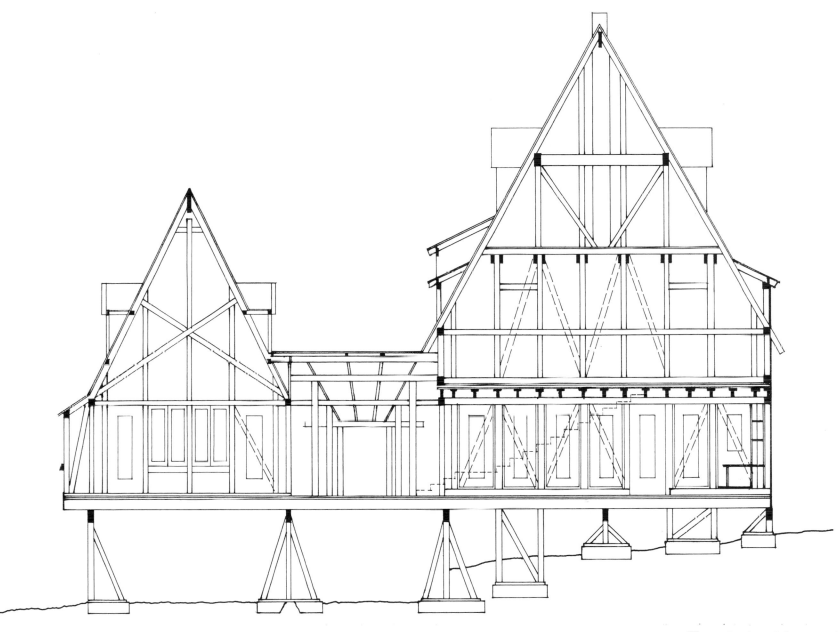

図 17. *Section of the Williston W. Davis house, c. 1897*

ings, open-air pageants, and musical evenings. One guiding spirit of this bohemian Hellenism was Isadora Duncan, who at the age of ten began teaching her interpretive style of free dance in San Francisco before moving to New York and eventually to Athens.

Among Duncan's devoted followers in Berkeley were the Boyntons, who bought property from the Maybecks not far from the houses on Highland Place and later had a romantic dwelling built on it called the Temple of the Wings (plates 19–22). Maybeck had made a preliminary design for the temple that featured two elliptical wings roofed with shallow domes; one wing was for dancing, the other for living. The walls were open colonnades that could be closed by letting down canvas awnings. However, before the design for the house was finished, the Maybecks and the Boyntons became embroiled in a legal dispute

RIGHT

▓ 18. *Charles Keeler robed for a hillside pageant*

OPPOSITE, TOP

▓ 19. *Temple of the Wings, Berkeley. Maybeck's preliminary design for the temple was completed by A. Randolph Monro, 1912.*

OPPOSITE, BOTTOM LEFT

▓ 20. *Dancing at the Temple of the Wings*

OPPOSITE, BOTTOM CENTER

▓ 21. *Florence Boynton and her children in the Temple of the Wings, c. 1915*

OPPOSITE, BOTTOM RIGHT

▓ 22. *Temple of the Wings in ruins after the 1923 fire*

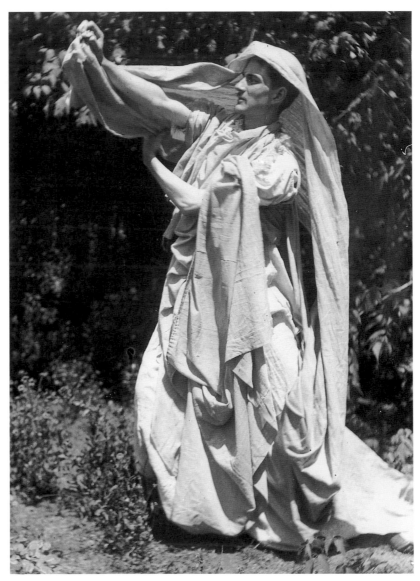

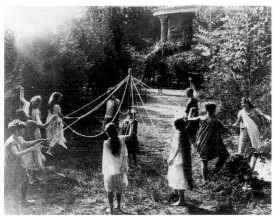

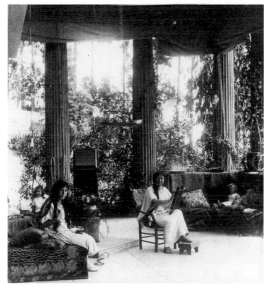

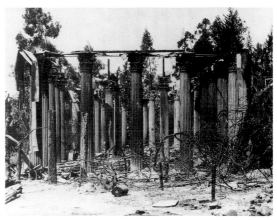

over the Boyntons' property boundary and another architect, A. Randolph Monro, finished the plans.

When completed in 1912, the Temple of the Wings was a model of planning for the simple life. Although open to the elements, it boasted such amenities for cold weather as a floor heated by hot water passed through pipes laid beneath the flagstones and a central concrete chimney with four hearths. Built-in cabinets for books and tables served as beds at night. Curtained dressing rooms opened onto a balcony at the back of the house that bridged the space between the two wings; bathrooms and lavatories occupied spaces beneath it. There was no kitchen because, as Charles Boynton explained in an interview for an article in the December 1918 issue of *Early Sunset* magazine, they cooked only one food and that was peanuts, which they roasted for fifteen minutes every day. In her part of the interview Mrs. Boynton declared that she had been inspired to build an out-

23. A. C. Schweinfurth, Unitarian Church, Berkeley, 1898

door house so that the family could live the simple life in dress and diet and not worry about the usual housekeeping chores.[2] She and her seven children wore sandals and one-piece flowing robes buttoned at the shoulders. Charles Boynton commuted to his San Francisco law office in a business suit, but he too donned robes at home.

Frank M. Wilson, the major developer of the northside neighborhood where this life-style flourished, had arrived in Berkeley from Chicago in 1891 and purchased an already subdivided tract atop the hill opposite Highland Place. He called the tract Daley's Scenic Park, after Thomas Daley, its previous owner. In 1894 Wilson built a simple brown-shingled house for himself in the park, and by 1900 a number of other houses had been built nearby as Berkeley enjoyed a boom period that more than tripled the population from 1900 to 1910.

With more and more people moving up into the north hills, those who had preceded them became increasingly concerned about preserving the natural landscape that had originally attracted them there. In 1896 Keeler, ever the mover and shaker, founded the all-male Ruskin Club to propagate the principles of the Arts and Crafts movement. Two years later the wives of some of the club members started the Hillside Club to study ways of implementing Arts and Crafts ideals. The Hillside Club met in the Unitarian Church designed by A. C. Schweinfurth and built in 1898 (both the Maybeck and the Keeler families were church members). With barked redwood trunks for columns and a low-pitched gable roof that descended nearly to the ground, the simple but dignified shingled building (plate 23) epitomized the club members' nature-based aesthetic.

In 1900 the Hillside School (plates 24, 25), designed by Louis Stone, was built north of the campus at LeRoy Avenue and Virginia Street. Mrs. Frank Morton Todd, wife of a newspaper editor and a founding member of the Hillside Club, recounted the story of how the school was changed from a conventional two-story building to the one-story shingled structure with airy verandahs, unpeeled redwood trunks for posts, hanging plants in the classrooms, and green rather than black chalkboards. "Now there was a group of women who had a study club in this district," said Mrs. Todd, "and . . . they got busy. . . ."[3] A committee of club women went to the trustees and proposed that the club plan a school suited to the hillside. "They promised that it would not cost the city anything extra. They already had a sketch by an architect of such a building and knew it could be managed." The tactic was successful, and the Hillside Club met in the schoolhouse until its own clubhouse was designed by Maybeck and built in 1906.

This success notwithstanding, the club lacked the political power its members sought because women could not vote. To gain the necessary clout to pass their tree-planting ordinances and other civic-improvement measures, the members invited their husbands to join them in their campaigns. In 1902 the Hillside Club was reconstituted for a membership of men and women (it was incorporated in 1909). Among the founding members of the co-ed club were prominent figures in the Berkeley community and important architects such as Bernard Maybeck,

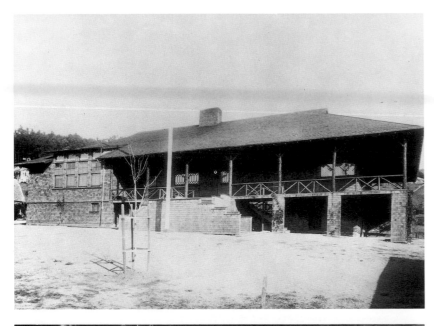

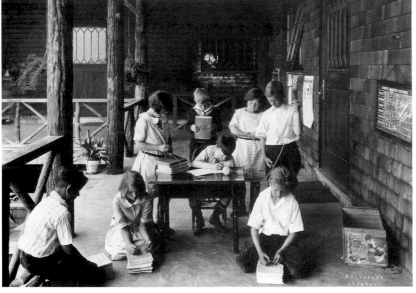

ABOVE, TOP

▦ 24. *Louis Stone, Hillside School, Berkeley, 1900*

ABOVE, BOTTOM

▦ 25. *Outdoor classes at the Hillside School*

John Galen Howard, and Ernest and Almeric Coxhead. The club members' urgent desire to make the northside a model community is best exemplified by a much-repeated account of Annie Maybeck's militant response when she and some other women came upon city employees preparing to cut down an oak tree that blocked the extension of LeRoy Avenue north of the campus. A diminutive woman of somewhat frail health, Maybeck valiantly commandeered a wagon and a team of horses and drove herself and her friends down to City Hall to protest the tree's removal. They prevailed, and the roadbed was altered to curve around the tree (plate 26).

The organization's platform had been published in "What the Club Advocates," a booklet issued in 1898 by the club's advisory board. The stated goals were to "protect the Berkeley Hills from unsightly grading and unsuitable and disfiguring houses. . . . to beautify these hills and above all to create and encourage a decided public opinion on the subject." The text noted the club's desire that "hillside streets be made convenient and beautiful by winding at an easy grade" and that they be "narrow country roads or lanes, except in case of important thoroughfares. . . . that trees be planted the length of streets suitable to the locality and of uniform variety." Subsequent club publications urged that roads "follow contour lines. . . . The steep parts can be handled in various ways, terraced in two levels . . . , divided into narrow ways for driving with footpaths above and below and connecting steps for pedestrians. . . . The few native trees that have survived centuries of fire and flood lived because they had chosen the best places. They should be jealously preserved. Bend the road, divide the lots, place the houses to accommodate them!"[4]

During his tenure as president of the Hillside Club, from 1903 to 1905, Keeler wrote *The Simple Home,* which he dedicated "to My Friend and Counselor Bernard

R. Maybeck." Although the words are Keeler's, Maybeck's ideas are evident throughout the book, which ranges from "the tunneled retreat of the field mouse" to the tribal dwellings of man to the grand bungalows of Charles and Henry Greene. On a practical level, the reader was told: "The style of the house is determined in no small degree by the material of which it is constructed, and this is to a large measure regulated by cost or availability. . . . Brick and stone . . . will be available chiefly for public or for commercial structures, except amongst the very rich, while the man of average means must be content with wood. In this there is no hardship if the one essential rule be observed of using every material in the manner for which it is structurally best adapted."[5] Keeler's most-quoted statement is "Hillside architecture is landscape gardening around a few rooms for use in case of rain."

26. "Annie's Oak," Le Roy Avenue, Berkeley, c. 1915

Addressing the local conditions of a rainy winter climate and a foggy summer one, Keeler recommended "plenty of glass on the south, east, and west. . . . wide porches without roofing on the east side for outside living." His own house was the subject of much of what he wrote, such as: "The lighting of the home is greatly improved by massing the windows, thus avoiding the strain on the eyes occasioned by cross lights. Three or four windows side by side give a far better light than the same number scattered about the room, and the wall space can be utilized to better advantage." In discussing the plan of the home, Keeler suggested that it be "large and simple in idea. A generous living room of ample dimensions is preferable to several small rooms without distinctive character. . . . The dining-room may open off from this assembly room as an annex or alcove." As for interior finishes, he noted: "Anything that tends to emphasize the constructive quality of the work enhances its value. No ceiling ornament can equal the charm of visible floor joists and girders, or of the rafters. . . . They are a most effective decoration with their parallel lines and shadows. . . . The redwood walls of the interior may be made by nailing vertical slabs to the outside of the studding, thus leaving the construction all exposed within, or by applying simple vertical panels to the inside of the studding."

For interior finishes, in addition to planed redwood panels, Keeler recommended a method Maybeck used of slightly charring the surface of rough-sawn boards, then rubbing them down with sand and an old broom to raise the grain. Sulphate of iron would turn redwood a silver gray; unplaned boards could be made to look mossy by the application of a soft green creosote stain. Keeler reserved special commendation for the fireplace, the center of home life and potentially the most beautiful feature of a room: "Let its ornamentation be wholly individual and hand wrought." He liked carved corbels supporting a plain mantelshelf; "but if something cannot be made for that particular spot, be content with a good generous fireplace of the rough, richly colored clinker brick . . . or big tiles." Plaster was never to be used with wood to imitate masonry con-

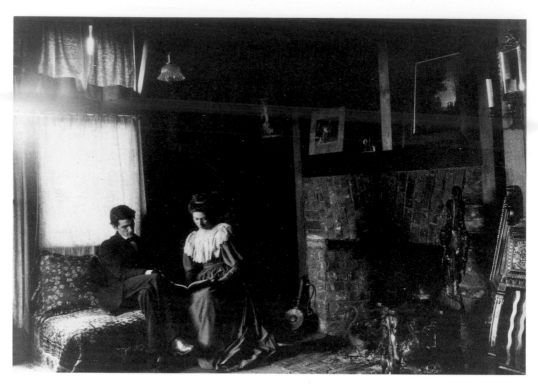

27. *Charles and Louise Keeler, c. 1900, in the living room of their house designed by Maybeck*

struction, as it often was in the fashionable but inauthentic Mission Revival style. However, the "Old English" style of plaster with timbers was acceptable because it was not mimicry. Of masonry itself Keeler wrote, "Every advance in the building of masonry homes is a progressive step, since it makes for greater stability, lessens the danger of fire, and saves our forests, which are so needful to the prosperity of the State."

Maybeck's penchant for giving advice to his friends and neighbors resulted in some Berkeley houses that can be described as "school of Maybeck," since others made the drawings for them. One such house, located in Daley's Scenic Park, belonged to Lillian Bridgman, a founding member of the Hillside Club. At the time she built the house, in 1900, Bridgman was a high-school science teacher and poet, and Maybeck is said to have supervised her drawings for the house. According to her niece-biographer, he advised and encouraged Bridgman in what she called her "wild idea for the house." "Forget symmetry," he said, "join the south and west windows together at the corner. Bring in the light and the bay and a garden."[6] The experience pleased her so much that she later enrolled in the university's architecture program and became an architect herself. In a similar way, Maybeck helped Gifford H. McGrew and Charles Keeler shape the design of the McGrew family house south of the campus (plate 28). Since Maybeck was preoccupied with the competition for the university campus plan, Keeler took charge of working out the design and supervising the construction of the McGrew house. The resulting structure has affinities with a small studio building near Keeler's house that Maybeck helped him design for himself in 1902.

In other parts of the country the steep slopes that characterize much of the northside would have been rejected in favor of flatter, more buildable sites. But in the Bay Area, mountainside living was an ideal that inspired the romantically inclined to reject the sensible flatlands in favor of, say, a dazzling view of Mount Tamalpais. None of Maybeck's hillside houses was more dramatic than the one he designed in 1905 for J. B. Tufts. A dentist by occupation, Tufts seems to have been a staunch patron of art and architecture, since he commissioned three houses from Maybeck: the first in San Anselmo in 1905, the second in San Rafael in 1908, and the third in Berkeley in 1931. (By now the San Anselmo house is nearly hidden from sight by the oaks that Maybeck carefully preserved around it in 1905.) Maybeck had just enough of the hillside cut away to establish flat patches for the three levels of the house. Midway up one side is a cavelike entrance set in a shingled ell and framed on one side by the jagged edge of a corbeled-brick chimney. Since no door is visible from the approach, the visitor can only assume that the dim space recessed under the house has a door—which it does, on the left wall. The door opens into a modest hall from which a passageway leads to small bedrooms on the south side. On the other side of the entry hall is a stairwell, open to the ceiling, which cranks upward past a landing to a small hall. There sits a wall bench, perhaps intended to encourage a restful pause in the ascent and a moment's appreciation of the view out the window on the opposite wall.

The upper floor, which has the living and dining rooms and the kitchen, is a platform tied to the hill on one side. On the other side is the living room, flanked by trellised decks that offer spectacular views of the scenery near and far. Given

▨ 28. *Gifford H. McGrew house, Berkeley, 1900, designed by Maybeck in an informal collaboration with Charles Keeler*

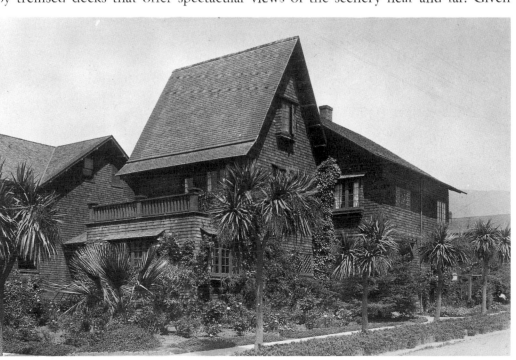

the woodsiness of the setting and the unadorned shingled sides of the house, it is a surprise to find that the living room is not a rustic aerie but a long, rectangular, half-timbered Tudor hall that stretches the length of the building. The formality of the dark beams against the white plaster ceiling is reinforced by a baronial fireplace with a mantel decorated with three sections of gilded Gothic tracery. (Similar tracery is used on the newel in the hall landing.) In creating the unexpected in interiors like this one, Maybeck may have been pursuing the dramatic effects that also attracted him to stage-set design.

In 1901 Maybeck began a series of houses related to the popular image of the Swiss chalet, a type of rustic house considered ideal for the hills of Berkeley and similarly woodsy settings in Marin County. Like the barn, the chalet was rooted in a vernacular tradition that provided an antidote to the Bay Area's Queen Anne houses with their towers and turrets and other nonfunctional frills. Maybeck's houses alluded to the traditional image of the chalet in their blocklike masses, in their dominant gable roofs with overhanging eaves supported on decorated brackets or struts, and in some of their decorative motifs, such as the cutout shapes of apples and hourglasses that adorned balcony railings. Yet they also departed from tradition in idiosyncratic ways, ranging from rustic to abstract.

Maybeck's first house for Isaac Flagg (a professor of classics for whom he eventually designed three houses on Flagg's Shattuck Avenue property) was not a literal translation of the Swiss chalet (plate 29). It is a rectangular building with a low-pitched gable roof that extends six feet beyond the main body of the house and is supported by cigar-shaped struts, tapered at each end, that stretch from bases set into the walls of the second story to the outer edge of the eaves. The shape of the struts expresses the concentration of stress in the middle of the member, a revelation of structure that Viollet-le-Duc would have appreciated. The top floor is cut into on the east side by a sleeping deck and bowed out on the west side by a prow-shaped window. The boxed sets of tripart casement windows on either side of the gable-roofed entrance are placed relatively low to the ground and have a stronger horizontal emphasis than the paired casement windows with flower boxes on the second story. Above the paired windows, the shingled walls change to wide boards and battens, a shift that both directs attention to the great sheltering roof and makes the walls look taller. Maybeck seemed to use the chalet image as an excuse to play games with proportions and materials that make the building seem larger and grander than a faithful rendition of the chalet would have been.

The house is sited on what was originally a corner lot so that the main entrance on its long side faces the interior of the large parcel of land. The symmetrical facade implies a central-hall plan, but the hall is not defined by interior walls. A stairway opposite the front door defines an axis but does not interrupt the flow of space across the front of the house. As a result, the house appears more spacious inside than it really is. The living and dining areas are anchored by

29. *South side of the Isaac Flagg house, no. 1, Berkeley, 1901*

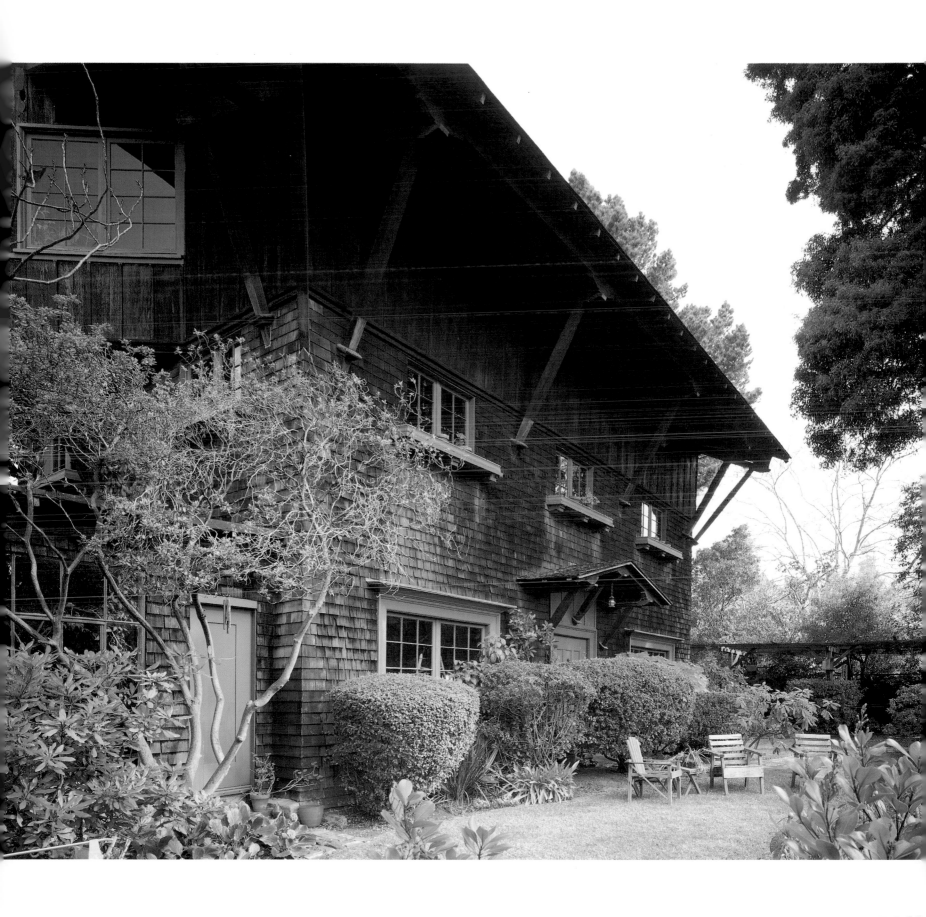

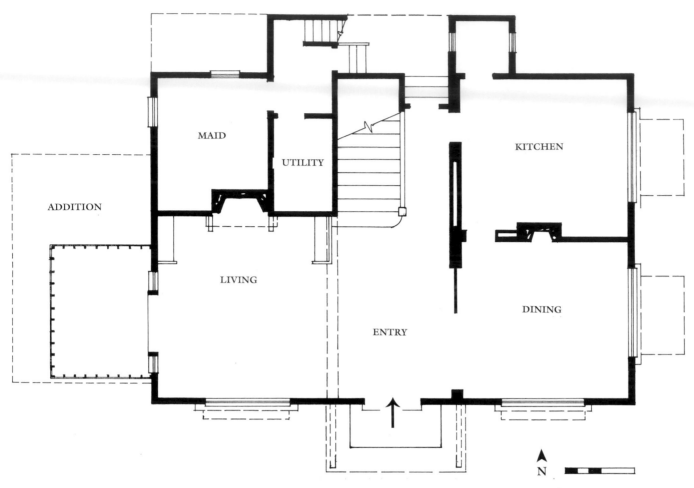

MAID

UTILITY

KITCHEN

ADDITION

LIVING

DINING

ENTRY

N

30. *First-floor plan, Flagg house*

fireplaces; the larger hearth, in the living room, has a bench that is also a screen wall attached to the fireplace wall.

The use of a monumental hearth to provide the vital center of the living room was an old idea given renewed force in residences designed by English architects such as Richard Norman Shaw and Philip Webb, and by American architects such as H. H. Richardson, Arthur Little, and William Ralph Emerson. The living hall was then assimilated into plans of dwellings for the affluent middle class and was also recommended for more modest houses. The invention of central heating, which was more widely used in the United States than in Europe, enabled architects to create the effect of more space by combining ground-floor living rooms, which, for practical reasons, had traditionally been separated by walls.

The free flow of space throughout these public rooms was a character-defining element of the innovative houses with spreading cruciform plans that Frank Lloyd Wright designed for the flat midwestern landscape. Maybeck's sites, by contrast, were rarely large or flat. The suburban lots in the Bay Area for which he designed most of his houses were in hilly terrain if not on hillsides, and some grading was usually necessary to provide a flat pad for the foundation of the

building. Maybeck's plans were often rectangular or L-shaped compositions that adjusted to the terrain, and he became a master at stacking volumes of spaces in complex vertical masses. In these plans he frequently treated the living hall as a separate spatial volume to call attention to its importance. Maybeck obviously found the living hall indispensable to creating a congenial setting, for he used it over and over again in houses large and small, changing the materials and colors as he saw fit—as, for example, in the Roos, Erlanger, and Young houses.

The Boke house of 1902 (plate 31), a smaller and less expensive version of the chalet than the Flagg house, is more straightforwardly rustic in appearance. It, too, has an open plan on the main floor, and the stairs from the ground to the upper level are on one side of the house, an efficient way to save space for the living and dining areas. The client, a lawyer named George Boke, was a rising star in the university law school. Like Maybeck, Boke was a maverick and a visionary.

31. *Main-floor plan, George H. Boke house, Berkeley, 1902*

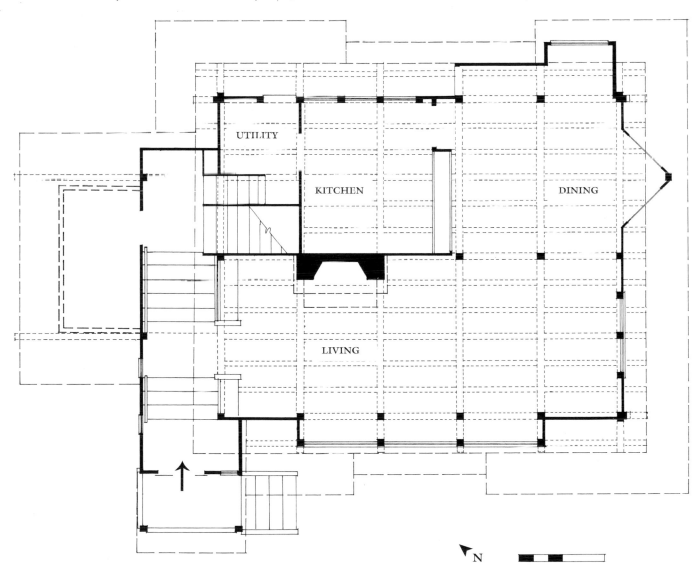

UTILITY

KITCHEN

DINING

LIVING

N

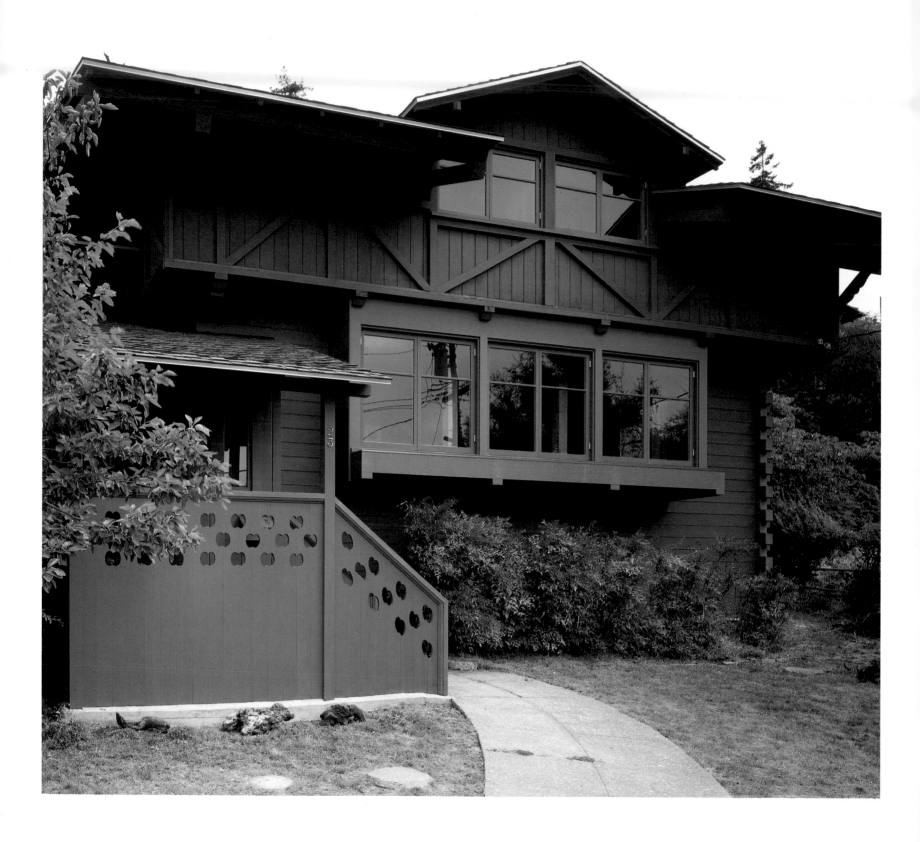

He joined a group of crusaders for political reform in San Francisco that included the newspaper editors Chester Rowell (for whom Maybeck designed a house in Fresno) and Fremont Older, Rudolph Spreckels, and others. When their efforts began to implicate members of the university's Board of Regents, Boke's career at the university was cut off. He pursued his goals for political reform independently and published a weekly in San Francisco called the *Liberator*. But, as Lincoln Steffens related in a posthumous tribute, "It was a long, dull deadening struggle and Boke, with all hope of promotion and appreciation cut off, stuck till something broke in the heart or the soul or—maybe it was only in the nerves of George Boke—and he was [physically] paralyzed [for life]."[7]

Before this tragedy occurred, but after Boke left the university, financial strains forced the family to give up their Maybeck-designed house on the hill behind the university. Whether or not the popular chalet image had been their choice, it would have been considered right for the steep slope that continued to a high ridge well above the house; their street was named Panoramic Way. Once again, Maybeck used the general form of the chalet as an antidote to the castlelike forms of the Queen Anne houses that were being built by the block in San Francisco.

The plan of the Boke house is a slightly irregular rectangle with projections for porches and windows. The upper floor extends beyond the lower part of the

OPPOSITE

▦ 32. *Boke house, view of the front from the west*

BELOW

▦ 33. *Mantelpiece, Boke house*

house by about two feet and is covered by a broadly overhanging roof. Diagonal bracing enlivens the upper-floor walls. The sleeping porch and the front porch have railings decorated with cutout apple shapes. One oddly extraneous bit of chalet imagery is the fake stack of log ends that adorns the southwestern corner of the house (plate 34). The job specifications for the Boke house state that special care should be taken to have the fake logs match the color of the adjoining boards so that they will look like an extension of the wall, but it is obvious that they are nailed on. Except for breaking up the hard edge of the corner and, like the cutouts, enhancing the play of light and shade on the wall surface, they are no more justifiable than the nailed-on ornament of the detested Queen Anne style.

Centered in the facade is a shallow bay composed of three sets of casement windows. The posts that frame the bay are hung by metal straps from the second-floor joists that cross the living-room ceiling and pierce the exterior wall. The casements are set between these posts, and a flower box is attached to the underside of the bay. This method of construction made the bay a structurally discrete feature independent of the wooden skin of boards nailed to the frame of the house itself. The studs are exposed on the living-room interior (plate 36), and the posts that support the upper-floor joists stand free of the walls, which are wide redwood boards and battens.

The four upper-floor bedrooms are as rustic as the exterior implies. Three-foot-long barn shingles cover the ceilings, and the framework of the central cross gable has been left exposed (plate 35). The redwood walls were originally stained a mossy green, as advocated in *The Simple Home,* to enhance their naturalness. The ridge of the upper-floor ceiling is offset from the central ridge of the gable roof above. This strategy created a low, tentlike ceiling for the front bedrooms.

Maybeck's most picturesque chalets were built in 1906 for J. H. Hopps in Ross and in 1907 for Albert Schneider in Berkeley. Hopps was a lumber baron who owned a large parcel of rolling, oak-studded land in Marin County where, in the latter part of the nineteenth century, the new suburban communities of San Anselmo and Ross grew up near the old centers of San Rafael and Mill Valley. These "scenic spots" (as they were often called) attracted wealthy residents because of their accessibility to San Francisco by rail and ferry lines.

Following his own advice for the siting of hillside houses, Maybeck placed the Hopps house (plate 38) parallel to the hill that rises above it on one side and falls away into a valley on the other. Although some grading must have been done to make a pad for the house, it seems to grow out of its setting. The landscape must have been wild indeed when the house was built, for even now, after decades of development on the neighboring hills, manmade structures do not intrude on the views from the house. It was perfect chalet country. The two-story house, with walls clad in three-foot-long redwood shakes (typically used on barns) above a stone base, is not as large as the spread of its roof suggests. In 1925 Maybeck designed an addition to it (plates 39, 40), which contained a grand room for entertaining and a lavatory, on the hillside above the main house. A bridge joins

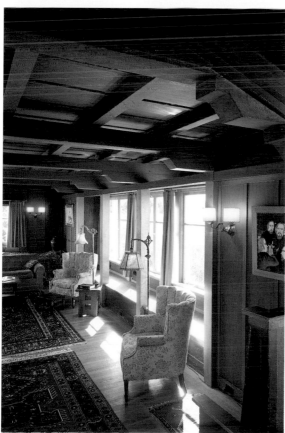

the addition to the main house and forms an ell that protects a terrace and stone pathways leading up and down the slope.

Although the design of the hillside circulation and landscaping is so perfectly integrated with the building that Maybeck's authorship of it seems certain, no drawings exist to verify this supposition. Maybeck certainly considered buildings and their landscaped settings to be one design problem, but drawings of landscape plans by his hand are rare. Most of the evidence on paper for his interest in landscaping exists in his sketches for buildings (many of them unbuilt) that incorporate landscaping; his renderings go well beyond the conventional "entourage" planting traditionally added to give the illusion of a mature setting.

The entrance to Grayoaks, as the Hopps house was called, is on the side of the house at a midpoint in the upward slope (plate 42); the door opens onto a

▨ 38. *J. H. Hopps house, known as Grayoaks, Ross, 1906. View of the main house*

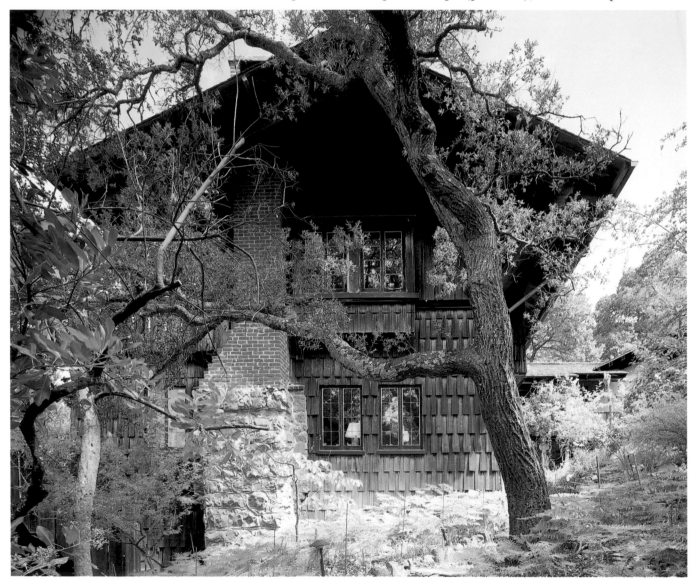

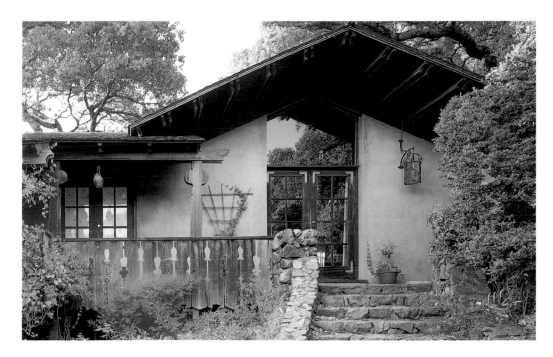

39. *Addition to the Hopps house, 1925*

stair landing that commands a view of the living room across the front of the house (plate 43). The linear quality of the living room's redwood board-and-batten walls, with a band of plaster above, contrasts with the massive fireplace mantel, with its polished redwood shelf supported on corbels and its five-foot-tall opening for the hearth (plate 44). The heavy, rough-sawn boxed beams with visible blade marks add to the primitive quality of the room. Like many of the great living rooms that Maybeck designed in the course of his career, the room demonstrates his talent for using traditional materials in ways that heightened their emotional impact.

The rest of the main floor, encompassing the dining room and the kitchen, is raised a few steps above the living-room level. Even though the Hopps family had servants and a Chinese butler, Maybeck introduced a pass-through from the kitchen to the dining room that reflected his interest in the modern, servantless house (an interest that he later pursued in other designs). Both the kitchen and the dining room have been remodeled, but the latter still commands a magical view of the wooded canyon, seen through a bank of openings that originally had window sash hinged at the top to permit opening the end of the room to the out-of-doors.

From the entrance landing the stairway continues along the side of the house to the upper-floor hall, which serves the four bedrooms (plates 45, 46). As is typical of Maybeck's houses, they are more comfortable than grand. A well-proportioned master bedroom is above the living room at the front of the house, two smaller bedrooms are along the southeastern side, and another bedroom is in the back. A subtle and sensitive aspect of this and other Maybeck houses is the size and character of the fenestration, which changes from room to room. The variation is most noticeable in the upstairs rooms, where the simple plaster walls and

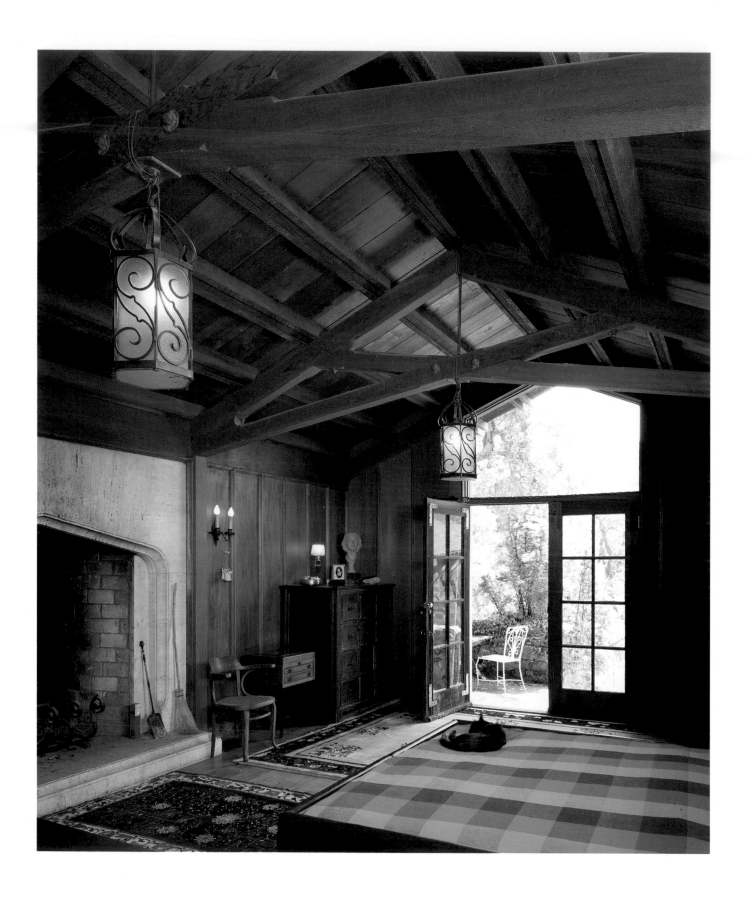

ceilings do not distract attention from the windows. In rooms with a horizontal emphasis, the casement windows have horizontal divisions, which interfere less with the view. In smaller rooms, where less wall space exists, the windows have vertical panes and more of them.

In 1906 Albert Schneider, a professor of classics, asked Maybeck to design a chalet for property he owned a few blocks up the hill from the earlier chalet commissioned by his colleague Isaac Flagg. Whether or not Schneider's desire for a Swiss chalet stemmed from the location of his lot on the crest of a hill with fine views toward the bay, or from a liking of the

OPPOSITE

🔲 40. *Interior of the 1925 addition to the Hopps house, now used as a bedroom but originally designed as a reception room for entertaining*

LEFT

🔲 41. *Path to the main entrance of the Hopps house, with part of the 1925 addition visible at the top of the hill*

BELOW

🔲 42. *View toward the entrance of the Hopps house from the balcony of the addition*

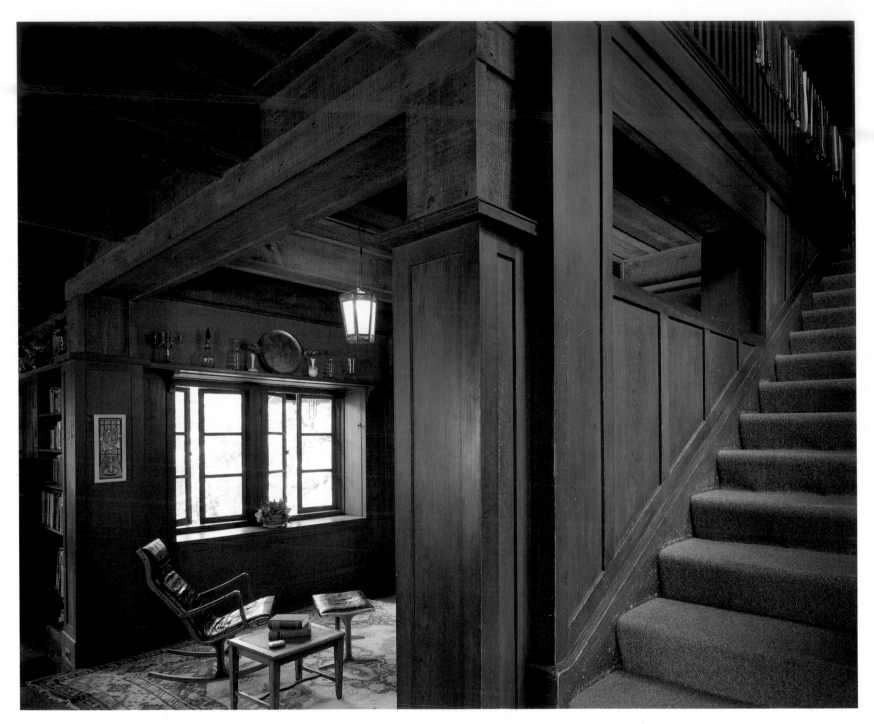

⊞ 43. *Interior of the Hopps house from the stair landing, showing part of the original dining room*

⊞ 44. *Living room, Hopps house. View from the original dining room*

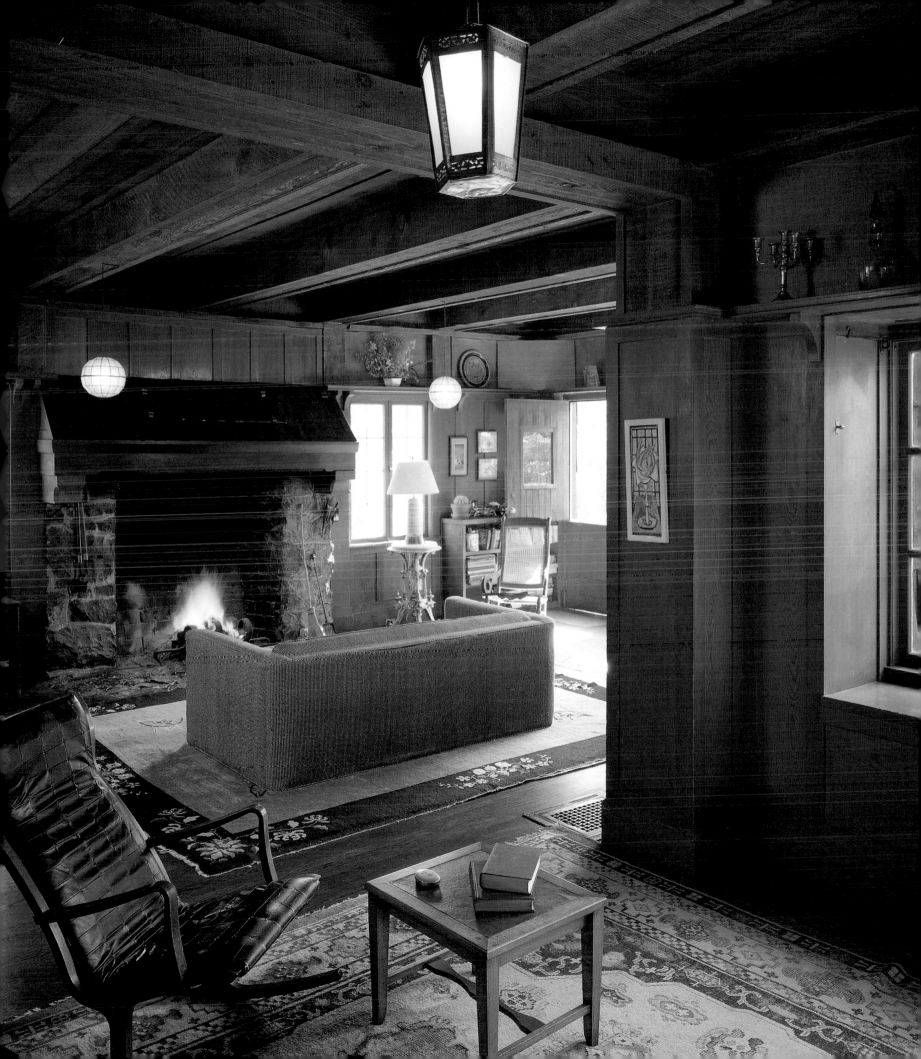

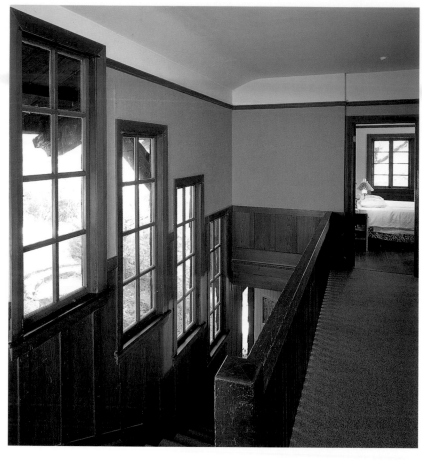

chalet Maybeck had designed for Flagg, or from both, is not known. In any case, Schneider's chalet (plate 47) is more folksy and rustic than the Flagg house and less rugged than the Hopps house. When built, it dominated the hill, and even today, surrounded by other houses, it remains an authoritative presence there.

The cross-gable roof is made asymmetrical by the extension of its western slope to cover a corner room on the south side. The eaves, which extend over the front balcony, are supported by heavy diagonal wooden braces at the corner. Curiously, one beam is laid across the eaves and supported awkwardly by a corner of the balcony railing, as though it had been an afterthought. The reason that Maybeck did not incorporate this side of the roof into the cross gable, as he did on the north side, may be that he wished to increase the wall area on the

ABOVE

45. *Stair hall, Hopps house*

RIGHT

46. *Master bedroom, Hopps house*

OPPOSITE

47. *Albert Schneider house, Berkeley, 1907, photographed c. 1910*

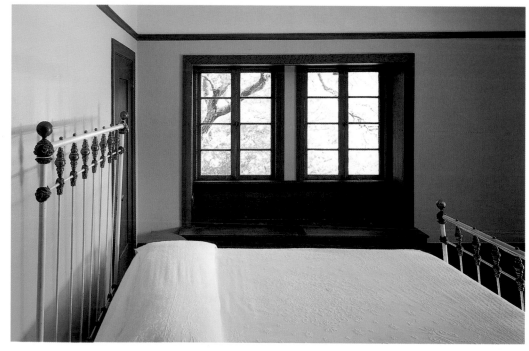

sunny south side, where bedrooms and a sleeping porch are located. After the house was built, Schneider is said to have expressed disappointment in its lack of upstairs closets to Maybeck, who replied that Swiss chalets had armoires instead of closets. Whether or not the story is true, the closets that were built into the bedrooms are not by Maybeck.[8]

Balconies project from the front of the Schneider house on both floors. The lower-floor balcony wraps around one corner to connect with the enclosed entryway, which is centered in the south side and reached by a short flight of steps. Putting the entrance on the side allowed the living room (plate 49) to extend across the front of the building with maximum effect, as in the Hopps house. Although the westward-facing living room occupies the "view side" of the house, it is not oriented toward that view in any dramatic way. The presence of French doors opening onto the balcony indicates that the panorama of the bay was meant to be enjoyed by stepping outside.

Horizontal redwood siding was used for the lower story, board and battens for the upper part of the house and the outside walls of the entryway. Maybeck finished the entrance wall with a decorative flourish that seems to be a pun on the idea of the grand entrance. Whereas in a mansion there might have been a large mirror, or perhaps a framed portrait, hanging near the entrance, here the window

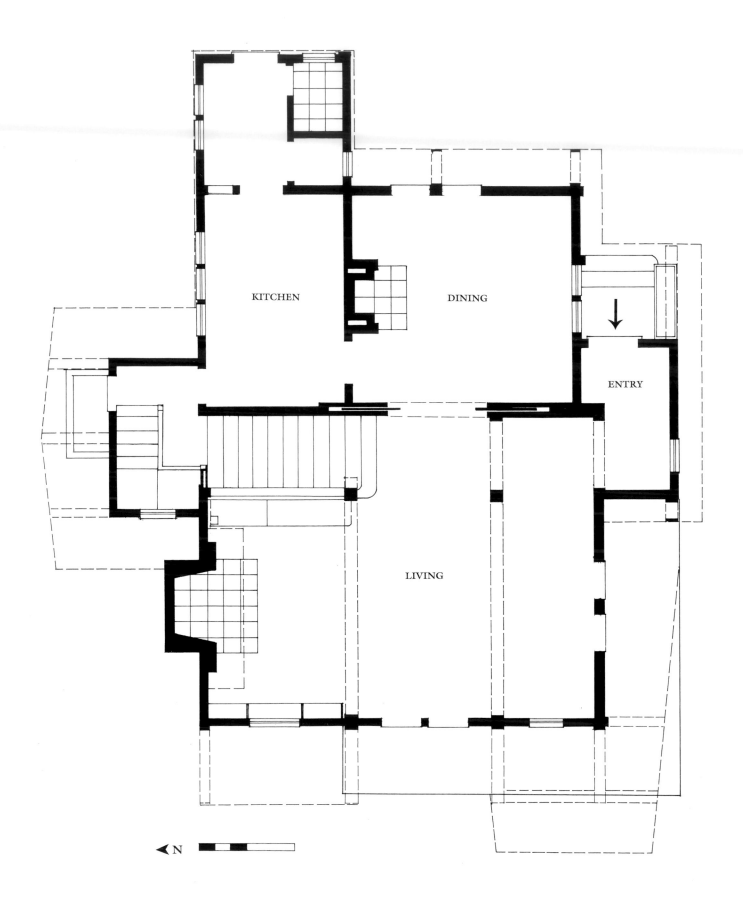

KITCHEN

DINING

ENTRY

LIVING

◄N

that illuminates the entry is surrounded by a flat redwood frame jigsawn with scrolls and curls. The playfulness evident in this frame recurs in the dining-room mantelpiece, which seems a shorthand version of a Chippendale scrolled pediment (plate 50). Although at thirteen by thirteen feet, the room is relatively modest in size, the fireplace occupies a third of one wall, and the mantelpiece, tapering toward the ceiling, creates an illusion of monumentality.

The Schneiders' lot (plate 51) was landscaped by John McLaren, a leading landscape gardener best known for his long tenure as superintendent of Golden Gate Park. It is likely that Maybeck designed the Schneiders' garden (he worked with McLaren, who had one of the Bay Area's largest nurseries, on other projects) but, as with the Hoppses' landscaping, there is no evidence to prove his involvement. The front garden is mostly planted in junipers. A formal circle of bulbs and roses around a central fountain originally occupied the eastern slope; stone walls defined the edges of the garden, and paved and gravel paths traced the circulation. Three redwood trees—which probably gave the house its name, Semper Virens—were planted at the northwestern corner of the house. By now they have been pruned and topped many times. The mania that gripped Berkeley residents in the nineteenth and early twentieth centuries for planting redwoods on the hillsides where they were not native was later lamented as the trees obscured people's views and buried their gardens under blankets of needles.

In 1928 Alfred L. and Theodora Kroeber bought the Schneider house. Already a preeminent figure in the university's Department of Anthropology, Alfred had published his famous *Handbook of the Indians of California* in 1925. Theodora, many years younger than her husband, was also to become famous through her writings, the best known of which is *Ishi in the Two Worlds: A Biography of the Last Wild Indian in North America*, published in 1961. She also recorded her memories of the Schneider house:

> Shortly after we were married, Kroeber found a house for sale on Arch Street in Berkeley. He went through it, took a week's option even before bringing me to see it, and before the week was out had bought it. This is one of the few occasions I can recall when Kroeber set his heart on ownership of a particular material object, but this house he wanted from his first moment of glimpsing it through its redwood-tree screen, nor did his satisfaction with it and his possessiveness toward it lessen over the years. When a thrombosis put him in the hospital, he began to worry lest he would not be allowed to return to his house of many stairs.[9]

Alfred was allowed to return to his house, where he died in 1961; Theodora died in 1979. The Kroebers made many changes to the service areas of the house and added an east wing. Of the garden, Theodora wrote: "It is obvious McLaren meant the fast growing and 'lesser' planting to be removed as the slower growing planting took hold. In fact, nothing was taken out and much added. The sloping

OPPOSITE

▦ 48. *Main-floor plan, Schneider house*

PAGES 60-61

▦ 49. *View toward the northwest end of the living room, Schneider house*

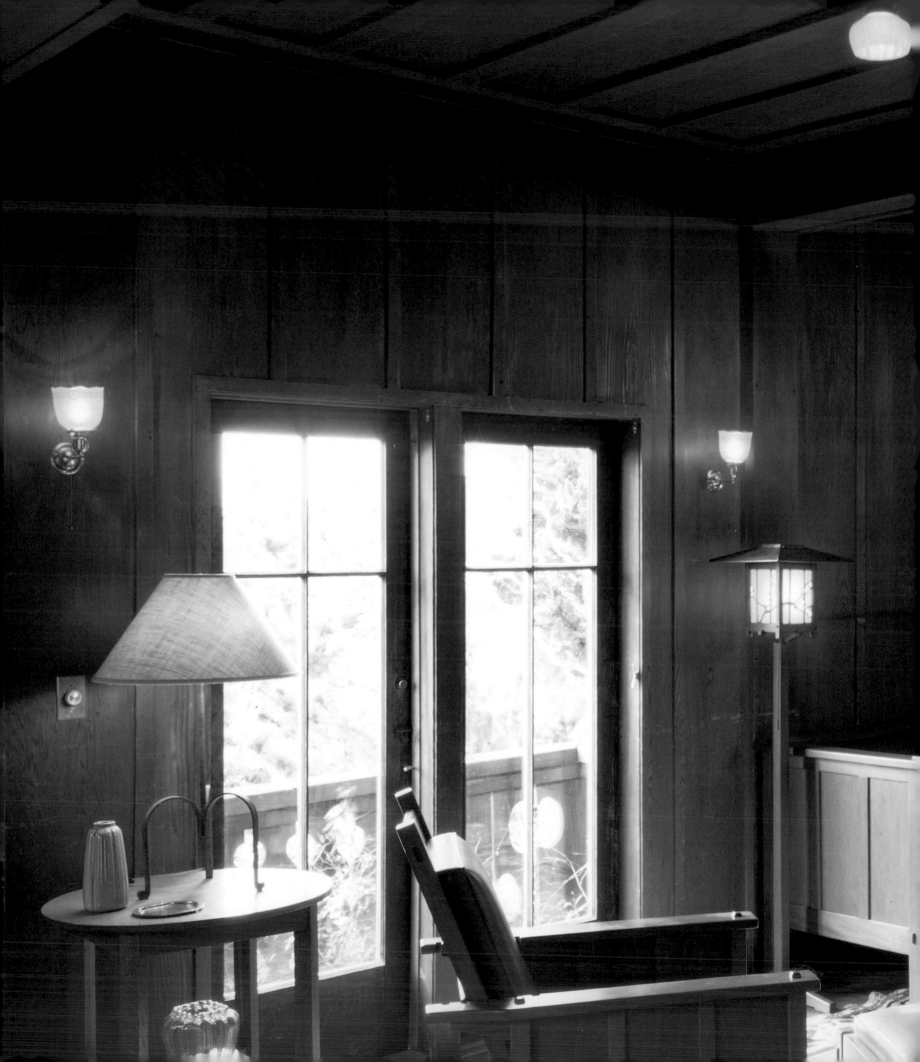

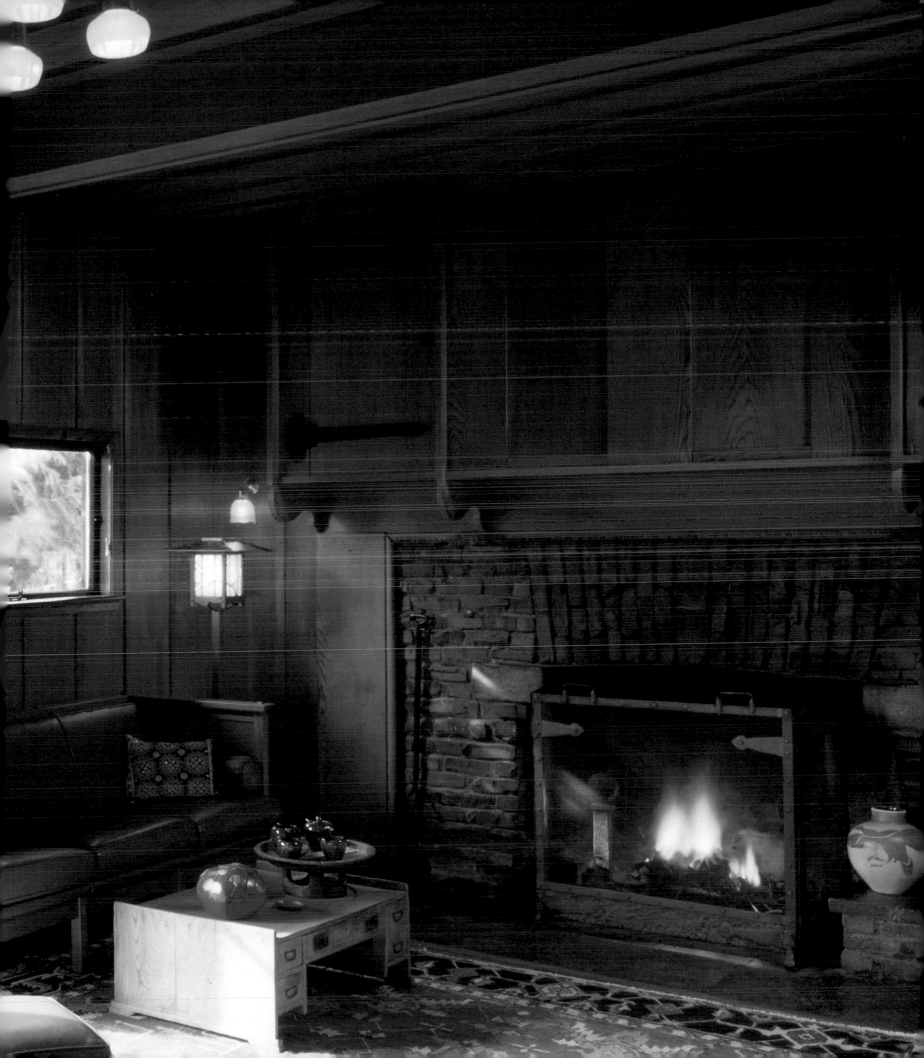

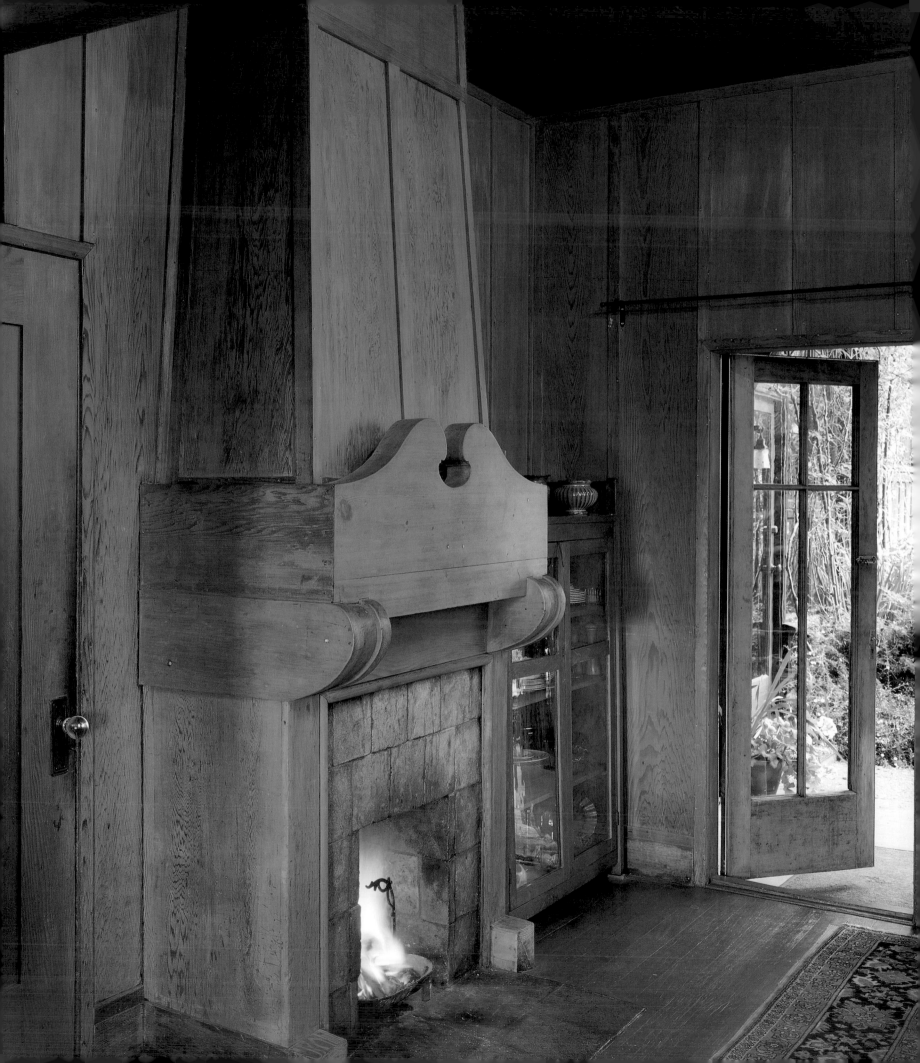

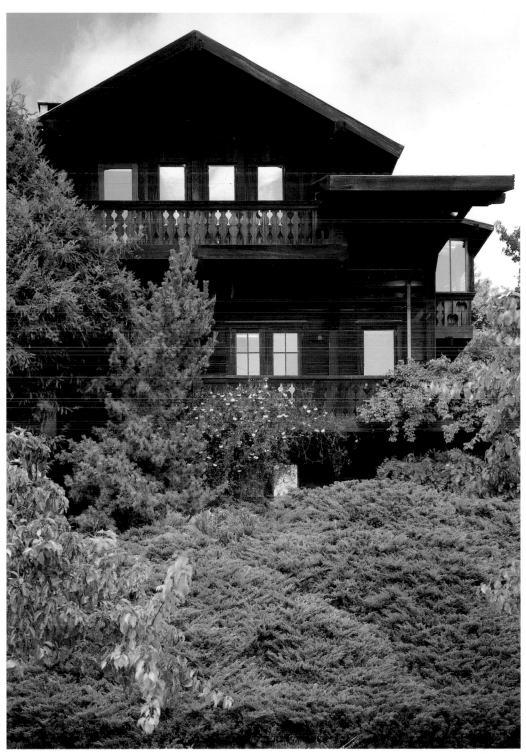

OPPOSITE

⊞ 50. *Dining room with "Chippendale" mantelpiece, Schneider house*

LEFT

⊞ 51. *Schneider house, view from the street*

RIGHT

▨ 52. *Faculty Club,
U.C. Berkeley, 1902–3.
Photograph by O. V. Lange*

BELOW

▨ 53. *West end of the
Faculty Club*

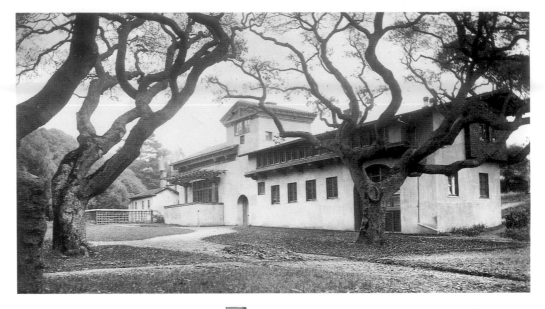

rose garden required constant maintenance and the bulbs rolled with the rains, to come up years after, always in new and surprising places."[10]

Another type of building that occupied Maybeck during his first decade of practice was the clubhouse. As the history of the Hillside Club attests, social clubs played an important part in the lives of Berkeley residents. By 1901, members of the university faculty who belonged to a dining association for students and faculty had decided to form their own organization and build a clubhouse so that they could socialize in a more informal way than the regular faculty meetings permitted. The twenty-two members had their first club meeting in March 1902, and six months later they held inauguration ceremonies and lit the fire in the great hall of the new clubhouse. The minutes of the Building Committee meetings state that Maybeck, who was a club member, offered to design the building at no charge. He also asked the members to vote on whether they wanted a high, pointed ceiling for the meeting hall or a low one. The high form won. The only other mention in the minutes of the design of the building was a recommendation that the roof be tiled.

The Faculty Club (plate 52) occupies one edge of an oak-studded, bowl-shaped glade on the Berkeley campus; the south fork of Strawberry Creek runs along the opposite edge. As the site of an Indian camping ground, the glade had once been the setting for sacred rites associated with food gathering; academic rites— graduations and assemblies of one kind and another—replaced those rituals. The long rectangular plan of the Faculty Club originally consisted of two wings flanking a central entrance, and it hardly intruded upon the glade until it was enlarged in 1914 by Warren Perry with a wing that turned the corner toward the north. Maybeck had apparently considered adding wings to the building to enclose a patio on the south side, but his proposal was abandoned in favor of an addition by John Galen Howard in 1903–4. Sympathetic additions were made by other architects over the years, and even with the many enlargements, the Faculty Club retains the unpretentious character that Maybeck gave it.

The design for the club building reveals that Maybeck's loyalty to his education at the Ecole never inhibited him from following his own ideas, for here he violated the principle of *caractère* by creating a Gothic hall inside a building of decidedly Mediterranean style. The exterior alludes to California's Franciscan missions in its rectangular tower, its tile roofs, and its adobe-colored plaster walls with large, arched openings on either side of the former library on the ground floor of the west wing (plate 53). A room was created in the tower for Henry Morse Stephens, a very popular professor of history, who paid for it and is said to haunt it.

Why Maybeck chose to use the mission as his model for the club is not known. The indefatigable writer and publisher of Californiana, Charles Lummis, had launched a crusade to save the missions in 1895 with the founding of the Landmarks Club in southern California. Images of the crumbling mission structures had been published even before that; a series of ten articles on the missions had appeared in *California Architect* during 1891, which increased interest in

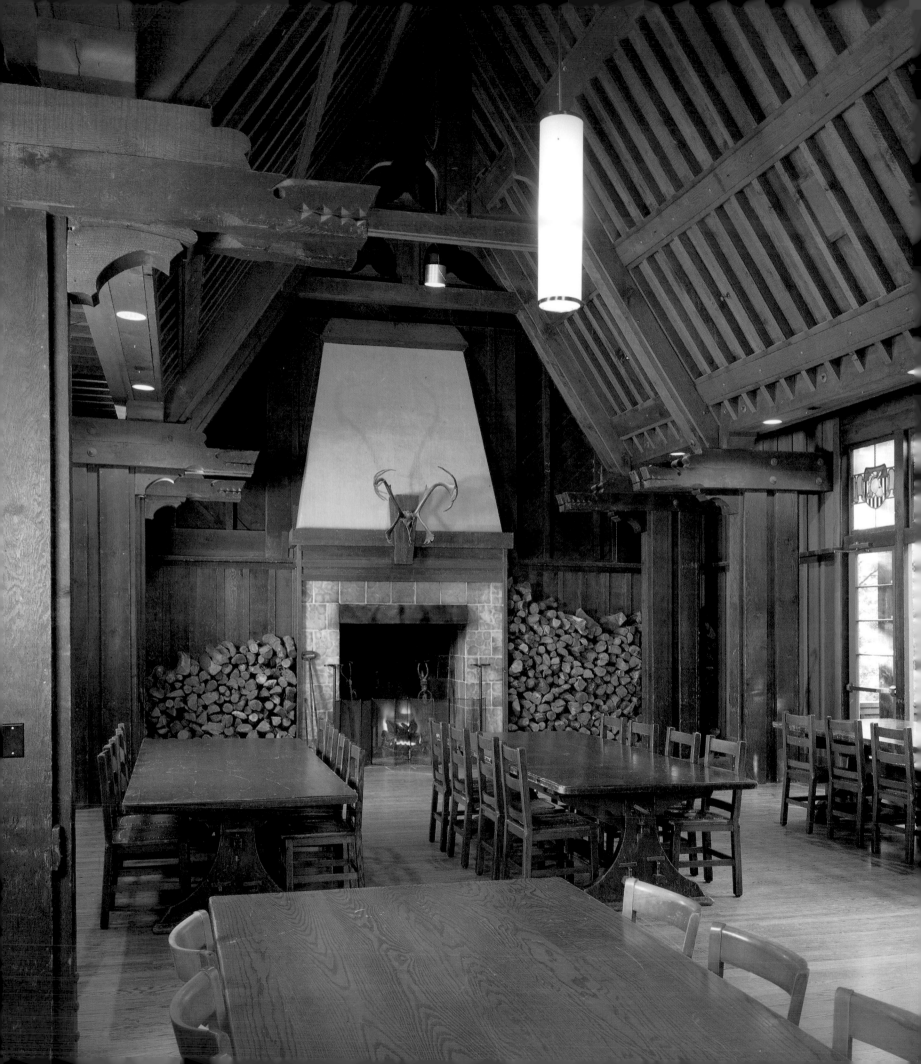

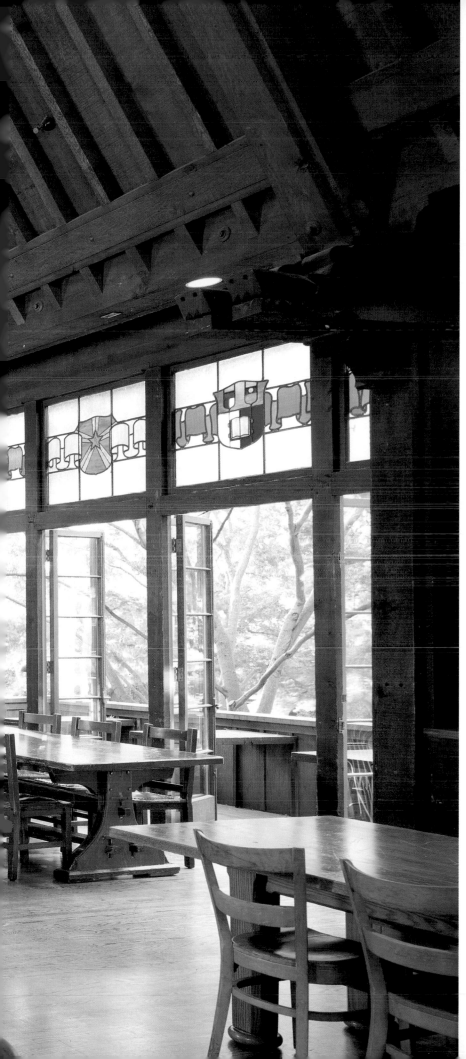

them. As artists and architects sketched what remained of the missions, a style known as Mission Revival, which synthesized their distinctive features, spread throughout the state.

The great hall, in the club's east wing (plate 54), is a Nordic contradiction of the Mediterranean exterior: the low-pitched gable roof gives no indication that the interior has a high-peaked ceiling. The ceiling's structure of heavy timbers rests on a system of short beams tied back into the walls and heavy piers built up of rough-sawn, two-by-ten-foot boards that stand away from the walls of the room. Thus the ceiling is a structure within the main building structure and recalls Semper's primal roof. Outside the hall on the north side is a terrace sheltered by a wooden trellis, which rests on beams that are extensions of those inside. The ends of the beams inside the hall are carved in pairs of stylized dragon heads (plate 55). (Maybeck once said that the dragon heads, a recurrent motif in his work, were a memorial to his father's wood carving.) Triangular braces at the ceiling ridge are perforated with trefoils. The great fireplace on the

OPPOSITE

▓ 54. *Interior of the great hall, Faculty Club*

ABOVE

▓ 55. *Interior detail of a beam in the great hall, carved with a dragon head*

west wall is faced with mat-glazed tiles and has a shallow mantelshelf made of a single timber placed about nine feet above floor level. Above the mantel are elk horns mounted on a large wooden "keystone." In creating this powerfully primitive setting, Maybeck seems to have tried to evoke an immemorial time and give the infant organization a head start on tradition.

The composition of the west wing is quite different. The ridge of the gable roof is offset from the center of the building toward the south, apparently to give more daylight to the assembly room, which occupies the upper floor. The longer, northern slope of the tile roof covers a projecting bay that runs the length of the room; the downward sweep of the ceiling makes the interior seem tentlike. These hints of Semper's lingering influence in the roof and ceiling structure of the Faculty Club are echoed in the other clubhouses that Maybeck designed.

Akin to the Faculty Club but less complex is the Outdoor Art Club (plate 56), constructed in 1904. This building also stands at the back of a wooded piece of land, but it faces a large garden and is bordered by two streets in suburban Mill Valley. Like the Faculty Club, the Outdoor Art Club building has had additions at the back and side to provide space for offices and a larger kitchen; the original building had only a tiny kitchen and a backstage lavatory and dressing room in addition to the main hall. The shingled exterior of the original clubhouse appears simple except for some eye-catching triangular features that punctuate its roof. On the interior (plate 58), where the framework of the roof is exposed, it is clear that the crossbeams extend through the roof to the outside; their ends are supported on extensions of the posts that, on the interior, stand free of the walls. The outside sections of the posts are shingled, and the corresponding parts of the beams have individual gable roofs. That Maybeck conceived of the building as a wooden tent is clearly indicated not only by the separation of the framework of the roof from its covering but also by the way that the eaves are lifted up like flaps to permit more light to enter through the French doors that line the walls. Had Maybeck just intended to create a rustic wooden hall, he could have done so with a much simpler structure. The king posts with turned and chamfered ends and the heavy boxed timbers of the truss supporting the dark wooden ceiling give the room a monumental dignity. A great stone fireplace stands off center on a dais at the end of the room, an odd location if it was intended to be the climax of the space. The explanation may be that this placement allowed for the doors to a backstage room that facilitated the staging of performances and ceremonies.

The year before the Outdoor Art Club was built, the Bohemian Club had authorized Maybeck to proceed with drawings for a clubhouse (plate 59) to be built in Meeker Grove, 160 acres of redwoods about one hundred miles north of the Bay Area. The building's site is a rounded ridge about two hundred feet above the left bank of the Russian River. The Bohemian Club had been founded in San Francisco in 1872 with the goal of promoting good fellowship among people concerned with the arts; the members had rented the grove as a camping ground periodically since 1882. Maybeck had been elected a professional, or

artistic, member of the Bohemian Club in 1899 and remained a staunch member for fifty-eight years. He particularly relished the many theatrical performances staged at the club's headquarters in the city and at the grove during the mid-summer encampment. His clubhouse, called both the Chalet and the Lodge, was the first permanent building in the grove. Drawings for it were completed in the spring of 1904, and the building was ready for use during the encampment that summer. Although the encampment provided the occasion for celebrating its completion, the building was mainly intended for use during the rest of the year. The budget of five thousand dollars was tight, but Maybeck stuck to it: the final bill was $4,992.05; of which $34.95 was spent on a special tabletop and $369.10 for fees and travel expenses.

The building's single floor is twenty-two feet above ground on the east side and meets the hillside at the southwestern corner. With its base shingled in slabs of redwood bark about three feet long, the structure seems as deeply rooted to its site as the trees that surround it and that even pierce its eaves. About three times the size of the single room it shelters, the roof projects well beyond the deck that encircles the 840-square-foot clubroom. On the long sides of the building the deck is only two feet eight inches wide, so narrow a space that the three-foot-wide French doors cannot be fully opened, indicating that only the much deeper decks on the ends were intended for active use. The clubroom is nearly square. The opening of the stone fireplace on the northwest wall was originally seventy-two inches wide by sixty-six inches high. After wind repeatedly drove smoke down the flue into the room, the opening was reconfigured to forty-eight inches wide by sixty inches high.

The interior walls of untreated redwood boards contribute to the effect of being inside a redwood tree. On the outside this impression is heightened by the branching supports for the massive roof overhangs. These supports of bundled tree trunks rise through the deck floor from the building's base, where diagonal braces are concealed behind the redwood-bark slabs. (The romantic effect was carefully plotted: the diagonal struts form multiple angles, each of which is an exact multiple of a five-degree angular module.) Maybeck placed redwood stakes above the beams that support the deck floors so that they project beyond the floor and intersect with the redwood stakes that form the deck railing.

Originally, the eaves of the roof were also feathered out with a lattice of wooden sticks that suggested foliage. Overshadowed by giant trees and recessed under its roof, the clubroom would seem even more like the hollow of a tree if its sides were not so generously glazed. Also, by locating the building on a ridge and by raising it above the ground into midair, Maybeck made the interior as light as a tree house should be. He designed simple furniture for the clubhouse: a high-backed rustic bench, a large table with a top made of a single slab of redwood, and some three-legged chairs modeled on Flemish milking stools.

The last of the small clubhouses that Maybeck designed during his first decade of practice was the 1906 Hillside Club in Berkeley. Since the club was

RIGHT

⊞ 56. *Outdoor Art Club, Mill Valley, 1904. View from the south side of the meeting hall*

BELOW

⊞ 57. *Detail of the pergola, Outdoor Art Club*

OPPOSITE

⊞ 58. *Main meeting room, Outdoor Art Club*

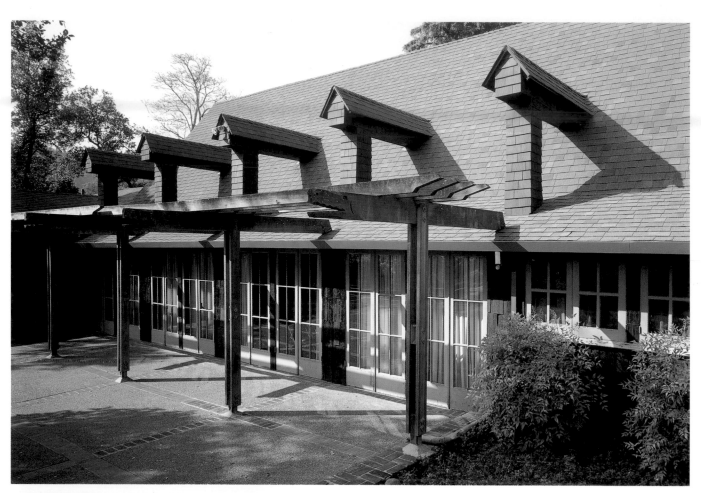

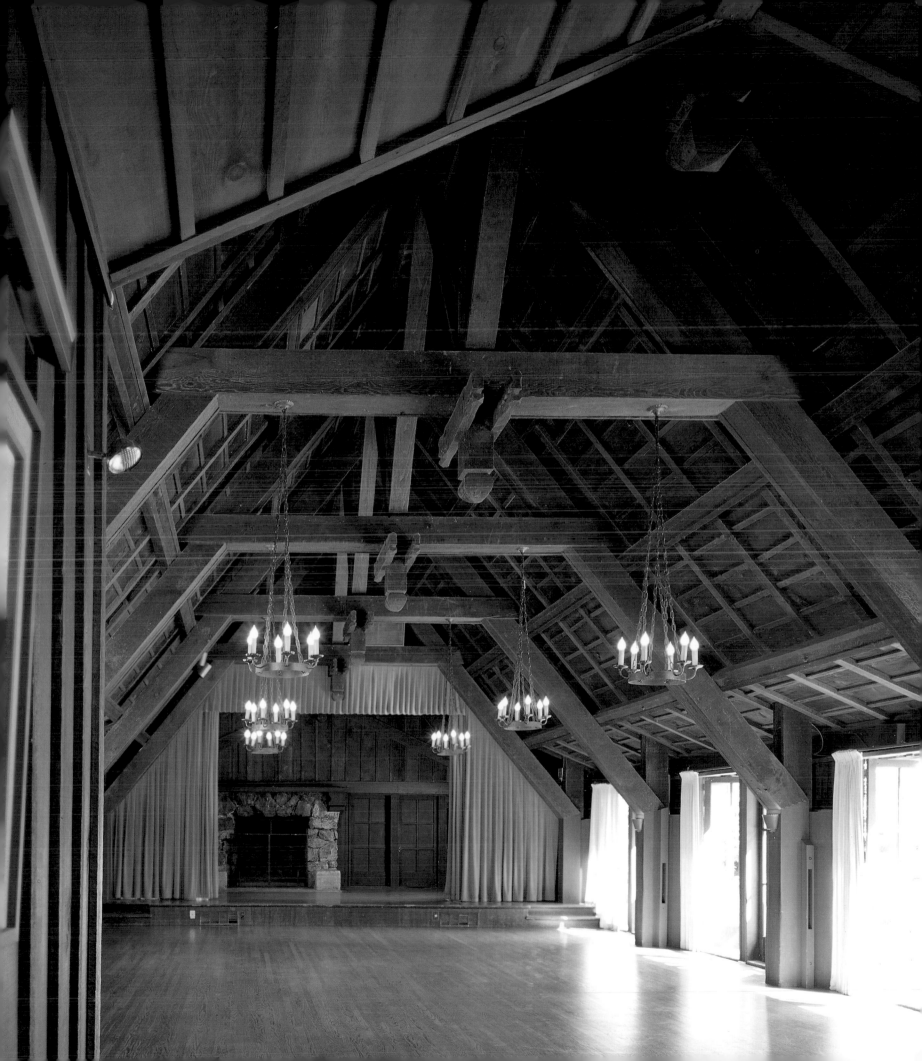

founded partly to popularize Maybeck's architectural recommendations for materials, structure, and siting, the design was, appropriately, an embodiment of Maybeck's innovative ideas. The newspaper editor Frank Morton Todd wrote that Maybeck said of the club: "This is an organization of neighbors who like one another and wish to have a sort of common home for the hours of their meeting together. It must *feel* that way!" Todd admired the way the "naked timbers were

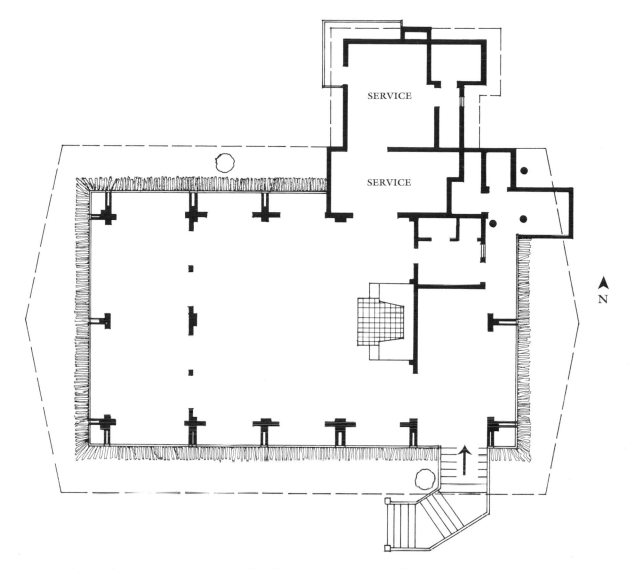

SERVICE

SERVICE

N

braced and tied together in the handsomest and most powerful structural forms."[11] He considered such "open timbering" to be Californian and added that the clubhouse was "as intimate and stable and homey as an old stump."

The building was compact, with its parts fused into a longitudinally symmetrical plan that ran parallel to Cedar Street and was composed of separate masses, each with its own gable roof. The main block of the building contained the meeting hall, with a central nave, a transept, side aisles, and triforium. Again the structural frame was expressed on the inside and the outside. The high-peaked ceiling with king posts supporting the ridge beam defined a Gothic space. The only wood used was redwood, cut and treated differently to produce various tones; only the casements were painted. The entire vocabulary of redwood was used, including shingles, rough-split barn shakes, boards and battens, heavy timbers, and small sticks for trellises. A culminating work for this period of Maybeck's practice and a landmark of the Berkeley Arts and Crafts movement, the clubhouse burned in the 1923 fire.

OPPOSITE

▦ 59. *Bohemian Grove clubhouse, near the left bank of the Russian River, 1903–4. Drawing by Diana Woodbridge of the main elevation*

ABOVE

▦ 60. *Main-floor plan, Bohemian Grove clubhouse*

MEMORIAL
TO
PHŒBE A HEARST

W R RANDOLPH HEARST
DONOR

MAYBECK

3

THE HEARST COMMISSIONS

hile he was in the midst of launching his practice during the mid-1890s, Maybeck met Phoebe A. Hearst, the immensely wealthy widow of the mining magnate and U.S. Senator George Hearst, who was to become his patron and client. As a result of this meeting, Maybeck was able to initiate a momentous undertaking, an international competition for a campus plan for the University of California. Both the meeting and the competition came about through a fortuitous combination of events, as things often did in Maybeck's life. In 1894, once again on the commuter ferry to San Francisco, Maybeck met Frank Soulé, Jr., head of the university's Civil Engineering College, who encouraged him to apply to the new Department of Instrumental Drawing and Engineering Design for a position to teach descriptive geometry.[1] Having excelled in the subject at the Ecole, Maybeck was well qualified for the job. Although the university salary did not match the pay in Brown's office, Maybeck took the academic position. A year later he also became the director of the Architectural Section at the Mark Hopkins Institute of Art, which had been installed in 1893 in the old Hopkins mansion atop Nob Hill in San Francisco.[2] The institute offered courses in sketching, in the use of materials in construction, and in architectural history. Maybeck himself taught Practical Architecture and Design, a title that suggests a response to the demand for basic architectural training in the Bay Area. This first architectural program must have caused some excitement in the youthful architectural community.

In 1895—while Maybeck was teaching in Berkeley and San Francisco and also designing the Keelers' Highland Place house—Phoebe A. Hearst met with the university president to discuss her desire to donate a mining building in her husband's memory. As the only architect on the faculty, Maybeck was charged with drawing up a design for Mrs. Hearst's fast-approaching next visit. He installed the hastily prepared drawing against a backdrop of drapery and surrounded it with

61. *Drawing of the proposed Hearst Memorial Art Gallery, 1927. Documents Collection, College of Environmental Design, University of California, Berkeley*

75

potted geraniums that he had brought from home. According to Maybeck, Mrs. Hearst was so impressed that she promptly decided to proceed with the building and even wished to visit its prospective site.[3]

Inspired by this first encounter, Maybeck saw an opportunity to create a comprehensive plan for the campus, which was developing in a random manner. Never shy when advocating his visions, Maybeck proposed the concept of a master plan to the Board of Regents. Their initial reaction was not favorable. In fact, Regent Jacob B. Reinstein, a brilliant lawyer and member of the first graduating class of 1873, reportedly called Maybeck a freak and said that none of the regents took him seriously.[4] But the need for new buildings to accommodate the rapid growth of the university made the case for a master plan difficult to dismiss. Berkeley's rivalry with nearby Stanford University, which had hired H. H. Richardson to create its campus plan a decade earlier, also encouraged serious consideration of the idea. Maybeck persevered, and soon he was perceived not as an impractical dreamer but a visionary. In the end, his staunchest ally was Reinstein. Maybeck's great charm and persuasiveness notwithstanding, it was probably the university's fledgling status, without established traditions or even a clear-cut plan for the future, that accounted for his success.

Since the university was required by law to hold competitions for architectural commissions for the campus, Maybeck pressed for an international competition, an idea that appealed to Mrs. Hearst. In October 1896 she endorsed the regents' April vote to hold the competition by pledging unrestricted funds for it. She also requested that, as the professional adviser for the competition, Maybeck be given a two-year leave from teaching to go to Europe and coordinate the event. Not surprisingly, the idea that the local commission of a lifetime might go to an architect from outside the region was galling to other Bay Area architects, whom Maybeck seems not to have consulted about making the competition international. Willis Polk, who had originally favored the international approach, said after reading the program that it was so permeated with Beaux-Arts academicism that nothing original or appropriate to California could come out of it.[5]

Although Maybeck had declined to participate in the competition, he did make some drawings to promote it that were published in the *San Francisco Examiner* in April 1896 and in *Wave* in November 1896. The drawing in the *Examiner* shows a vast elliptical plaza with pools, monuments, and parterres framed by a colonnaded walkway connecting various pavilions around its perimeter. Strawberry Creek flows out of the west side under an arcaded bridge. On the east side the composition culminates in a domed building on a stepped plinth that merges with the hills. The absence from the drawing of any existing structures suggests that it was made to illustrate Maybeck's statement in the competition prospectus: "All the buildings that have been constructed up to the present time are to be ignored, and the grounds are to be treated as a blank space, to be filled in with a single, beautiful and harmonious picture as a painter fills his canvas."[6]

In the spring of 1897, following publication of the competition prospectus, the Maybecks left for Europe, where they made their headquarters in Paris. Their sojourn was rewarding on many levels. Maybeck was able to provide information about the university campus to Julien Guadet, professor of theory at the Ecole, whom he had asked to write the competition program. Maybeck also spent time with the various students from the University of California he had encouraged to attend the Ecole. Among them were John Bakewell, Arthur Brown, Jr., Edward Bennett, and Julia Morgan (who had not yet gained admission and was greatly helped in her efforts by Maybeck). His duties as coordinator for the competition also required him to publicize it throughout Europe and to confer with the jurors he had selected: Jean-Louis Pascal, the *patron* of a major Paris atelier; Paul Wallot, architect of the Reichstag in Berlin; Richard Norman Shaw, one of England's foremost architects; the well-known New York architect Walter Cook; and Jacob Reinstein, the sole nonarchitect on the jury.

After the program presenting the competition's goals and regulations was drawn up, the Maybecks traveled extensively to European cities and visited the jurors and Ben's old friends from the Ecole, who offered their hospitality and took Ben on architectural tours. Observing new as well as old buildings, Maybeck was unimpressed by such contemporary developments in European architecture as Art Nouveau, which he saw in Vienna and dismissed as ephemeral. In October 1898, after overseeing the completion of the first stage of the competition in Antwerp, he and Annie came home with their infant son, Wallen, who had been born in Paris. The university recognized Maybeck's service by creating for him the position of instructor in architecture in the Department of Instrumental Drawing and Engineering Design. Maybeck thus introduced architecture into the curriculum of the university.

While in Paris, Maybeck had begun work on a commission for Phoebe Hearst, who was in Europe keeping an eye on the competition. She wanted to build a hall to hold the official receptions for the jurors and other officials who would be visiting the Bay Area to attend events associated with the final judging of the competition. The building was to be sited next to a house in Berkeley that she had rented for the duration of the competition activities, after which the hall was to be taken apart and moved to the campus. This requirement inspired an unusual design for the hall (plate 62), which was completed by August 1899, when the jurors arrived for the final phase of the competition.

Upon his return Maybeck collaborated with the engineer Herman Kower, a university colleague, to design a building in which laminated-wood arches would be joined to prefabricated sections of walls in such a way that the structure could be taken apart, moved, and reassembled, as Mrs. Hearst had requested. The result was the most innovative design of Maybeck's career. Called Hearst Hall, the 60-foot-wide and 140-foot-long building had twelve arches that rose fifty-four feet above the ground-floor level and were paired to make six structural bays. Each end wall had a single arch. The design was clearly based on Semper's theory of

62. *Hearst Hall, Berkeley, 1899*

63. *Main reception room, Hearst Hall*

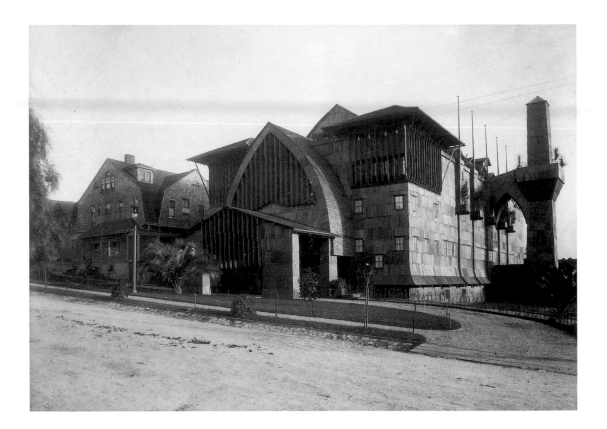

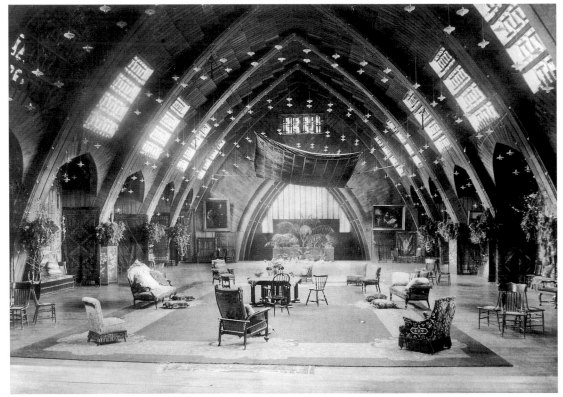

the four elements: the main floor was designed as a platform, raised twelve feet above the ground floor and braced with a diagonal grid of beams and joists left exposed on the ceiling of the ground-floor dining room; the mighty arches constituted a structural system that was independent of the curtainlike walls clad in three-foot-long redwood shakes; and the dais in an apse at the end of the hall occupied the place of the hearth. The building had many unusual features, such as dormers the size of small rooms that admitted light through large windows faced with ornamental grilles of turned balusters. An outdoor gallery at the level of the dormers was lined with evergreen trees. At about half the height of the building, the arches were tied to wall columns with short beams that poked through the outside wall, where their ends supported planters containing small trees. The most capricious component was a sculptural tower next to the west side of the building, which had the practical function of encasing the flue for the heating plant. Maybeck's penchant for dramatizing the practical is nowhere more obvious than in this tower, which he encircled with a balcony and connected to the hall's outdoor gallery to provide a special lookout for viewing the bay and the Golden Gate.

The north entrance had a low-pitched, gable-roofed porte cochere connected to a broad vestibule with an arched roof. Louvers were used in the walls of the porte cochere and the vestibule and to create a linear pattern for the two mock towers. Two stairways led from inside the porte cochere to the anteroom of the dining room and were then joined in a single broad stair that climbed up to the main reception hall (plate 63). The interior of the dining room, dominated by the timbering of the hall floor above, recalled German rathskellers. The walls of the high and airy reception hall were finished with barn shakes turned silvery gray by treatment with an iron-sulphate solution. Lateral arches between the main arches formed alcoves in each bay that were hung with Gobelin tapestries and paintings. Each of the main arches had two rows of colored lights mounted on it and two rows of white lights with milk-glass reflectors suspended from it to create a second arch of lights. At night these thousand or so incandescent bulbs transformed the room into a twinkling firmament.

The building's exterior was ridiculed at the time as "railway Gothic," mainly by architects who thought it resembled a train shed with a Gothicky frontispiece but failed to notice, or could not comprehend, its innovations. In photographs the dramatic sweep of the arches and the diffused quality of the light filtered through the screened windows give the interior a Nordic quality that may have appeared out of place in California. In Europe, however, the great Viennese architect Otto Wagner adapted the structure of Hearst Hall for his Interimskirche (Temporary Church) of 1905. Instead of wood, he used unfaced iron for the arches and metal panels for the exterior; he also eliminated the towers and used a less monumental arched form for the vestibule. It seems most fitting that another architect who shared Semper's Germanic heritage should have recognized, as Maybeck did, that the irreducible, eternal parts of architecture, which Semper

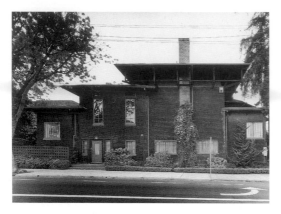

🔲 64. *Town and Gown Club, Berkeley, 1899*

🔲 65. *Wyntoon, on the McCloud River, Siskiyou County, 1902–3*

defined as the four elements, could be perfectly expressed in a temporary building.

In 1901, when Mrs. Hearst left Berkeley for her estate in Pleasanton, California, the hall was dismantled and moved to the campus. There it served as women's gymnasium, social center, and performance hall for theatricals and musicals until its destruction by fire in 1922. Even hung with sports equipment instead of lights, it looks nonetheless magical in the extant photographs.

Phoebe Hearst was an honorary member of the Town and Gown Club, which commissioned a clubhouse by Maybeck in 1899 for a site south of campus. As the name suggests, the club was intended as a place where university and nonuniversity residents of Berkeley could mingle. In this building (plate 64), as in the Rieger house (plate 16), the umbrellalike roof is supported on outriggers extending from the main structure. The outriggers also continue inside to support ties to the roof rafters and a horizontal grid of beams. The rectangular volume of the clubhouse is enclosed in a shingled skin. On the ground floor, an open space used as a lounge is punctuated with posts, set at an angle to the floor, that support the longitudinal ceiling beams; those beams in turn carry the crossbeams of the floor above. In this respect the building is a simple version of Hearst Hall. On the second floor the open auditorium space could be screened off with curtains and redwood panels. The building was published in a newspaper article of 1899 headed, "An Odd Clubhouse for Berkeley Women." The reporter noted that the building was "attracting much interest and curiosity on account of its peculiar oddity and eccentricity of design." Unable to contain himself, the writer concluded by saying that the partially completed building was a "structure of the most unique kind, a radical departure from the conventional, bordering almost upon the freakish."[7]

Although "freak" seems to have been a word often used to describe Maybeck and his work in this period, it is unlikely that he felt like an outcast. In addition to a circle of close friends and ardent admirers in Berkeley, Maybeck had a powerful patron in Phoebe Hearst, and her commissions enabled him to build architectural visions that less munificent clients would not even have considered. For Wyntoon, on the McCloud River in the northern California county of Siskiyou, Maybeck designed a "castle on the Rhine"—with Japanese overtones—that was built in 1902–3 (plate 65). Mrs. Hearst had requested plans for the McCloud River property after she returned from a tour of European castles. In a letter written in 1930, Maybeck recalled that the combination of Wyntoon's setting and Mrs. Hearst's character called for a castle instead of an ordinary country place.[8]

In January 1904 Maybeck wrote a text about Wyntoon that reads in part like program notes for a theatrical performance and in part like the description of a painting.[9] He began by noting an important feature of the site—six immense evergreen trees in a semicircle—and then named other influences on the design,

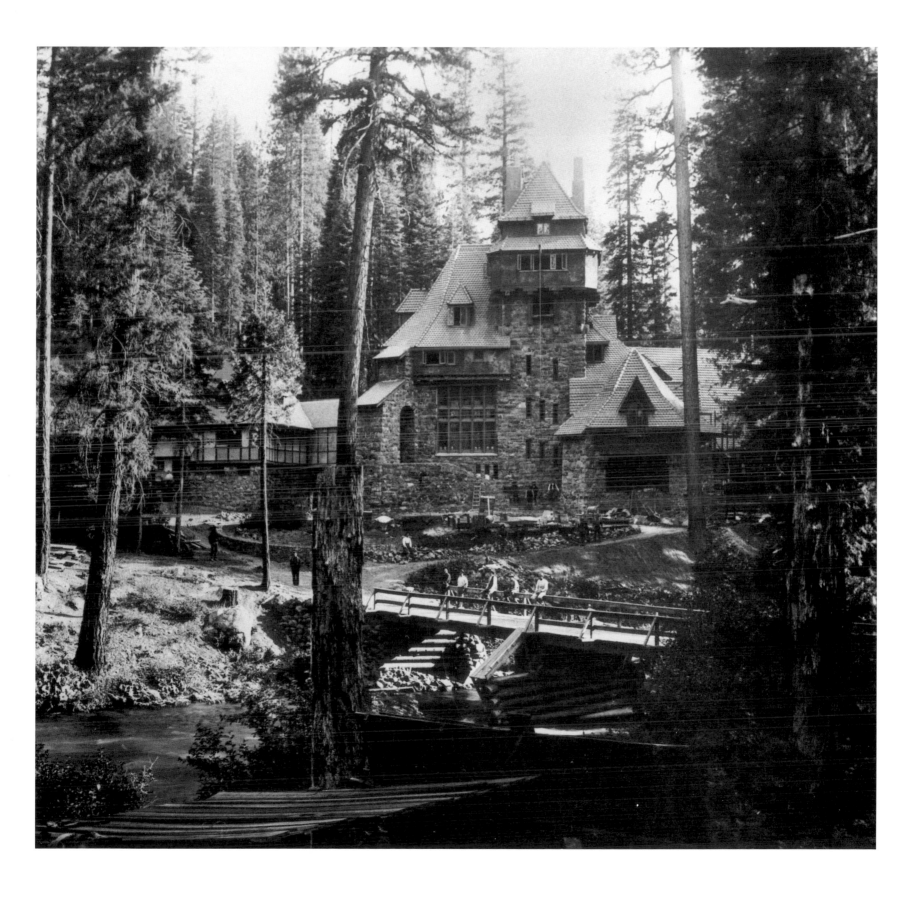

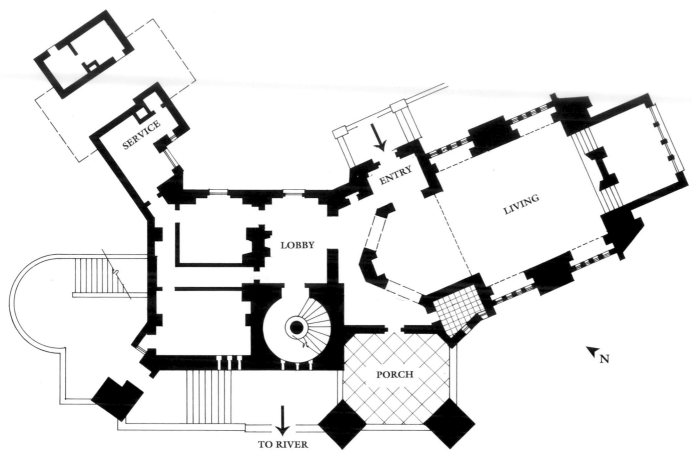

SERVICE

ENTRY

LIVING

LOBBY

N

PORCH

TO RIVER

ABOVE

📖 66. *Main-floor plan, Wyntoon*

OPPOSITE

📖 67. *Stair tower, Wyntoon*

such as the alpine climate and the danger of forest fires. However, he never explained how he dealt with these practical considerations, being far more concerned with explaining visual aspects of the composition. Because of the proximity of the river, described as a "crystal torrent," the bedrooms were raised high above the ground. "This was an advantage," Maybeck wrote, "for if the building had been only one or two stories high, it would have looked like a hovel in the hillside. As it is, the line of stone (lava flow quarried nearby) begins at the opposite side of the river at the beginning of the arched stone bridge . . . and continues up, broken by trees and shrubbery, along the living room to the top of the tower and chimney. This tone color is blue-grey, verging on warm siennas." More description of the colors followed as he filled in the canvas, balancing foreground and background. "To have built a red tile roof on the building would have been fatal, so we put on a dead [mat] Paris-green glazed tile, which, from afar, and against the trees, gives a misty color like the holes between the branches in the trees in the forest." The woodwork was stained a violet brown, which Maybeck had matched to the bark of the surrounding yellow-pine trees.

Shifting to the role of stage director, Maybeck continued: "Now, fill the windows with leaded glass, and see the light through the dining-room windows,

which are large enough to light a cathedral. Imagine the clear blue and white foam of the river in the foreground roaring ceaselessly, and you have a picture of rest, and, at the dawn of day, an enchanted castle. I pointedly refer to the dawn, because the colors are pearly and do not suggest the evening light."

Moving indoors, Maybeck continued his scenario:

As you enter the house there is a rubble stone vestibule, with an archway to the living room. At one end of the living room is a fireplace as high as a man, and beyond it a copy of thirteenth-century stained glass from the apse of the Lorenzen Kirke in Nuremburg. Old tapestries of the fifteenth and sixteenth centuries keep the moisture from the stone from making the room clammy. . . . The dark height of the room, the unobstructed archways, the deep blues, reds, and yellows of the cathedral window . . . the little flicker of fire, and the roaring of the river outside; and you, satiated, tired, and inspired by the day's trip among hazel, dogwood, great aged pines, rocks, cascades, great trunks of trees fallen years ago—a dishevelled harmony,—here you can reach all that is within you.

It is often observed that Maybeck never wrote much about his architecture; he himself said that he never really learned to read or write in school. It may be that he could not write learned prose, but he did create vivid word pictures, balancing poetic allusions and meticulous detail. He was never boring.

Maybeck's article on Wyntoon closes with a puzzling statement: "It is perhaps strange that, having the opportunity and the money, the architect did not do architecture. There are places where moldings and carvings are suggestive of pastry and perfume . . . ; the only modern thing that could be introduced into a problem of this kind was that of proportions; given a 'hoary forest' and stone as a theme, make the work in exact accord with the sentiment and use, and give it a beautiful mass." Perhaps Maybeck was acknowledging here that the staged quality of the building overshadowed its architec-

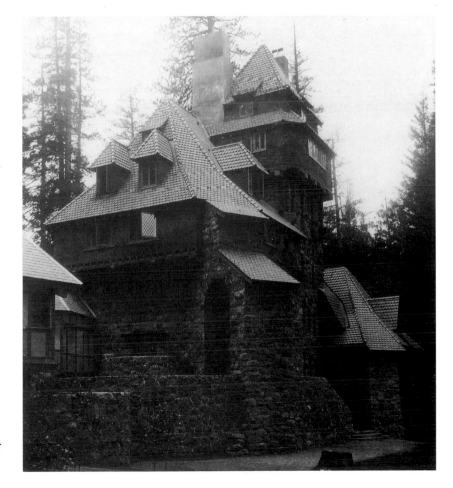

ture. His Ruskinian allusion to the hoary forest and the theme of stone seems to suggest that the building was meant to transcend the idea of modern architecture as functional form and to achieve the higher goal of becoming "a beautiful mass."

The building appeared to grow out of the site, its stone roots, as Maybeck wrote, even reaching to the opposite side of the river. The stony pieces piled up asymmetrically to embrace the tower on one side and cascaded down on the other. As in a Japanese castle, the form became more complicated at the top, where the main roof was broken up by a variety of dormers (plate 67). The cap-like roofs directed the mass down toward the earth again so that, unlike European castles, the building did not reach for the sky. In writing about the design of Wyntoon's living hall in 1930, Maybeck gave a detailed account of the use of great halls in the Middle Ages, noting that they were not provided with central staircases from which rooms opened at various levels, but that the stairway was contained within a stone tower that reached to the highest floor under the roof.[10] With this in mind, Maybeck had divided the composition of the main part of Wyntoon into a wing with a great hall and a multistoried section with a stair tower. A covered bridge over the driveway connected the main building to a separate building that housed the kitchen and other service rooms.

The living hall (plate 68) reached a dramatic climax in the stone fireplace, which had an overscaled keystone carved with PAH (for "Phoebe Apperson Hearst"). Looming up behind the arch and backlit with the colored light from the window-wall, the hearth suggested an altar to the mountain gods. Although the stony mass dominated the hall, a lot of wood was also used in the building. Beneath the tile roof, for example, the ceiling was made of log trusses and barked

68. *Living hall, Wyntoon*

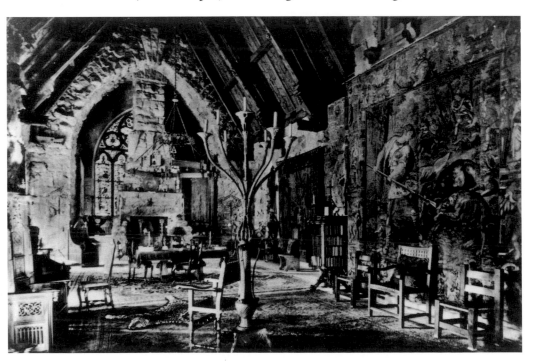

panels. In the winter of 1929–30 a fire, possibly caused by chipmunks chewing the insulation off the electrical wiring, reduced the castle to a ruin.

Although Maybeck continued to enjoy Mrs. Hearst's friendship after designing Wyntoon (her correspondence files contain regular thank-you notes from Annie for birthday gifts and holiday greetings), the only other commission that he owed to her was for the 1918 general plan for Mills College in Oakland, which was never fully carried out. Even though photographic records of Hearst Hall and Wyntoon exist, it is deplorable that these two milestones of Maybeck's career, both designed for Phoebe Hearst, were destroyed by fire after her death in 1919. Had they been destroyed during her lifetime, she would probably have hired Maybeck—then in his prime—to design their replacements. Instead, the commissions for new buildings came from her son, William Randolph Hearst, whose plans for a Phoebe A. Hearst memorial gymnasium, auditorium, museum, and art gallery on the university campus and for a new complex at Wyntoon were ultimately of more benefit to Julia Morgan than to her old mentor.

The destruction of Hearst Hall in 1922 prompted William Randolph Hearst to offer funds to the university for a new building to honor his mother. Naturally eager to take him up on this offer, the university officials pressed for a building that would satisfy their urgent need both for a women's gymnasium and for an auditorium. As was typical of Hearst, the project began to expand in his mind. He authorized Maybeck to prepare drawings for a gymnasium, an auditorium, an art gallery, and a museum to house the art and anthropological collections that Mrs. Hearst had given to the university over the years. Maybeck produced many sketches and drawings (plates 69–72) for a grand complex that was intended to

69. *Plan for the proposed Phoebe A. Hearst Memorial, 1927, approximately 45 x 75 in. In this version the gymnasium, drawn in the upper-right corner, is linked with the barrel-vaulted gallery below. Documents Collection, College of Environmental Design, University of California, Berkeley*

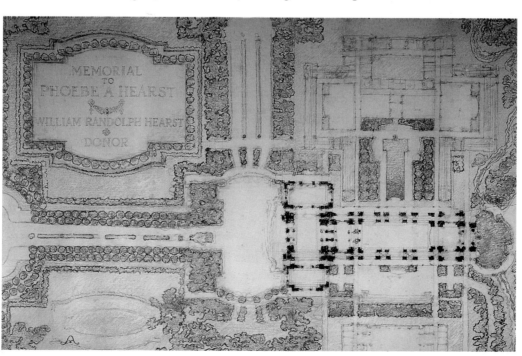

RIGHT

⊞ *70. Another version of the proposed memorial, showing the gymnasium in the upper-right corner introducing a domed rotunda on Strawberry Creek. The gallery is to the left, and the museum complex lies along College Avenue at the left side of the drawing. Colored chalk and pencil on paper. Documents Collection, College of Environmental Design, University of California, Berkeley*

BELOW

⊞ *71. A mixed-media rendering of the proposed memorial, showing the gymnasium with the auditorium rising behind it. Documents Collection, College of Environmental Design, University of California, Berkeley*

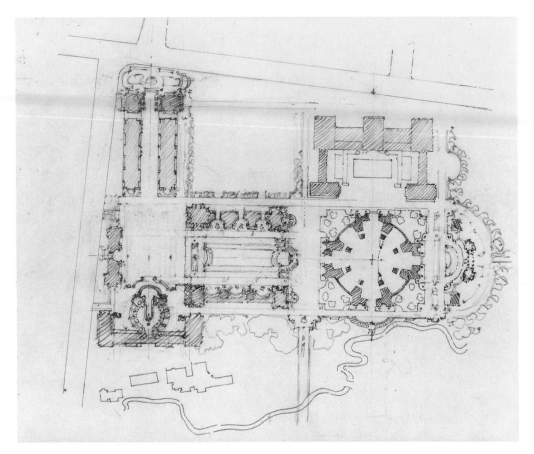

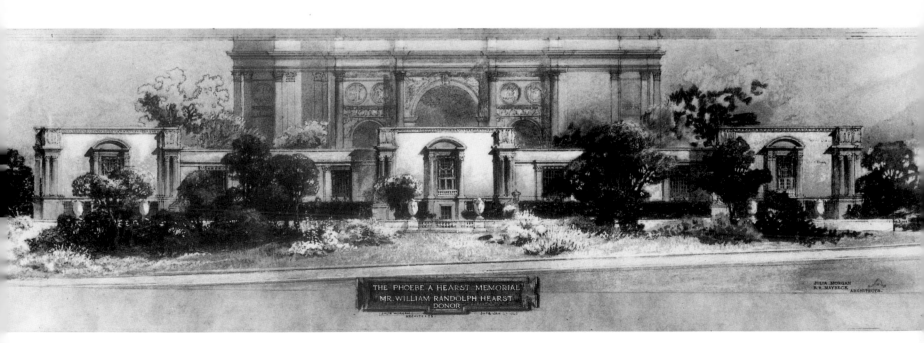

THE PHOEBE A HEARST MEMORIAL
MR. WILLIAM RANDOLPH HEARST
DONOR

fill the southwestern corner of the campus, from the south fork of Strawberry Creek (which would have defined the northern edge of the site) to Bancroft Way, on the southern edge of the campus. College Avenue established the eastern edge of the complex, and existing university buildings limited the site on the west.

As depicted in the drawings, Maybeck's buildings echo the classical imagery of the 1915 Panama-Pacific International Exposition; the domed auditorium was a modified version of Maybeck's Palace of Fine Arts (plate 90). One drawing (plate 61) shows a long barrel-vaulted loggia beside a watercourse, reminiscent of the Jardins de la Fontaine in Nîmes, France. Both formal, geometric watercourses and ponds with irregular banks (like the palace lagoon) are shown. It is difficult to tell from the drawings if Strawberry Creek was to be redirected or whether some of its water was to be diverted to flow in other channels.

While Maybeck rendered his visions in beautiful impressionistic pastel drawings on large sheets of brown paper, the university administration pursued its practical goals, and in 1925 Hearst provided funds for the women's gymnasium. For this project Maybeck collaborated with Julia Morgan, and the construction drawings were prepared in her office. When the building was completed in 1927, it bore the unmistakable imprint of Maybeck's romantic imagination in the great urns set about its base (as on the Palace of Fine Arts) and in the huge planters embellished with reliefs of dancing women on the pool terrace. Under Morgan's direction, the interior of the building was designed in a frankly functional way. Indeed, Maybeck was so disconnected from the interior planning that, according to one story, when Hearst asked him where the bathroom was at the dedication ceremony, Maybeck did not know.

Maybeck's attention had been focused on the grand ensemble of the art gallery's loggia and the museum in its landscaped setting. In his drawings these structures have the qualities of ruins. The gymnasium was just a fragment of this composition, intended by Maybeck to serve as the frontispiece for the auditorium, to which it would have been connected by its terraces and other promenades. Alas, the gymnasium remained a fragment. Whether Hearst was too preoccupied with his building campaigns at San Simeon or whether Maybeck dallied too long over the drawings and lost his patron's attention is a mystery. In any event, the rest of the complex was never built, and Maybeck never received another Hearst commission.

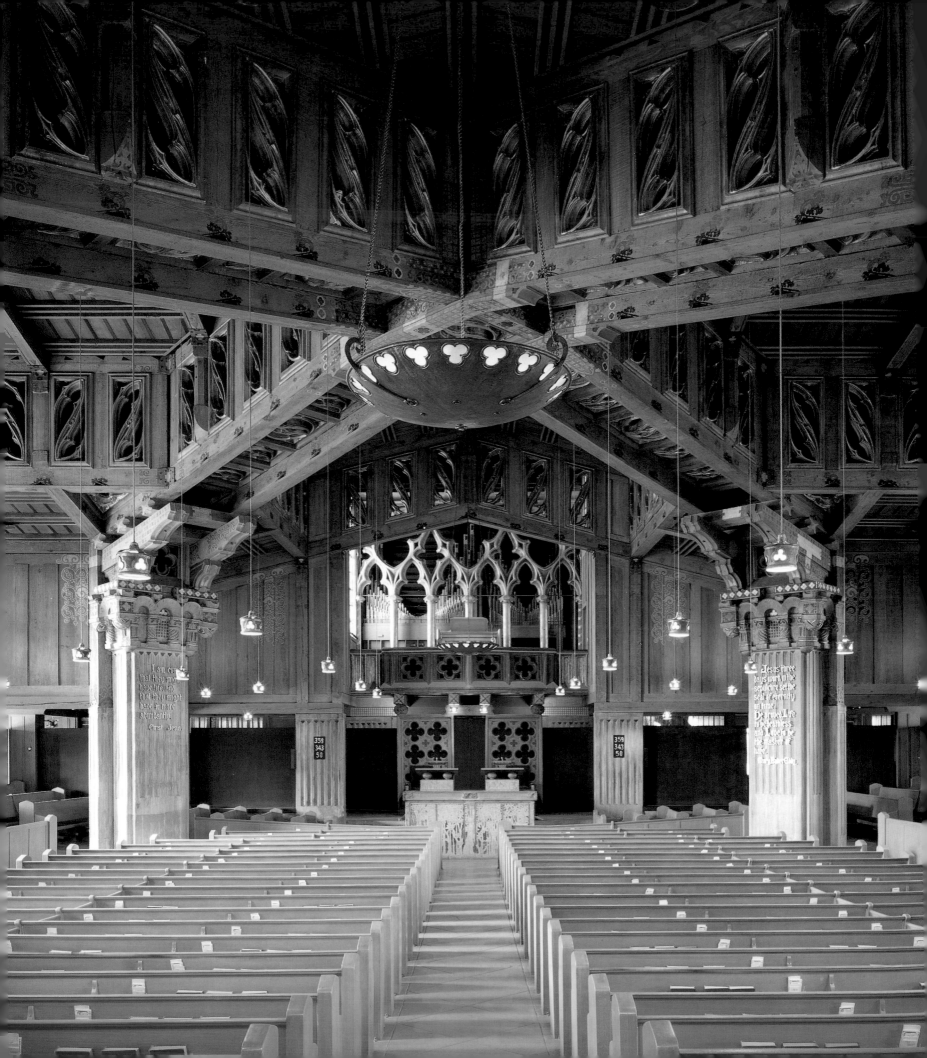

4

THE CHURCH AND
THE PALACE

he First Church of Christ, Scientist, in Berkeley, constructed in 1910, and the Palace of Fine Arts, designed for the 1915 Panama-Pacific International Exposition, are the cornerstones of Maybeck's fame, praised in every book that mentions his architecture. The latter work had great public exposure and was an immediate popular success; the former had limited exposure and only gradually became known to the national and international architectural audience. By now it is acknowledged as Maybeck's masterpiece.

Even more complex in its imagery than Maybeck's other works, the First Church of Christ, Scientist (plate 73), beggars description and must be seen to be comprehended. Although it was not Maybeck's first church commission, his two earlier designs (one of which went no further than sketches) were for smaller buildings, and they gave no inkling of what he would do here. At first he resisted the commission, doing his best to put the members of the church's building committee on their guard by implying that they would not like the building he had in mind. He told them, for example, that he would use unfinished concrete and would make the building "the same on the inside as the outside, without sham or hypocrisy."[1] His warnings seemed only to confirm the committee members in their resolve. Finally convinced of their faith and sincerity, Maybeck sought to invigorate the design process with the spirit of the twelfth century.

A letter of instruction from the committee to Maybeck expresses concerns that matched his own; the letter was no doubt an attempt to summarize what both sides had already agreed to. The church, it stated, should manifest "unity, harmony, beauty, light and peace."[2] It was to be a progressive structure designed to express the special character of the congregation and to match its surroundings. "Homelikeness, exemplified in a surrounding garden," was called for. "It should express reverence . . . sincerity and honesty exemplified in the use of genuine con-

73. *First Church of Christ, Scientist, Berkeley, 1910. View toward the Reader's desk.*

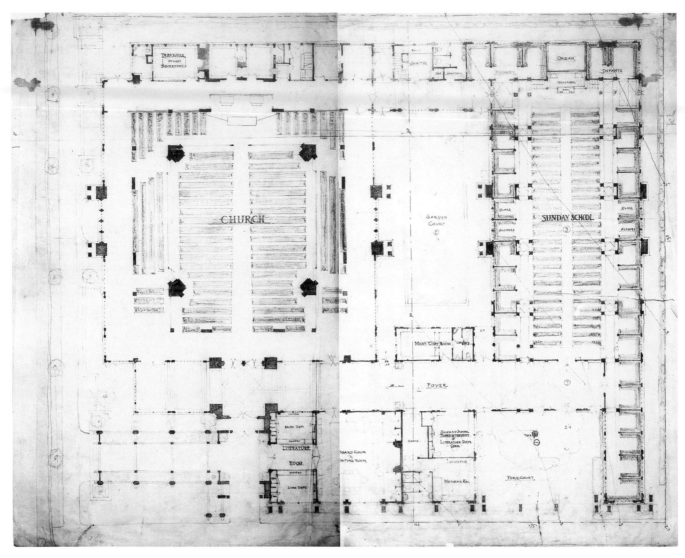

CHURCH

SUNDAY SCHOOL

GARDEN COURT

FOYER

LITERATURE ROOM

BOARD ROOM & WAITING ROOM

LOAN DEPT.

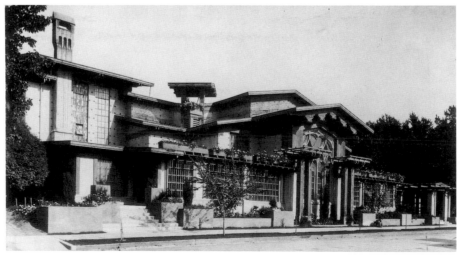

struction and materials which are what they claim to be and are not imitations. It should express welcome to all exemplified in its entrance . . . comfort, quietness, and peace . . . in the plan of seating and the kind of seats." In practical terms, the program called for a church that could seat seven hundred people, a Sunday school that could also be used for church social functions, and service spaces.

The structure that resulted was like no church ever built in the Bay Area, or in the state, or even in the nation. Nor did it look like the twelfth-century churches Maybeck so revered, or like H. H. Richardson's Trinity Church in Boston, which he said was his favorite church in America. Instead it fused Gothic elements with Byzantine massing and Mediterranean pergolas to produce a building so frankly eclectic that only a wizard like Maybeck could have kept it from being visually chaotic.

The site slopes gently toward the corner on the entrance side, where a pergola stretches from a portico that shelters the two entrances, one to the Sunday school and the other to the church (plate 76). The portico roof is lifted up so that light enters obliquely, illuminating the name of the church in raised blue letters on a tablet set into a richly ornamented corner niche (plate 78). In his design of the columns for the portico and the pergola one senses that Maybeck was stepping into the boots of the twelfth-century man. The square, fluted columns have capitals derived from French Romanesque churches (plate 77). Cast in concrete, they are soft and blurred, as if filtered through the lens of time. The trellis they support gives the church a gracious presence on the street and heightens the ceremonial quality of the recessed entrance. Once more, Maybeck has orchestrated the path to the entrance to give the impression of entering right into the building's heart.

The west elevation of the building is symmetrical and no more churchlike than the entrance side. A planting bed steps out from the building on the west side, giving it a natural green base. The fragmented exterior culminates in a central, cross-gabled roof, but the roof does not soar up to the heavens. Instead, its force is directed down by secondary gable roofs. Planters on the low flat roofs and a trellis for wisteria attached to the great west-facing window tie the building to the earth. Originally, there were even planters, later removed, on top of the ventilators—one of which can be seen, trailing vines, in a photograph taken about 1912 (plate 75).

Inside, a generous hallway (plate 81) stretches nearly the length of the building, dividing the Sunday school meeting room from the church proper. The Sunday school room (plate 80) has a simple but massive board-formed-concrete mantelpiece and, like the rest of the building, is well lit by windows with panes of translucent Belgian glass, which has a hammered surface that makes the windows shimmer. The panes are set in industrial steel sash, which Maybeck had difficulty persuading the manufacturers to make for him because they questioned its appropriateness for a church. He altered the sash from the factory stock by adding a metal mullion, which bisected the individual panes and created a more delicate

OPPOSITE, TOP

74. *Plan of the main auditorium and the original Sunday School room*

OPPOSITE, BOTTOM

75. *West side of the church, photographed c. 1912*

91

▨ *76. View along church's pergola on Dwight Way*

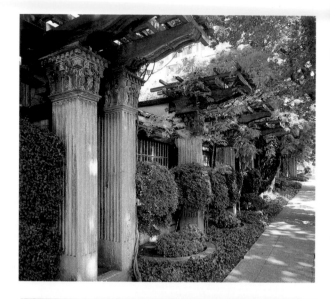

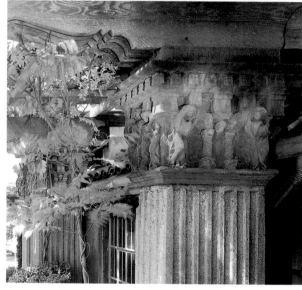

▨ *77. Detail of cast-concrete capital and fluted shaft in the pergola*

▨ *78. Tablet set in one corner of the entrance portico*

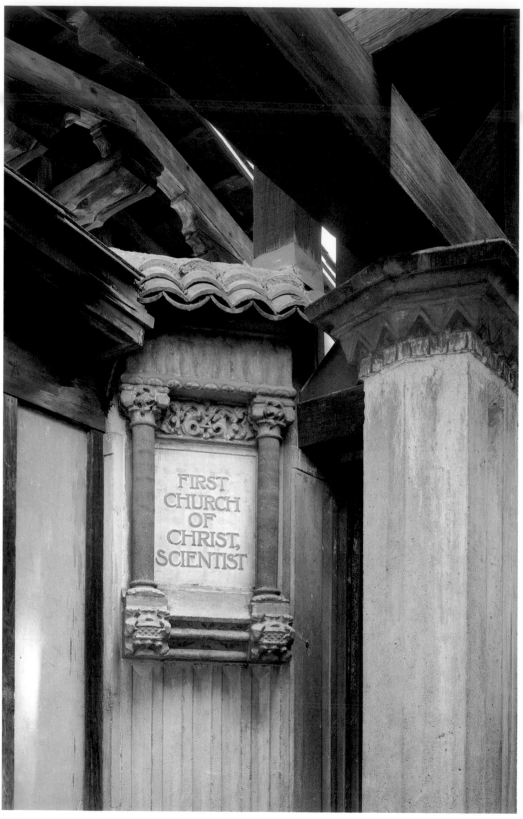

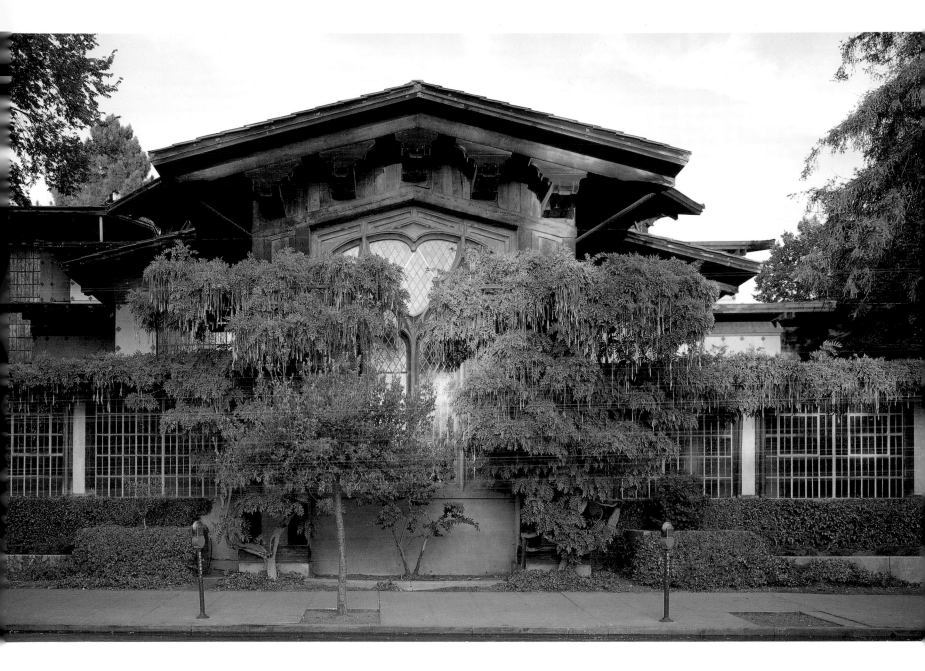

79. *West side of the church*

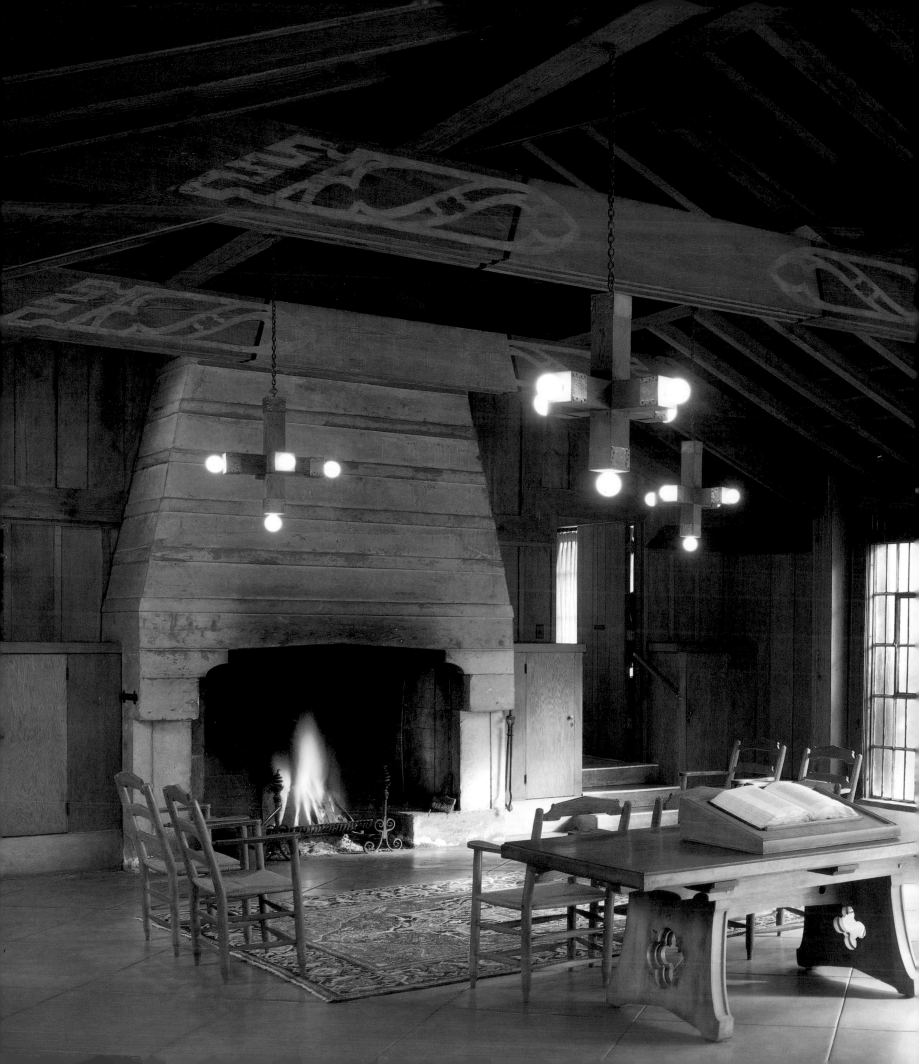

LEFT

80. *The Sunday School room, with its board-form concrete mantelpiece*

BELOW

81. *The entrance hallway between the Sunday School room and the auditorium*

linear pattern. Here and in the auditorium of the church the large windows (which alternate with the posts that support the beams capping the walls) give the effect of walls hung with glass curtains.

The repetitive rhythm of the windows in the auditorium creates the feeling of light and peace called for in the committee's letter. During late spring, purple blossoms on the wisteria outside the windows tint them and the light inside. Unity is expressed by the cruciform structure of the four great trusses, supported on concrete piers, that intersect in the center of the space and form a flattened dome (plate 73). Panels of gilded Gothic tracery lighten the effect of the trusses, and the direction of the tracery echoes the direction of the diagonal tension rods within the trusses (plates 82, 84). Other hidden elements of the structural system are represented in ornamental form, stenciled on the surfaces of the corbels above the pier caps and on the sections of walls that connect the piers to the structural frame of the building. Throughout the interior, tracery is used to dematerialize

BELOW, LEFT

▓ 82. *View of the auditorium, looking toward the entrance*

BELOW, RIGHT

▓ 83. *View of the auditorium, looking toward the west window*

OPPOSITE

▓ 84. *View of the auditorium from above*

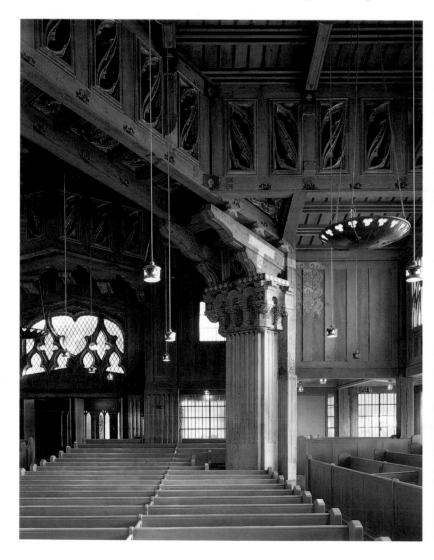

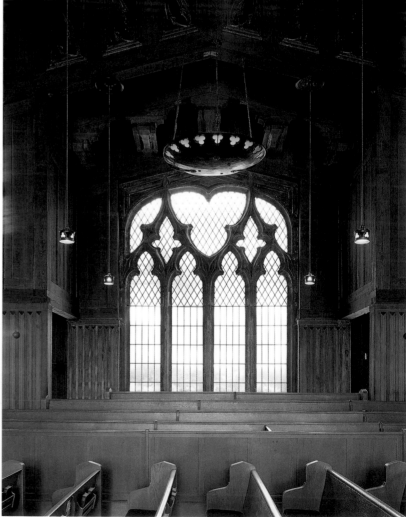

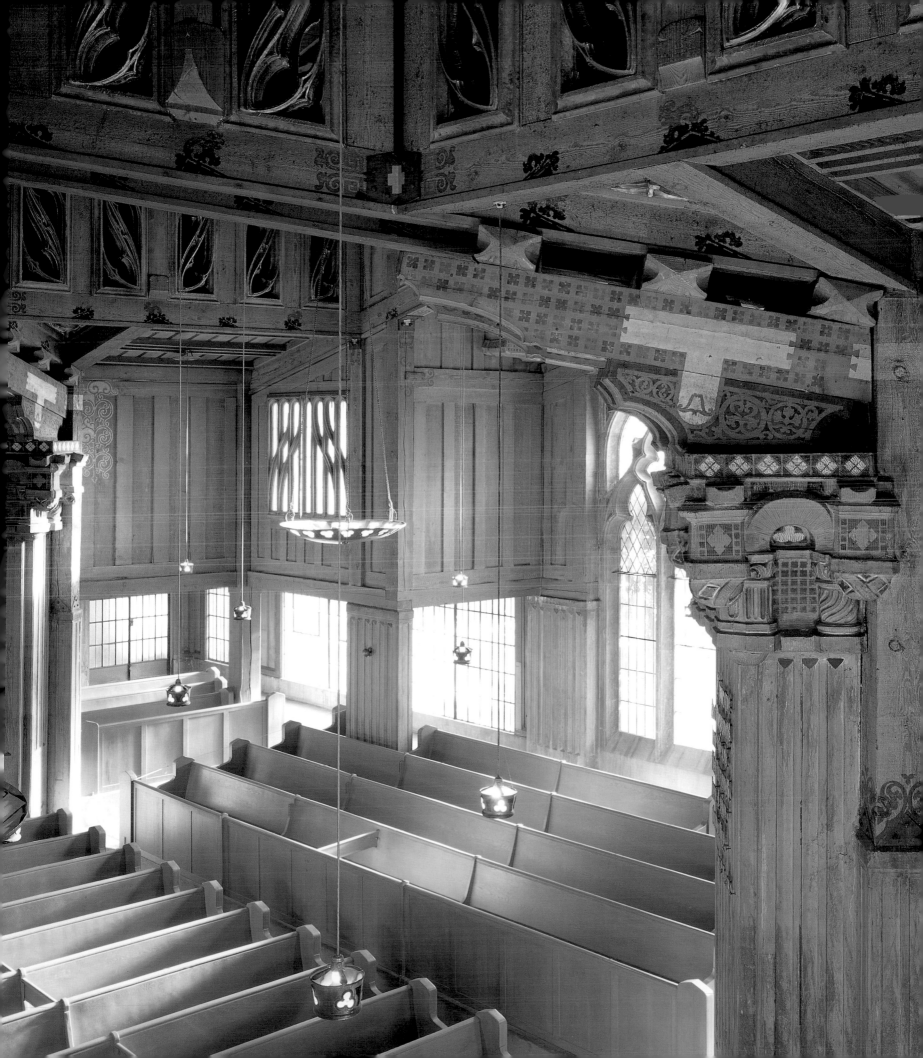

walls and surfaces so that instead of being ponderous, the mighty hood of the room is so activated by linear rhythms that it seems almost to be in motion. One has the feeling of sitting beneath a great tree whose limbs and foliage respond to spiritual forces.

The floor slopes very gradually toward the Reader's desk, which occupies the central place that an altar would have in a church of another sect. Behind it is the organ balcony screened with Gothic tracery. Maybeck designed all of the interior furnishings of the church, including the pews of fumed, waxed oak and the red plush cushions. Accents of red, blue, and gold enrich the warm, woodsy tone of the interior. Suspended from the ceiling are bowl-shaped metal reflectors to direct light upward and small lights in metal cones to light the pews; both have trefoil cutouts (plate 83). The magical effect of the nighttime illumination is intensified by the highlighted curves of the tracery. Here Maybeck marshalled effects perfected by his years of practice and observation as an architect and as a stage-set designer.

For the building's exterior Maybeck used cement-asbestos panels called Transite, an industrial material that, like the steel sash, had no previous history of use in churches or even, for that matter, on walls. Since it was normally used on roofs and for insulation, the suppliers had such difficulty estimating its cost for the church building that Maybeck finally had to provide them with a list of every piece of paneling that he intended to use. Had he not been constantly on the site seeing to it that such materials were used as specified in the drawings, the effectiveness of his innovations would doubtless have suffered.

Although the church was published soon after it was built and received high praise from many who saw it, it was too unconventional to be immediately popular with the congregation and the community. When Maybeck responded to those who asked about the style of the building that it was "Modern," they were even more confused and put off. What he doubtless intended to convey by this cryptic answer was that he had designed the building by thinking things through from first principles and by using the most appropriate vocabulary of forms for the materials; style was incidental.

Even though the First Church of Christ, Scientist, has been visited by great numbers of people over the years, it never attracted the vast crowds lured by the Palace of Fine Arts (plate 85). During the Panama-Pacific International Exposition's run from February 4 to December 4, 1915, some nineteen million people visited the palace. The main purpose of the exposition was to boost San Francisco out of the economic doldrums that had followed the 1906 earthquake and fire. Planning for the fair began in 1909, and soon it was made the official international exposition for 1915—there could be only one—which was also the year of celebrating the opening of the Panama Canal. The exposition site was a shallow cove indented in the shoreline of the bay, extending west from Fort Mason into a brackish lagoon within the military reservation of the Presidio. Hundreds of buildings scattered over the adjacent shores were removed, and the

85. *Palace of Fine Arts, San Francisco, 1913–15; reconstructed 1962. View of the rotunda through the colonnade*

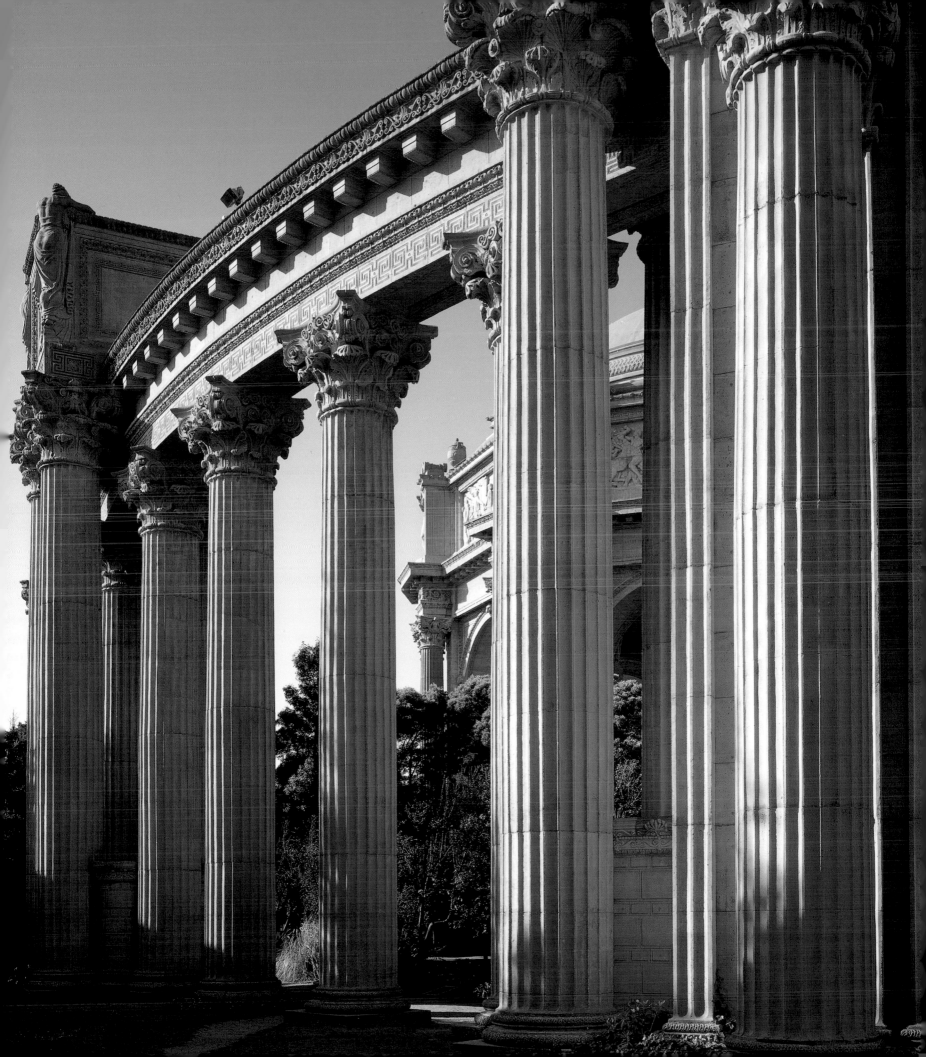

86. *Palace of Fine Arts,
1915 photograph showing
the "green walls" of ice
plant that connected the
rotunda to the water*

87. *Palace of Fine Arts,
1915 photograph showing
the original landscaping
and the two-tone pattern
of the colonnade's faux-
travertine walls*

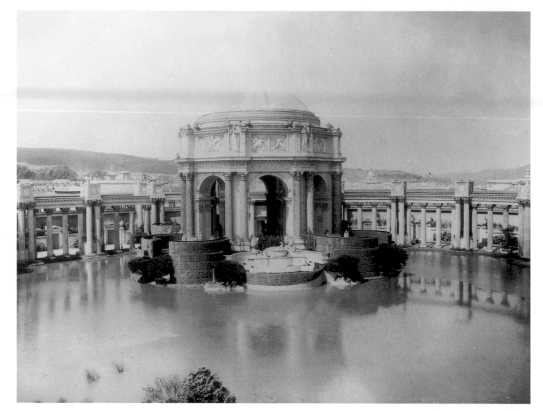

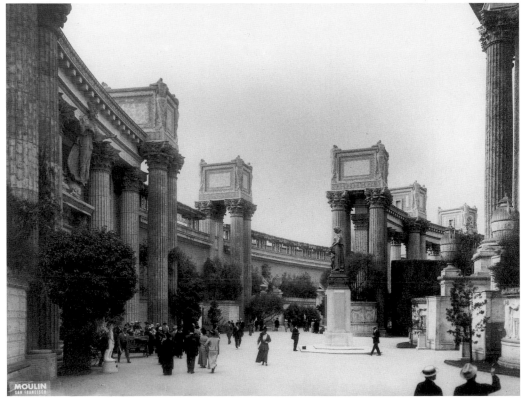

cove was filled to prepare a 635-acre site for the exposition. More than one hundred acres within the Presidio were also filled with dredged materials. By February 1913 a 2½-mile-long site on the bay was ready for the construction of the fairgrounds. Here, according to a site plan developed by Edward Bennett, ten main exhibition palaces were built facing inward upon a series of eight courts—four on either side of a main central axis—that suggested a walled Mediterranean city. Jules Guerin, the famous architectural renderer from Chicago, devised the color scheme for the fair (it was the first world's fair to have one), using red for the tile roofs and the domes and earth colors for the walls of fake travertine that composed the buildings and surrounded the exhibition area. The eastern part of the fairgrounds was filled with hundreds of concessions and an amusement park. With the exception of the tiered Tower of Jewels, designed by Louis Christian Mullgardt, which was strung with gleaming jewels of glass, the exhibition palaces were mainly domed buildings with classical styling.

The popular favorite of all the fair buildings, according to newspaper accounts, was the Palace of Fine Arts, which housed exhibitions of paintings and sculpture from the countries participating in the fair. The palace did not start out to be Maybeck's commission. It originally belonged to Maybeck's old friend Willis Polk, chairman of the exposition's Executive Council for Architecture. Polk appointed himself and two other architects, William Faville and Clarence Ward, as a special committee to choose the architects for the exposition buildings. In 1912 Polk's committee named an advisory architectural commission for the exposition; its members, who also designed buildings for the fair, were Thomas Hastings, Henry Bacon, and the firm of McKim, Mead and White, all from New York; George W. Kelham, Mullgardt, and Arthur Brown, Jr., from San Francisco; and Robert D. Farquhar from Los Angeles. Maybeck was not asked to be on the commission because he had a very small office and had not done the kind of large-scale office or commercial buildings that were deemed a prerequisite for designing the huge warehouse-type buildings needed for the fair's exhibitions.

Polk himself had a commission for one of the fair buildings, the Palace of Fine Arts, but he was very glum about the site he was assigned, which he said was the worst one on the exposition grounds. True, it was a water-filled bog, but Maybeck—who was working for Polk at the time—tried to get Polk to see this as an opportunity and apparently prevented him from draining the site. Polk remained unconvinced, but before departing for a short stay at Bohemian Grove, he directed his staff to hold a competition within the office for the building design. When he returned, he found that his staff had voted for Maybeck's proposal, executed in an atmospheric charcoal sketch. When the sketch was presented to the advisory architectural commission, it was much admired. Saying that he did not wish to execute another man's design, Polk acknowledged that the proposal was Maybeck's and magnanimously gave him the commission.

When Maybeck wrote about architecture, he did not state his principles straightforwardly. He preferred telling fables about his work in flowery prose that

is hard to take seriously today. But if read carefully and with sympathy, his accounts of his buildings are wonderfully revealing of his thought process. His essay published as a booklet titled *Palace of Fine Arts and Lagoon* (1915) is key to an understanding both of that most famous ensemble and of his work in general.[3] He began by letting the reader know that intuition was important even in making plans for a world's fair:

> It is necessary to assume that the hearers admit there are mental processes not to be expressed in language. . . . Music and architecture are vehicles of expression for phases of our human experience.
>
> Omitting construction, we will discuss only the architecture as a conveyor of ideas and sentiments. The combinations and arrangements of the buildings and gardens at the Fair were planned according to . . . the fundamental idea . . . that the picture presented by the ground plan of a group of buildings and their surroundings should be agreeable to the eye, and therefore in the development of the plan it is treated as though it were an ornament, without regard to the fact that it represents buildings. If the plan of the Panama-Pacific International Exposition group of main buildings [Palace of Fine Arts, plate 88] were reduced in scale to the size of a golden brooch and the courts and buildings were made in Venetian cloisonné jewelry, that brooch thus made would pass as . . . jewelry without causing a suspicion that it represented a plan for a World's Fair.

88. *Plan of the Palace of Fine Arts, Panama-Pacific International Exposition, emphasizing its resemblance to a jeweled brooch*

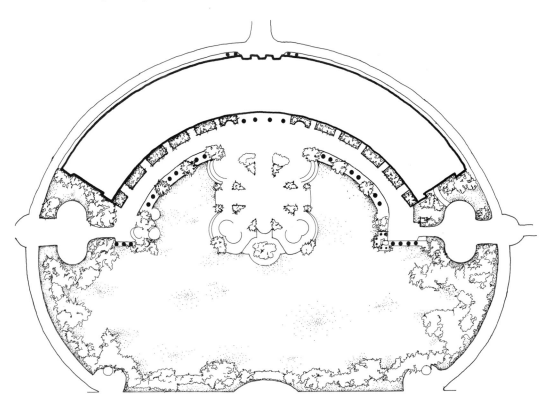

Having made the plan comprehensible for the reader by miniaturizing it, Maybeck introduced the story of the palace with wonderfully farfetched summaries of the impressions inspired by a walk through the fairgrounds:

> The Court of Abundance . . . suggests the medieval with all its rising power of idealism in conflict with the physical. The Court of the Universe suggests Rome inhabited by some unknown placid people. The Court of the Four Seasons suggests grace, beauty and peace in the land where the souls of philosophers and poets dwell in continued satisfaction. The Fine Arts Palace suggests the romantic of the period after the classic Renaissance. Someone familiar with the philosophy of art will no doubt wish to challenge this classification of the various courts, but I believe it will be admitted that some such classification can be made for one class of mind, and other classifications for other minds. These terms, "romantic," "classic," etc., are usually covered by the word "atmosphere"—the physical forms reflect a mental condition.

Maybeck's last sentences are clearly disclaimers for the poetic license he had just taken with the canons of art history.

Moving on to discuss the program for the building, Maybeck introduced Mr. Trask, his client and the director of the Division of Fine Arts. Mr. Trask "did not want the visitors to come directly from a noisy boulevard into collections of pictures . . . he wanted everybody to pass through a gradual transition from the exciting influences of the Fair to the quiet serenity of the galleries." Very thoughtful about details, Trask "wanted the pedestals, the water pools, the rubbish cans, the color of the walls, all to fit in. All of these details collectively make an atmosphere." The text continues: "Let us analyze the Fine Arts Palace and lake . . . with reference to the effect of architectural forms on the mind and feelings, and discuss the various elements which influenced the composition of the architecture and landscape. The first question to settle is, what character should an exhibition building of paintings have; the second question is, by what process may we find the elements of architectural forms that give the feeling that corresponds to that of the exhibition of paintings."

At this point in the narrative Maybeck described with obvious relish a fictional "Palatial Picture Palace"—"an art gallery composed of five-dollar Broadway paintings, the gold frames of which cost more than the labor of painting the picture." The appropriate character for such a building would be "an overdone ice-cream parlor or candy store, with many steam orchestrions playing various tunes just far enough apart so that they audibly compete with each other. The magnificent gardens should be all hand-made artificial plants and artificial waterfalls. Such an art palace might be deemed to have a Broadway atmosphere and . . . a harmony of discords." Next we read that Maybeck's and Trask's palace will be far from such gaudy commercialism because the paintings therein will come from

the wellspring of the artist's being. In Maybeck's description of the creative process that resulted in these paintings, we hear him telling his own experience, in his own roundabout way:

> The artist began his work a long time ago in a nebulous haze of whys, and it is usually a long experience before his paintings are nearly as good as a photograph, and oftener a great deal of hard work and disappointment must have come before he suspects that it is not the object nor the likeness to the object that he is working for, but a portrayal of the life that is behind the visible.
>
> Here he comes face to face with the real things of this life; no assistance can be given him; he cannot hire a boy in gold buttons fashionably to open the door to the Muse, nor a clerk nor an accountant to do the drudgery. He is alone before his problem and drifts away from superficial portrayals.

Following this parenthetical account of the artist's lonely vocation, Maybeck resumed his discussion of an appropriate character for the palace, given that people would be going there to see art. Presumably he was drawing once more on his personal experience with art. He recalled the utter weariness experienced at the end of a trek through the art gallery in Munich—probably a memory from his and Annie's tour through Europe at the time of the Hearst competition. "We dragged ourselves along," he explained and noted some of the works they looked at, including Arnold Böcklin's *Isle of the Dead*. Before leaving the gallery, they rested by a sculpture of a cheery little boy and observed how the spirits of other weary tourists were raised by this note of happiness. "We realized right there," wrote Maybeck, "that an art gallery was a sad and serious business."

One more personal anecdote follows to introduce Maybeck's concept for the palace. This one relates that an artist's illustrations—Maybeck calls them a "frontispiece"—for the opening of each chapter of a story he had come across were so successful that he could perfectly anticipate its contents. He then moved directly to the point: "Now what Mr. Trask wanted was a frontispiece to his art collection, which would anticipate the general impression of the whole. . . . Summing up my general impression, I find that the keynote of a Fine Arts Palace should be that of sadness modified by the feeling that beauty has a soothing influence."

Why Maybeck felt it necessary to tell two rather disconnected anecdotes to bolster his scheme remains a puzzle. The most revealing statement, almost hidden in the account, is that he had seen Böcklin's *Isle of the Dead*—one of the most famous and popular paintings of its day, which many people made a special trip to see. Near the end of his essay Maybeck returned to the painting, which he called "overdone in sadness." He then described it as "a dark picture of an island of tall black trees enclosing a white marble columbarium; in the foreground a boat car-

rying the dead across. The islands of Clear Lakes, California," he continued, "where the trees and bushes seem to rise out of the water, make the same impression of sadness as Böcklin's picture, but in a lesser degree." And circling around the issue of *caractère* once more, he wrote: "As an example of what is meant by matching impressions: suppose you were to put a Greek temple in the middle of a small mountain lake surrounded by dark, deep, rocky cliffs, with the white foam dashing over the marble temple floor—you would have a sense of mysterious fear and even terror, as of something uncanny. If the same temple, pure and beautiful in lines and color, were placed on the face of a placid lake," a mood of sadness

89. *Palace of Fine Arts, detail of the rotunda showing a column and an urn*

modified by the soothing effect of beauty would be achieved.

Although Maybeck had veiled his objectives up to this point in his essay, he divulged at last his recipe for finding the right forms to achieve the desired effect. "The process," he wrote, "is similar to that of matching the color of ribbons. You pick up a blue ribbon, hold it alongside the sample in your hand, and at a glance you know it matches or it does not. You do the same with architecture; you examine a historic form and see whether the effect it produced on your mind matches the feeling you are trying to portray." Maybeck never indicated how many forms he tried out, but the right form for the Palace of Fine Arts is finally revealed as "an old Roman ruin, away from civilization, which two thousand years before was the center of action and full of life, and now is partly over-grown with bushes and trees—such ruins give the mind a sense of sadness." The details of his vision are vague, but "great examples of melancholy in archi-tecture and gardening may be seen in the engravings of Piranesi, . . . whose remarkable work conveys the sad, minor note of old Roman ruins cov-ered with bushes and trees." The note of vanished grandeur has rarely if ever been achieved more effectively than in

Maybeck's fairground ensemble of a rotunda and colonnade set on what appears to be an island in the still waters of a lagoon (plate 90).

Maybeck's romantic essay about the palace leaves no doubt about his intention to have the rotunda and its landscaped colonnade provide a respite from the melancholy-inducing experience of viewing the art installed in the huge steel-framed exhibition building behind the colonnade. In a typewritten statement, probably intended for publication, Maybeck was much more forthcoming with specific explanations for his design.[4] He pointed out that the curved walls of the exhibition hall should have followed the line of an ellipse in order to make the ends of the hall parallel with two neighboring exhibition palaces. In an interview with William Jordy, which the historian described as taking place when Maybeck was a very old man, Maybeck reiterated this idea, saying that if he had it to do over, he would have also flattened the curve of the colonnade and thus freed the rotunda from its tight embrace.[5] This change of geometry would have created a broader vista for the walkway between the colonnade and the rotunda, and it would also have shifted the center of the ensemble which, in the existing composition, is in the middle of the lagoon. By removing the rotunda from the center of the composition to its periphery, Maybeck placed the viewer standing opposite it in the same position as a gallery visitor standing opposite a painting on a wall.

Although Maybeck discussed his search for the right form, he almost certainly had no specific model for the rotunda and the colonnade. Domed buildings, mainly modeled on the Pantheon (c. A.D. 118–26) in Rome, appear in many student projects before, during, and after Maybeck's years at the Ecole, and domes dominated the 1893 World's Columbian Exposition, which exerted a strong influence on subsequent expositions. Like the casual reference to Böcklin's painting, Maybeck's mention of the engravings of Piranesi reveals a source of his inspiration for the building. It conjures up that artist's engraving of the ruins of the so-called Temple of Minerva Medica, from the artist's 1764 *Views of Rome*. The round apse—crumbling, full of holes, and sprouting ragged vegetation—wonderfully summons up the vanished grandeur of the past.

Maybeck's typescript provides another clue to his sources for the design of the rotunda: "The elevation was designed to harmonize with a cornice belonging to a Temple of the Sun published in the restoration of Rome by d'Espouy. I chose the cornice of this man who died about 2000 years ago because it is the one cornice that had the simplicity of the Greeks." The typescript also reveals that he changed the height of the Corinthian columns in the colonnade from the traditional eleven diameters to eight, inviting criticism from those who felt that the proportions of the orders were inviolable. Maybeck's idiosyncratic use of the term "Greek" to describe the character of the rotunda must have either perplexed or infuriated those—and they would have been the majority of trained architects—who had even a rudimentary knowledge of ancient Greek architecture, which had no domed structures. Maybeck said that the base line from which the rotunda's arches sprang was not accentuated because it would have spoiled the proportion of the central

90. *Palace of Fine Arts illuminated at dusk*

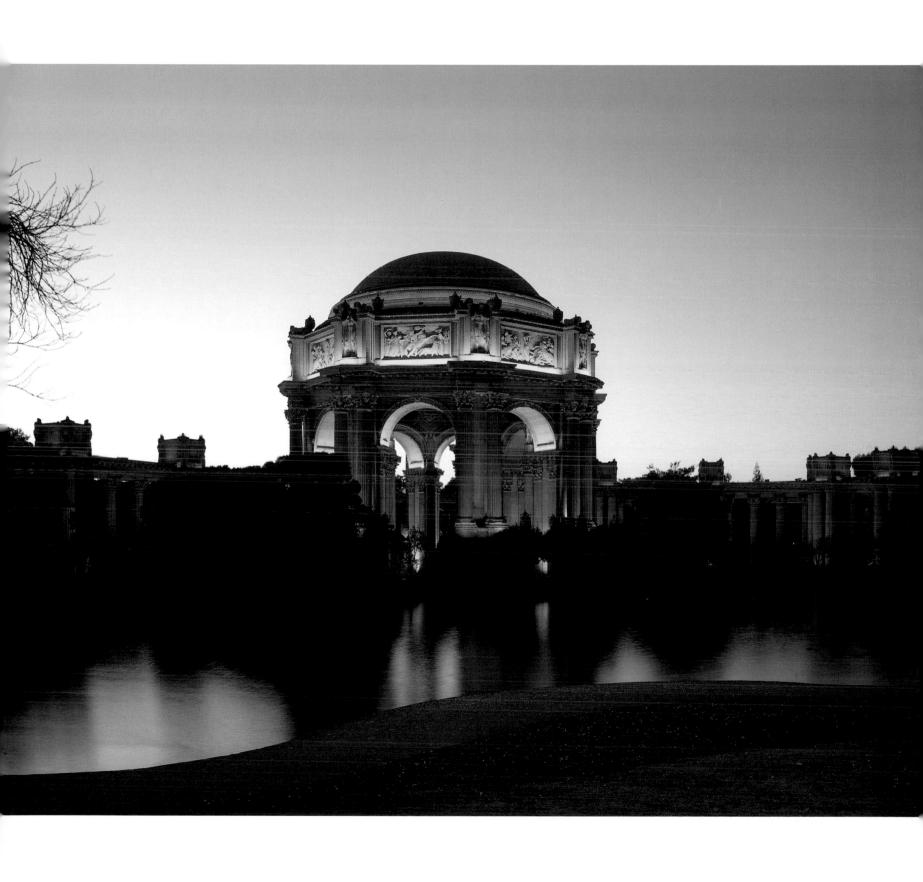

arch seen from the opposite side of the lagoon. The other arches had to reach to the ground and therefore pilasters and entablatures accentuated the spring line.

Although Maybeck's rotunda is not ruinlike, the colonnade with its fragmented attic story hints at ruins. The huge containers atop the entablature are supported on Corinthian columns raised to the level of the cornice as if to emphasize the weight above (plate 93). Indeed, the coffers would have been even heavier if they had been filled with earth and planted, as Maybeck wished them to be. The species he intended is not known, but one can imagine the theatrical effect of having the figures gradually entwined with vines. Still, common sense argued against any planting for which no maintenance was possible. Although Maybeck must have been asked many times about the meaning of his brooding ladies, his answers have not come down to us. His typescript refers to the planters as "boxes" and notes that after the Renaissance, the practice was to break up such forms with shields and garlands. "But," he noted, "a Greek did not decorate that way. He would have put human figures on the corners."

This statement suggests that the primary role of the figures was formal. However, the stance of the draped figures peering over the tops of the tomblike planters and the funerary urns stationed around the rotunda do suggest a state of mourning. Why all this funerary paraphernalia? One plausible explanation is that by the time of the exposition, the war torn present loomed over the vanished past. Maybeck may have intended some reference to the tragic events that surrounded the escapist world of the exposition, but history's political aspects seem never to have engaged his mind, and no evidence exists that the design of the palace was in any way his response to the calamitous times.

Finally, Maybeck's typescript is helpful in explaining the landscaping for the palace complex. His description is once again pictorial: "Usually in good planning, when the plan of the walls of the building are blacked in on paper the picture thus made is agreeable to the eye. . . . To get this result in the Fine Arts plan, the shrubs were used to fill the vacancies that usually are filled out with walls, which are called 'points de Pocher.' I do not mention the above in light of an apology, but rather wish to show that those who plan in snow countries have a different problem from our Californian architects."

We can infer from this cryptic statement that the mild winter climate—the exposition opened in February—permitted a generous use of vegetation in place of structure, a cost savings as well as an attractive idea for Maybeck, who always stressed the combination of nature and structure. "It was intended," he stated in closing, "that the foliage should be high and romantic avoiding all stiff lines, but the scale being so large it was impossible to plant things large enough, and [because of] restricted means and time to realize the intention. If it were a permanent building the planting could be arranged to have the proper mass in ten to 20 years or more. On the whole the lagoon is the crux of the whole composition and fortunately no bridge had to be put across it as was at first demanded. We must be thankful to the chief of construction that it was omitted."

91. *Main elevation from Maybeck's submission to the competition for the San Francisco City Hall, 1912. India ink on paper. Documents Collection, College of Environmental Design, University of California, Berkeley*

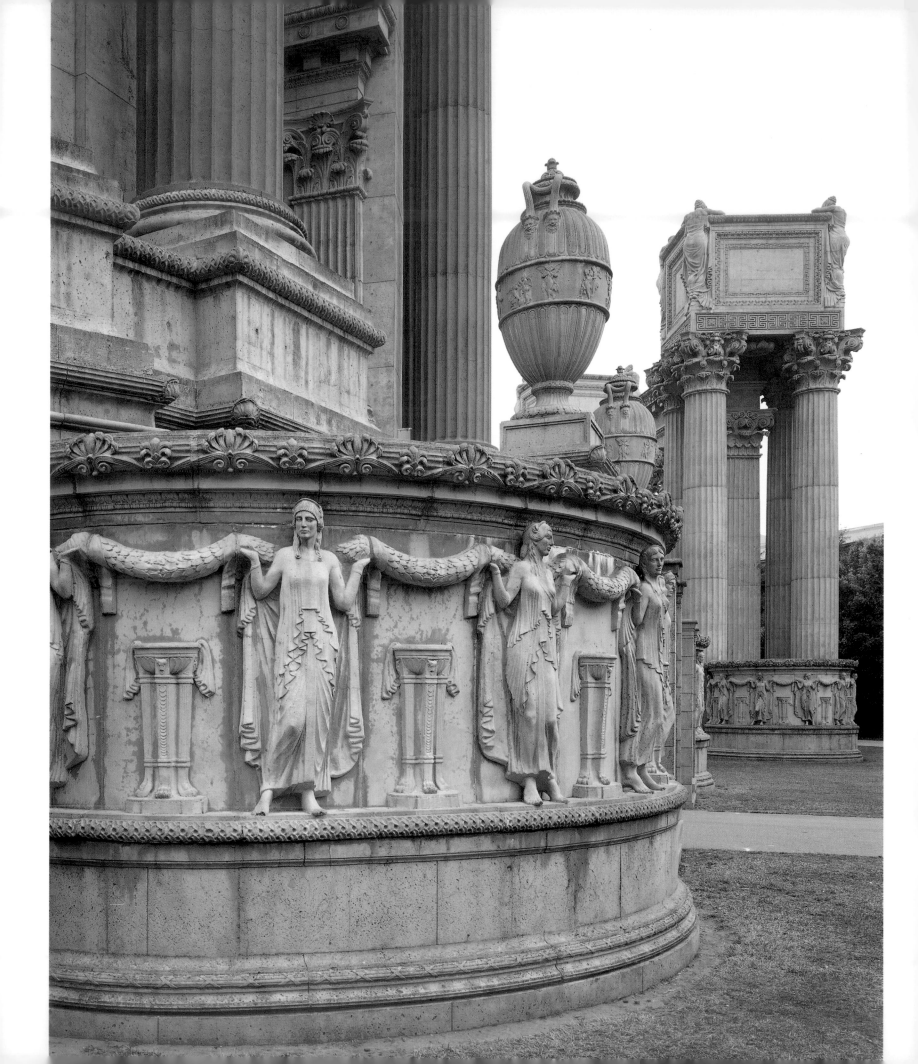

Maybeck also had reason to thank John McLaren, his friend and the director of landscaping for the fair, for procuring the mature trees—Monterey cypress and other species—that contributed so much to the effect of the palace. It seems that the trees had been promised to George Kelham for his building, but McLaren—probably with Maybeck's knowledge—had them trucked to the palace lagoon, where they were quickly embedded in the mud and could not be removed when the irritated Kelham arrived to claim them. McLaren also created two "living walls" of mesembryanthemum (ice plant), which projected from either side of the rotunda's central arch and curved around to form a gateway that replaced the arch of Constantine originally intended for that spot.

OPPOSITE

▦ 92. *Palace of Fine Arts, detail of the rotunda base with a frieze of dancers*

LEFT

▦ 93. *Detail of one end of the colonnade*

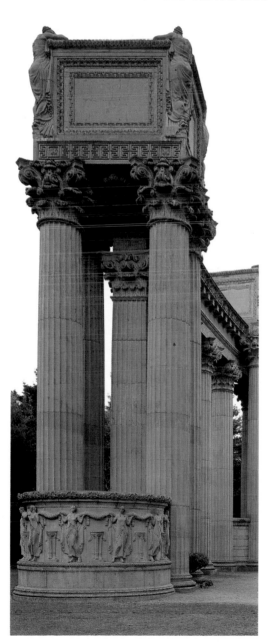

An enormous popular success, the palace was the only exposition building not demolished after the exposition closed. Eventually, though, its stucco-over-wire-lath exterior all but crumbled, and in the early 1960s it had to be reconstructed in concrete. Maybeck had been ambivalent about its preservation. When first interviewed about it, he said: "I think the main building should be torn down and redwoods planted around—completely around—the rotunda. . . . As they grow, the columns would slowly crumble at the same speed. Then I would like to design an altar, with the figure of a maiden praying, to install in the grove of redwoods. . . . I should like my palace to die behind those great trees of its own accord, and become its own cemetery."[6] Later, when a fund-raising campaign was initiated for the preservation of the building, Maybeck said that he would be happy to see it restored.[7] Its reconstruction was completed in 1967, ten years after his death.

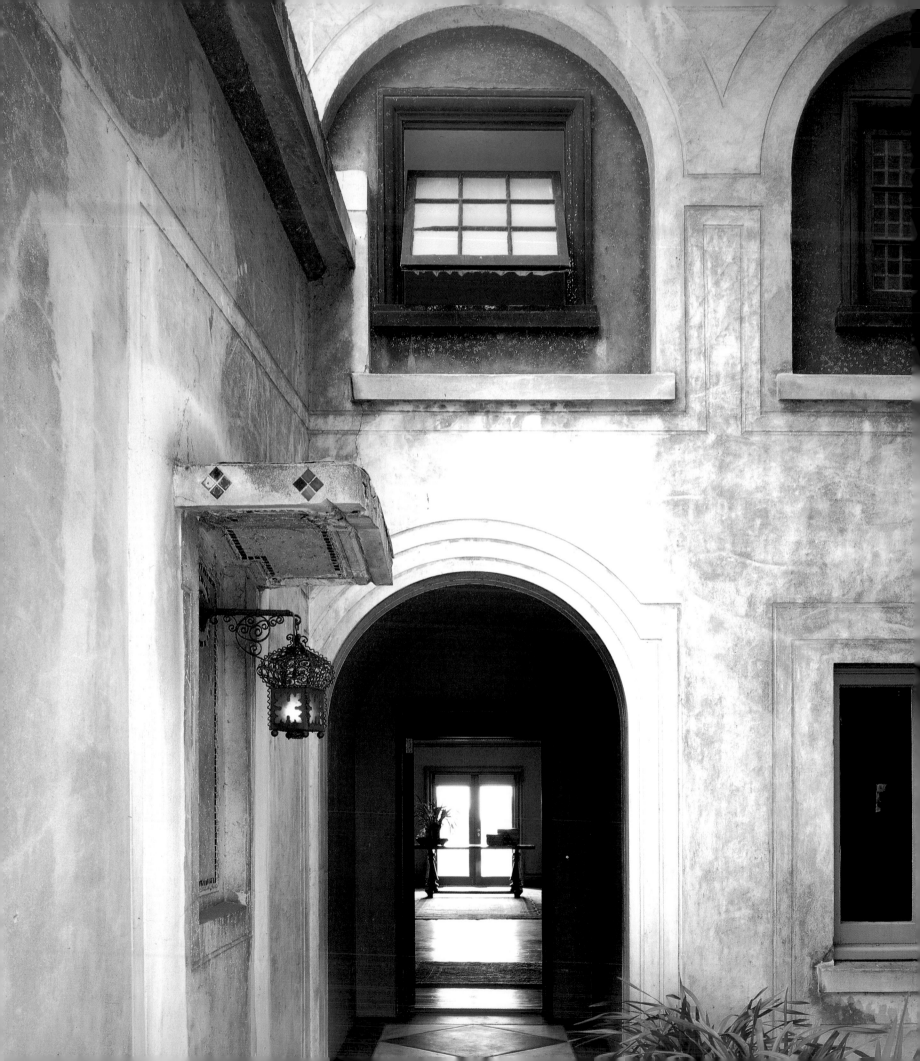

5
MID-CAREER HOUSES

The years 1906 through 1910 were very productive ones for Maybeck. Although the 1906 earthquake and fire, which destroyed so much of San Francisco, caused much less damage in residential areas of the East Bay, an area-wide building boom followed that brought good times to local architects. After the April disaster so much work came into the San Francisco office Maybeck had opened in 1902 with Mark White that he formed another firm—called Maybeck, Howard, and White— with his other brother-in-law, John White, and George Howard. The new firm had temporary offices at 821 Eddy Street, near the Civic Center, and lasted fifteen months. At the end of 1907 the firm split up, and Maybeck and Mark White returned to their former, earthquake-damaged office at 35 Montgomery Street, which by then had been renovated.

One 1907 project by Maybeck, Howard, and White was a grand Mediterranean villa for Charles Josselyn in Woodside (plate 95). Because the peninsula south of San Francisco was less plagued by fog than the city it had become a favorite place for the wealthy to build summer homes; later, year-round country villas were built there. Woodside was farther south than the centers of early development in Burlingame and Atherton, and it had more open countryside, with oak trees on rolling hills and redwood groves in canyons. The Josselyn house enjoyed both kinds of scenery in a setting that might have been painted by William Keith.

Stripped of its architectural finery, this Italianesque villa could have been a California ranch house. The front court of the H-shaped plan is enclosed by an Ionic colonnade. The great gable roofs—their broad overhangs supported on multiple shaped-wood brackets springing from rough stuccoed walls—dominate the composition (plate 96). The formality of the romantically overscaled Baroque broken pediments, the balconies with classical railings, and the columns with ornate Ionic capitals completes a composition that begins in a series of stepped

▨ 94. *Entrance to Andrew C. Lawson house, Berkeley, 1907*

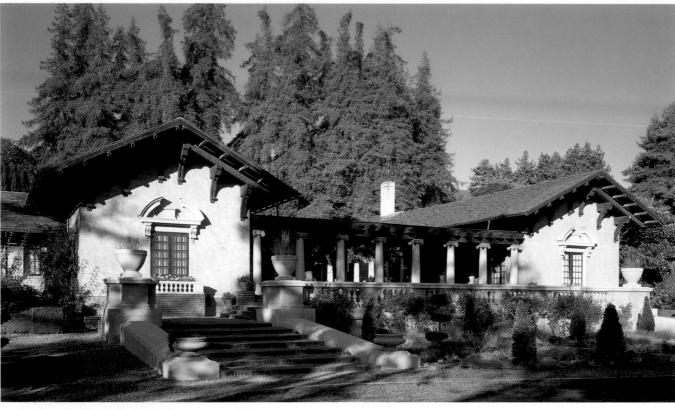

LEFT

▨ 95. *Charles Josselyn house, Woodside, 1907*

BELOW

▨ 96. *Detail of roof, Josselyn house*

terraces that raise the front of the house above ground level. Sited at the edge of a meadow against a backdrop of somber redwoods, this Tuscan farmhouse transformed into a grand villa has a sunny openness to the south and a brooding darkness to the north. The mood it conveys, one often rendered by contemporary California landscape painters, is of a perpetual golden afternoon.

Even before the 1923 fire provided irrefutable evidence that houses with wooden exteriors were not an ideal choice for Berkeley, Maybeck had broadened his repertory to include the half-timbered style traditional in northern Europe and England and the masonry tradition of the Mediterranean. The Senger and Lawson houses, both completed in 1907, illustrate his mastery of these dissimilar idioms.

Both shingles and half-timbering are used in the house for Professor J. H. Senger, who taught German at the university and took an active part in Berkeley's musical community. These two aspects of the client's life affected the design of the house mainly in its formal front section (plate 98), where decorative half-timbering alludes to structural forces and to the owner's Teutonic background. The main purpose of this section was to provide a formal setting for the combination living, dining, and music

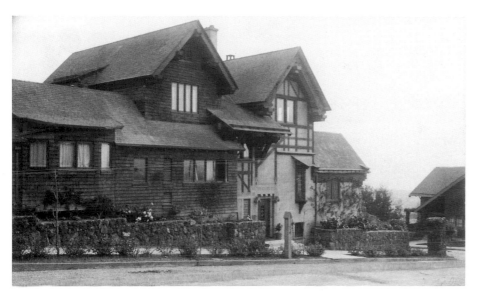

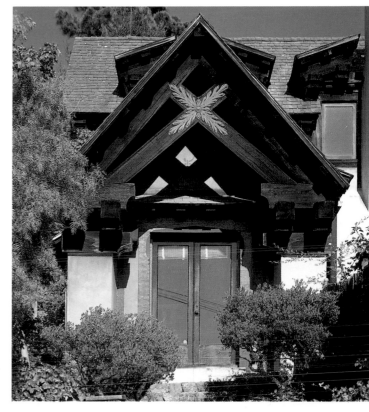

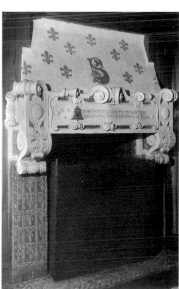

ABOVE, LEFT

◼ 97 *North side of J. H. Senger house, Berkeley, 1907. Photographed c. 1908*

ABOVE, RIGHT

◼ 98. *The formal, west entrance to the Senger house.*

RIGHT

◼ 99. *Living-room fire-place, Senger house. Photograph by Rob Super, 1976*

room, which accounts for most of the ground-floor space. That the music room was not intended for everyday use was indicated by the provision of drapery-covered screens, which could close it off from the stairs ascending from the vestibule. These stairs also lead to the back of the house, where the kitchen and other service areas, including what were originally the servants' quarters, are located. As if to indicate the secondary nature of the street-level entrance on the side of the house, which leads directly to the kitchen and service areas, Maybeck gave it a decorative Gothic surround of wood members painted a bright blue and set flush with the wall (plate 97). He expressed the difference between the public front and the service-oriented back by changing the materials from half-timbering to shingles, and he coupled the Baroque broken pediment with medieval half-timbering in the dormers on the front roof. Maybeck seems to have enjoyed playing in this way with well-known signature elements from different styles, mixing them together here, no doubt, to entertain and shock sophisticated observers.

The redwood box beams of the ceiling in the main public space have gilded bands along their edges that lighten the effect. Small bare bulbs set in sockets behind the wooden surface of the walls and some of the beams softly light the ceiling. The room has a double axis: one going west-east from the ornate plaster fireplace (plate 99) to the raised platform at the east end, labeled an "erker"

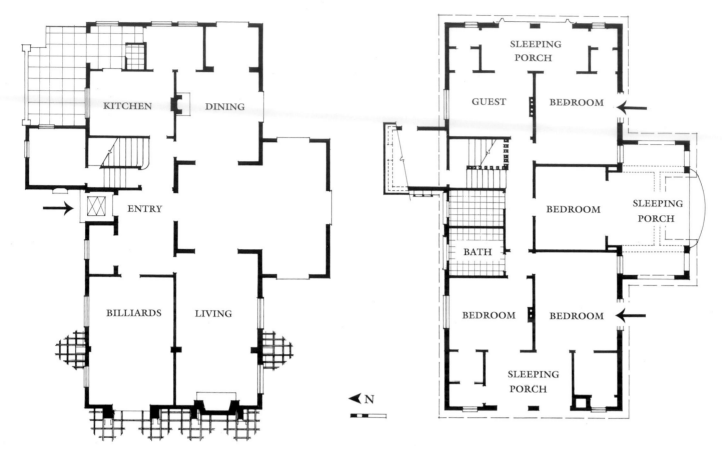

KITCHEN DINING

ENTRY

BILLIARDS LIVING

SLEEPING PORCH

GUEST BEDROOM

BEDROOM SLEEPING PORCH

BATH

BEDROOM BEDROOM

SLEEPING PORCH

◄N

ABOVE

❖ 100. *Plan of first and second floors, Lawson house*

OPPOSITE

❖ 101. *Central section, southwest side of the Lawson house*

(alcove) on the plans. Musicians may have played from this stagelike area to guests seated in the main part of the room. The north-south axis ends in a porch on the south side with access to the garden terrace on the east and with views of the hills and the bay to the west. Enclosed by the L-form of the house, the garden also has a rustic barn or studio on the east side, which helps to frame and shelter it.

While Maybeck was working on the Senger house, he also designed a house (plate 101) for Professor Andrew Lawson, who was to become world famous as the geologist associated with the Golden Gate Bridge from 1933 to 1937. In 1900 Lawson had joined the Maybecks and Farnum Griffith (a lawyer and some-time secretary to university president Benjamin Ide Wheeler) in purchasing a tract of land called La Loma Park, north of Daley's Scenic Park. Four years earlier Maybeck had designed a wooden house for Lawson south of the campus. Lawson's reasons for buying the new property are not known, but he may have been enticed by the views from the northern hills and by the prospect of building something again. As he later proved by constructing other houses on his property with his own labor, Lawson thoroughly enjoyed the building process; his experience with his Maybeck house was a kind of apprenticeship.

While exploring the geological conditions that caused the 1906 earthquake, Lawson ascertained that the main trace of the Hayward Fault ran right through

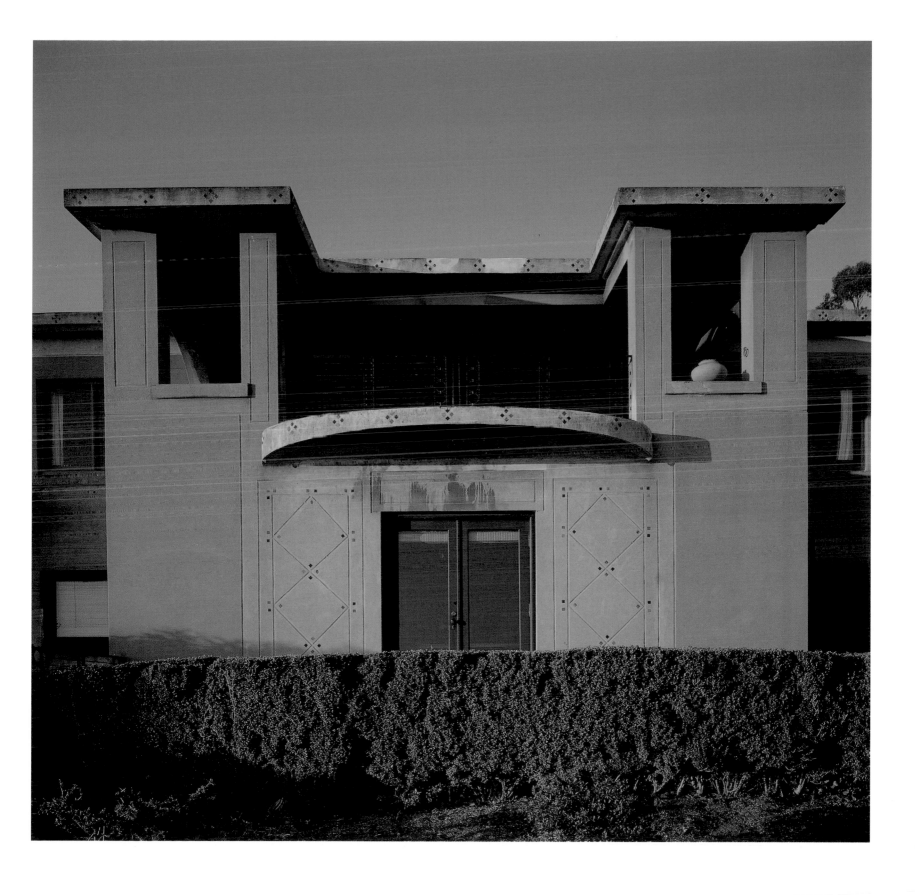

the La Loma property on which he intended to build his new house. He became obsessed with constructing it to withstand earthquakes. Even though wooden houses had survived the shaking quite well, Lawson chose reinforced concrete as the most earthquake-proof—and also the most fire-resistant—material and immersed himself in its study. Maybeck was similarly engaged by the concept of building a house in concrete, a material that had fascinated architects in the United States and in Europe beginning in the nineteenth century. Frank Lloyd Wright's first building executed in poured concrete, Unity Temple in Oak Park, Illinois, had been built in 1906 and was well known throughout the architectural community. Maybeck's former protégé, Julia Morgan, had started up her office with a commission for a concrete bell tower for Mills College in Oakland.

102. Southwest wall of the Lawson house, photographed c. 1910, showing the wooden trellis Maybeck built into the wall to help integrate the landscaping with the house

Always interested in threading a path from past to present, Maybeck became captivated by the idea of designing a contemporary Pompeian villa to link the 1906 earthquake to the destruction of ancient Pompeii by volcanic eruption.

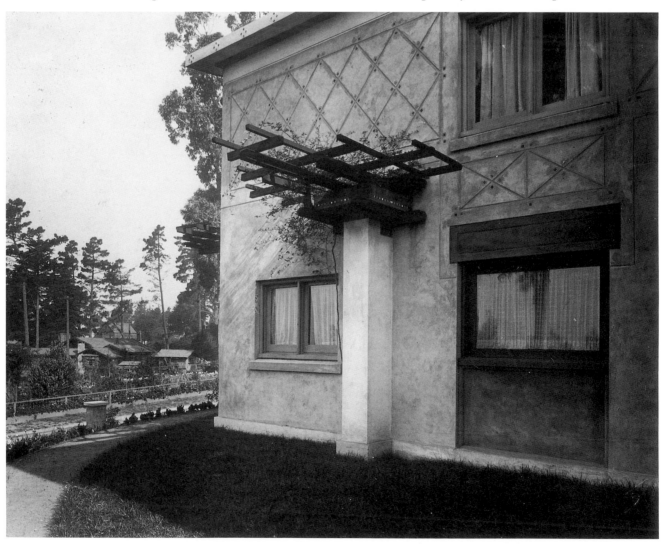

Perhaps the idea came from his days at the Ecole, where student projects involving such historical prototypes were not unusual. Since Pompeian houses were of masonry construction and had cubistic forms with tile roofs and plaster walls decorated with mural paintings, they offered an appropriate historical antecedent. It is not clear in this and other works that Maybeck embedded in history which came first: his own design or his awareness of the architectural prototype. In any case, for the Lawson house he designed a long rectangular volume with a small projecting room on the north side next to the entry and a shallow wing on the south side; the latter provided a sunny day room on the lower floor, with a sleeping porch above.

In contrast to the picturesque irregular massing of the Senger house, the simple mass of Lawson's house, punctuated by the voids of porches, expresses its masonry construction. The plaster of the framework was left white and outlined by scored lines on the walls; the plastered walls within the framework were integrally colored light red on the lower part and buff on the upper. As a student Maybeck had doubtless seen studies of Pompeian and Roman houses showing these colors. The buff walls are incised with a diaper pattern accented at the crossings with four small tiles (plate 103). Other diamonds of small tiles appear on the eaves, and the shapes of the window and door openings are accented with lines scored around them (plate 94). This decorative scheme relates less to Pompeian

103. *Detail of wall with diaper pattern and inset tiles, Lawson house*

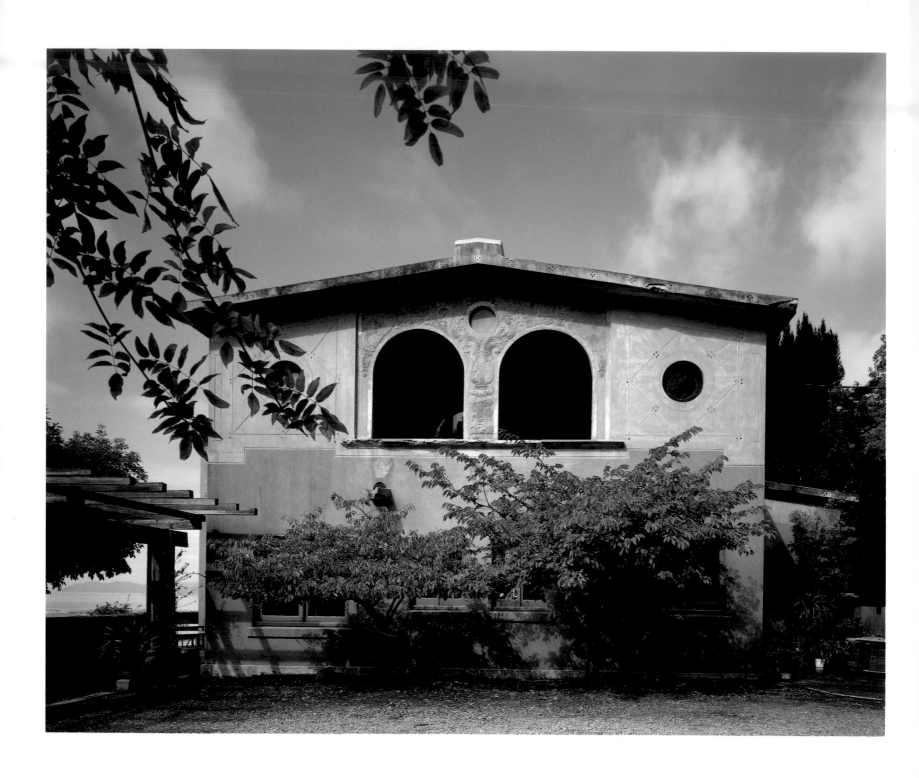

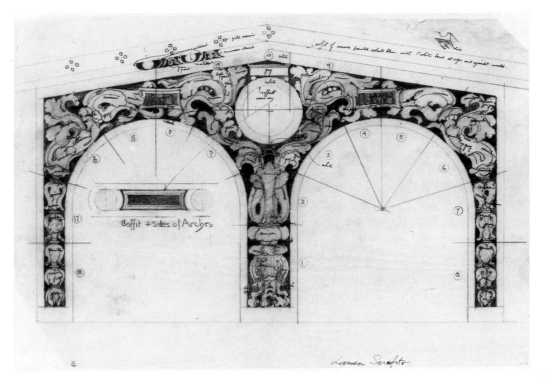

Soffit + Sides of Arches

Lawson Serafito

styles than to the geometric patterns associated with the Viennese Secessionist movement. (A similar but richer surface treatment enlivens the upper walls of Frank Lloyd Wright's Avery Coonley house of 1908 in Riverside, Illinois.) An elaborate foliated design in sgrafitto surrounds the arched openings of the sleeping porch on the back of the house (plate 104). This was apparently a trial piece—a carefully executed drawing (plate 105) indicates what Maybeck intended for other wall surfaces. But as construction costs rose ever higher, Lawson must have eliminated the sgrafitto work along with the tile roof, both of which would have heightened the Mediterranean aspect of the house and lessened its stark, modern look.

Lawson's intense interest in concrete apparently blinded him and Maybeck to its cost; they probably led each other on in their enthusiasm for the project. Although the earthquake had accelerated the use of reinforced concrete in non-residential urban buildings, the high costs of labor and materials had generally precluded its use in houses. The large and lavishly appointed Senger house, for example, cost $8,400—less than half the Lawson house, which cost $17,533. Lawson seems to have been determined to take part in the structural design, and the accounts of friends and neighbors indicate that he and Maybeck battled their way through the process until the house was completed in 1908.

The specifications included two sets of plans, one by the architects and one by Herman Kower, the engineer who had advised Maybeck on Hearst Hall. For the concrete work, two grades of cement were used: a rich grade for the framework of floors, beams, girders, roofs, and the stairs; a poorer mix for walls and partitions.

OPPOSITE

▣ 104. *Back of the Lawson house showing the sgrafitto work around the arched openings of the sleeping porch*

ABOVE

▣ 105. *Maybeck's preparatory drawing for the sgrafitto work. Documents Collection, College of Environmental Design, University of California, Berkeley*

121

The concrete was mixed by hand in batches of one cubic yard and poured one foot, at most, at a time. The lack of paved roads up the hill added to the difficulty and the expense, since mule-drawn wagons had to be used to haul cement to the site. The ornamental plasterwork was done by Hoff and Hoff, a firm of architectural sculptors, who also estimated the sgrafitto work at $350 to $375. Estimates for the roof of "Mission Tile" ran from $950 to $1,225. The Caen stone that Maybeck had wanted to import from France to use for the stairway was estimated at $225. When that proved too expensive, it was replaced by concrete that was integrally colored black and inset with diamond and other linear patterns made of gilt glass tesserae (plate 107). The railing has black-plaster balusters cast in a scrolled motif. By exaggerating the structural forms and varying the surface treatment of the materials, Maybeck transformed the ordinary materials into art.

The sweep of space from the entrance beside the stair hall to the doors leading to the terrace makes clear the path of movement into the central area. From this point the clarity of the ground-floor plan is revealed by axial views through the living room to the west and the dining room to the east. The orderly arrangement of spaces perceived through generous openings and the horizontal emphasis achieved by the wide spans of the concrete frame and the low ceilings induce a feeling of calm (plate 106). The denlike living room is divided into a reading area and an alcove introduced by a low arch that establishes an intimate fireside setting (plate 108). The dining room communicates with the outdoors through an opening onto the garden terrace (plate 109).

BELOW

▨ 106. *Interior view across hall and main living room, Lawson house*

OPPOSITE

▨ 107. *Main staircase, Lawson house*

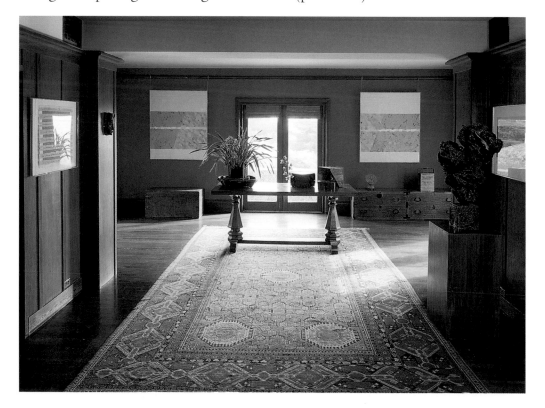

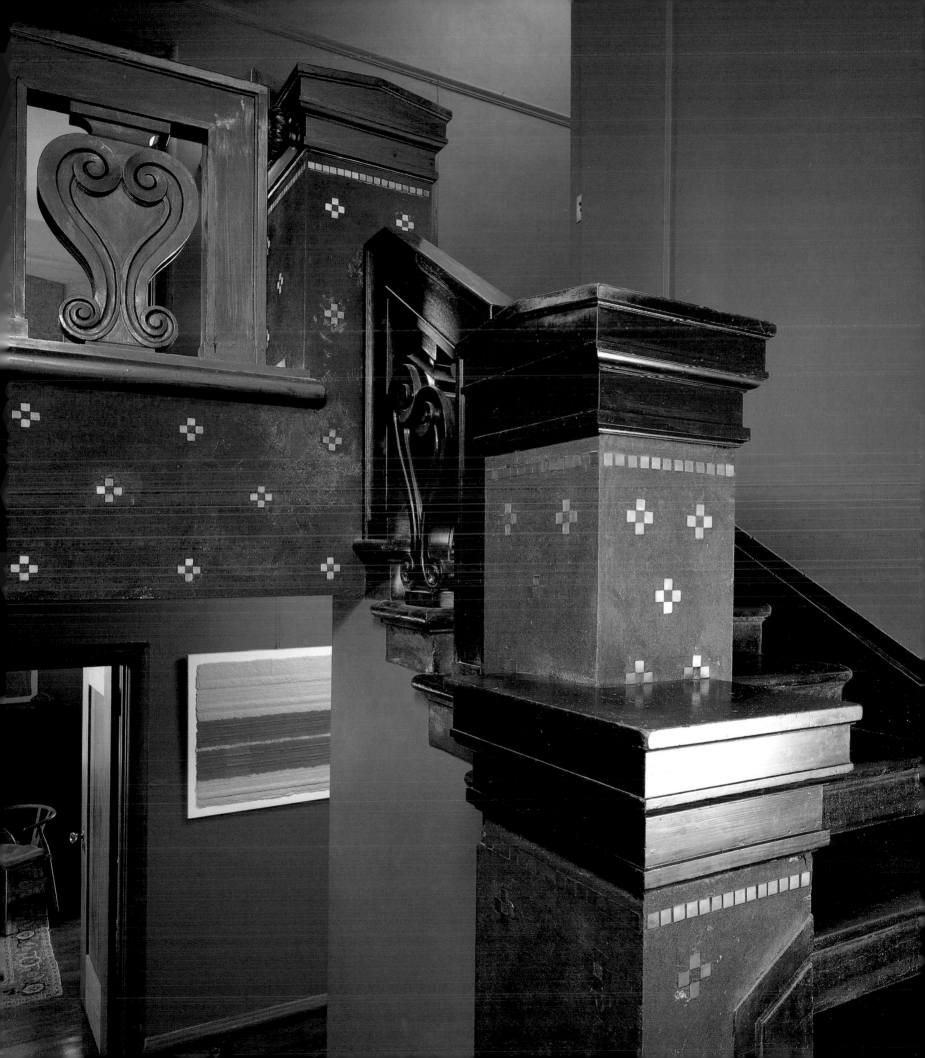

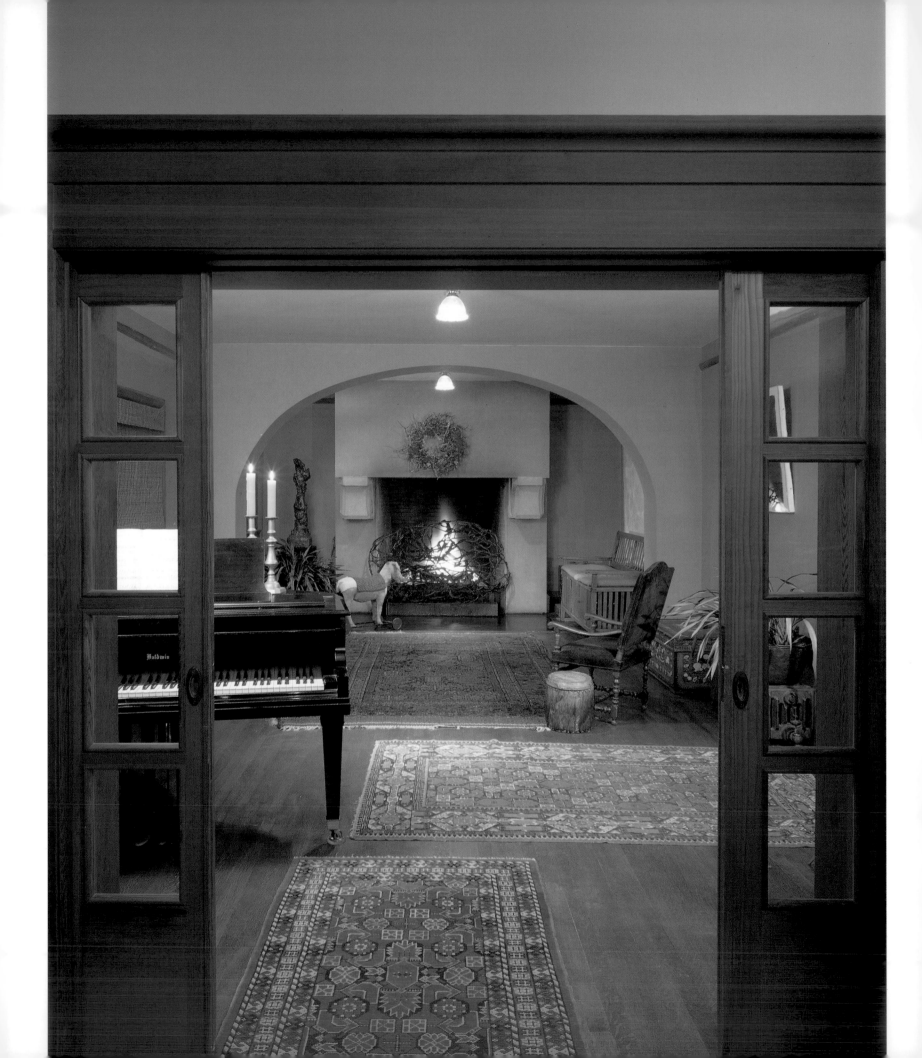

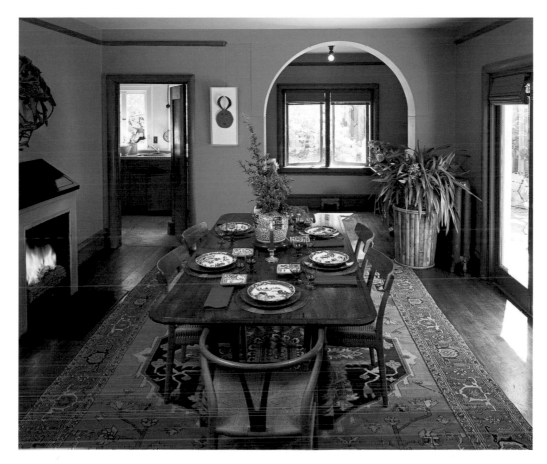

The five bedrooms upstairs are simple and well lighted. They all communicate directly with two sleeping porches; the one at the back of the house was equipped with two cold-water showers, a reminder of the generally spartan regimen of the health-conscious community. For the walls of the main bathroom upstairs (plate 110), Maybeck used large milk-white tiles of Vitrolite, the brand name of a high-fired vitreous material used extensively on shop fronts because of its durability. The large size of the tiles and their lustrous surface give the bathroom an unexpectedly luxurious feeling, considering the cheapness of the material. Here, as in the stairway, Maybeck's innovative use of practical materials makes one wish that he had lived long enough to practice in the age of plastics. Looking back on his career, he himself expressed that wish.[1]

The Lawson family lived in the house until Mrs. Lawson's death, by which time their sons had grown up and left home. Thereafter, Lawson traveled a lot and occupied only a part of the house when he was in Berkeley; the rest he rented. In the 1920s he married the daughter of a colleague, and they moved into a smaller house, with a concrete frame and hollow tile walls, on the back of his property, which was designed by a young architect named Jack Ballantine. Lawson himself added a gallery wing to this house in the 1930s, and in the 1940s he supervised the building of one last house on his property. The neighbors

OPPOSITE

108. *Second living room–study, Lawson house*

ABOVE

109. *Dining room, Lawson house*

110. *Main bathroom, upstairs, Lawson house*

watched anxiously as this aged and famous man teetered back and forth carrying loads of mortar across the roof of the adjacent garage.

Apparently the Lawsons moved from the house designed by Maybeck because the new Mrs. Lawson found it too large and dark. Admittedly, the billiard room on the ground floor at the front of the house had been painted a deep maroon as a substitute for dark wood paneling, which had been eliminated to reduce costs; the other rooms were painted in earth colors. But the house need not have been dark inside, and it certainly is not today. The large openings for windows and doors, no longer hung with heavy drapes, now let in an abundance of daylight on

the south side of the house; the dark billiard room and the richly colored entrance hall on the north side are more dimly lit.

The Maybecks did not build on their own La Loma Park property, which lay to the north and uphill from Lawson's, until after the Senger and Lawson houses were built. The Maybeck tract lay within the loop of what became Buena Vista Way and La Loma Avenue, once they were finally laid down and paved. Maybeck introduced a driveway, now called Maybeck Twin Drive, that curves gently through the property. The first lots, probably determined by natural features, were polygonal and fit together like a crazy quilt. Maybeck's plan for his property was to sell preliminary plans for houses along with the lots. But few plans appear to have been made other than the Maybecks' own house (plate 111), built in 1909. It was a realization of the precepts that Ben had composed and that appeared, unsigned, in an essay published in the Hillside Club's *Yearbook* of 1907.

The essay begins with a quotation from Jules André (the master of Maybeck's atelier at the Ecole), which Maybeck states is the fundamental law of landscape architecture: "In laying out a landscape, never take away what is there. Group with it what you add to it." In the course of the essay Maybeck made recommendations for platting lots, which he followed for his own property: "The irregularity of the hillside dictates the shape of the block and makes rectangular lots undesirable. Choose wide lots. . . . Build around the hill on contour lines or step the houses up against the hill, one story back and above the other. The correctly planned hillside house is parallel, not perpendicular to the slope."

Maybeck's house was indeed aligned parallel to the slope, and it stepped up the hill with one story above and in back of the other. The interior organization

111. *Bernard Maybeck house, no. 2, Berkeley, built in 1909 and destroyed in the 1923 fire. This is the only extant photograph, originally published in* Homes and Grounds, *May 1916.*

of the space was expressed by roofing important sections separately. Clad in both weatherboard and shingle siding, with stone steps leading up to the house and low rock walls around garden terraces, this woodsy dwelling fulfilled Maybeck's promise: "A house of natural materials absorbs the light and, with the help of trellises and vines, hides among the browns and greens of the hillside and is finished for all time." Alas, this prophecy was not fulfilled, for the house burned in the 1923 fire.

The only firsthand account of Maybeck's house was written by a sensitive and well-qualified observer, the midwestern architect William Gray Purcell, who visited Maybeck in 1914 while working for John Galen Howard in Berkeley:

Walked to Maybeck's house, a brown shingle house with a broad redwood slab door, sat on a seat in a window recess. My first experience in a room with a shed slope ceiling—low where I sat, rising to a considerable height on the far wall, with a very tall fireplace and chimney. To the right of the chimney a tall opening was carried up to the ceiling beam, and between the door jambs at its base some very broad steps led to an adjoining room. A tall curtain of thin woolen stuff fell the full height of the door and draped its extra length in terminal folds on the steps.

BELOW

▧ 112. *Leon L. Roos house, San Francisco, 1909, with later additions. View from Jackson Street*

OPPOSITE

▧ 113. *Main-floor plan, Roos house*

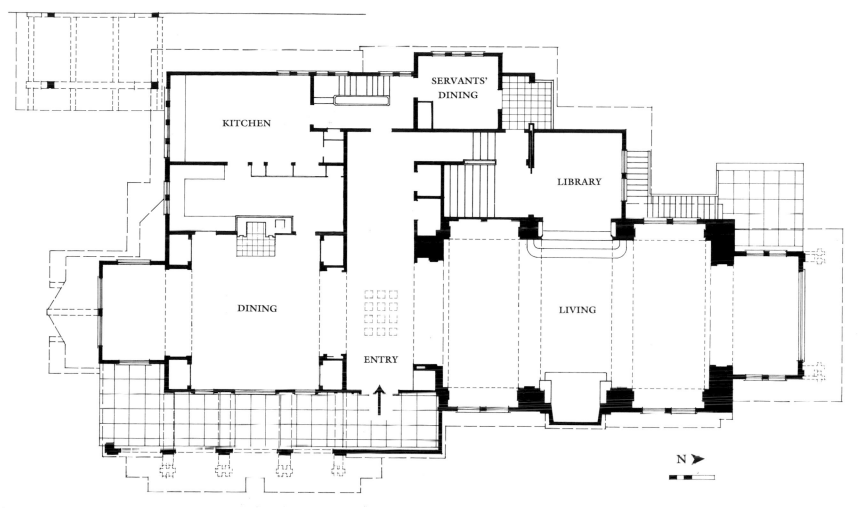

KITCHEN

SERVANTS' DINING

LIBRARY

DINING

LIVING

ENTRY

N ▶

Purcell sat in a Morris chair asking Maybeck questions and thinking over his answers. Some of the conversation that he recalled years later concerned Louis Sullivan:

> Maybeck was familiar with Sullivan's thesis or the "Form and Function principle" and understood its logic in buildings. Maybeck took no occasion to discount or reinterpret Sullivan in relation to his own original work but talked about his own views and experience in buildings. [He agreed with] what Sullivan had said, "you cannot produce a living architecture as a system of applied logic. Architecture is Life-Poetry. The logic is something not to be caught by intellectual machinery. Architecture is the imprint of a greater logic of Man and Nature which no smart brain can take apart and make simple—its simplicity is already profound."[2]

The house that Maybeck designed in 1909 for the Leon L. Roos family (plate 112) was definitely Life-Poetry. In Mrs. Roos, Maybeck had a client whose

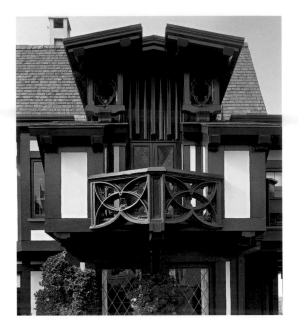

interest in theater paralleled his own. The house was a wedding present from her father, Morris Meyerfeld, who was a partner in the Orpheum Theater Circuit company. He had taken Elizabeth Leslie with him when he traveled to Europe in search of talent, and these tours gave her a lasting enthusiasm for the theater and for theatricality. When she heard that Mr. Maybeck designed theatrical houses, she rejected the architect her father had chosen and hired Maybeck.

At about 9,000 square feet, this is Maybeck's largest San Francisco residence. It has two distinct sections: a two-story front part with dining room (plate 116), entrance hall, kitchen, and service spaces on the ground floor and bedrooms above; and a back part with only one floor but nearly the same height as the front part—the back part contains the great two-story living hall, the largest room in the house. Though difficult to ignore for other reasons, the house does not immediately reveal its considerable size. Instead of the grand entrance typical of mansions of the time, the front door is at the end of the loggia on the east side of the house, and it is not visible from the street. Even before a garage and an upper-level room were added to the west side, the facade was asymmetrical; its focus is the balcony off the second-story bedroom and the elaborate dormer above (plate 114). Here Maybeck put his early experience in furniture design to use in an idiosyncratic

ABOVE

❖ 114. *Detail of front elevation showing balcony and dormer, Roos house*

RIGHT

❖ 115. *East side of the Roos house*

OPPOSITE

❖ 116. *Dining room, Roos house*

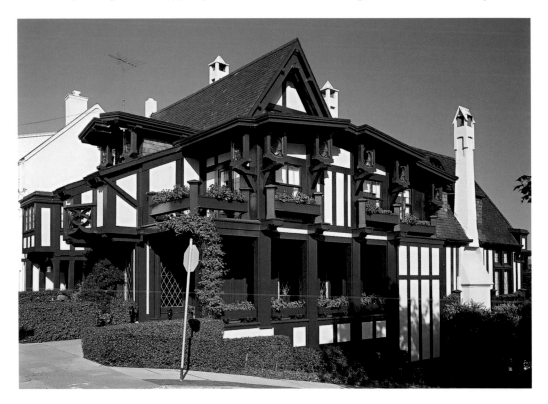

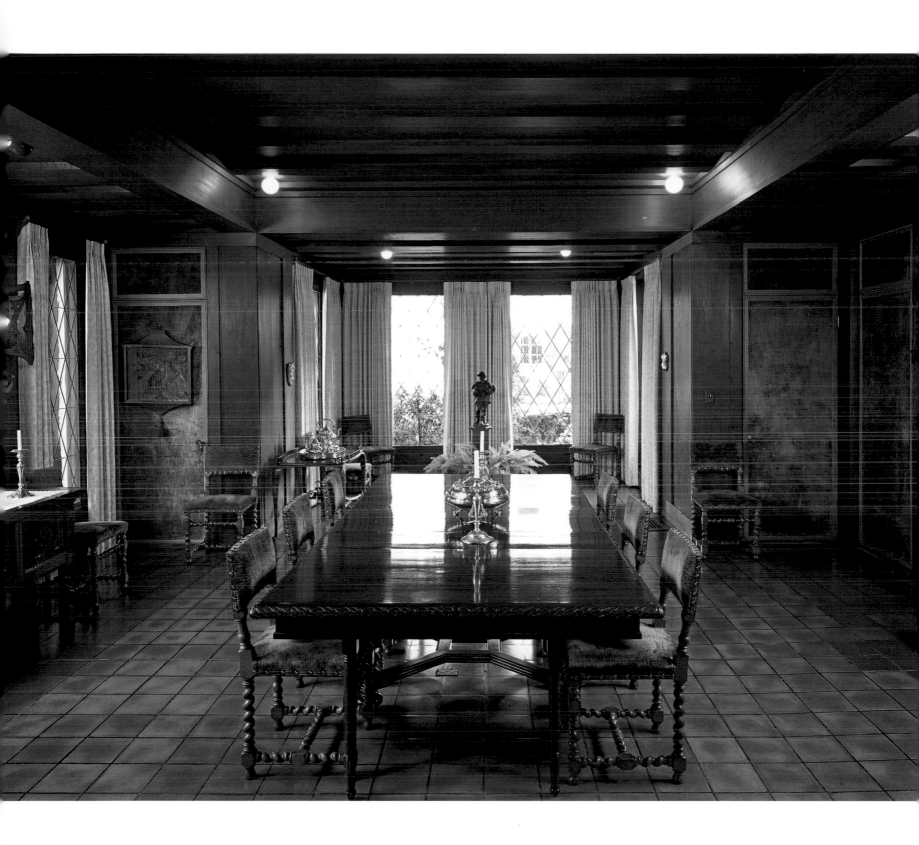

composition that transforms the projecting bedroom into a giant cabinet. "Fanciful" is not quite the right word to convey the effect of this composition, although there is a certain whimsy to the face detectable in the quatrefoil eyes under heavy brows. No one played with trefoils, quatrefoils, and other Gothic ornament with more verve than Maybeck; few other architects dared to combine different stylistic details so freely or to alter their effects by using them in untraditional materials.

The east side of the house (plate 115), which follows the steep slope of the site, reveals its large mass. Perhaps with some help from the engineer Herman Kower, Maybeck designed a latticed foundation of heavy wooden beams attached to wooden piles driven into the hillside. The purpose of this raftlike foundation was to permit the house to rock with the movement of the earth during a quake and to obviate the need for the high, fortresslike foundation walls that are typical of other large hillside buildings in San Francisco neighborhoods. Structurally integrated with the hillside, the house does seem to grow out of its site. When the full complement of house and gardens existed, the house certainly met the Hillside Club's standards. Originally the grounds extended behind the house to encompass a formal vegetable garden designed by Maybeck. Although this garden has vanished, other of his landscape elements—clipped hedges and shrubbery that soften the base, trellised vines, and planters filled with geraniums—still contribute to the picturesque qualities of this grand but informal mansion.

The Roos family, like Phoebe Hearst, entertained frequently and formally. Their guests would approach the house through the loggia, which serves as an open foyer, and enter the low-ceilinged, skylit entry. From this point the sequence of spaces along the lengthy north-south axis is visible. The passage from the dining room at the front to the secondary living room, or alcove, at the back (plate 118) is also a progression from the closed and private street side to the more open garden side. The low-ceilinged alcove is a setting for contemplation of the view through the large window overlooking the Presidio grounds and Marin County across the bay. While the guests proceeded into the living hall (plate 119), the hosts would descend from the upper floor by means of a stair hidden behind a wall and appear on a stagelike landing to greet those assembled in the hall. The landing, raised four steps above floor level, forms one end of a cross axis anchored on the opposite side of the room by a cast-stone fireplace that rises to the ceiling. After making an initial appearance, the hosts would usually stand by the hearth and receive their guests less formally. Dr. Jane Roos, who inherited the

house in the late 1970s, recalls that she first saw her mother-in-law dressed in a tea gown, standing by the fireplace.

The Rooses had a wonderful time living a baronial life. Leon Roos (who was an owner of Roos Brothers, one of San Francisco's major men's furnishing stores) designed a family crest (plate 120) and commissioned furniture from Maybeck to complement the pieces they purchased in Europe and elsewhere. Maybeck's mas-

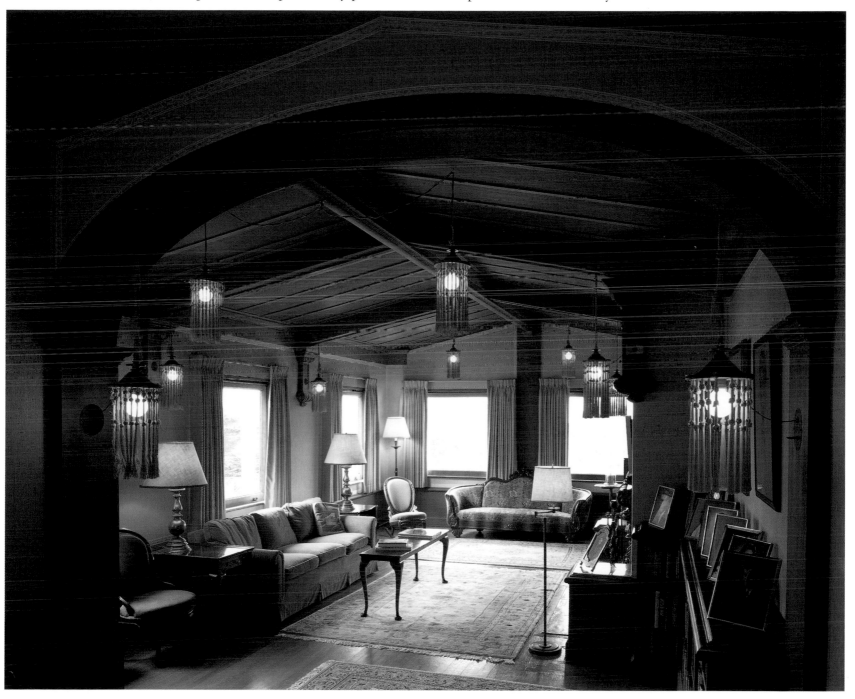

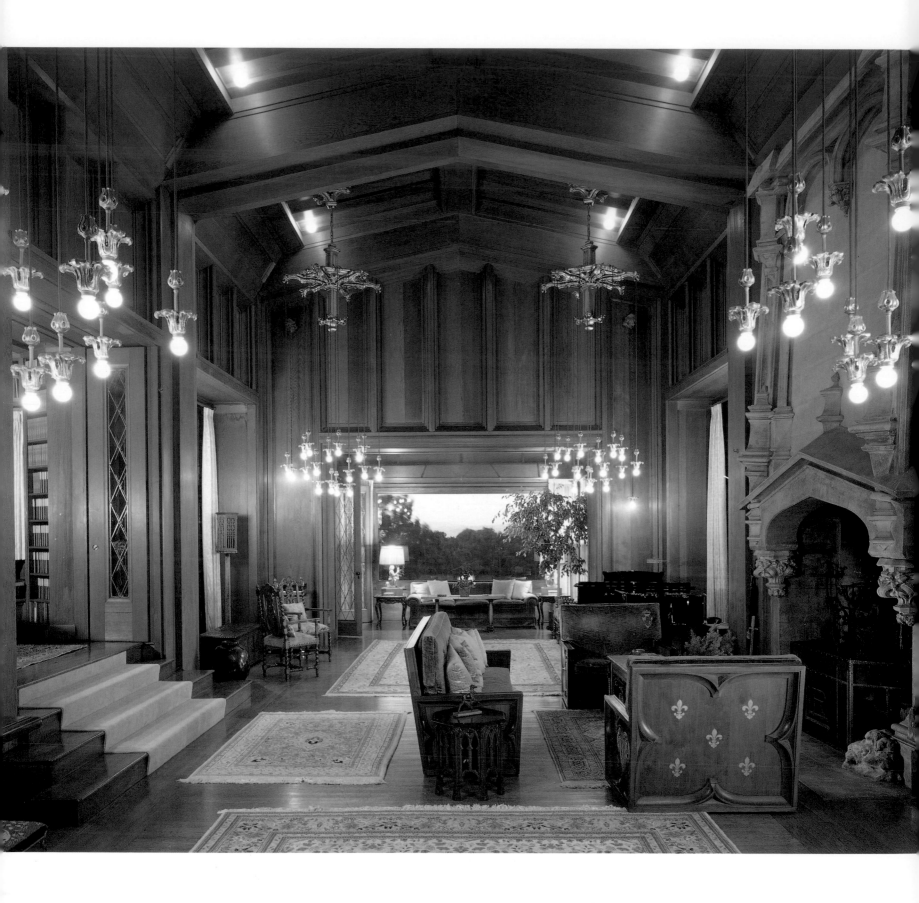

sive armchairs and couch, their ends inset with giant quatrefoils, effectively frame a social area by the fireplace (plate 121). Silken banners from Europe hung from standards set in holders that Maybeck designed for them (plate 122). (By the 1970s the banners had all but rotted away and were removed.) Clusters of lights suspended at slightly different heights from branching metal ceiling fixtures glow like fireflies. Similar to the lights that Maybeck had devised for Hearst Hall and

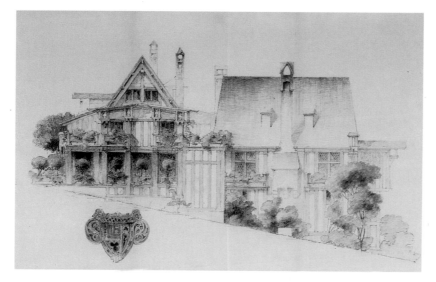

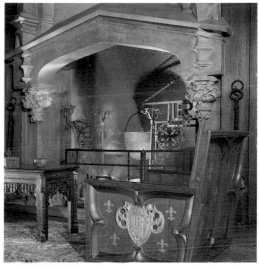

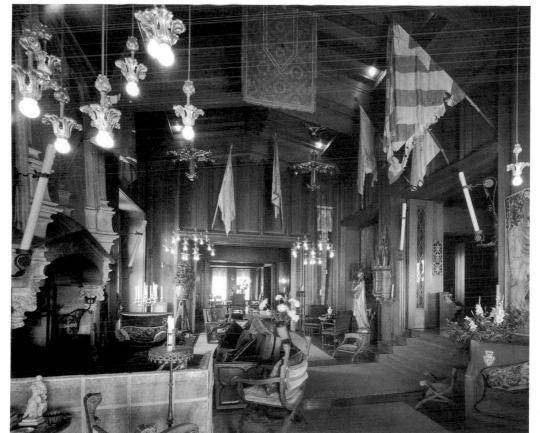

was to use again in the First Church of Christ, Scientist, they help to set a human scale. Maybeck referred to them as "atmospheric lights"—an aptly theatrical term for their effect on the room's character. The lights and the banners served to veil but not conceal the low-pitched gable ceiling, twenty-five feet high at the ridge, that caps the space. For all its grandeur, the hall never dwarfs its occupants.

The use of redwood for the whole room distances this hall from the historicist half-timbered style popularized by designers in the mainstream of the Arts and Crafts movement. Redwood paneling set in modules of three establishes a spatial rhythm. The uneven number of modules on the long walls establishes a continuous rhythm sympathetic to the direction of the hall's main axis; the symmetry of the end walls, which have seven modules, balances this rhythm with stasis and gives a feeling of completion to the room as a whole. Filling one section of the wall, the mantelpiece of cast plaster and concrete tinted to mimic stone is a mélange of Tudorish detail. Although it commands attention from those in the room, the mantelpiece does not project so far into the space that it detracts from the total view of the room from the entrance hall.

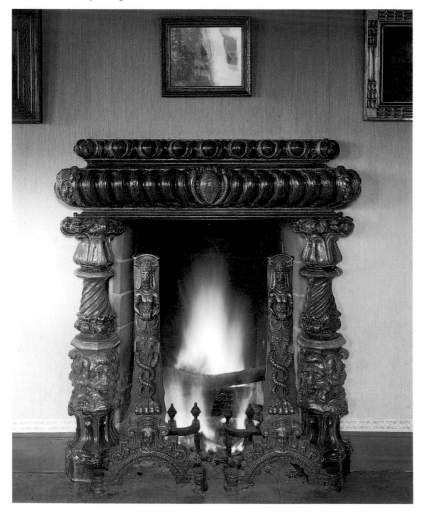

Maybeck added a garden room on the southeastern corner in 1913 and a garage in 1916. Leon Roos owned one of the first gasoline-powered automobiles in California, a grand open touring car that served the family unexpectedly well by transporting them to San Jose in the aftermath of the earthquake. Garaged elsewhere at first, the car was eventually kept under the house, where a mechanical turntable was installed so that it could be turned around and driven forward out to the street. The turntable finally rotted away and has been replaced with a commemorative circle of concrete. A second-floor dressing room was added in 1919 and an upstairs study in 1926. Well lit by large windows, this informal living room has one of Maybeck's fanciful fireplaces, a concoction of polychrome Renaissance detail complemented by andirons that match its free spirit (plate 123). The board-and-batten ceiling strikes a rustic note echoed in a series of delightful lanterns with sides of knotted-silk cords (plate 124).

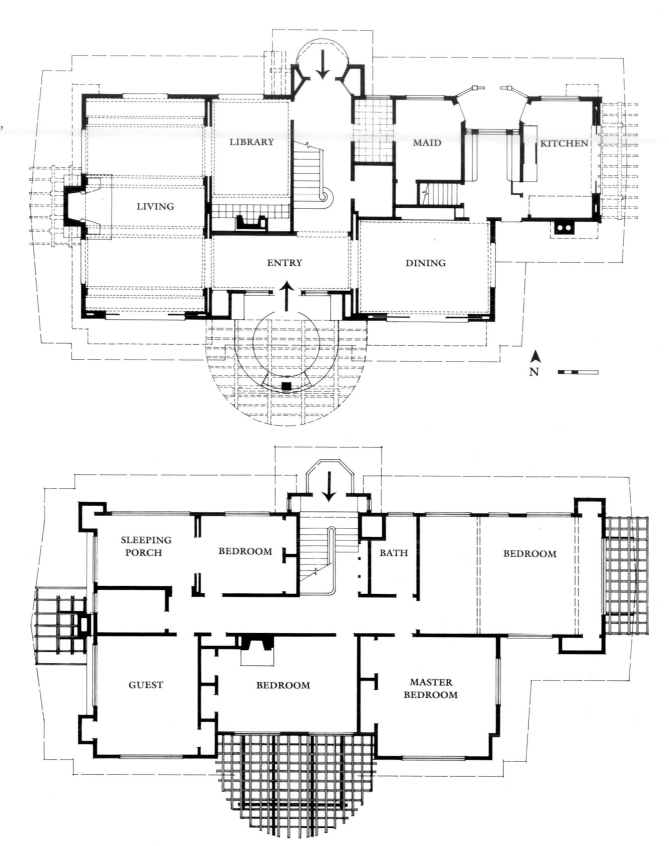

LIBRARY

MAID

KITCHEN

LIVING

ENTRY

DINING

N

SLEEPING
PORCH

BEDROOM

BATH

BEDROOM

GUEST

BEDROOM

MASTER
BEDROOM

In 1913 Maybeck designed a house for the Guy Hyde Chick family in a canyon filled with oaks in Oakland near the Berkeley border. The siting of this house relates it to a design for a hillside house that Maybeck had drawn up years earlier (plate 127), perhaps for a Hillside Club publication, but never built. The house in his drawing straddles a hillside and has a cross axis that starts with a terrace on the lower slope then proceeds up a flight of steps and through the house to a terrace on the other side, from which another flight of steps resumes the ascent up the hill. The Chick house does not incorporate the same sequence of stairs and terraces shown in the drawing—nor is there any evidence that Maybeck even suggested it. But in not carrying out some plan for a landscaped cross axis, both Maybeck and the owners missed an opportunity to fulfill one of his finest visions.

When he designed the Chick house, Maybeck seems not only to have been reacting to the possibilities of the hillside site but also to have been reflecting on the chalet-inspired houses of his earlier years. Indeed, the closest relative of the Chick house is the 1901 Flagg house (plate 29). The Chick house has a rectangular plan subdivided on the ground floor into three rectangular sections of the same proportion as the house itself. The kitchen breaks out of the main rectangle to form one side of a southeast-facing terrace, connected to the dining room by double doors. Like the house in Maybeck's drawing, the Chick

ABOVE

127. Drawing for a Hillside House. *Ink and pencil on tracing paper. Documents Collection, College of Environmental Design, University of California, Berkeley*

LEFT

128. *South entrance, Chick house*

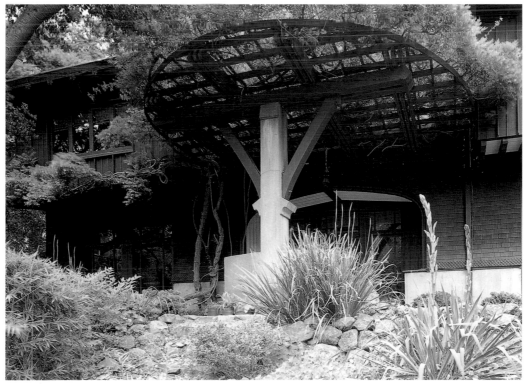

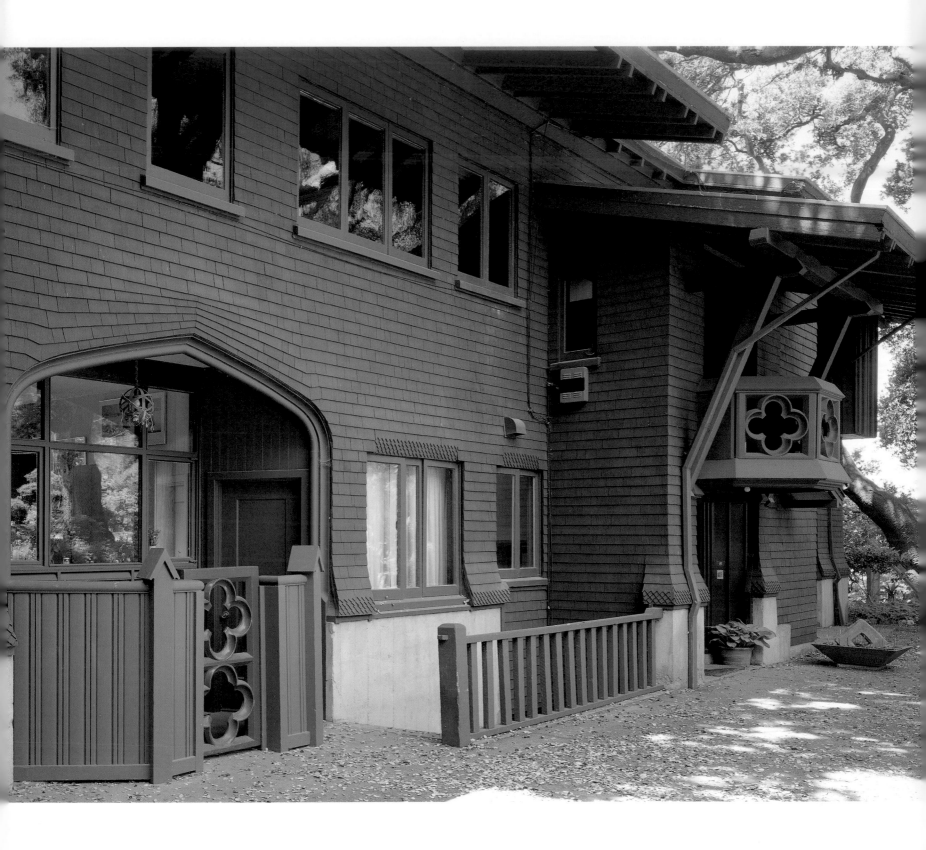

house has two important entrances centered in the long sides. The formal entrance to the house, on the sharply sloping south side, is preceded by an intimate hemispherical terrace sheltered by a trellis of the same shape, which extends several feet beyond it (plate 128). The graceful arc of the trellis complements the generous width of the arched opening in which the entrance doors and flanking windows are set. The north-side entrance (plate 129), located beneath a balcony with a railing of cutout trefoils, opens from flat land near the driveway and the kitchen, making it the more convenient one for everyday use. The importance of the kitchen entrance is signaled by recessing it under a low Tudor arch. At the apex of the arch the shingles are cinched up as though a curtain has been lifted to reveal a stage. The yellow ceiling of this recessed entry adds to the drama.

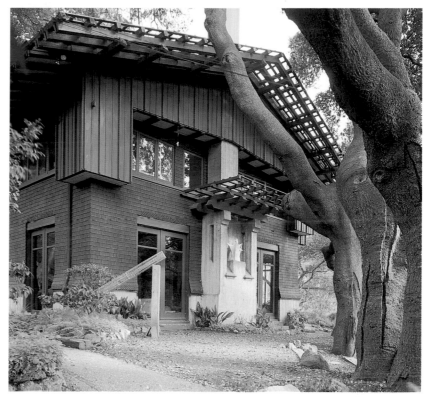

129. *North side of the Chick house, with the kitchen entrance at left*
130. *West side of the Chick house, showing the "corner saddlebags" for storage*

Accents of bright colors were added to specific parts of the rosy brown building, not to create patterns but to highlight elements of the composition, as in a painting. The specifications call for yellow on the roof soffits; red for the rafters and for the balcony and kitchen-gate tracery as well as the doors; green for the heavy timbers and the upper-story bays; and Prussian blue for the front door. A member of the family later recalled standing on the downslope with her mother and Maybeck looking up at the freshly painted house and hearing her mother ask him, "Do you think perhaps it is a little too bright?" "Madam," Maybeck replied, with a sweep of his arm that embraced the whole house, "in twenty years it will be beautiful!" They were left to ponder his meaning. Did he think that the colors would mellow by then, or that they would never fade? They soon learned to love them as they were.[3]

The exterior alludes to the chalet in its roof form and in the use of materials associated with rusticity: wooden shingles for the walls and board-and-batten cladding for the upper parts of the walls at the corners and on the ends, where the upper floor projects and hangs over the lower floor like a saddlebag (plate 130). These projections contain storage space and are an ingenious solution to the problem of providing closets for rooms without diminishing the interior space. Their placement on the exterior near the roof adds to the sculptural quality of the house.

The plan invites circulation through the ground-floor public rooms in the most gracious way. The long east-west axis through the front rooms and out the

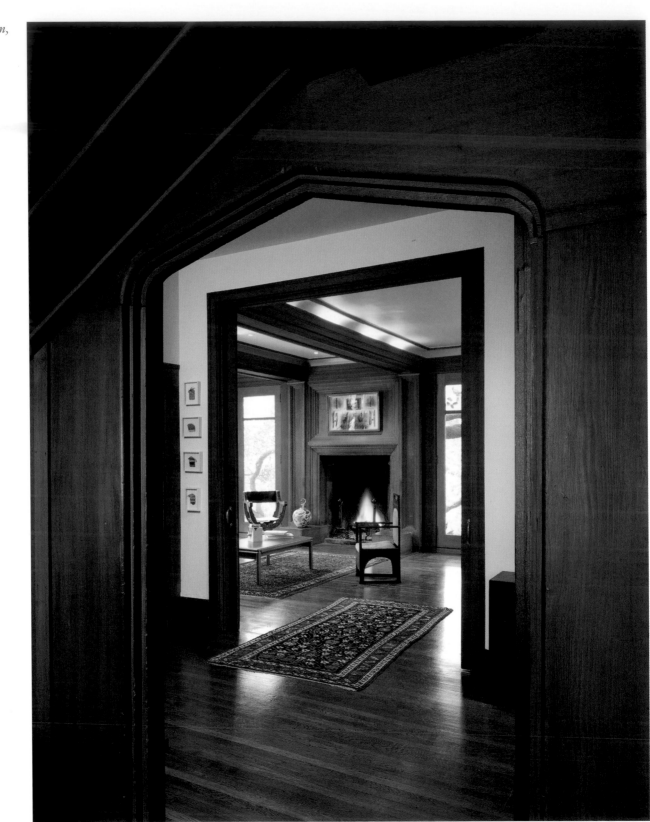

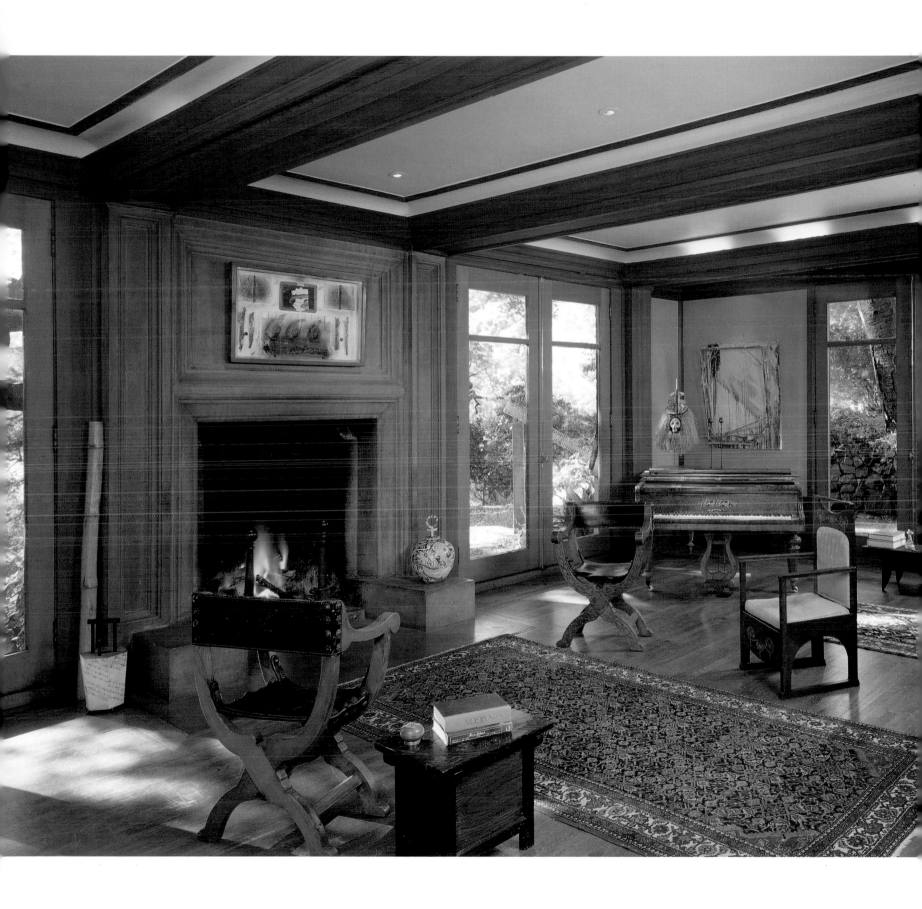

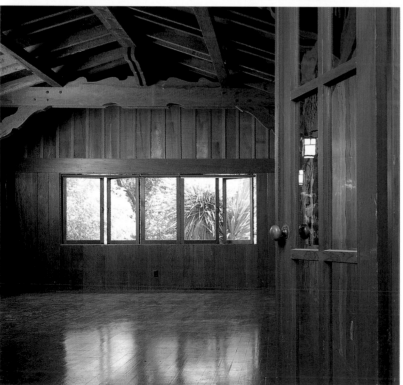

openings at either end is balanced by a cross axis created by windows on the north and south sides of the living room (plates 131–33). The free circulation of space and the opening up of the walls to the outside through seven-foot-tall double doors of plate glass has caused many people to label Maybeck a proto-modernist. But in the central-hall staircase (plate 135), we find Maybeck up to his usual tricks of using traditional forms in startling ways. A post supporting the ceiling has been made into an elegant classical urn in redwood set on a paneled base that interrupts the stair railing. The railing ends in a gracefully turned newel post and has slender balusters that recall the Regency style. The staircase is an ensemble, a set piece that plays against the simplicity of its surroundings.

The three upstairs bedrooms are practical rooms that have no strong features to detract from their views into the oak trees. The yellow on the undersides of the eaves lightens the effect of their broad overhang. On the east end a sleeping porch (plate 134), formerly enclosed only with screens, is given the full rustic treatment with shaped rafters and board-and-batten walls. This kind of rustic family room was common in the Californian houses of the time.

The years 1910 to 1915 witnessed many more stillborn projects for Maybeck than the active five years they followed. The economic stagnation caused by the threat of war in Europe tended to discourage people from building, as recessions always do. One of the few projects that developed during these slack times was a prestigious San Francisco subdivision called

LEFT, TOP

▦ 133. *View of the south hall from the living room, Chick house*

LEFT, BOTTOM

▦ 134. *Upstairs sleeping porch, Chick house*

OPPOSITE

▦ 135. *Interior of the central hall, Chick house, with a redwood post shaped like an urn*

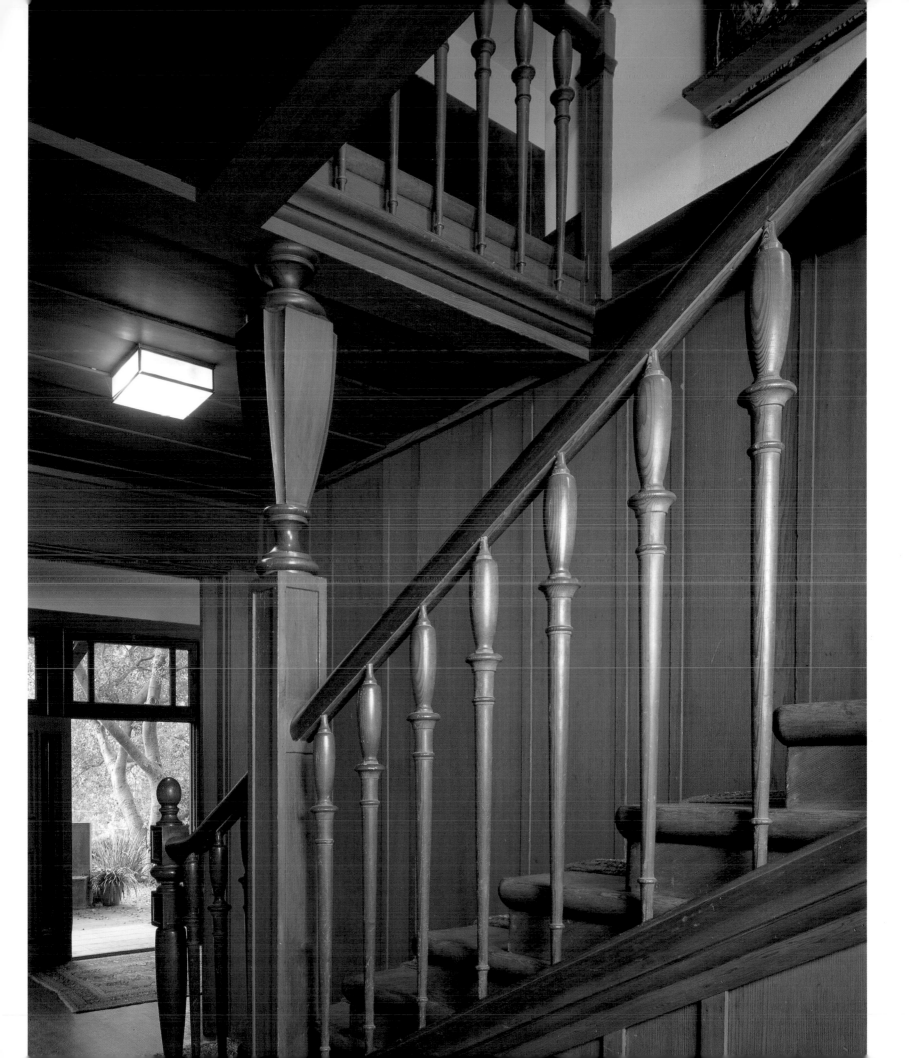

Forest Hill, which was inspired by the success of St. Francis Wood, a luxuriously landscaped subdivision nearby. Forest Hill was planned in 1913 by Mark Daniels, who made a specialty of such developments and laid out several upper-middle-class subdivisions in California, among them Sea Cliff in San Francisco. The new development was signaled by a huge urn at the bottom of a long flight of stone steps climbing the hillside. Its looping street pattern, which the Hillside Club would have endorsed, identified it when the landscape was still quite open, but by now the boundaries of Forest Hill have merged with its surroundings.

In 1913 E. C. Young, a Bohemian Club member who owned a choice hilltop site in Forest Hill with a breathtaking view, asked Maybeck to design a house on it for him. Maybeck made a long rectangular plan that set a two-story living room at the front of the lot and raised it above the street to allow for a garage on one side (plate 138). Steps curve up from the sidewalk to a terrace atop the garage. The terrace extends along the south side of the house to a shallow court formed by one end of the living room to the east and a study wing to the west. Set in one corner of a trellised court, the entrance door is flanked on either side by double glass doors (plate 137). One set of doors opens into the dining room, and when they are open, the terrace becomes an extension of the room.

Making the main entrance door so much a part of the private side of the house seems surprising, but the siting of the house suggests an explanation. Maybeck's plan provides a southern exposure for the important living areas,

▦ 136. *Main-floor plan, E. C. Young house, San Francisco, 1913*

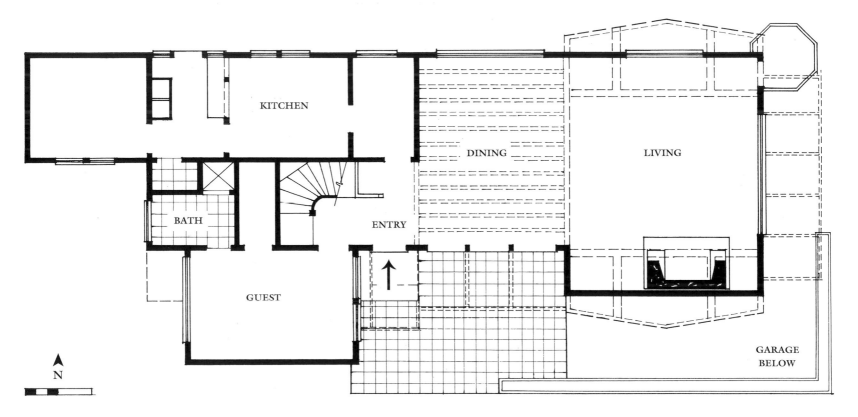

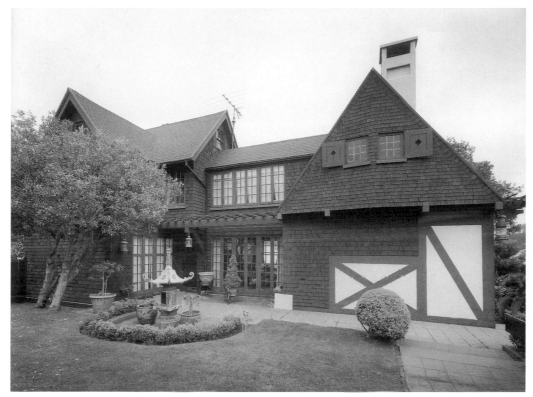

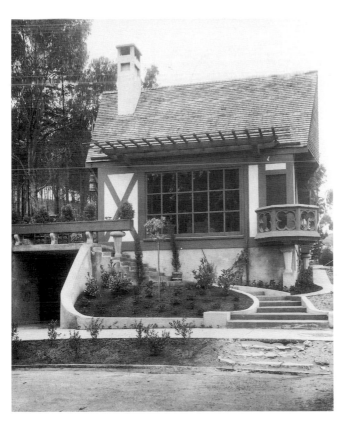

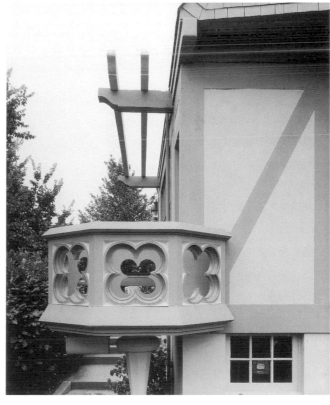

inside and out, and captures the splendid views north to the Golden Gate Bridge and east to the city. Also, interrupting the living room with a street entrance would have destroyed the dramatic effect gained by approaching the room indirectly. The plan provides clearly separated public and private sides and an uninterrupted flow of space from the entrance hall through the important rooms. The entry and the stair hall are also well situated for circulation to the upstairs rooms and to the kitchen at the back of the house. Tucked away in the northeastern corner and barely detectable from the inside or the outside is a simple, narrow door opening onto a small balcony that takes in the sweep of the view to the north. Maybeck directed more attention to the balcony on the outside by giving it a boldly scaled railing with Gothic quatrefoils and a sculptural pedestal (plate 139).

BELOW, LEFT

▣ 140. *Living room, Young house. Maybeck designed the hanging lights.*

BELOW, RIGHT

▣ 141. *Freestanding concrete chimney, Young house*

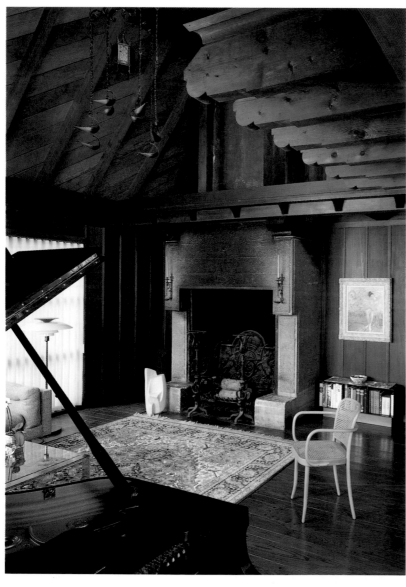

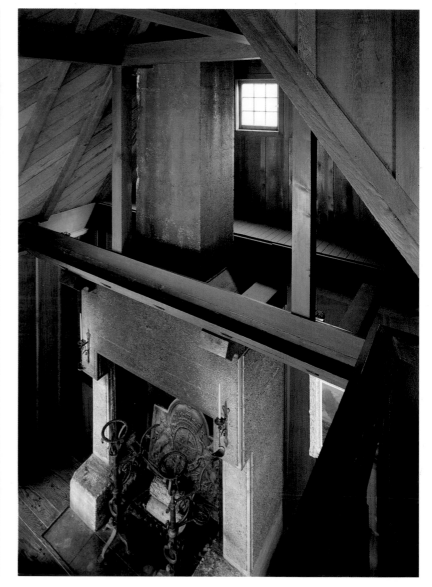

The outside of the Young house seems almost a parody of the English half-timber style; by 1913 that style had become so common that parody probably seemed appropriate to Maybeck. Just as the plan divides the house into a front and a back section, so the exterior has two different claddings: a half-timbered front and a shingled back (like the 1907 Senger house). At first glance, the half-timbering seems perfunctory; it turns the corner in a slapdash way and stops abruptly. Yet the absence of a graceful transition can be read as Maybeck's declaration that such half-timbering was purely and arbitrarily decorative.

The interior of the Young house is more frankly rustic than the outside would suggest. The dining-room ceiling has the exposed floor joists of the upper floor; the high-peaked living-room ceiling is braced with heavy beams and lined with rough-sawn boards laid diagonally (plate 140). The large windows on two sides of the living room provide ample daylight and give the room an openness that is countered on its north side by the tall concrete fireplace, which has its chimney exposed all the way to the ceiling (plate 141). The rudeness of the exposed framing of the ceiling is somewhat countered by the richness of the fireplace mantel. The room makes a strong impression largely because of the elemental forms and expressiveness of the materials. Against its solid strength Maybeck

played off the delicacy of one of his most enchanting lighting fixtures, an arrangement of miniature lamps in black iron suspended at different levels—not exactly the Roos house lighting gone rustic but with a similar effect. Just as the eighteen-by-twenty-two-foot living room gives the impression of being larger than it really is because of the drama of its upper area, so the high ceiling of the square master bedroom, nineteen by nineteen feet, makes it appear larger (plate 142). Here the exposed framing on the ceiling is refined into elegant molded-wood members that give the room a grand feeling.

Regarding the 1916 Erlanger house (plate 143), also built in Forest Hill, Maybeck wrote a cryptic but revealing description:

> The house is our attempt to suggest the idea of an English character in California. Although this house would never happen in England, it yet has an English feeling. The lower wing is a chapel form living room greatly used in an early period, the ceiling of this room is very similar to one in Sainesbury Hill Lancashire. The second story windows are of iron like their English prototypes. The building and its setting among the trees loudly proclaims the good taste of Mrs. and Mr. Erlanger from whom the suggestions came.[4]

143. S. H. Erlanger house, San Francisco, 1916, photographed from the north, c. 1916

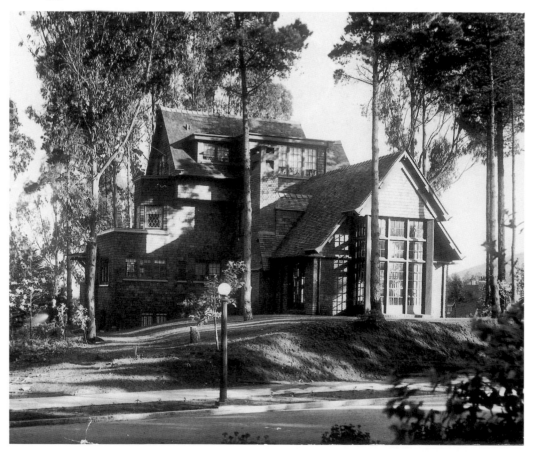

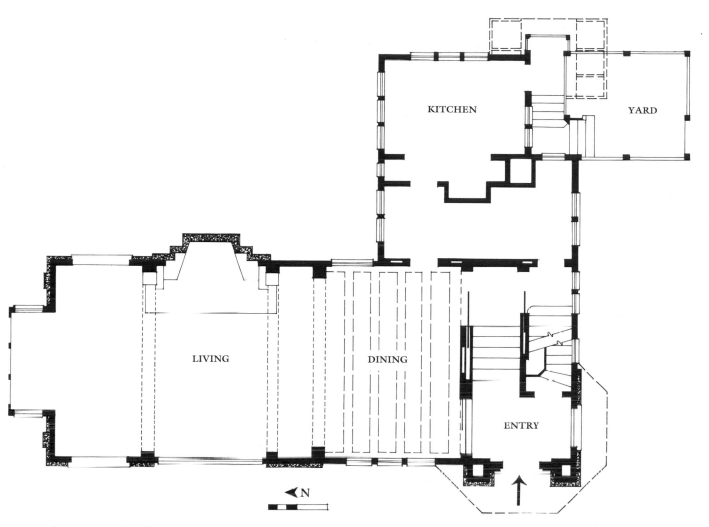

KITCHEN

YARD

LIVING

DINING

ENTRY

◄N

🔲 144. *First-floor plan, Erlanger house*

As is typical of Maybeck's allusive descriptions of buildings, he has omitted specific references here in favor of conveying a mood, leaving the reader to fill in the gaps. The term "English house" was widely understood at the time to mean the half-timber, Tudor Revival–style house that was espoused in England by Richard Norman Shaw and Philip Webb; in the 1870s they had started what became known as the revival of English domestic architecture, which soon became identified with the British Arts and Crafts movement. In the decade before World War I, the English influence reached a peak in parts of the United States, including California.

Maybeck complied with the Erlangers' wishes for an English effect by giving their house a Tudorish exterior and a "chapel form living room" that occupies a wing by itself on the north side (plate 147). The low eaves of the living-room roof create a horizontal emphasis along the street side of the house. The rest of the rooms pile up on the south side in a gable-roofed block set perpendicular to the living-room wing. A bank of dormer windows across the northern slope of the roof lights the third-floor bedroom, which has a view over the living-room roof.

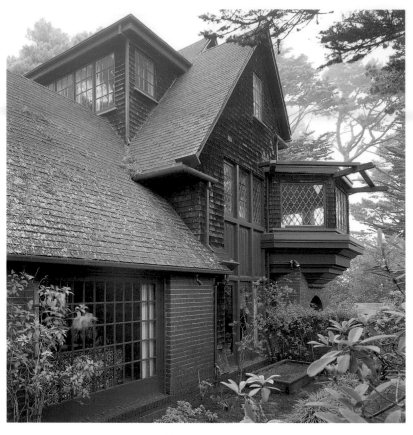 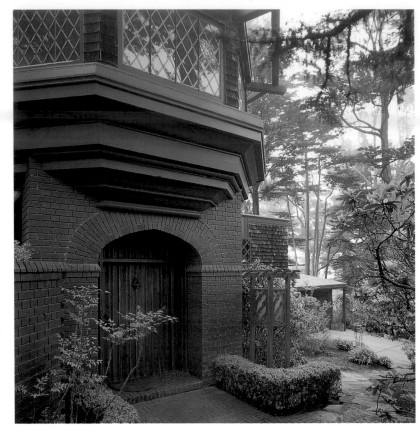

ABOVE, LEFT

▦ 145. *South side of the Erlanger house, showing the sleeping porch*

ABOVE, RIGHT

▦ 146. *Detail of the sleeping porch above the entrance, Erlanger house*

OPPOSITE

▦ 147. *View of the living room toward the bay window, Erlanger house*

On the southeastern corner is a polygonal sleeping porch (plate 146) that has the best exposure and a panoramic view. Where the porch projects over the brick walls of the entrance below, Maybeck has given it a tiered base of boldly scaled moldings that cuts into the walls and swells out above. The fanfare of the base suggests that a weighty element like a tower is bearing down on this important corner of the house, yet the transparency of the porch above contradicts this suggestion. The resulting composition is a trope on the whole idea of a castle keep.

Most of Maybeck's great living halls are entered indirectly from a hall or anteroom so that they strike the eyes of the beholder with maximum effect. This strategy was not peculiar to Maybeck; Frank Lloyd Wright, among others, also understood the dramatic effect of coming from a low, dark space into a high, airy one. In the Erlanger house a heavy beam on ornate consoles forms a secondary entrance arch over a short flight of steps that mount from the front door to the stair hall (plate 148). On the right side of the hall the stairway continues to the second floor; on the left is the living room, a step lower than the hall. The changing levels of this warm redwood entry contribute to the drama of the entrance sequence. So does the window behind a balustrade on the left wall just inside the door, which offers a preview of the grand hall that will come into full view around the corner.

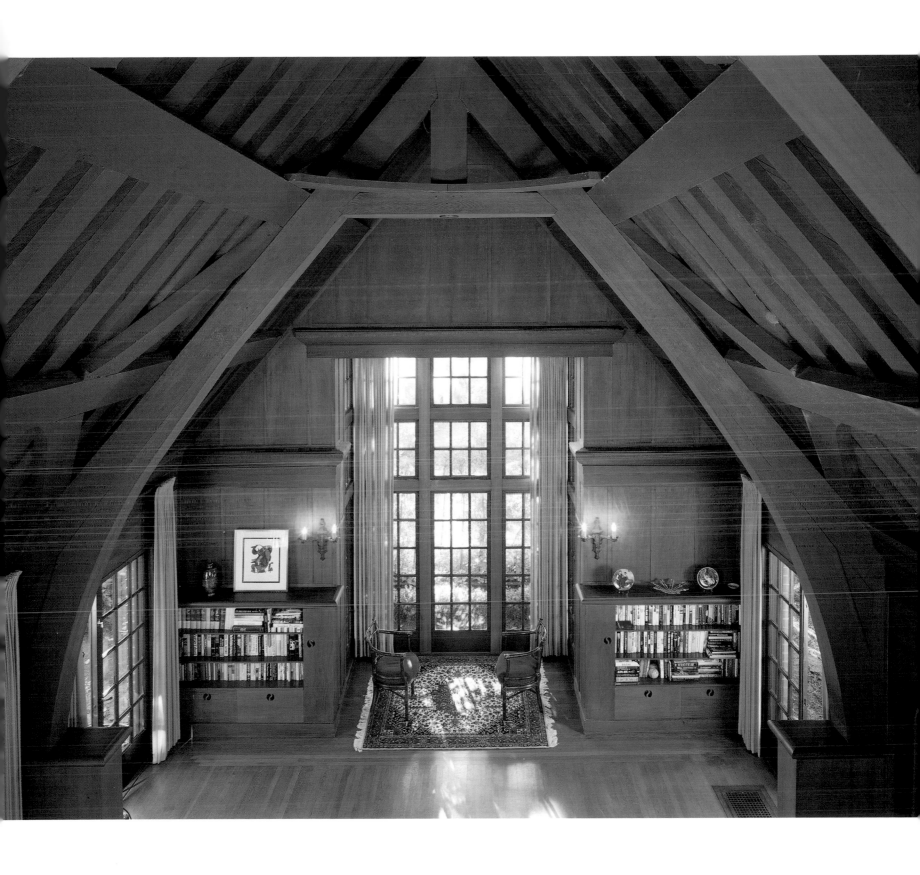

The Erlangers' living room is as theatrical as the Rooses' but composed in a different key. A great medieval barn is suggested by the exposed structural system of curved laminated arches set against horizontal, vertical, and diagonal boards woven together in a wooden brocade. Its effect recalls the sentiment Ruskin expressed in his 1853 "Lectures on Architecture" that the expression "beneath my roof" was more descriptive of the idea of hospitable shelter than its counter-

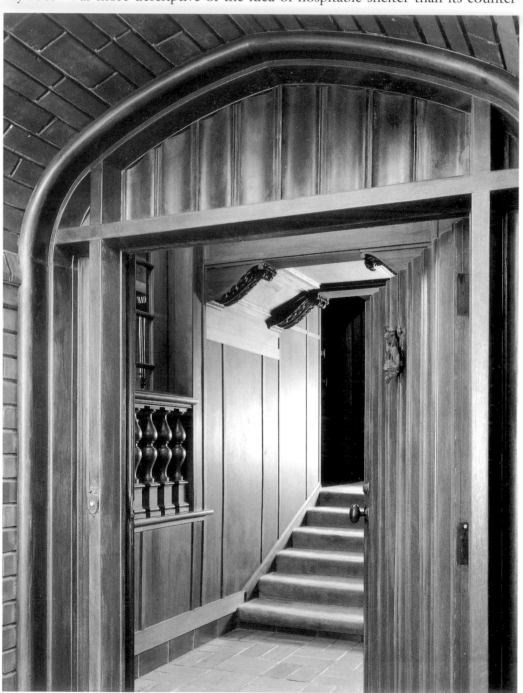

148. *View through the entrance and stair hall, Erlanger house*

part "within my walls." At the northern end of the room is a loft occupied by the master bedroom, from which casement windows open to permit a close view of the ceiling, as well as the room below (plate 149). Underneath it is the dining room in a low-ceilinged alcove. At the other end of the living room is a twelve-foot-tall bay into which sunlight streams through three tiers of windows on its three sides (plate 150). The space within the bay, large enough for two chairs and an occasional table, provides a place for intimate conversation or for contemplation of the garden. Like the Rooses' living room, the Erlangers' balances intimacy with grandeur by incorporating the elements—the monumental hearth, the high-peaked ceiling, and the bay—that Ruskin and his followers, particularly Richard Norman Shaw, considered sacred to the house.

Although Maybeck greatly admired Shaw's early domestic work of the 1860s, an English architect whose career more closely paralleled his own was Mackay Hugh—shortened to M. H.—Baillie Scott, who was born in 1865, started his practice in 1889, and retired in 1939. Like Maybeck, he has been seen both as a proto-modernist and a romantic escapist who failed to move with the times. Scott had an enormous influence on the Arts and Crafts movement in Europe and the United States. Not only was his work published, from 1894 on, in the *Studio* (an English magazine widely read by American architects), but it also frequently appeared in European and American magazines. Scott himself published two popular books—*Houses and Gardens,* in 1906, and a second volume with the same title in 1933. In them he advanced his theory of open planning—he called it "agglutinative planning"—which allowed a free flow of space through the public rooms of a house.

In the *Daily Mail* of September 18, 1901, Scott wrote:

The artisan's residence invariably comprises two or three small rooms on the ground floor, each a few feet square, utilized as a parlour, kitchen and scullery, respectively. It is our contention that this practice should be discouraged. Instead of two apartments, there should be one spacious living room, providing therein the extra comfort, if any, that was to be derived from the parlour, with a number of secluded cosy corners and inglenooks, to serve precisely the same purpose as extra rooms. It should be made as comfortable and as artistic as possible. Wallpapers of incongruous patterns, ceilings with ugly cornices, and square-set, built-in fireplaces should be entirely dispensed with and substituted by the plain wooden rafters for the ceiling, stained a harmonious colour, tinted or frescoed walls, and a high fireplace similar to the old chimney corner.

Scott's advocacy of open planning was the aspect of his work that most influenced modern architects. Yet both he and Maybeck have been dismissed by critics for having turned their backs on the modern movement. Maybeck was too inconsistent, Scott too single-minded.

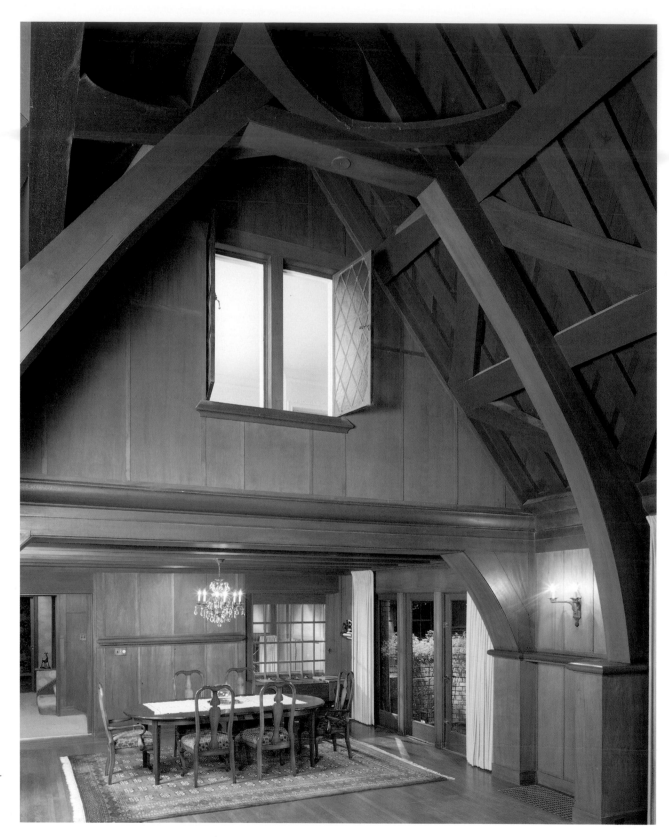

149. *View from the living room, looking toward the dining room and the loft, Erlanger house*

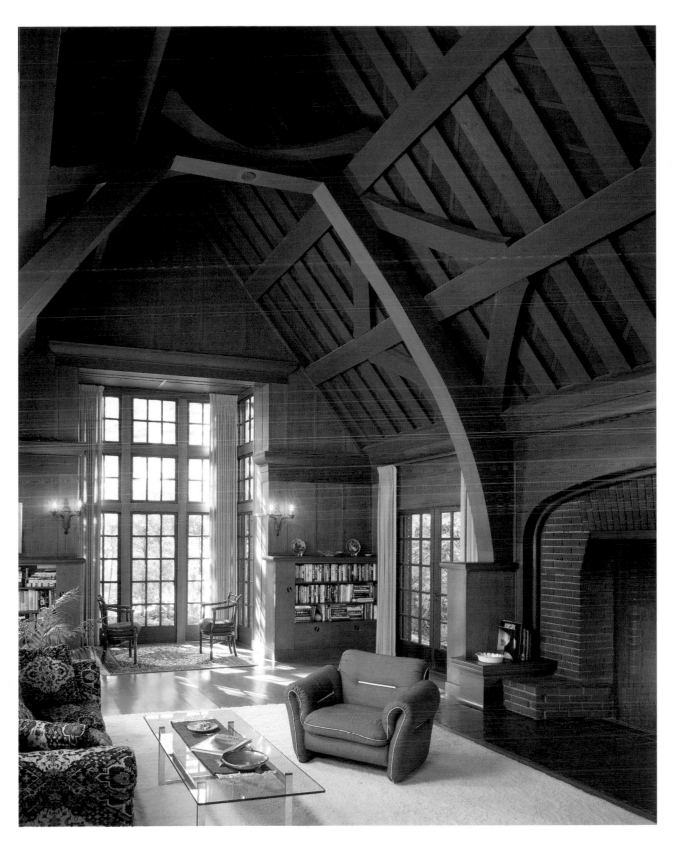

150. *View of the northern end of the living room, with the twelve-foot high bay, Erlanger house*

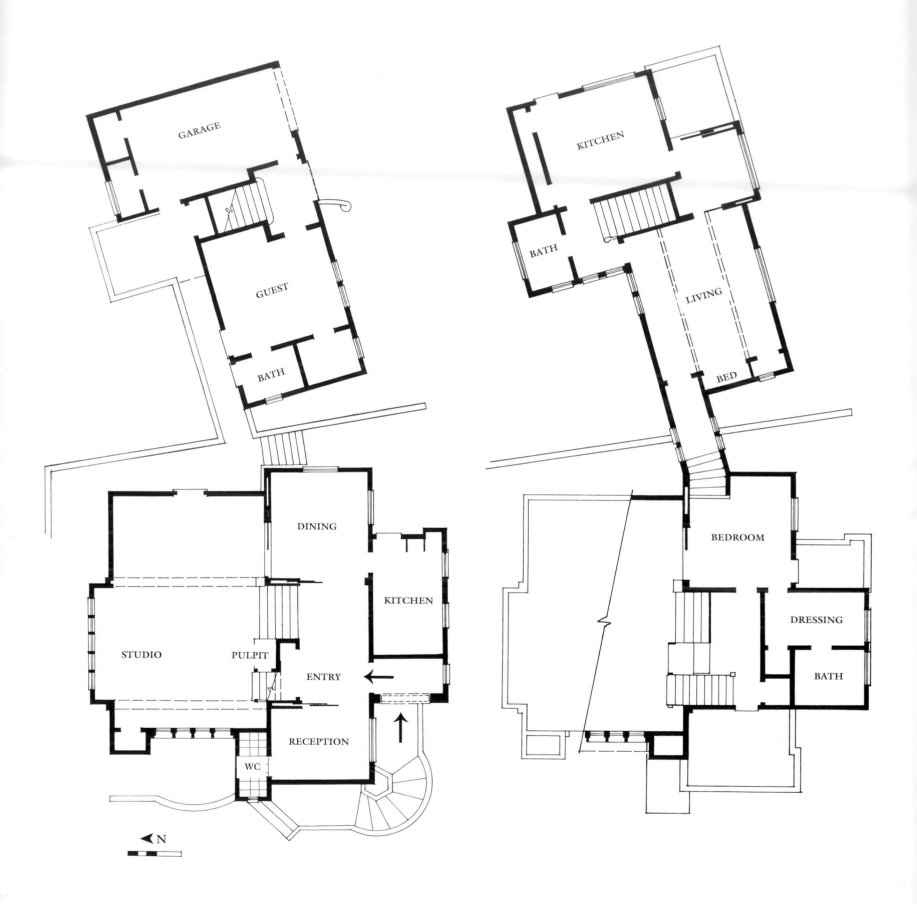

GARAGE

GUEST

BATH

DINING

KITCHEN

STUDIO

PULPIT

ENTRY

RECEPTION

WC

N

KITCHEN

BATH

LIVING

BED

BEDROOM

DRESSING

BATH

One of Maybeck's variations on the theme of the living room was a recital hall (plate 153) for Alma Schmidt Kennedy, a piano teacher in Berkeley who was so admired by the Joseph R. Nixons, parents of one of her students, that they commissioned Maybeck to design a combination recital studio and living space for her. The studio was built in 1914 on hillside property owned by the Nixons, whose brown-shingle house stood next door. Both the studio and the Nixons' house burned in the 1923 fire, after which Maybeck rebuilt the studio as it had been, except that the shingled roof, opened up at the eaves in a wooden trellis, was replaced with fire-resistant tile (plate 154). He designed a new house for the Nixons and attached it by a bridge to the studio. The relatively plain little house is sited on the street edge of the property to allow room for a garden on the other side.

The exterior of the Kennedy studio is an idiosyncratic mixture: Tudor arched windows, a band of half-timbering under the roof, and tracery reminiscent of the Roos house, with Mediterranean massing and colors. The split eaves of the low-

OPPOSITE, LEFT

▦ 151. *First-floor plan, Alma S. Kennedy studio, Berkeley, built in 1914, destroyed in the 1923 fire, and rebuilt with additions in 1923*

OPPOSITE, RIGHT

▦ 152. *Second-floor plan, Kennedy studio*

BELOW

▦ 153. *Original recital hall for Alma Schmidt Kennedy, photographed before 1923*

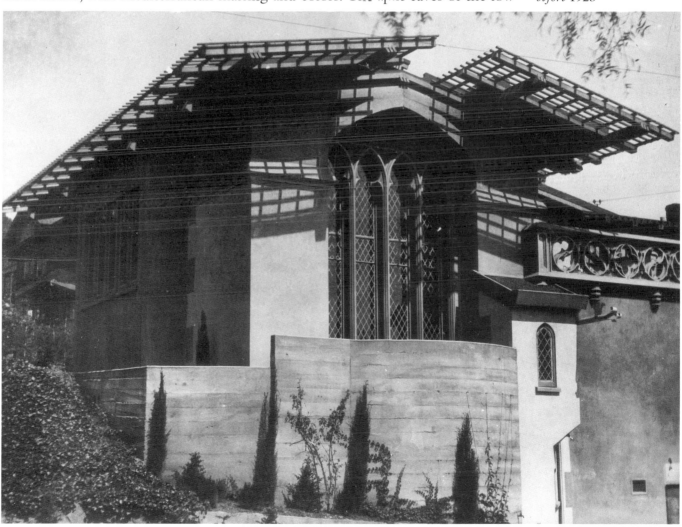

RIGHT

🔲 154. *South side of the Kennedy studio*

FAR RIGHT

🔲 155. *Detail of balcony tracery, screened by a Leptospernum tree, Kennedy studio*

BELOW, LEFT

🔲 156. *West side of the Kennedy studio*

BELOW, RIGHT

🔲 157. *Detail of cast-concrete quatrefoil in wall, Kennedy studio*

OPPOSITE, LEFT

🔲 158. *West wall of recital hall, Kennedy studio*

OPPOSITE, TOP RIGHT

🔲 159. *East wall of recital hall, Kennedy studio*

OPPOSITE, BOTTOM RIGHT

🔲 160. *North side of recital hall, showing built-in storage space, Kennedy studio*

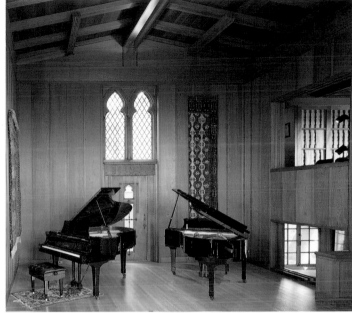

pitched gable roof let light into the recital hall on the west and into the upper-floor living quarters on the south. When the eaves were trellised, the light would have dappled the walls, adding variation to their tone. Maybeck achieved a similarly atmospheric effect in the Joralemon house, built just before the 1923 fire, by spattering walls with different colors, using the Impressionists' pointillist technique.

The dual entrance to the Kennedy studio—one entrance for the living quarters and one for the recital hall (plate 156)—shows that the sloping site could be used to advantage. Maybeck created a ceremonial spatial sequence that circles upward around the corner of the site and into the vestibule several steps below the level of the recital hall. The living spaces are clearly subordinate to the more important recital hall (plates 158–60). Although this two-story room has a different purpose from the living rooms in the houses previously discussed, its form remains much the same. The major difference is that there is no monumental fireplace to distract attention from the main east-west axis. Instead, the wall opposite the entrance to the room is lined with storage and high windows with diamond panes. As in the Rooses' living room, the Kennedy hall has a redwood lining that glows as the light of the afternoon sun floods into the space. Afternoon was probably a favorite time for recitals, but the evening, when light spilled gently over the edge of the metal trough along the ceiling ridge and from other invisible sources, would have been as warmly welcoming. Overflow crowds were accommodated with seating in the balcony on the south side of the hall and on the lower reception level.

A photograph of the Kennedy studio as it was before the fire was used to illustrate "The Maybeck One-Room House," an article by Mira Abbott Maclay in the July 1923 issue of *Early Sunset* magazine. Her discussion goes beyond the Kennedy studio to present a generic Maybeck family house as an antidote to the complexity of modern life. Maclay wrote that the plan "is a scheme to incorporate the house and garden into one home entity, concentrating the expense of the house . . . upon one large, beautiful living-room, supplemented by several utility rooms, so small and insignificant as far as space goes that they do not justify the name of room. They are merely alcoves or additions. Dressing-rooms, bath and kitchen come under this head." As to the style of the house, Maclay noted that Maybeck favored expressing the owner's preference. "Any material—wood, concrete, plaster, brick—may be used. . . . Almost any period or type of architecture may be bent to its requirements." The large room could be any size or shape and furnished in any style, "Period-Colonial, Mission, Louis the somesteenth or other, Italian—it does not matter." Concentrating on furniture for the main room meant fewer pieces, perhaps, but of higher quality.

The article goes on to discuss the usefulness of having a mezzanine with spaces for children's beds and for study and work areas where the typewriter and sewing machine can be kept. The kitchen is described in detail, including features from the Maybecks' own house, such as the provision of an outdoor sink so that

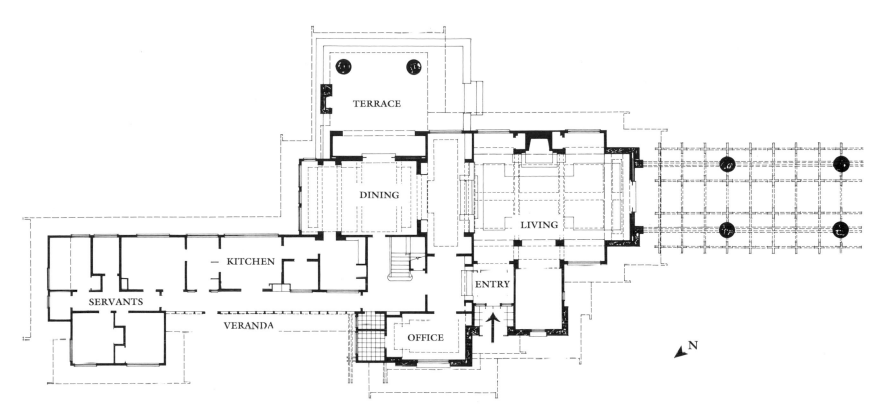

the housewife might spend "health-building hours" outside washing and peeling vegetables. Maybeck advocated putting the dining table on rollers so that it could be "rolled to the entrance of the kitchen alcove for setting, then either rolled out of doors, through the French door by the sink, for out-door dining when the weather is fine, or be pushed back into the living-room for that cosiest of meals by the fireplace." He recommended incorporating many doors to the garden to bring fragrance and vitality into the house and to weave the house and garden into a cohesive unit. Finally, a hedge planted around the house and garden would provide privacy.

This text presents Maybeck's belief that the best things in life, though not exactly free, were available to those who used their imaginations and enriched their lives by doing simple, practical, yet pleasurable things—such as putting their dining table on rollers. Living well did not require large sums of money, but Maybeck was always willing to work with as much zeal on the mansions of the wealthy as he devoted to the modest one-room house. Two commissions that called for great living rooms and outdoor spaces to match illustrate his ability to reinvent the elements of stylish living on a grand scale. One was for Arthur E. Bingham in Montecito, 1916 (plate 162); the other was for Earle C. Anthony in Los Angeles, 1924–30 (see chapter 6).

The Bingham house offers more proof, if any were needed, that the site of a Maybeck house determined its form. Maybeck had almost no large, flat sites on which to build; in fact, the Binghams' fifteen and a half acres in Montecito (a millionaire's suburb near Santa Barbara) gave him his first opportunity to design a

■ 161. *Main-floor plan, Arthur E. Bingham house, Montecito, 1916*

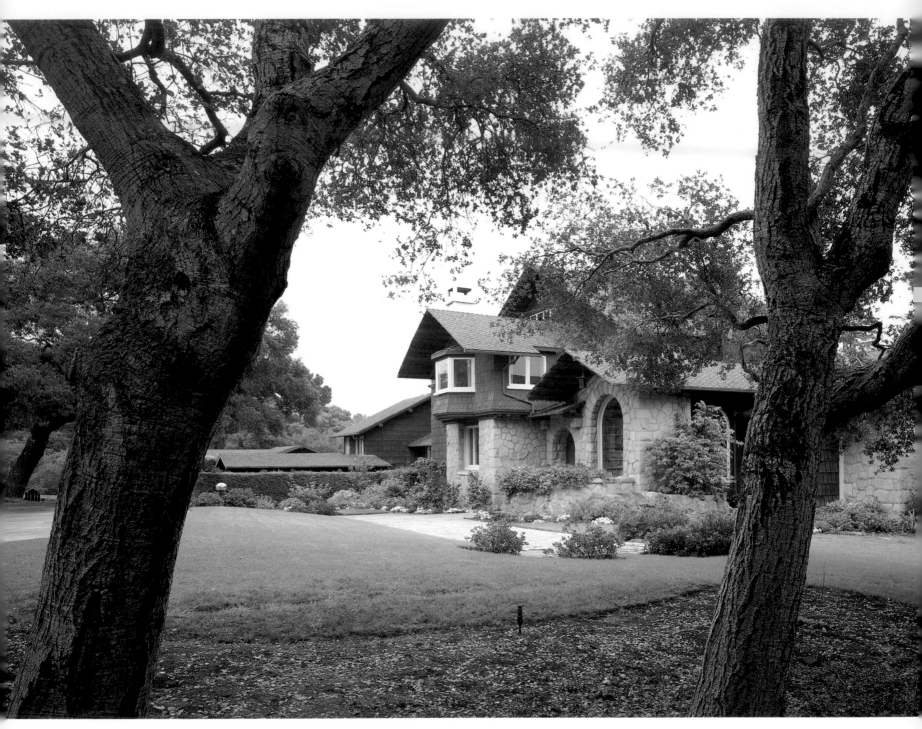

162. *Bingham house*

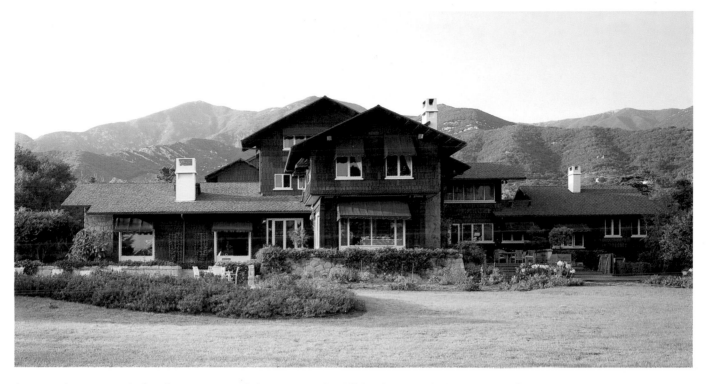

house that occupied a large part of the site and still had enough level land for orchards and large gardens. When originally built, the Bingham house stretched more than 136 feet in an east-west direction across a landscape sprinkled with oaks; it included a pergola (plate 164) more than half the length of the main part of the house. The dimensions of the pergola and the scale of its short, thick stone columns and its rhythmic wooden superstructure make the house seem even longer, as though it were curving with the earth's surface. The central part of the house rises in a series of cross-gabled forms that echo the distant Santa Inez Mountains (plate 163). The roof is punctuated by the strong geometry of the venturi chimneys, which are a Maybeck signature and virtually the only form he never altered.

The off-center entrance inside a low stone arch is understated, as Maybeck's entrances often are; the most imposing arch belongs to the alcove adjacent to the entry but opening from the living room, which was designed for the Binghams' pipe organ. The use of rough stone laid in irregular courses for the lower part of this front section of the house calls attention to its centrality. On the southeastern, or garden, side of the house, the same stone is used in the base of a large terrace opening off the central hall and dining room. The sequence of spaces from the entrance through the house sets up another axis across the long main axis. Both axes end in outdoor living areas that are stops along the way to the gardens and the open landscape beyond.

The living room (plates 165, 166) was called the music room by the Binghams because it was designed for performances and housed a grand piano in addition to

163. *View showing the complementary massing of the Bingham house against the Santa Inez Mountains*

164. *View through the pergola, Bingham house*

the organ. The intersection of the hallway with the living room provides a stage from which to appreciate the grand room before descending the four steps to its level. The strong directional emphasis of the room toward the pergola is countered by multiple cross-axes set up by the opposition of the organ alcove to the massive dark-veined-white-marble fireplace and large windows on either side of the room that frame views of the landscape. Massive box beams made of laminated timbers are spaced every five feet to carry the weight of the roof. The large ceiling coffers were framed by an egg-and-dart frieze and filled with panels covered in raw silk dyed ultramarine blue. The upper part of the walls was clad with the same cloth; the lower part and the box beams were faced with lightly stained white birch. Lights recessed behind the ceiling cornice lit the ceiling.

Compared to the Rooses' great hall, the surfaces and appointments of the Binghams' living room were more conventionally luxurious and showed less of Maybeck's inventiveness with materials and details. The clients seem to have dictated much of the room's appearance, and its furnishings were of great concern to them. Maybeck's office files reveal that Bingham stipulated and carefully checked the materials for the house and that he conveyed suggestions, often from his wife, for almost everything, even for the size and placement of the attic windows. Maybeck's hand is most telling in the harmonious proportions of the music room, which are carried through the rest of the ground floor. The plan of the main part of the house is perfectly balanced between a variety of spatial volumes on different levels and interpenetrations of outside and inside spaces.

Even after they moved into the house, the Binghams continued to add to it, extending the service wing in 1918. The next year Bingham requested a sketch for a mailbox and a paper box; plans for the extensive gardens were a continuing pre-

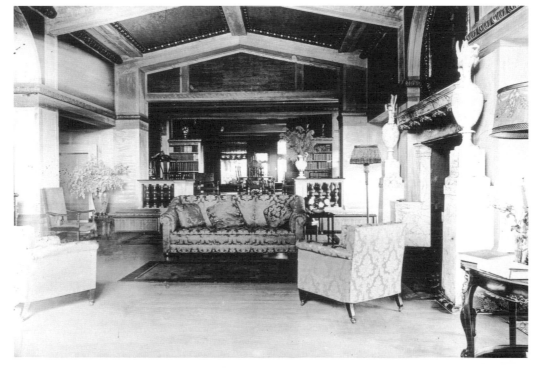

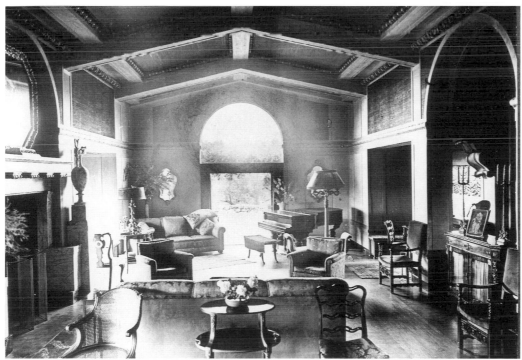

165, 166. *Two views of the Bingham house living room as it was c. 1916*

occupation. Apparently, the demands of Bingham's business obliged them to move, and they sold the house in 1925. Bingham later wrote to Maybeck, "We did dislike to leave our beautiful home in Santa Barbara—Mrs. Bingham loved it so."[5]

The Binghams' house was Maybeck's rendition of the oversize brown-shingle bungalow that the Greene brothers made famous through their work in Pasadena. As far as Maybeck's documented work is concerned, this style of house was an aberration, perhaps only because he had no commissions to design others like it. During the rest of his career he mainly designed buildings that used wood as a secondary rather than a primary material. The nationwide preference for traditional building styles from northern European and Mediterranean countries reasserted itself in the 1920s and yielded an enormous number of buildings in California using generic Mediterranean elements: tile roofs, warm-toned stuccoed walls with arched openings, and wood trellises and pergolas that defined outdoor spaces.

It was this kind of California-Mediterranean house that Maybeck designed in 1920 for a fellow Bohemian Club member, James J. Fagan, who was vice president of the Crocker Bank. The house was in the rural-suburban community of Woodside, the location of the 1907 Josselyn house (plate 95), and the office files call it "a pavilion for a summer camp at Woodside Oaks." The description suggests something rustic and provisional, but this was more a villa than a camp. The

BELOW

■ 167. *Plan of the James J. Fagan house, Woodside, 1920*

OPPOSITE

■ 168. *Fagan house, view from the southwest toward the two-story living room*

main pavilion was a high gable-roofed living room; a spacious outdoor terrace (plates 168, 169) covered by an arbor the width of the living room joined it to a flat-roofed pavilion with two guest suites that had their own terraces. For sleeping under the moon and stars, two fold-out beds were built into one side of the main terrace. It functioned as an outdoor room that spread out into the landscape in two hemispherical sections, which softened the geometry of the main pavilion. The ensemble of buildings and terraces conveyed the impression that a single building had been taken apart and recomposed in a counterpoint of solids and voids to incorporate the landscaping, which was planned by John McLaren. Vintage photographs, taken for publication, show rather formally attired people enjoying this hedonistic setting. Tunics and chitons would have been more appropriate. Sadly, the great trellises over the terraces are gone, and the buildings have been remodeled past recognition.

Equally picturesque, but for a different climate and terrain, is the dining hall and kitchen that Maybeck designed in 1921 for the lodge at Glen Alpine Springs (plate 170), located near Fallen Leaf Lake not far from Lake Tahoe. Glen Alpine had been a resort since early in the century, and Bay Area mountain lovers, the Maybecks among them, summered there despite the arduous journey by train, lake steamer, and portage. Maybeck designed cabins for the lodge as they were needed; in exchange, he was able to take Annie and their two children, Wallen and Kerna, there free of charge.

169. *Garden, Fagan house*

After the lodge's dining facility burned in 1920, Maybeck designed a new one, which looks like a work of nature topped off by the hand of man. Battered stone piers laid up without mortar and spaced wide apart frame windows of industrial steel sash. The floors are concrete, and the heavy timbers of the roofs are covered with corrugated iron to protect them from future fires. The oval kitchen at one end of the building is connected to the dining room by a short passageway. This hyphenated composition stretches across a flat piece of rocky soil. The sequence of forms suggests an alpine church with its nave and apse pulled apart—not to let in the landscape, as in the Fagan house, but to mimic the mountainous forms around it. However, Maybeck took care not to have the building perceived as a church by placing the high part of the nave in the middle rather than at the end, as would have been appropriate for a church. Although another designer might have seen the practicality of using corrugated iron, steel sash, concrete, and stone for this modest building, it was Maybeck's poetic vision that, once more, made the combination of materials so powerful.

170. *Dining hall and kitchen of the Glen Alpine Springs resort, near Fallen Leaf Lake, 1921*

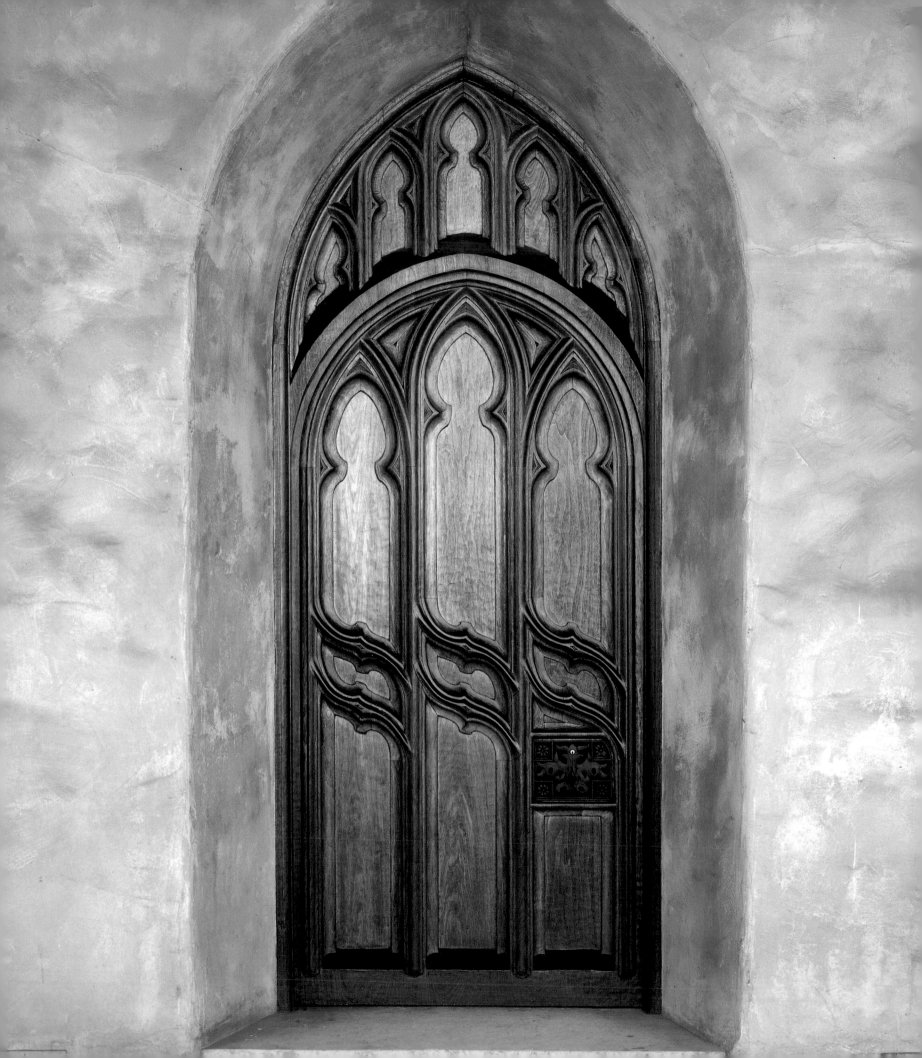

6

PROJECTS FOR
EARLE C. ANTHONY

T wo rich and powerful clients, Phoebe Apperson Hearst and Earle C. Anthony, bracketed Maybeck's career. For both of them he built fairy-tale mansions: the first, a stony Teutonic castle on a river in a northern forest; the second, a medieval Mediterranean manor on a Los Angeles hilltop. Maybeck's work for Anthony, which also included elaborate automobile showrooms, began in 1923 and lasted through the decade. Unlike Mrs. Hearst, who left Maybeck alone to carry out her interests, Anthony took an active role in the design process. Ideas inspired by what he saw and purchased on his frequent trips throughout the United States and in Europe prompted revisions that continued well into the construction phase of his house.

The work during this phase of Maybeck's career reflected a change in his practice. With the receipt of large-scale commissions in the early 1920s from Anthony, Principia College, and William Randolph Hearst, Maybeck had to choose either to enlarge his office staff considerably and assume greater business responsibilities or to reduce his involvement in this aspect of the practice by associating with other architects who would do the working drawings and specifications and manage the construction process. Given his artistic temperament, the latter course was a logical choice; it enabled him to be the maestro orchestrating the special effects that increasingly captivated him. Contracts for Maybeck's contribution from this time on refer to it as "art work," a term that he never defined but that clearly meant the aesthetic aspects of the design.

Anthony and Maybeck may have met at the Bohemian Club, but if not, they certainly saw each other there and would have shared an interest in the theatricals staged by the club. Anthony built his fortune in the glamorous world of automobiles, starting a Packard dealership in California in 1904 (he is said to have opened the first gas station there), which continued until 1956. He also owned two radio stations in Los Angeles and became familiar with the Hollywood film

171. *Earle C. Anthony house, Los Angeles, 1924–30, entrance to tower room*

world. Eighteen years younger than Maybeck, Anthony was in his early forties when he acquired about fifteen acres on a hilltop in Los Feliz Park in Los Angeles, apparently as a speculative real-estate venture as well as a site for his own house. Correspondence from October 30, 1923, relates that Maybeck had visited the property and given Anthony his advice about an access road and appropriate landscaping. "After many pros and cons," the letter states, "Mr. A decided to have sketches made, using the old reservoir as a sunken garden with a living room to the east, dining room west, studio north, and bedrooms south."[1] This general disposition of the rooms in what would be the Anthony house remained constant throughout the four-plus years of the design process. Everything else was subject to change.

A letter of May 4, 1927, in the office files reviews the history of the Anthony residence, beginning with sketches for a frame house made in the fall of 1923. The sketches became plans; then a complete set of twenty-four working drawings and specifications was prepared in spring 1924. Bids were obtained from four different contractors, ranging from $75,228 to $90,500. When additional work not included in the bid was figured in, the estimated cost rose to $126,326. Subsequent enlargements and revisions that also changed the basic material from wood to concrete raised the cost still higher, so that by October 12, 1926, it had reached $232,687. These figures did not include estimates for the costs of the garden-wall balustrade, steps, and the pool, which in February 1927 came to a total of $14,550. The final plans are dated November 1928 and updated to December 31; the final cost was about $500,000. The construction period lasted through the stock-market crash of October 1929, and the finishing details continued into 1930, when the Anthonys finally moved into the house.

Before construction on the house could begin, the hilltop was sculpted into a platform for the building, and the rest of the site was reconfigured for the terraced gardens designed by Mark Daniels. This work, which covered eight acres, began in 1923. The main east-west axis for the long dimension of the site ran from the service spaces and dining hall, across the pool terrace, through the great hall, and out through the loggia to a broad terrace with a panoramic view to the northeast over Los Angeles. Given his contractual agreement with Anthony, it is unlikely that Maybeck participated in any responsible way in Daniels's design for the landscaping, but they undoubtedly conferred on it.

Anthony's letters to the office of Maybeck and White read as though he were his own designer. For example, a single-spaced, three-page typed letter dated October 2, 1924, precisely details Anthony's concerns about the terraces and their walls from the lower road to the upper level of the driveway: "I am quite anxious to get the lower wall in as soon as possible, as we will gain all this fall and winter growth of the trees. I figure that [the outside face of] this wall should be 2 ft. inside of the stage line, which brings it 3 ft. inside the gutter line. . . . That will permit a 3 ft. space for planting a high hedge up to the face of the wall. I then

figure we should put occasional flower pots on top of the wall, and put trailing vines out of these flower pots to drop down over the face of it."

The letter continues with more dimensions for various terraces and the placement of trees; half of it is devoted to the character of the walls. Anthony wrote that he was sending Maybeck a sketch of a French wall that he made from a photograph—he was an avid collector of photographs that illustrated his desires—and wanted from Maybeck a design for the top, the return, and the bottom of the wall. "If this wall is made of cement, it can be left roughened, and then we can either squirt it with cement afterwards, to give a cement finish, which I personally don't like very much, or we can face it with rocks, if we ever get the [right] price to do it." Anthony's observations reveal an appetite for detail that seemed never to be fully satisfied. He favored the walls he saw in France because they had moldings top and bottom that caught the light and did not end abruptly in plain edges, which he found crude. Anthony always wanted stone for the walls but usually had to settle for concrete with a cement finish because it was so much less expensive. He fretted constantly over the design of the garden balustrade and other details of the terraces.

The correspondence conveys an image of Anthony forever stepping into or out of one of his fleet of seven Packards, with sketches and photographs in hand, and issuing rapid-fire directions about doing this or undoing that. Still, he would occasionally have second thoughts about his role. In a letter dated August 10, 1926, and addressed to "My dear Mr. Maybeck," he stated:

> In working out the plans for my house, I have a feeling that a great many of the completion details are being held up for my decision, because of your desire to give me just what I want.
>
> The main detail of the rooms and general plan has been settled of course. I think we will get along better if matters such as floor materials, widths of marble, entrance halls, or such things are left to your decision and that you do these things just exactly the way you would if I were in Europe. I think you have held back a little bit in your desire to put my personality into the house and I feel now that the plans have been worked over and made to suit Mrs. Anthony and me, that you as Architect should finish up the details, putting your personality and ideals into them just as if you were designing it yourself.

Unfortunately, we do not have Maybeck's reply, but subsequent correspondence leaves no doubt that Anthony continued to direct everything as if he were designing it himself. A particularly telling letter was sent by Anthony to Addison Mizner in Florida on December 2, 1926. Anthony had greatly admired the design of the main dining room in Mizner's Everglades Club in Palm Beach. He asked Mizner to send him recipes for the mottled plaster and its antique

finish, samples of the Spanish roof tile, some boards of the pecky cypress used in the ceiling, and some of the local sand so that he could have some samples of plaster made from it. Mizner sent back a telegram stating coolly that Anthony must realize that it had taken him years to perfect his techniques and that he saw no advantage in sending them out into the world. Undeterred, Anthony got pictures of the room and directed Maybeck's office to get the samples. Pecky cypress, a swamp wood riddled with holes that made it seem centuries old, was shipped from Florida and used for the ceilings, balconies, and beam ends that protruded from the medievalized towers of Anthony's house.

Before construction began on the house in 1929, two smaller buildings—one for temporary living quarters that later became a guest house and the other a studio with a movie theater—were built in 1925 and 1927, respectively. Their design seems not to have been of much concern to Anthony, who was preoccupied with building his Packard showroom in San Francisco, completed in 1926, and his Oakland Packard showroom of 1928—both designed by Maybeck in association with John H. Powers and John H. Ahnden. In addition, Maybeck designed interiors for Anthony's Packard showroom and offices in Los Angeles, also built in 1928, for which John and Donald B. Parkinson were the architects. For all of these commissions the office of Maybeck and White prepared preliminary structural, mechanical, and electrical drawings according to Maybeck's schematics, which he then approved and turned over to the associated architects to complete. Maybeck then did the "art work," for which he billed Anthony separately.

Each of the Packard buildings had a glamorous showroom in front where the cars were displayed and a practical backstage where they were stored and serviced. In San Francisco (the only one that survives), the showroom was a single space with a high ceiling backed up with four floors of utilitarian character, which were largely encased in glass for maximum daylight (plate 176). Anthony's clever use of

OPPOSITE, TOP

172. *Section drawing through the length of the Anthony house. Documents Collection, College of Environmental Design, University of California, Berkeley*

OPPOSITE, BOTTOM

173. *Colored-chalk drawing by Maybeck of the Anthony house. Documents Collection, College of Environmental Design, University of California, Berkeley*

BELOW

174. *Exterior of the San Francisco Packard showroom, 1926, charcoal-and-colored-chalk drawing by Maybeck. Documents Collection, College of Environmental Design, University of California, Berkeley*

OPPOSITE

▓ 175. *Colored-chalk drawing of a capital for the interior of the San Francisco Packard showroom. Documents Collection, College of Environmental Design, University of California, Berkeley*

BELOW

▓ 176. *San Francisco Packard showroom from Van Ness Avenue*

show-business tactics to market his cars was evident in the opening-night gala, attended by movie stars and broadcast by means of the two radio towers on the Packard building. Special lighting effects mimicking the atmospherics of a movie palace continued every night: a motor-driven switchboard controlled colored lights that were programmed to follow the course of the day from dawn to moon-light in twenty minutes.

To honor the building Anthony published a slim booklet titled *A Saga of Transportation* in April 1927. A drawing of a figure on a flying carpet gliding past one of the showroom columns graces the gold cover. The text, some of which is signed by Anthony and some not, reveals the hold that the "aristocrat of motordom" (by which Anthony meant the Packard, not himself) had on the public imagination: "The history of the mental and physical growth of the nations of the earth is, in the final analysis," he wrote, "a Saga of Transportation." In praise of Maybeck's design, he continued:

> Maybeck has vitalized with his own dynamic personality the exotic influences which drift in through the Golden Gate from the Seven Seas. . . . Discarding the shackles of architectural convention [he used] rose marble from Numidia and black from Belgium, travertine in tawny foam and glittering scaggiola—lanterns from a Persian Hareem—Spanish doorways and Gothic doorways—columns crowned with Corinthian acanthus supporting Byzantine corbels [to create] an Aladdin's palace in which the gorgeous panoply of the Arabian Nights vies with the luxury of the Middle Ages.

Maybeck's instructions to the craftsmen, who are all named, are also recorded: "Imagine that no cars roar by on Van Ness Avenue [the street in front of the building] and that no telephone will call you from your work. Believe yourselves, instead, working in the gloom of a cathedral of the Middle Ages, your overseer a monk or an artisan who loves, as you do, the work in hand."

The Oakland Packard building (plates 177,178) was a different kind of tour de force, more suggestive of the Arabian Nights than the classical San Francisco showroom but ultimately untied from any historical precedent. Maybeck mottled the walls with passages of rose, brown, and other tones that made them look stained and aged. He achieved this effect by using Gunite, a mechanical process in which cement, pigments, and water were mixed as they were shot from spray-guns at a wall. This airbrush technique allowed Maybeck to indulge in a kind of mural painting that satisfied his deep desire to suggest the effects of time and nature in his buildings. During the painting process he positioned himself on an island in Lake Merritt across from the building's shoreline site and, using a field telephone, he directed the crew of spray-gun operators. The building and its reflection in the water formed a coherent composition. Maybeck reiterated his concerns about time's effects on his buildings many times, but never more point-

177, 178. *Oakland Packard salesroom, 1928. Two of many colored-chalk drawings that Maybeck made of possible designs for the exterior. Both convey the general character of the final design, but neither is an accurate rendering. Documents Collection, College of Environmental Design, University of California, Berkeley*

edly than in the following statement about the two Packard buildings: "The frieze on the San Francisco Packard [building] should be multicolored like the paintings of Raphael in the Vatican. It was made to be treated that way [and] it must never be allowed to look faded. Oakland can look old—San Francisco must look snappy."

On December 2, 1928, a contract between Anthony and the contractor Donald F. Harrison was signed for the construction of Anthony's residence and garage. The owner reserved the right to alter plans and specifications "any way, any time, as many times as the owner may desire even though such changes may require tearing out work." The contractor had to absorb the costs of the changes, and a strict accounting procedure was outlined. Although Maybeck had intended to spend a great deal of time on site, a life-threatening infection following prostate surgery confined him to the Glendale Sanitarium for much of that winter and the following spring. Judging by correspondence and family accounts, February of 1929 seems to have been the critical month. Annie came to stay near him, and after he was permanently released from the sanitarium in May, they lived

179. *Main elevation, Anthony house*

in the Anthony guesthouse. Although Annie tried to restrain him while he recuperated, Ben appears to have spent considerable time on a cot set up in the courtyard, overseeing the art work, particularly the polychrome plastering of the walls by the Gunite process.

While Maybeck was in the sanitarium, construction proceeded. A long letter dated February 14, 1929, and signed "Mark" (probably the staff architect Mark Manning) to Charles Lundgren in the Maybeck and White office in San Francisco, exemplifies the trials the office staff faced in trying to accommodate their frenetic client:

> Mr. A. came in yesterday. First thing he spotted ht. of L.R. [living room] loggia above terrace where forms [for concrete] are in on loggia and east L.R. wall to floor level ready to pour. Said loggia floor would have to be lowered. Suggested a step outside single east L.R. door, then he didn't think that so good. Wanted me to suggest a solution. Today he looked at a ¼" section at that point and saw finished grade at about 18" above lawn—wanted to know how could he raise his garden level. . . . impossible to raise it.
>
> Didn't like study fireplace . . . had a picture of a mantel he wanted to use there, etc. Didn't like L.R. fireplace, said it had been changed from the old scheme . . . said the present one was a jazzy type and not like the former classical type. Then I think he said it was too big.
>
> Said the pool was too big, but don't think he will change it now since all packing is in and outer wall has been in 2 weeks and they are filling in soil around pool.
>
> Looked at ent. [entrance] tower section and said he thought maybe it was too high. Said the balcony door in ent. tower shouldn't come over passage door where it was before, wanted to hang tapestry on balcony rail and it could n't hang down over front door etc.
>
> Said L.R. was too big and high. Was it raised after model was made and was it raised to accommodate a tapestry or something? The upshot was that he told H[arrison] to build a skeleton of L.R. so that he could see what it looked like so all carpenters stopped and went to building this skeleton. They have 2 posts up to the plate line and it sure does look high and the rest of the roof will raise it some more while chimney goes up 14' more above the plate. It's a corker.

The rest of the six-page letter is devoted to similar problems and to a discussion of how Harrison could stick to the schedule when Anthony was constantly changing things, wanted quick sketches to look at, and, in general, was a man "who must see things moving fast."

The completed building (plate 179) shows none of the strains of its planning and construction. Topping the hill like a natural outcropping of the site, it gives

the impression of a Mediterranean hill town composed of domestic buildings attached to the ruins of a medieval castle. A huge round tower is set into the corner of what appears to be a surviving piece of the castle facade. The impression of entering a walled castle is reinforced by a metal portcullis suspended inside the arch in front of the deeply recessed entry (plate 180). Since the wall rises only a few feet above the arch, it is clear that the portcullis is a stage prop and could not descend to close off the entrance. To the right is a mighty wooden door of Gothic persuasion carved with Maybeck's favorite tracery forms (plate 171). Opposite this door is a grated window, from which, presumably, the keeper of the castle could scrutinize those who entered. Inside, the forty-eight-foot-tall tower room dwarfs those who enter. As reported in the letter, Anthony thought it was too high, but it may have been too late to change it. In any case, the height seems exaggerated and makes those entering the space feel like suppliants.

From the tower room—which, in spite of Anthony's concerns, does have a balcony above the entrance door—a flight of steps winds up to the great hall. Its beamed ceiling of pecky cypress is stenciled in uneven tones so that it seems to have faded over the course of time. The walls are faced with Caen stone shipped from France. Through the high arched windows on either side of the hall is visible the trace of the long axis from the dining hall on the opposite side of the court to the end of the terrace. The loggia attached to the northeastern side of the hall is indeed high, but it seems commensurate with the view. From the street below, tantalizing partial views of the loggia and hall roofs are visible through the trees; the terrace is indicated by its balustrade. The long southern elevation is the front stage, or public side, of the complex. The northern side of the hilltop falls away steeply. Since the relatively plain base of the building comes nearly to the hill's edge, leaving room at the back only for service pathways, this elevation reinforces the idea of a stage/backstage concept for the overall composition.

The open court with its keyhole-shaped pool serves as center stage (plate 181). There are any number of possible entrances and exits on different levels from spiraling stairways, raised terraces, doors placed at oblique angles to the space, and balconies. No straight path crosses the space; the vistas across the pool do not intersect at right angles. Even the pool is slightly skewed. This distortion may have resulted inadvertently from the addition of an organ loft to the great hall, but it seems intended. The painterly effects that Maybeck achieved through the use of Gunite combine with the dapple of sun and shadow to bewitch the eye

Since no correspondence exists to verify the Anthonys' satisfaction with the house, one can only assume that, when they were not traveling, they lived there contentedly until Anthony's death in 1961. In 1964 Daniel and Bernardine Donohue purchased the property, which they named the Villa Giuseppe. More given to entertaining than to travel, the Donohues found the house suited to their needs, but they commissioned Lutah Maria Riggs, a Santa Barbara architect who had designed several gardens, to relandscape the site. Under her direction most of Mark Daniels's gardens were replaced with more formal arrangements

180. *Main entrance, Anthony house*

based on fifteenth- and sixteenth-century Italian gardens. A new street wall and entrance were built, and a new driveway was constructed to ascend the slope. At the angle of the dramatic hairpin turn, the drive now extends into a plaza with a terrace and a belvedere that juts out farther than the main terrace off the loggia above. A *tempietto* purchased by the Donohues in Europe occupies the belvedere. The main terrace was paved in a mosaic shell pattern; a tiered marble fountain marks its end (plate 184). Although Riggs's landscaping is quite in tune with the mixed Mediterranean character of the building and changes the hilltop site into a more Italianesque architectural composition, as the clients wished, old photographs reveal that Daniels's landscaping, which used a greater variety of plant forms, had matured to embrace the structure, masking out parts of the walls so that the building appeared to be embedded in a lushly verdant site rather than raised up on a formal pedestal.

OPPOSITE

▦ 181. *Courtyard and swimming pool, Anthony house*

ABOVE

▦ 182. *Lower terrace, Anthony house*

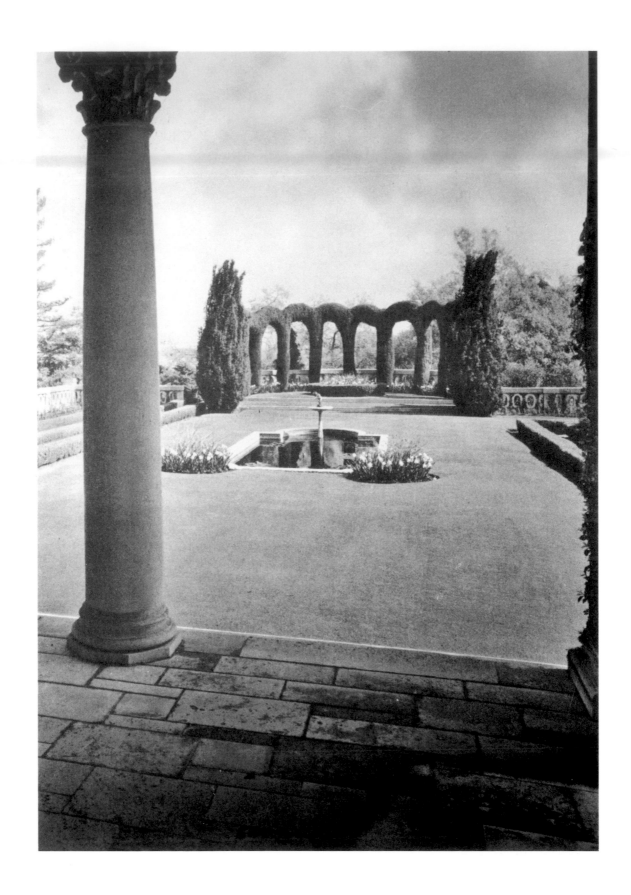

Despite the size and importance of Anthony's commissions—Maybeck designed two other houses for his property in Los Feliz Park, in 1925 and 1927, that were sold, as well as the Los Angeles Packard showroom and office interiors in 1928—they spawned no other work for him in Los Angeles. If the Great Depression and World War II had not occupied the decade and a half following the completion of Anthony's house, things might have been different. As it was, the Maybecks packed up and returned to the Bay Area, where they settled back into family life in La Loma Park, which had been drastically changed by the destruction of their house in the Berkeley fire of 1923.

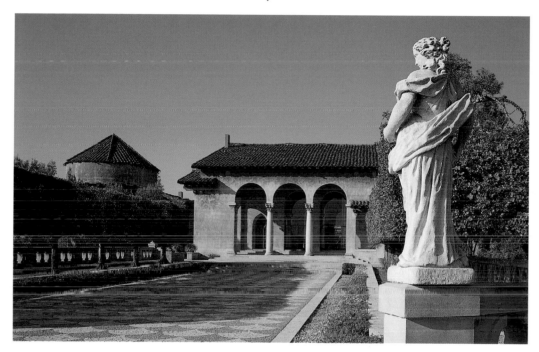

OPPOSITE

⊞ 183. *Original landscaping by Maybeck and Mark Daniels for the Anthony house. Photograph from an undated real-estate brochure in the collection of Kenneth H. Cardwell*

LEFT

⊞ 184. *Main terrace, Anthony house, as redesigned by Lutah Maria Riggs*

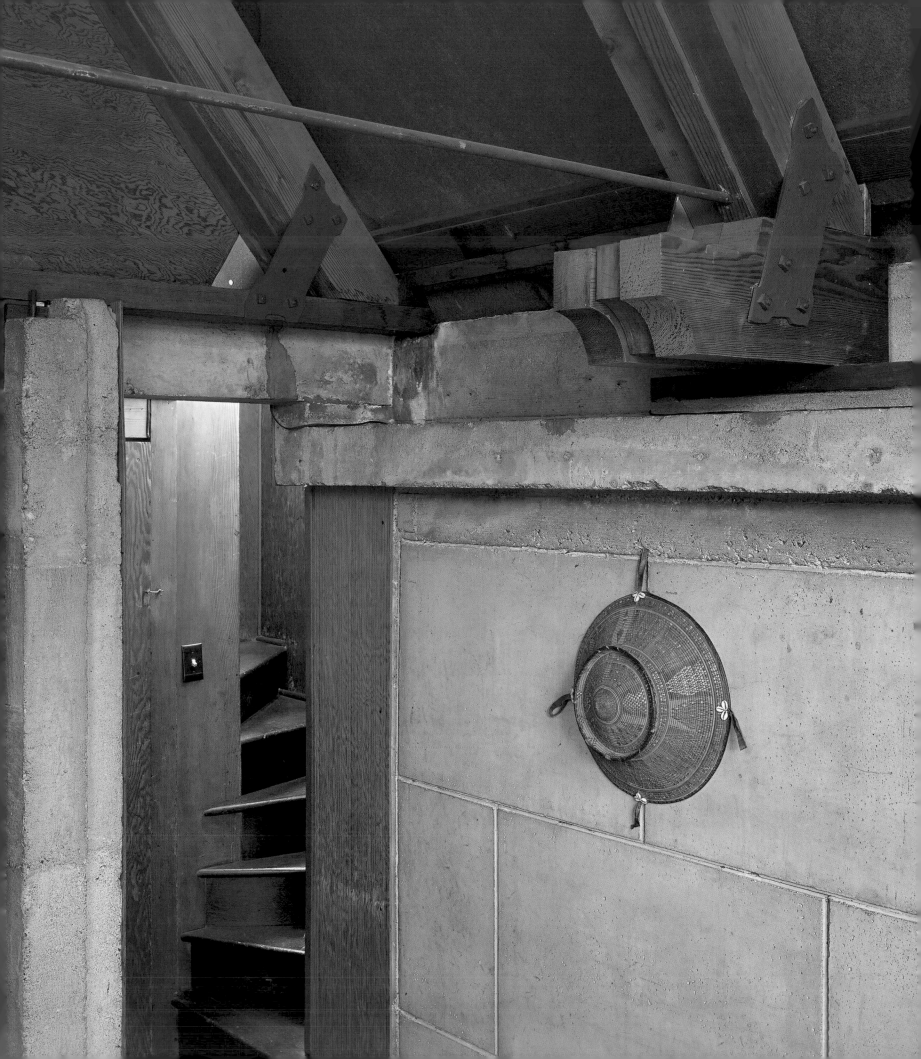

7

AFTER THE FIRE

On the hot, dry afternoon of September 17, 1923, strong winds carried burning embers, probably from a brush fire, over the northern hills of Berkeley. They rapidly ignited the highly flammable wooden houses of the northside area, most of them in Daley's Scenic Park. When the fire was finally extinguished, over five hundred buildings had burned, including the Maybecks' house on Buena Vista Way. Maybeck was already thoroughly familiar with the calamitous effects of fire, which had destroyed the Maybeck and White office and records in 1906. Although other fires had provided him with opportunities—the 1920 fire at Glen Alpine Springs had given him the chance to design an innovative communal building—this one seems to have discouraged Maybeck from even designing a new house for himself. He and his family moved in with Annie's mother in cramped quarters in another part of Berkeley. Instead of building a fine new house of their own, the Maybecks gradually began a somewhat nomadic existence, which ultimately involved the construction of four houses on their La Loma property between 1924 and about 1938.

Two of these experimented in the use of a material called Bubblestone,[1] a cellular concrete patented in about 1923 by John A. Rice, a mining engineer and geologist who had retired to Berkeley. He introduced it to Maybeck, who tried it out for an experimental cabin at Glen Alpine. The two men prefabricated the structure and shipped it up to the mountains, where it performed very well through the winter. Excited by the effective insulating properties of Bubblestone and its light weight—it was only one-quarter to one-half the density of concrete—Maybeck was eager to try it out elsewhere. Little did he know that he would use it next on the burned-out site of his own house.

That Bubblestone building, called the Studio by the family but popularly known as the Sack House, evolved slowly during the year after the fire (plates 186–87, 189–90). The Maybecks' twenty-three-year-old son, Wallen, began the

185. *Wallen Maybeck house, no. 2, known as Hilltop, Kensington, 1937–38. View of living-room wall, with stairs to upper floor at left*

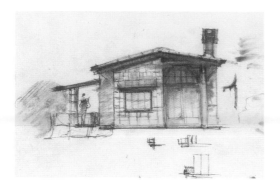

186. *Charcoal sketch for the east elevation of the Studio/Sack House, Berkeley, c. 1924*

process by camping on the concrete slab that had been the garage floor. Soon the rest of the family decided to join him there, and Maybeck and Rice devised a procedure for making huge shingles of Bubblestone: they dipped burlap sacks into the foamy mixture that resulted when the ingredients were beaten like cake batter in a huge mixing vat. The coated sacks were draped over wires or slats nailed to the wall studs. When wet, the sacks were easy to mold; when dry, they were stiff, and openings could be cut where desired. The result was a handmade house in the best Arts and Crafts tradition (plate 190). Inside, it is a one-room house of the genre that Maclay had lauded in *Early Sunset*

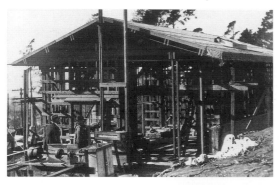

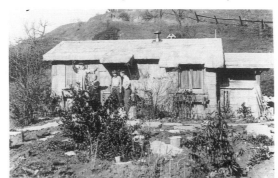

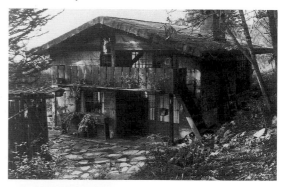

ABOVE, LEFT

187. *The Studio/ Sack House under construction, 1924*

ABOVE, CENTER

188. *Ben, Annie, Jacomena, and Wallen in front of the Cottage, 1926*

ABOVE, RIGHT

189. *The Studio/ Sack House, c. 1924. Photograph by Lionel Berryhill*

RIGHT

190. *The Studio/ Sack House. View from Buena Vista Way*

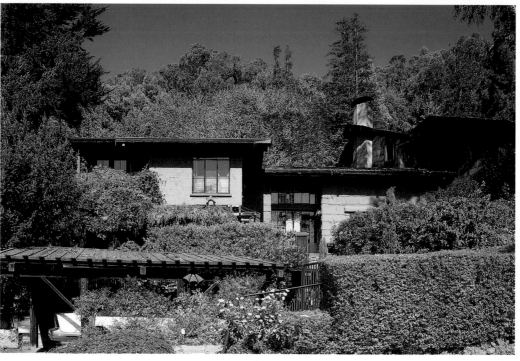

magazine. The entrance doors and other openings have metal industrial sash that runs up to the roof eaves. The wooden ceiling has a simple truss with shaped wood brackets of the kind that Maybeck had often used before (plate 191); their members were doubled so that the light catches them in lively ways. The hearth with its rough concrete mantel has rudimentary concrete seats called "hobs" extending from the base on either side (plate 192). Sleeping lofts on the east and west ends of the house were for the Maybeck children and their friends. After Ben and Annie returned to Berkeley in 1930 from their stay in the Anthonys' guest-house, they moved into another Bubblestone building, the Cottage (plate 188)—north of the Studio and similar to it—which was built about 1925; they went to the Studio for family gatherings and meals.

As the Depression deepened, Maybeck appeared to be drifting into retire-ment. But everyone needed money, and he felt responsible for his small staff as well as for the craftsmen who had long depended on him for work. According to

BELOW, LEFT

▨ 191. *The Studio/Sack house, c. 1924. Photograph by Lionel Berryhill*

BELOW, RIGHT

▨ 192. *Concrete fireplace in the Studio/Sack House, with a tapestry given to the Maybecks by Phoebe A. Hearst*

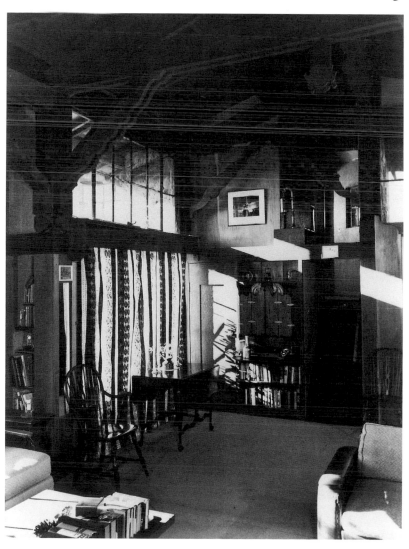

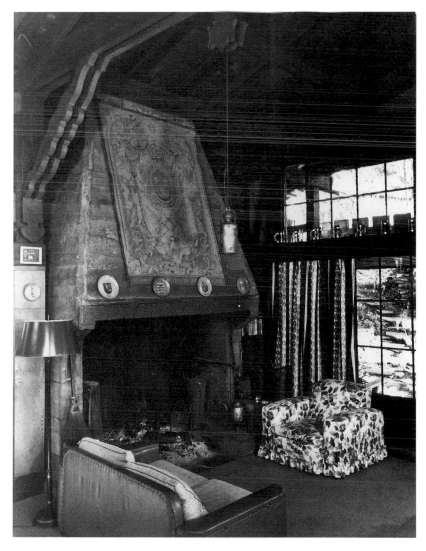

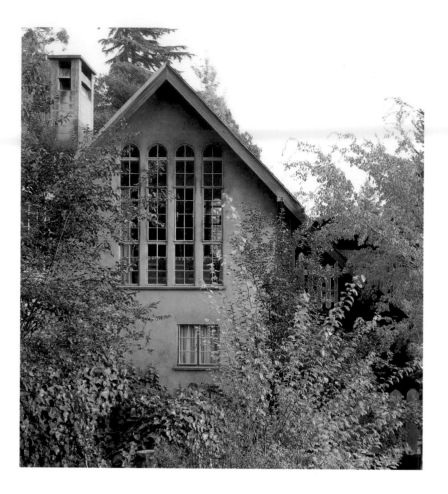

his daughter-in-law, Jacomena Maybeck, he and Annie decided to build two small houses on their La Loma Park property: one for Wallen and Jacomena (plates 193–97), the other for Ben and Annie and their daughter, Kerna (plates 198–201).[2] (Maybeck called that one "Annie's house" and said it was a proper replacement for the house destroyed in the fire.) Both were hillside houses located on Buena Vista Way, and their plans were essentially the same except that parts of them were shifted around in response to the sites. In both there was an entrance convenient to the kitchen alcove, which shared the first floor with the living and dining areas. The sleeping quarters were on the floor below. Though the houses were not large, the fine craftsmanship of the wood interiors and the elegant metal-sash casement windows and French doors made them distinctive as well as

LEFT

▣ 193. *North end of the Wallen Maybeck house, no. 1, Berkeley, 1933*

BELOW, LEFT

▣ 194. *Main-floor plan, Wallen Maybeck house, no. 1*

BELOW, RIGHT

▣ 195. *Ground-floor plan, Wallen Maybeck house, no. 1*

OPPOSITE

▣ 196. *South end of the Wallen Maybeck house, no. 1, showing Maybeck's pun on the idea of a broken pediment at the end of the balcony*

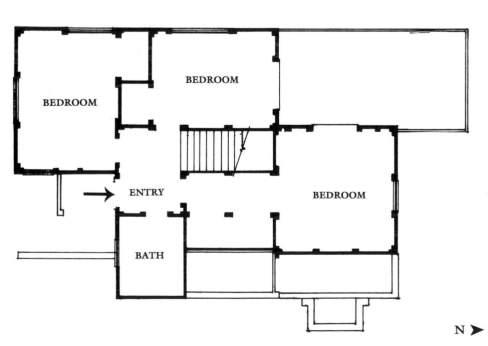

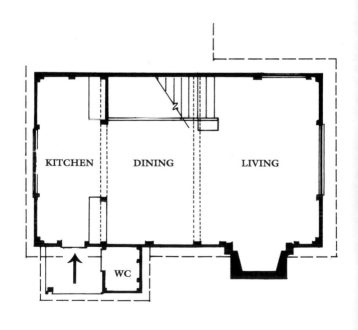

N ▶

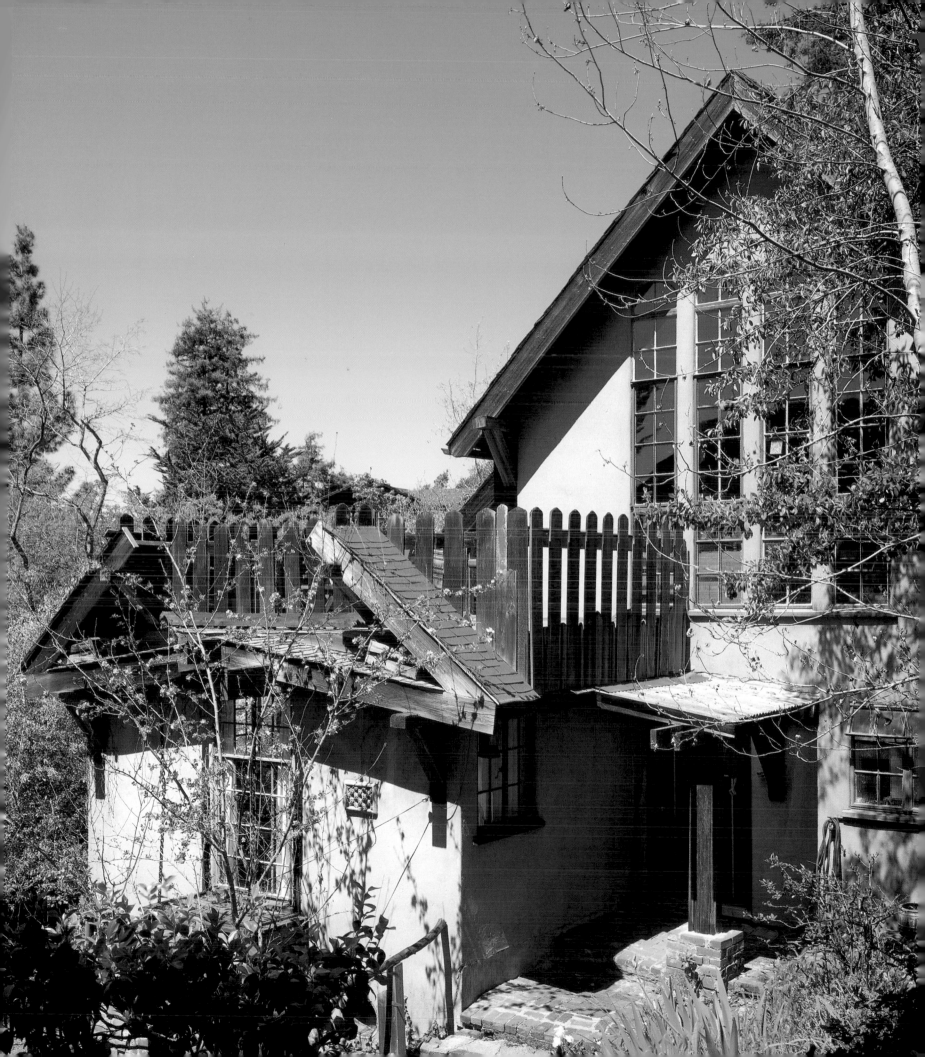

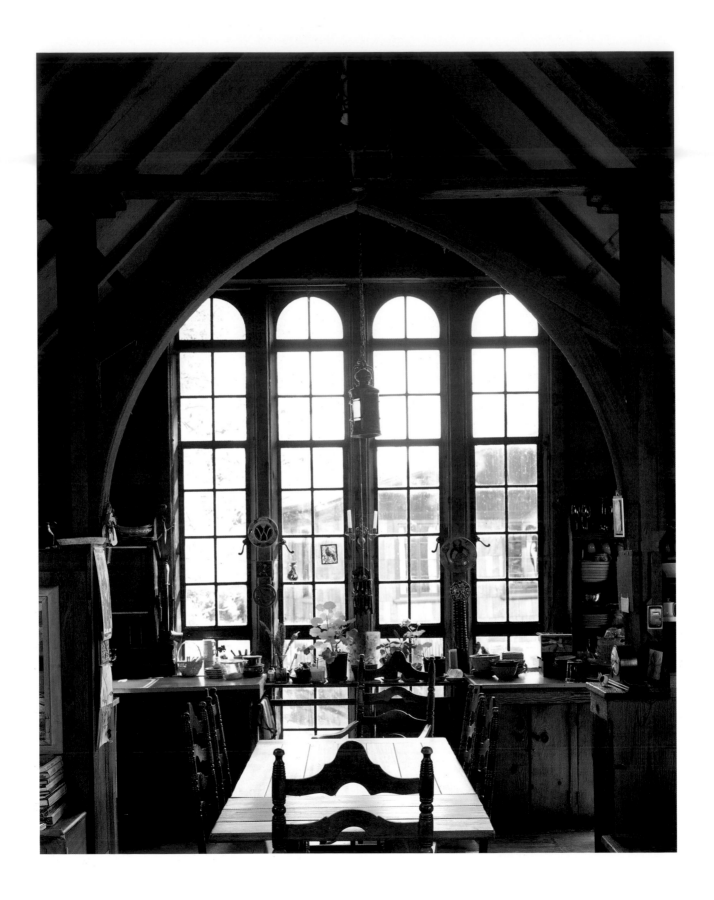

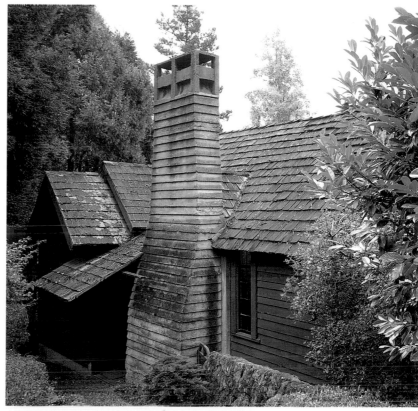

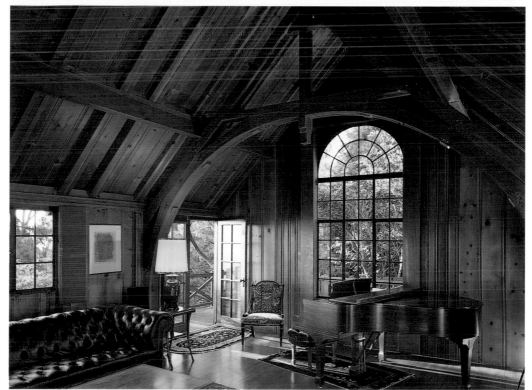

OPPOSITE

▦ 197. *Wullen Maybeck house, no. 1. View toward the kitchen, showing the ceiling truss, which was charred in a fire and then sandblasted to accentuate the grain of the wood*

ABOVE, LEFT

▦ 198. *Detail of ceiling construction with carved dragon head, Kerna Maybeck house, Berkeley, 1933*

ABOVE, RIGHT

▦ 199. *East side of Kerna Maybeck house*

LEFT

▦ 200. *View toward the north end of the living floor, Kerna Maybeck house, with French doors open to the balcony*

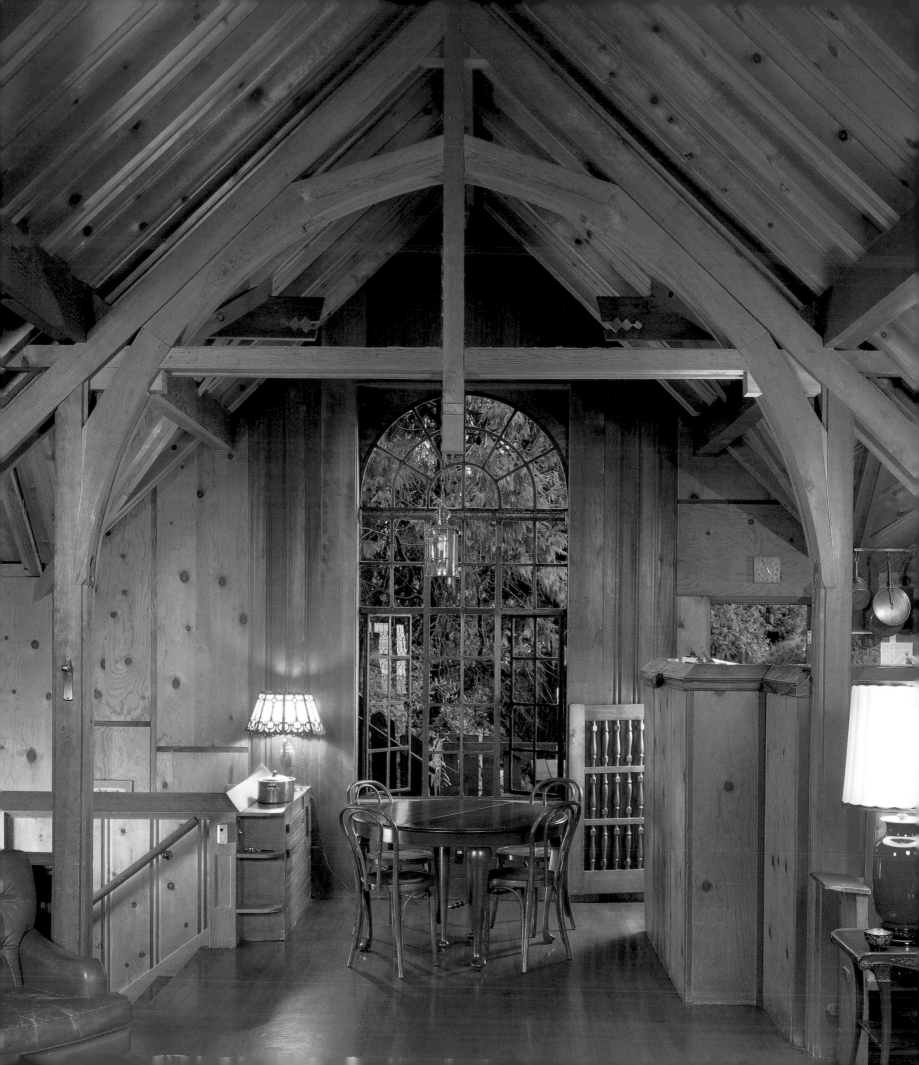

practical. The family, particularly the younger generation, continued to use the Studio/Sack House for parties.

Wallen and Jacomena spent 1936 in Marin County; they returned to Berkeley the next year to find that Ben and Annie had moved into their house in their absence because Kerna had married and the uphill house was too small for both couples. Loath to move again, Ben offered to plan another house for Wallen and Jacomena on ten acres of open land that he and Annie owned in Kensington, about three miles north of their Buena Vista Way property.

Having bought the land at a bargain price in 1908, the Maybecks had held on to it with the idea that they would eventually sell lots to young families—Annie preferred teetotalers who did not smoke—who wanted to build their own houses. Maybeck often made complimentary house drawings for prospective buyers. Though idealistic, this approach to developing the property had not proved to be particularly practical. The remote hilltop was exceptionally windy and foggy, and it took courage and imagination to see it as a homesite, even given the grand views east and west. As the first settlers, Wallen and Jacomena became guinea pigs for Maybeck's innovative ideas about appropriate construction methods for the site.

Since no fire department served the area, which became a tinderbox of dry grassland during the long summer, fire-resistant concrete walls (plate 202) and metal roofs were part of the program. Because the family with its young twin daughters had to be sheltered in short order, the plan called for two building phases. The first phase resulted in a long rectangular structure, facing east and west, that had two bedrooms, a bath, and a kitchen. A garage, perpendicular to the other structure and used for eating and sleeping, was also part of the first phase. Thus two wings of a future courtyard were made. As for the style of the house, Jacomena has recalled that Ben had them study books on English manor houses.[3] Riding the crest of the hill (plate 205), the building does evoke the image of a manor house on, say, a Scottish moor. Later residents of the area called the house "Wuthering Heights."

OPPOSITE

⊞ 201. *View toward the south end of the living floor, Kerna Maybeck house. The stairs to the main entrance are on the left.*

BELOW

⊞ 202. *West side of the Wallen Maybeck house, no. 2, Kensington, 1937*

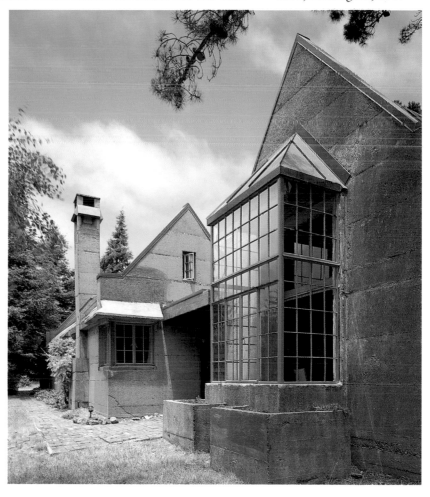

199

The family moved into the house—which they called Hilltop—on New Year's Day, 1938. Ben was seventy-six that year, but he had regularly walked the three miles from the house on Buena Vista Way to supervise the construction, and he continued this trek in the months to come. All aspects of the construction process interested him, and virtually every detail reveals his inventive way with cheap materials. The front door (plate 204) is made of six one-inch-by-six-inch redwood planks laminated to a sheet of plywood and banded by steel straps with unfinished edges cut from flat sheets. The ends of the bands are shaped like bow ties, and simple strap hinges welded to the bands support this heavy door. Folding doors, which have a hinged door in the middle, separate the living from the dining

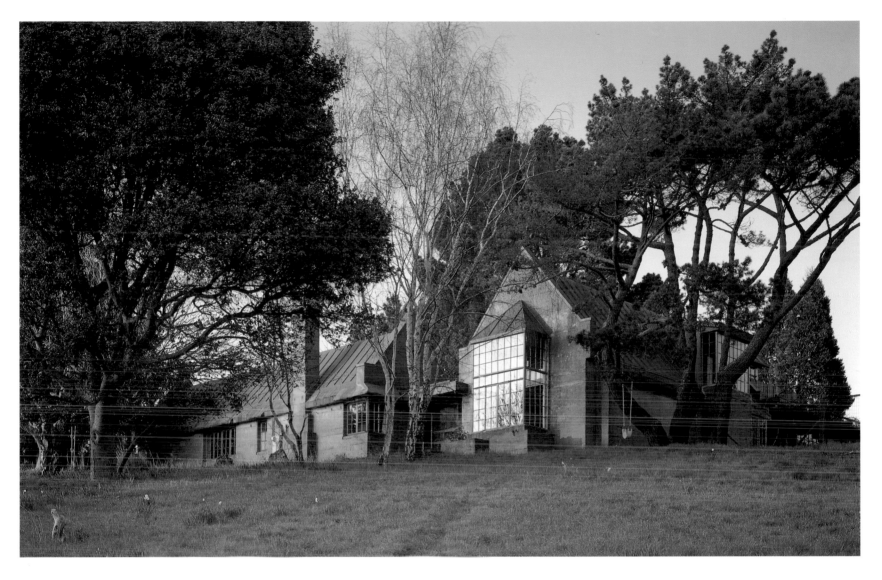

area. The concrete fireplace (plate 206) was cast with a sloping shelf at the back of the opening to trap the smoke. The walk-in hearth is set in an inglenook.

The major experiment involved casting the concrete walls (plate 207), which was done on site, with members of the family assisting.[4] A friend of Ben's named A. E. Troeil had developed a modular system for concrete construction that he called the Steel Speed-form Method. This method used two-foot-tall flanged steel panels of various widths, which could be clamped together with steel hooks that fitted into holes in the steel ties. These holes occurred at regular intervals so that the panels could be spaced in graduated widths and layers of concrete could be poured in successive operations. The walls of the west wing had two outer layers, each four inches thick, and an inner layer of Bubblestone six inches thick, which provided much-needed insulation. The steels panels were set at the desired width, and the concrete was poured inside; after it had cured, the forms were pulled

OPPOSITE, TOP

▨ 203. *Plan of Wallen Maybeck house, no. 2*

OPPOSITE, BOTTOM

▨ 204. *Front door, Wallen Maybeck house, no. 2*

ABOVE

▨ 205. *West side of Wallen Maybeck house, no. 2*

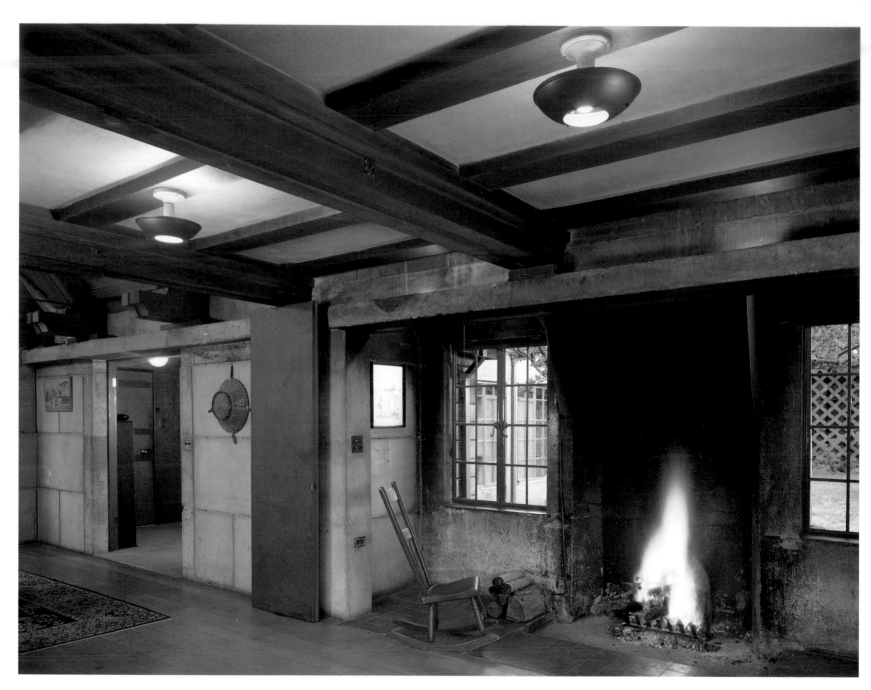

206. Fireplace inglenook, seen from the dining room, Wallen Maybeck house, no. 2

207. *South wall of living room, showing Bubblestone wall panels, Wallen Maybeck house, no. 2*

away and set for the next pour. Troeil had also developed special forms for 90-degree projections and turns, along with steel forms for doors and windows that could be set between the steel panels. When the doorway forms were removed, a steel doorstop was embedded in the concrete, and a curved molding remained impressed around the doorjamb and doorhead. When Troeil's module was not suitable, Maybeck built wooden forms.

The sequence of constructing the walls with the modular forms had to be carefully planned. The concrete footings were poured first, with reinforcing bars set into them. Then the forms were set in place to a height of nine feet, and six-inch-by-six-inch wire mesh reinforcement was put in place around the steel window forms. Conduit and switch boxes for electrical service also had to be routed within the walls. The concrete was made in batches poured a foot high at a time. The final exterior layer required that steel-and-wood forms be set up in special ways to create a triangular cap that bonded together the three layers (two of concrete, one of Bubble-

▣ 208. *West bay window with steel sash, Wallen Maybeck house, no. 2*

▣ 209, 210. *Exterior and interior of kitchen wall with glass blocks, Wallen Maybeck house, no. 2*

stone) of the wall. Steel framing designed for barns and industrial buildings was used to support the corrugated-metal sheeting of the roof. The sheeting was bolted to steel purlins (rubber washers on the exterior provided a waterproof shield), which were, in turn, bolted to the steel rafters. The ceilings were hung from steel straps bolted to the rafters and insulated with redwood bark; the doors were hung, and the steel window frames installed (plate 208). No sooner had the family moved in than they began planning the next phase.

Meanwhile, the garage had been built using another of Mr. Troeil's methods. This one consisted of a diagonal lattice of two-by-fours cut to form two eight-by-four-foot panels spaced five inches apart. Hollow metal forms were pushed through the holes in the lattice, wire reinforcing was inserted, and concrete was poured in from the

top. By the force of gravity and much tamping, the concrete found its way to the bottom of the form and gradually filled it up around the metal cross-forms. The result was an open grille that could be filled with glass block. The garage walls were left open, but the south-facing kitchen wall, which was made by this method, was filled in with glass block (plates 209, 210).

A third method was used to cast the walls of the living or studio wing (plate 211), which was phase two. The ten-inch-thick wall was cast in one operation, with the steel panels used on the exterior and the precast two-foot-by-four-foot Bubblestone panels held in place by two-by-six-foot wooden posts. Wooden forms also supported the steel molds for the overhangs. As in the west wing, reinforcing and electrical conduit were installed before the concrete was poured into the cavity between the Bubblestone panels and the steel panels. A shelf was cast at the top of the wall on the inside, and the ends of the four-by-ten-inch wooden ceiling beams were supported by wooden blocks set on the shelf. The block ends were finished with a decorative cut; metal straps were bolted to bind the blocks and the beams. Ordinarily the blocks would have been extended as chords or ties to complete the triangular truss supporting the roof. Here, however, the heavy wooden chords were replaced by three-quarter-inch steel tie-rods with vertical members, painted red, connected to the ridge (plate 212). The use of metal rods minimizes the interruption to the space while providing a subtle, rhythmic reminder of the modular framing system. The wooden floor of the sleeping loft above the dining room was suspended from the beams by steel ties. Below the floor, the particle-board ceiling of the dining/inglenook area was insulated with redwood bark. The folding doors described above could be pulled across the end of the room to keep the fire's heat from escaping into the main space.

Despite the thick walls and the measures taken to insulate the inte-

OPPOSITE

211: *View from the dining room into the living room, Wallen Maybeck house, no. 2*

BELOW

212. *View from the bedroom loft showing the tie-rods used to brace the ceiling, Wallen Maybeck house, no. 2*

rior, the cold, clammy wind pushed its way in through the high glass bay at the studio's west end and through other openings. Maybeck devised a heating system for the winter room, the dining room, that Rube Goldberg would have saluted. He routed hot water from the furnace (located in a small room next to the kitchen) through a radiator from a Model A Ford. The hot water circulated first through this radiator, which was encased under the stairway to the loft, and then out to other radiators in the house. A blower forced air through the Model A radiator into the plenum between the concrete floor slab and the oak floor in the dining room, creating a kind of radiant heat.

Another fireplace, a small one, is in the main bedroom of the west wing (plate 213); it has a redwood flue cover to keep out drafts when no fire is needed. The chimneys themselves end in Maybeck's signature caps—a lantern-like form skirted with concrete tiles angled to create a venturi effect to draw the smoke out at a rapid rate. The flat cover also helped keep the rain from pouring in, at least when there was a good fire going.

When the studio wing was completed, it was connected to the original west wing by a wooden hallway with the main entrance door (plate 214). A third wing, which was to enclose the courtyard, was never built. Wallen Maybeck went off to serve in the army in World War II, leaving his wife and daughters to brave the elements alone. An antiaircraft bunker was set up on the ridge to the north, within sight of the house, and the men in charge of it got their water and electricity from the same source as the house. The wind howled, the fog rolled in, and Jacomena moved back to La Loma Park. Hilltop was rented and eventually sold.

We don't know how Maybeck evaluated Hilltop. His repeated visits to the house after it was rented suggest that it was a pet project, one in which he was able to indulge his passion for experimenting with structure and materials. Since it was built after he retired from practice, we can only speculate if he would ever

OPPOSITE

213. *View past the front door into the original bedroom, with a small fireplace in the corner, Wallen Maybeck house, no. 2*

ABOVE

214. *Hallway linking the main part of the house with the north wing, Wallen Maybeck house, no. 2*

209

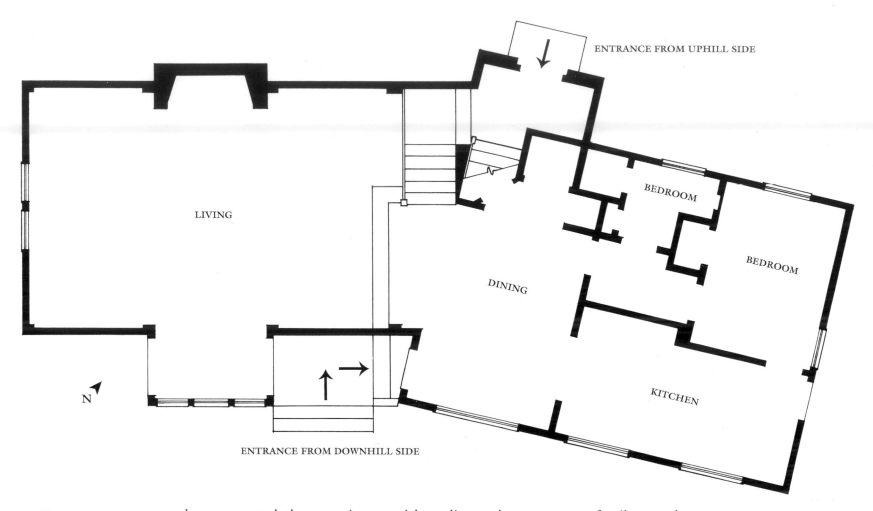

ENTRANCE FROM UPHILL SIDE

LIVING

BEDROOM

BEDROOM

DINING

N

KITCHEN

ENTRANCE FROM DOWNHILL SIDE

215. *Plan of Charles Aikin house, Berkeley, 1940*

216. *View from the living room to the dining room, Aikin house. Photograph taken in 1990, with original furnishings in place*

have repeated the experiment with a client who was not a family member. Though Hilltop is not a mansion, it is a great house and one that never fails to astound its viewers. Perhaps it can be thought of as a peak moment in a long career that had more personal than public moments of triumph.

Maybeck's last house, built in 1940, was more a neighborly act than a commission. Charles Aikin, a professor of political science, and his wife, Audrey, an artist, bought property from the Maybecks on Buena Vista Way. (According to family accounts, Mrs. Aikin pestered Maybeck to help her design their house, but declined to pay him any commission after it was built.) Now nearly eighty, Maybeck seems to have retained his delight in creating, and Audrey Aikin recorded his statements about the work in her diary. Of the living room (plate 216) he said: "It is a grand and quiet room. What I want you to do is this: look around for a poet or a musician. Invite him in and let him just sit in here. Some spaces are disquieting, but this is all right. Give him something to drink—ah, but nothing with whiskey in it—or he'll stay all night!"[5]

This last of Maybeck's living halls is a rerun of those we have seen before, but with new variations in materials. The ceiling has pecky cypress, the "poor man's

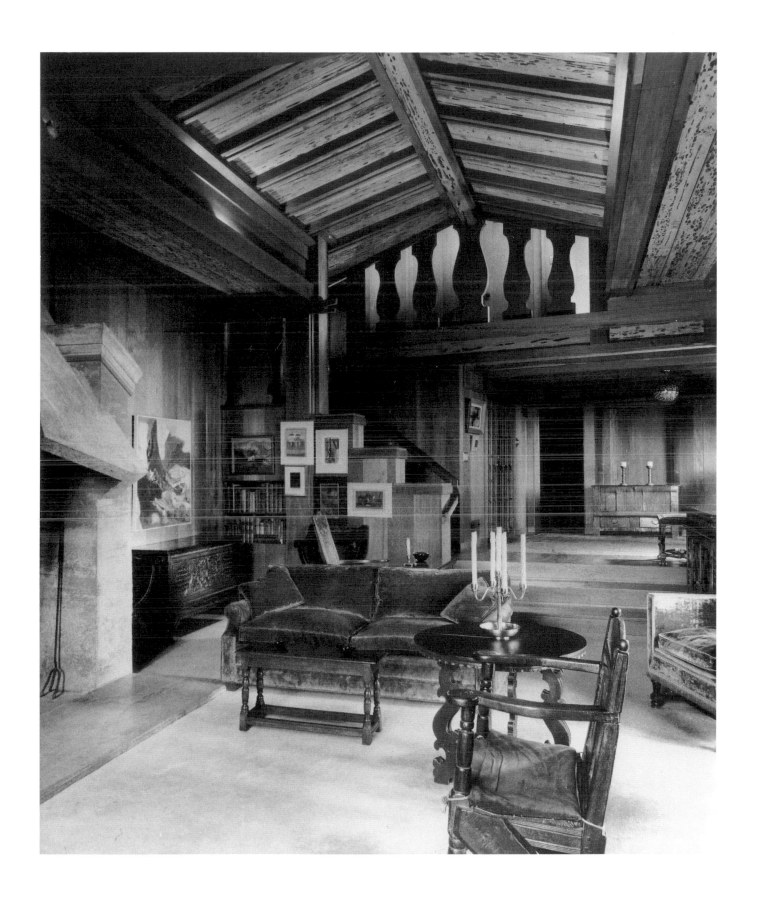

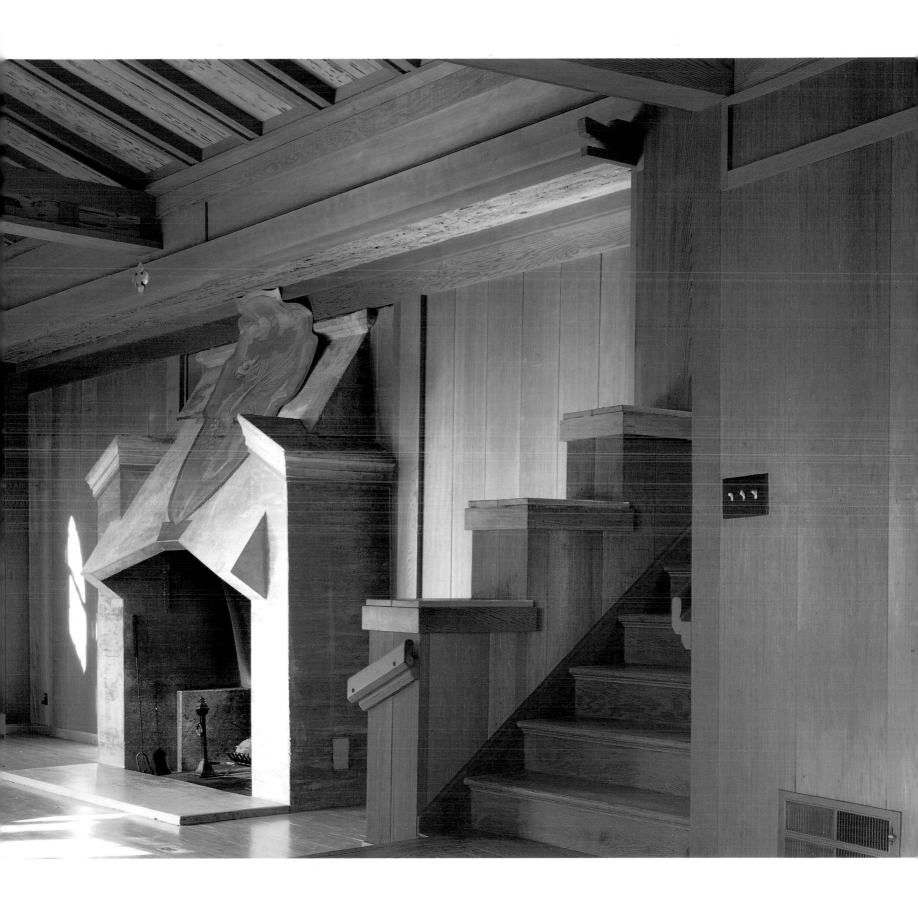

carving," between the beams; the main feature of the room is a sculptural concrete fireplace (plate 219) that is baronial in scale—Maybeck said that he wanted Charles Aikin to be able to impress his students. As usual, the hall is approached indirectly from both the uphill and the downhill entrance. The two entrances occur almost opposite each other, on line with the stone steps that ascend the hill. Thus the house is also a "hillside house" very similar to the one in the undated drawing (see plate 127) that Maybeck had made years earlier. The stucco-and-wood exterior of the Aikins' house is modest in character, like the 1933 family houses and a few other houses on Buena Vista Way whose owners Maybeck advised. According to Jacomena Maybeck, he persisted in this habit of giving advice as long as he was able, and whenever construction was going on in the neighborhood he could be found sitting in a chair near the workmen, chatting with them and offering suggestions.[6]

In 1951 the American Institute of Architects awarded Maybeck the Gold Medal of Honor, citing him as a pioneer who had the "hunger of an artist after beauty." By this time he was eighty-nine and so feeble that he could not attend the award ceremonies in Chicago. Instead, he taped his speech and sent Wallen in his place. It may have been in connection with this award that Maybeck compiled his undated "Autobiographical Notes," which provide a personal assessment of the benchmarks of his career.[7] Not surprisingly, he cited Hearst Hall and the Palace of Fine Arts. But he did not mention many other of his well-known buildings—such as the First Church of Christ, Scientist—or his work for Earle C. Anthony, or any of the houses discussed in these pages. He did state that he was the founder of the Architecture Department at the University of California and the originator and manager of the International Competition for the Phoebe A. Hearst Architectural Plan for the University of California, and that he prepared the general plan for Mills College and for the new company town of Brookings, Oregon, for the Brookings Lumber Company. (Neither of these two general plans was ever fully implemented.) He noted his work for Principia College and stated that he was the advisory architect for the Temple Emanu-el in San Francisco and the San Francisco Memorial Opera House. Under awards he listed two silver medals from the Ecole des Beaux-Arts, gold medals from the 1904 Saint Louis world's fair and the 1915 Panama-Pacific International Exposition, and a medal from the New York Architects' Society, which he received for the Hearst competition. Perhaps this is only a partial list that he later amended, but the omission of buildings that have spread Maybeck's fame around the world is still puzzling.

The list reveals that Maybeck regarded urban design, then called "the art of civic design," as the architect's major contribution. Since virtually none of his commissions for such work went beyond the planning stage—Principia College is the sole exception—we may wonder if his citation of planning projects was a way to gain a kind of reality for them that had been denied by circumstances. Not that many architects succeeded in the field of large-scale planning. Like Maybeck,

Frank Lloyd Wright wrote about and drew up ideal plans for cities and governmental complexes. In Wright's case only the Marin County Civic Center, started just before he died, was ever partially implemented. Even Daniel Burnham, who had more civic centers and city plans to his credit than anyone else of his generation, had to content himself for the most part with drawings on paper. His famous dictum "Make no little plans; they have no power to stir men's minds" was grand but rather empty advice. Maybeck's training at the Ecole made a knowledge of planning on a grand scale the centerpiece of architectural education. Given his pride in his training and his periodic involvement throughout his career in large-scale plans, his need to commemorate them is understandable.

A comprehensive discussion of Maybeck's ideas about civic design and their relationship to the planning concepts of the times is too large a topic to be covered here. But it is worth noting that in both his planning and his building projects, Maybeck applied the principles he had learned in Jules-Louis André's atelier at the Ecole and always gave the natural landscape the highest priority. At Mills

220. *Maybeck in academic robes on the occasion of receiving an honorary degree from U.C. Berkeley, 1930*

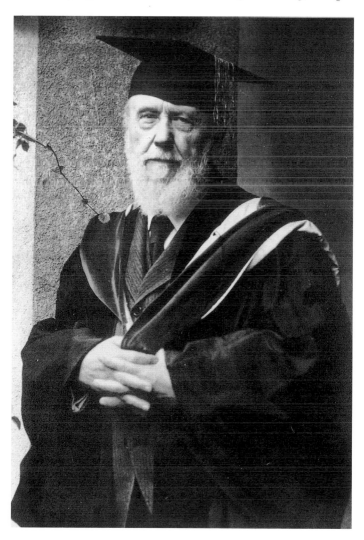

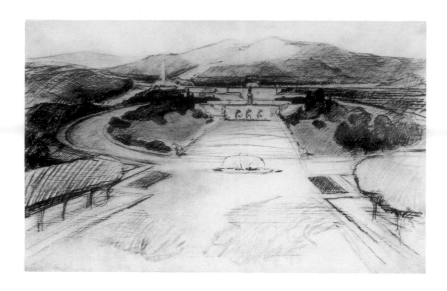

College, for example, he began with the existing features of the site and planned the landscape and the campus infrastructure of roads and gateways around them. He thought this work should be carried out at the beginning so that the landscape could inform the architects about the siting of buildings. "The avenues can be marked in with planting and even remain ungraded with the wild grass growing and kept cropped with a lawn mower until the time has come to grade and pave the way."[8]

For Principia College, which occupied Maybeck from 1923 to 1938, he made plans for two sites: one in East Saint Louis, Illinois, and the other for Elsah, Illinois, where the college was finally built. The reorganization of his practice, which delegated management of the construction process to associated architects, resulted in the designation of Julia Morgan as supervising architect for the college and Maybeck as design consultant. In 1938 he withdrew from the project altogether, leaving Julia Morgan and Henry Gutterson to carry on the work. Maybeck was then seventy-six and, understandably, could no longer keep up with a large project so far from home.

Ben and Annie spent World War II in a little bark-covered ski lodge at Twain Harte, near Sonora, California; here, as Jacomena put it, "Maybeck went back to designing airplanes and talking to people."[9] After the war they returned to Berkeley and moved back into the small La Loma Park house called the Cottage, where they had lived periodically after the 1923 fire. Wallen and Jacomena were nearby in their house at 2751 Buena Vista Way, and Kerna and her husband lived up the hill at 2780 Buena Vista Way.

Maybeck occupied himself, as he had before, with drawing. "Never lay your pencil down," he advised Jacomena.[10] He drew grand plans for San Francisco, including a waterfront scheme that would have linked the Golden Gate Bridge and the Bay Bridge by means of a tree-lined boulevard with a planted median strip. He took up themes from Daniel Burnham's plan for the city, which had been prepared in 1904–5 for the Association for the Improvement and Adornment of San Francisco, but never implemented. Maybeck seems to have been particularly interested in the possibility of creating a monumental approach to Twin Peaks from Market Street (plate 221). Several drawings representing a stepped watercourse descending from a hilltop temple illustrate his ideas for the hillside (plate 222), but no specific location on this miles-long slope is indicated.

These drawings provoke questions about Maybeck's participation in the preparation of the Burnham plan, on which his good friend Willis Polk and his

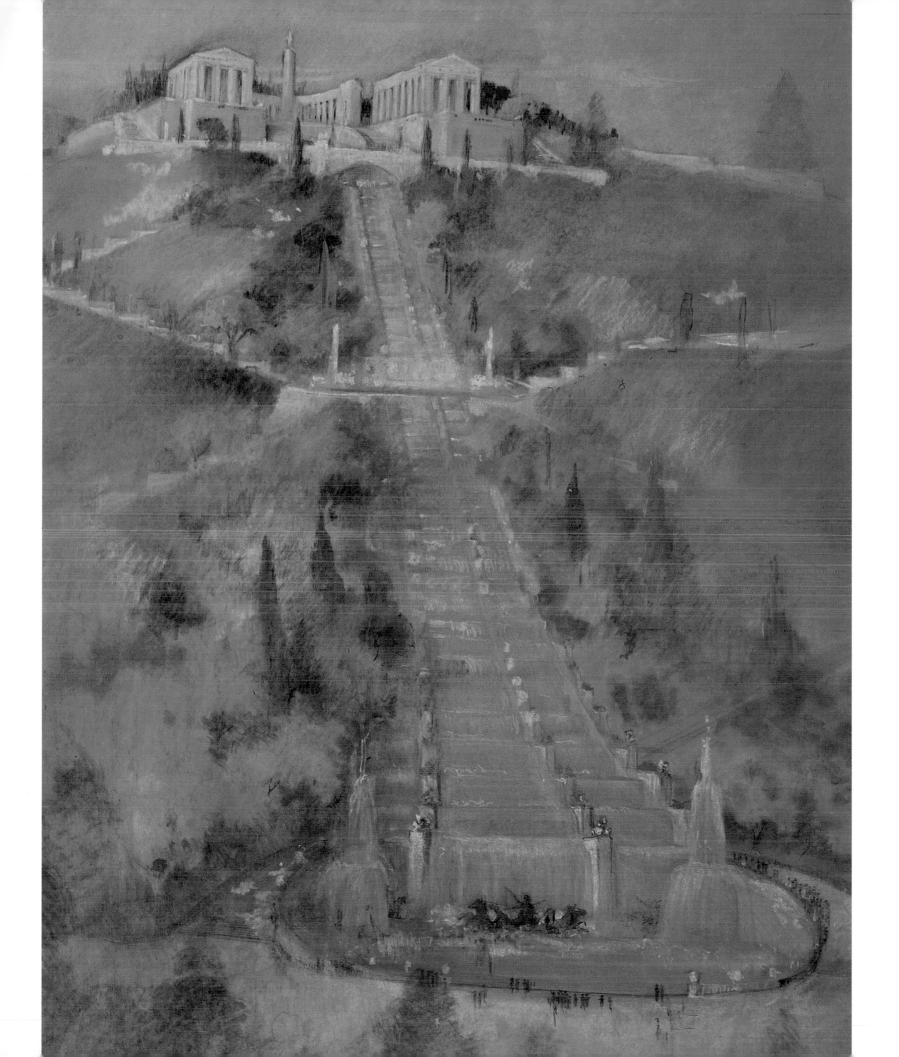

223. *Maybeck sitting by the fireplace, Wallen Maybeck house, no. 1. Photograph by Cedric Wright, 1926*

former student Edward Bennett are known to have collaborated. Polk had designed the studio building—which Burnham called "the shanty"—on a spur of Twin Peaks, where Bennett sat day after day, drawing up the plans. Indeed, Twin Peaks was among the areas of the city selected for special treatment in the plan, and it was given an amphitheater that, according to the plan's text, "would recall by its location the stadium in the hills at Delphi, which overlooks the Gulf of Corinth."[11] The text is full of references to the classical world of Greece and Rome, as was Maybeck's prospectus for the Hearst competition. Not that Burnham needed Maybeck's ideas; his experience as director of the neoclassical "White City" of the 1893 World's Columbian Exposition in Chicago would have been reason enough for him to have conceived of a San Francisco acropolis. But it seems quite plausible that Maybeck visited Bennett in his aerie, and it would have been quite out of character for him not to have offered advice. And since nothing ever came of the Burnham plan's vision for Twin Peaks, Maybeck may have considered it appropriate to return to the site and use it as a tabula rasa for his own visions.

Maybeck's taped remarks to the American Institute of Architects in 1951 ranged over the history of architecture, from cave dwellings to the pyramids, from Greek temples to Swiss lake-houses and Alaskan igloos. He said, most poignantly: "The architect of this architecture does not need to talk. His business is to listen. . . . Our sons and grandsons are going to do things that will stagger us. Let your watchword be order, your beacon beauty."[12]

Annie died in the fall of 1956, four days after having a heart attack. Ben lived on with Wallen and Jacomena, who later recalled that he spent much of his time by the window, watching the colors change over the bay to the west. "I go way out there," he told her, "and it's getting harder and harder to come back."[13] In October of the following year he died, leaving behind a treasure of ideas and drawings in addition to the inimitable buildings that bear witness to his long-distance dreaming.

NOTES

INTRODUCTION (pages 7–13)

1. Dorothy Rieber Joralemon, "Memories of Bernard Maybeck, 1923: From the Journal of Dorothy Rieber Joralemon," 1977; manuscript given to the author by Mrs. Joralemon.

2. Bernard Maybeck, undated manuscript on hillside building, Maybeck Papers, Documents Collection, College of Environmental Design, University of California, Berkeley; hereafter cited as *Maybeck Papers*.

3. William Gray Purcell, "Bernard Maybeck: Poet of Building," typescript written for Mrs. Harwell Harris (Jean Murray Bangs), 1949, Maybeck Papers.

4. Bernard Maybeck, *San Francisco Call*, June 21, 1923.

5. Charles Keeler, "Friends Bearing Torches," manuscript, begun c. 1934, p. 226, Keeler Papers, Bancroft Library, University of California, Berkeley.

1. FOUNDATIONS (pages 15–27)

1. Bernard Maybeck, 1927, chapter 1 epigraph in Kenneth H. Cardwell, *Bernard Maybeck: Artisan, Architect, Artist* (Santa Barbara, Calif., and Salt Lake City: Peregrine Smith, 1977), p. 13; hereafter cited as *Cardwell*. A more detailed account of Maybeck's family background is given in Cardwell's chapter 1 and in the Maybeck family papers file in the Maybeck Papers.

2. Bernard Maybeck, taped interview with Robert Schulz, February 1953, for radio station KPFA in Berkeley, Calif., Maybeck Papers; hereafter cited as *KPFA interview*.

3. Cardwell, pp. 16, 27. Maybeck apparently sold his design for the reversible coach seat, but no drawing of it or record of what happened to it has been found.

4. Maybeck, KPFA interview.

5. Viollet-Le-Duc, in Donald Drew Egbert, *The Beaux-Arts Tradition in French Architecture* (Princeton, N.J.: Princeton University Press, 1980), p. 62.

6. Maybeck, KPFA interview.

7. In the KPFA interview and in a dedication speech at the opening of his San Francisco Packard showroom, Maybeck referred to Claude Bragdon's translation of P. D. Ouspensky's *Tertium Organum*—specifically, to Ouspensky's statement that even the stones took part in the life of buildings. Bragdon was an architect and a contemporary of Maybeck's; in 1910 he published *The Beautiful Necessity: Architecture as "Frozen Music"* (a reference to Ruskin's famous description). In this widely read book (reprinted in 1922 and 1938), Bragdon discussed architecture in the mystical context of Theosophy, presenting ideas that have much in common with those expressed by Maybeck in his own writings.

8. The concept of *caractère* is discussed by David Van Zanten in Arthur Drexler, ed., *The Architecture of the Ecole des Beaux-Arts* (New York: Museum of Modern Art, 1977), p. 112, and at length in Egbert, *Beaux-Arts Tradition*, chap. 6.

9. Maybeck, KPFA interview.

10. Jacomena Maybeck, *Maybeck: The Family View*, new ed. (Berkeley, Calif.: Berkeley Architectural Heritage Association, 1991), p. 4; hereafter cited as *Family View*.

11. Maybeck, KPFA interview.

12. Richard Longstreth, *On the Edge of the World: Four Architects in San Francisco at the Turn of the Century* (New York: Architectural History Foundation; Cambridge, Mass., and London: MIT Press, 1983), p. 366 n. 40; hereafter cited as *Longstreth*.

13. Polk and Maybeck may have met in Kansas City, where the Polk family had lived and where Willis had worked before going to New York, or they may have met in New York. Polk worked for A. Page Brown, whose office was in the same building, at 57 Broadway, as the office of Carrere and Hastings.

14. Kenneth H. Cardwell, conversation with author, October 1991.

15. Cardwell, p. 26, and Longstreth, p. 371 n. 10.

16. Victoria Post Ranney, ed., *The California Frontier*, vol. 5 of *The Papers of Frederick Law Olmsted* (Baltimore and London: Johns Hopkins University Press, 1990), pp. 1 and 410 n. 2. Olmsted was greatly influenced by the writings of Horace Bushnell, a Congregational theologian who visited California in 1856 and had considerable influence on the choice of the East Bay site for the College of California. Olmsted also knew Frederick Billings, a Mariposa Company trustee, who suggested the name Berkeley for the college town in 1866. Olmsted had prepared the first plan for the new campus for the College of California the year before.

17. Muir, in Walton Bean and James J. Rawls, *California: An Interpretive History* (Santa Barbara, Calif., and Salt Lake City: Peregrine Smith, 1981), p. 315.

18. James D. Hart, *A Companion to California* (Berkeley and Los Angeles: University of California Press, 1987), p. 473.

19. Keeler, "Friends Bearing Torches," p. 223 ff.

20. Ibid., p. 227.

21. Ibid., p. 228. This is the source for all quotations in this paragraph.

22. Maybeck, in Dimitri Shipounoff, introduction to Charles Keeler, *The Simple Home* (Santa Barbara, Calif., and Salt Lake City: Peregrine Smith, 1979; reprint of 1904 edition published by Paul Elder and Co., San Francisco), p. xvi; hereafter cited as *Simple Home*. Architects in eastern and western centers reacted strongly against the Queen Anne style, which reached a peak of popularity around the turn of the century. In an article of July 1894 in the *Architectural Record* (p. 214), Ernest Flagg, later a prominent architect in the Midwest, wrote: "Architecture in the time of Queen Anne, having reached probably the lowest state of debasement and degradation ever known in a civilized country, appealed strongly to our tastes, and upon it was founded the style with which we are all familiar. . . . The guiding idea seems to be to pile together in an unstudied heap, roofs, gables, towers, bay windows, projects, etc., in the utmost degree of confusion in order to secure what is regarded as a picturesque result."

23. *The Life and Letters of John Muir*, 1924, in Leslie Mandelson Freudenheim and Elisabeth Sacks Sussman, *Building with Nature: Roots of the San Francisco Bay Region Tradition* (Santa Barbara, Calif., and Salt Lake City: Peregrine Smith, 1974), p. 11.

24. Keeler, "Friends Bearing Torches," p. 226.

25. For a discussion of the design of the church, see Cardwell, pp. 32–34; Longstreth, pp. 273–76 and p. 371 n. 10; and Freudenheim and Sussman, *Building with Nature*, pp. 20–31. As Cardwell asserts, the sturdy rush-bottom chairs in the church appear to be the same design as those Maybeck made for the William Rieger house and for Wyntoon, where they are visible in photographs of the great hall.

26. Maybeck, in Keeler, "Friends Bearing Torches," p. 227.

27. Gottfried Semper, "On Architectural Styles," in *The Four Elements of Architecture and Other Writings*, trans. Harry Francis Mallgrave and Wolfgang Herrmann (New York: Cambridge University Press, 1989), p. 269.

28. Ibid., p. 271.

2. SIMPLE HOMES AND CLUBHOUSES
(pages 29–73)

1. Keeler, "Friends Bearing Torches," p. 231.

2. Laura Bethell, "The Temple of Wings," *Early Sunset*, December 1918, pp. 174–75.

3. Mrs. Frank Morton Todd, in Freudenheim and Sussman, *Building with Nature*, p. 57.

4. *Hillside Club Yearbook*, 1906–7, Hillside Club Papers, Bancroft Library, University of California, Berkeley.

5. Keeler, *Simple Home*, is the source for all the Keeler quotations in this paragraph and in the two that follow.

6. Maybeck, Lillian Bridgman file, n.d., Berkeley Architectural Heritage Association.

7. Obituary (without date or source) pasted into endpapers of a bound volume of the *Liberator*, 1908–10, given to the author by Sara Boke DeWitt, granddaughter of George Boke.

8. File on the history of the house compiled from various sources by the present owners.

9. Ibid.

10. Ibid.

11. Bernard Maybeck, *Palace of Fine Arts and Lagoon*, introduction by Frank Morton Todd (San Francisco: Paul Elder and Co., 1915), p. 3.

3. THE HEARST COMMISSIONS
(pages 75–87)

1. First codified by Gaspard Monge in his 1799 publication, *Géométrie descriptive*, this discipline revolutionized the representation of structures because it formalized and synthesized procedures for using geometric projections in drawings.

2. The men who volunteered their time to assist Maybeck were H. T. Bestor, editor of *California Architect and Building News*; George W. Percy, who had gone to California in the employ of Shepley, Rutan and Coolidge to supervise the first phase of construction at Stanford University and stayed on to establish the firm of Percy and Hamilton; and George Sanders, for whom Maybeck had worked when he first arrived in San Francisco.

3. Longstreth, p. 385 n. 41. According to Longstreth, plans for the building did not proceed as rapidly as Maybeck suggested in his later, orally transmitted accounts; it was not until 1897 that Mrs. Hearst released funds for the building, which was eventually designed and built by John Galen Howard (1902–7).

4. Ibid., p. 245 and p. 385 n. 38.

5. Ibid., p. 256.

6. Maybeck, prospectus of August 1897, in Trustees of the Phoebe Apperson Hearst Architectural Plan for the University of California, *The International Competition for the Phoebe Hearst Architectural Plan for the University of California* (San Francisco, [1899]), p. 8.

7. Clipping (without date or source) in Hearst Hall file, Maybeck Papers.

8. Maybeck to Mr. Clark, 1930, Wyntoon file, Maybeck Papers.

9. His text was originally written for the Boston *Architectural Review*, but it was not published in full. Wyntoon was also published in an article by E. Brown entitled "'Wyntoon,' a Medieval Castle in Shasta, California," *American Homes and Gardens*, February 1906, pp. 100–102. The typescript of Maybeck's 1904 text is in the Wyntoon file, Maybeck Papers.

10. Maybeck, handwritten notes, 1930, Wyntoon file, Maybeck Papers.

4. THE CHURCH AND THE PALACE
(pages 89–111)

1. File on the First Church of Christ, Scientist, Maybeck Papers; and Cardwell, pp. 122-23.

2. Letter from the church committee, church file, Maybeck Papers.

3. Maybeck, *Palace of Fine Arts*. All of the following quotes by Maybeck concerning the palace come from this source.

4. Typescript, Palace of Fine Arts file, Maybeck Papers.

5. William Jordy, *American Buildings and Their Architects: Progressive and Academic Ideals at the Turn of the Twentieth Century* (Garden City, N.Y.: Anchor Press/Doubleday, 1976), p. 287, note.

6. Maybeck, in Ruth Waldo Newhall, *San Francisco's Enchanted Palace* (Berkeley, Calif.: Privately printed, 1967), p. 75.

7. *Family View*, p. 15.

5. MID-CAREER HOUSES (pages 113–71)

1. Kenneth H. Cardwell, in conversation with the author, recalling his conversations with Maybeck.

2. Purcell, "Poet of Building," Maybeck Papers.

3. Frances C. Heidner (daughter of Guy Hyde Chick), letter to the author, July 26, 1990.

4. Maybeck, manuscript, n.d., Erlanger file, Maybeck Papers.

5. Letter in the Bingham file of 1928, Maybeck Papers. Arthur E. Bingham was a Christian Scientist and may have been on the Board of Trustees of Principia College; Maybeck may have met the Binghams because of his work on the Berkeley church. Statements in the Principia College file in the Maybeck Papers indicate that Maybeck met the president of Principia, Frank Morgan, in the Bingham's Montecito home—Morgan was the Binghams' son-in-law. According to Jacomena Maybeck, Arthur Bingham was known for his fine wardrobe and once gave Maybeck an expensively tailored suit of a dark color, which Maybeck wore with great pleasure to quasi-formal functions—his family called it his "Bingham suit."

6. PROJECTS FOR EARLE C. ANTHONY (pages 173–89)

1. All references and quotations in this chapter about Maybeck's work for Anthony are from papers and correspondence in the Earle C. Anthony files, Maybeck Papers.

7. AFTER THE FIRE (pages 191–218)

1. Richard B. Rice, son of the inventor of Bubblestone, has kept his father's records and published an account of his father's and Maybeck's work together in the May 1981 *LA Architect* (American Institute of Architects, Los Angeles chapter) entitled "Bernard Maybeck: Experiments with Cellular Concrete," pp. 2-3.

2. *Family View*, p. 29.

3. Ibid.

4. For more information on the construction process, see Thomas Gordon Smith, "Bernard Maybeck's Wallen II House," *Fine Homebuilding*, April–May 1981, pp. 18–25.

5. Maybeck, in Audrey Aikin's journal in the family collection.

6. Jacomena Maybeck, conversations with the author.

7. Maybeck, "Biographical Notes," n.d., Maybeck Papers.

8. Maybeck, Mills College file, Maybeck Papers.

9. *Family View*, p. 34.

10. Ibid., p. 38.

11. Daniel H. Burnham and Edward H. Bennett, *Report on a Plan for San Francisco*, ed. Edward O'Day (City of San Francisco, 1905; reprint, Berkeley, Calif.: Urban Books, 1971).

12. *Family View*, p. 38.

13. Ibid.

ACKNOWLEDGMENTS

Two people who have been most helpful to me through their generous gifts of time and of pertinent information from personal recollections are Jacomena Maybeck and Kenneth H. Cardwell; both have written important books on Bernard Maybeck from different points of view. The insights, anecdotes, and photographs that Jacomena provided were invaluable in acquainting me with Maybeck as a person. Ken Cardwell provided information on aspects of Maybeck's career for which no records exist and assisted my understanding of the design of some of the buildings. Elizabeth Chester, staff person for the College of Environmental Design Documents Collection, was unfailingly helpful in the search for drawings, plans, and photographs in the Maybeck files. Anthony Bruce, staff person for the Berkeley Architectural Heritage Association, was of great assistance in reviewing the records in that archive.

Richard Barnes's photography has enriched this book immeasurably; his photographs are easily worth thousands of words; the words themselves have been made to count for more through the excellent editing of Nancy Grubb. For redrawing the plans and for the drawing of the Bohemian Grove clubhouse, I thank my daughter, Diana Woodbridge. And, finally, I thank the owners of the houses: Paul and Sandy Bessieres, Warren E. and Lorna Byrne, Robert and Jeanne Dennis, Tom and Nancy Genn, Foster and Monique Goldstrum, Josephine Grace, Jonas and Marilyn Langer, Dr. Jane Roos, Dore and Betsy Schwab, Lisa Ann Stadelhofer, Mr. and Mrs. William Wayne, and Dick and Marion Whittington. Their enthusiasm for Maybeck's architecture and their cooperation in the photography for this book are much appreciated by myself and Richard Barnes.

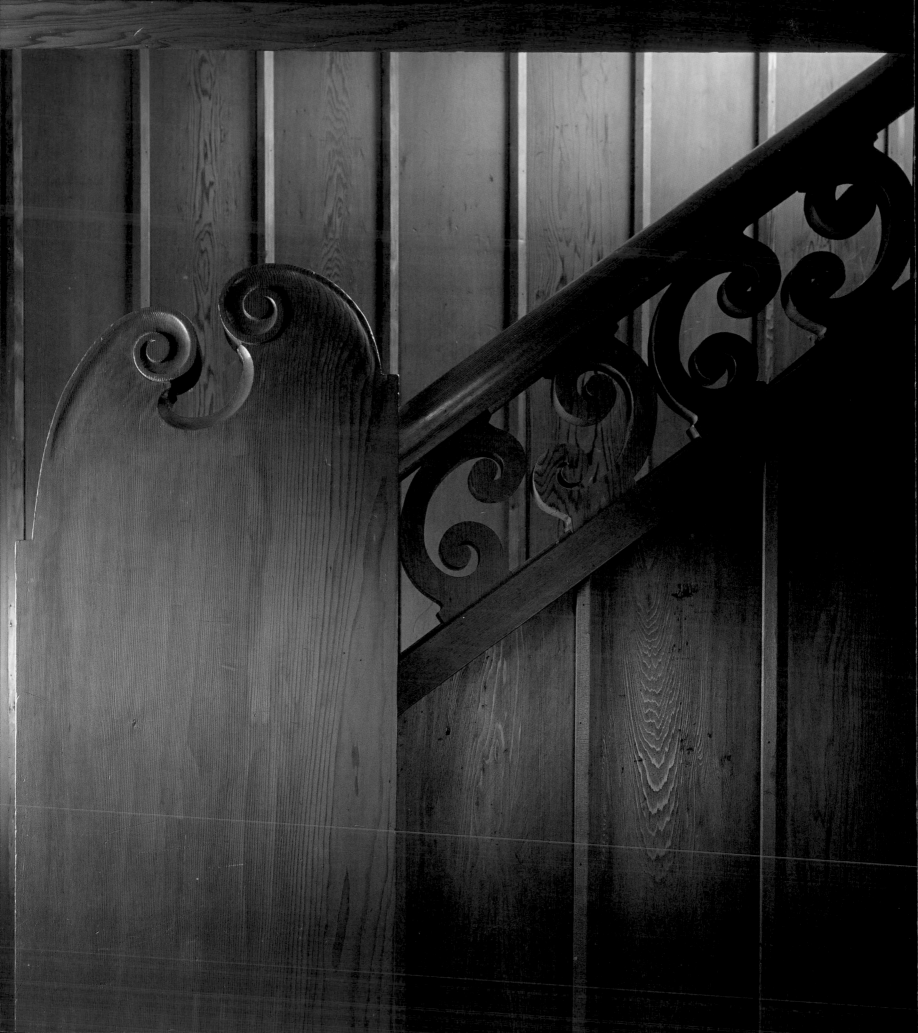

BUILDINGS AND PROJECTS BY BERNARD MAYBECK

This chronology of Maybeck's work is based on the list compiled by Kenneth H. Cardwell for his monograph, *Bernard Maybeck: Artisan, Architect, Artist,* published in 1977. Among the difficulties encountered by Cardwell and others seeking to document Maybeck's work are the losses of drawings and office records in the 1906 fire in San Francisco, which damaged Maybeck's office, and the 1923 fire in Berkeley, which destroyed his house. Thus the possibility remains strong that he designed more buildings, particularly in the period 1895–1906, than are listed here. Some of the houses for which drawings and other records exist have not been located because of insufficiently documented addresses or because street numbering has changed.

There have been no additions to the archives of Maybeck papers and drawings in the Documents Collection at the University of California College of Environmental Design in Berkeley since the publication of Cardwell's list, and no verifiable evidence of previously unknown work by him. However, some of the known buildings have, regrettably, been altered significantly or demolished. In October 1991 another catastrophic fire occurred in the East Bay hills, this time in south Berkeley and Oakland; it destroyed Maybeck's Warren P. Staniford house of 1925 and the Edwin S. Pillsbury house of 1928. Miraculously, his house for Guy Hyde Chick, which was in the path of the fire, was saved. Although the number of constructed works by Maybeck has decreased, many of those that remain have been lovingly restored, and the growing admiration for his work will doubtless assure its survival—barring, that is, future natural catastrophes.

Unless otherwise noted, all the buildings and projects are in California; within each year, they are listed in the chronological order in which they were designed or in which construction was begun. Brackets indicate an uncertain location.

224. *Detail of the carved stair railing, E. C. Young house, San Francisco, 1913*

1892–1902	Bernard R. Maybeck house, no. 1 Grove and Berryman streets, Berkeley Purchased as a one-story cottage, 1892; remodeled and enlarged, 1892–1902 Altered and turned into a multi-unit dwelling by subsequent owners
c. 1895	Charles Keeler house Ridge Road and Highland Place, Berkeley Remodeled and stuccoed for Keeler by Maybeck, c. 1929; converted into apartments by subsequent owners
c. 1896	Laura G. Hall house Highland Place, Berkeley Destroyed, 1956
1896	Emma Kellogg house, no. 1 Palo Alto Destroyed, 1899
	Andrew C. Lawson house, no. 1 Warring Street, Berkeley Destroyed
c. 1897	Williston W. Davis house Ridge Road, Berkeley Demolished, 1957
1899	Town and Gown Club 2401 Dwight Way, Berkeley Major addition, 1909 by the contractor A. H. Broad
	Emma Kellogg house, no. 2 1061 Bryant Street, Palo Alto

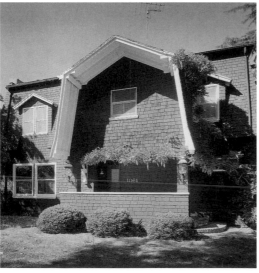

225. Emma Kellogg house, no. 2, Palo Alto, 1899. Photograph by Morley Baer

	Hearst Hall Phoebe Apperson Hearst, client Channing Way near College Avenue, Berkeley Moved to the University of California campus, 1901; converted to a gymnasium-social center-performance hall; destroyed by fire, 1922
	William P. Rieger house Highland Place, Berkeley Demolished, 1958
1900	Lillian Bridgman house 1715 La Loma Street, Berkeley Maybeck assisted Bridgman in the design of this house.
	Gifford H. McGrew house 2601 Derby Street, Berkeley Maybeck and Charles Keeler collaborated informally on this house.
1901	Isaac Flagg house, no. 1 Shattuck Avenue near Eunice Street, Berkeley
1902	Unbuilt project: barn University of California, Berkeley
	Irving Whitney house Hawthorne Terrace, Berkeley Destroyed in 1923 fire
	Hiram D. Kellogg house Regent Street, Berkeley Moved to 2960 Linden Street, Berkeley
	Miss Stockton house Le Roy Avenue, Berkeley Destroyed in 1923 fire
	T. J. Bunnell house: living-room addition San Francisco Location and condition unknown
	Unbuilt project (drawings only): Barnett house San Francisco
	George H. Boke house 23 Panoramic Way, Berkeley

F. B. Dresslar house
Le Conte Avenue, Berkeley
Destroyed in 1923 fire

Charles Keeler studio
1736 Highland Place, Berkeley

1902–3 Faculty Club
University of California,
Berkeley
Subsequent additions by John
Galen Howard, Warren Perry,
and others

Phoebe A. Hearst estate
(Wyntoon)
Siskiyou County
Destroyed by fire, 1929–30

1903 Newhall Brothers store
George and Irving Newhall,
clients
San Jose
Demolished

Unbuilt project (drawings only):
W. C. Jones house
[Berkeley]

J. W. Thomas house: additions
Greenwood Terrace, Berkeley
Destroyed in 1923 fire

Competition drawings:
University of California Hospital
San Francisco

1903–4 Unbuilt project: Cooley house
Haste Street, Berkeley

Clubhouse, Bohemian Club of
San Francisco
Bohemian Grove, near the
Russian River
First design, April 1903; final
design, December 1903;
building completed, April 1904

1904 Howard B. Gates house
62 S. Thirteenth Street, San Jose

California Wine Association
exhibit, Saint Louis Exposition

George Newhall house
Burlingame
Extensively remodeled, 1904
and 1906; location and condi-
tion unknown

Unbuilt project (drawing only):
Bettys house
[Berkeley]

T. J. Bunnell house
San Francisco
Location and condition
unknown

William W. Underhill house,
no. 1
Le Roy Avenue, Berkeley
Destroyed in 1923 fire

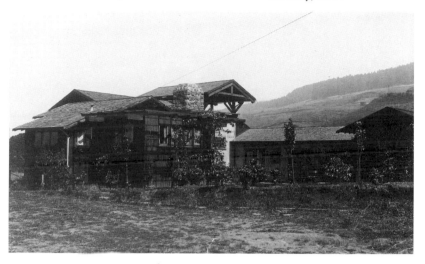

*226. William W.
Underhill house, no. 1,
Berkeley, 1904*

Outdoor Art Club
Buena Vista Way and West
Blithedale Avenue, Mill Valley

Ranson E. Beach house
110 Sunnyside Avenue, Oakland

1905 Frederick E. Farrington house
Arch Street, Berkeley
Destroyed in 1923 fire

C. S. Diggles house
Lomita Park, San Mateo
Location and condition
unknown

J. B. Tufts house, no. 1
14 Entrata Avenue,
San Anselmo

c. 1906 William Rees house
Designed for A. E. Hargreaves,
builder
La Loma and Virginia streets,
Berkeley

1906 Unbuilt project (drawings only):
Hamilton Church
Belvedere and Waller streets,
San Francisco

School
Morgan Hill
Location and condition unknown

Hillside Club
Cedar Street near Arch Street,
Berkeley
Destroyed in 1923 fire; existing
clubhouse designed by John
White

Imogene L. Sanderson house
Le Roy Avenue, Berkeley
Destroyed in 1923 fire

Unbuilt project: Francis E.
Gregory house
Hilgard Street, Berkeley

Unitarian Church
Cowper and Channing streets,
Palo Alto
Demolished

Isaac Flagg studio
Shattuck Avenue, Berkeley

Unbuilt project (drawings only):
Miall house
Burlingame

George H. Robinson house
El Camino Real, Burlingame
Demolished

Unbuilt project: Frey house
[Berkeley]

Unbuilt project: George R.
Stiles house
Piedmont

Unbuilt project: William C. Tait
house
Oakland

J. H. Hopps house
("Grayoaks")
Winding Way, Ross
Additions by Maybeck, 1925

Paul Elder and Co. Bookstore
Van Ness Avenue and Pine
Street, San Francisco
Demolished

Unbuilt project:
de Lemascheffsky house
Berkeley

Unbuilt (?) project: Four specu-
lative house designs for George
Hansen
[Berkeley]

Unbuilt project: Ernest H.
Evans house
Berkeley

Unbuilt project: L. W. Read
house
Stockton

Unbuilt project: Samuel B.
Welch house
San Francisco

1906–8 J. B. Elston house
217 N. Broadway
Aberdeen, Washington
Built using plans and
specifications of the 1902 Boke
house in Berkeley

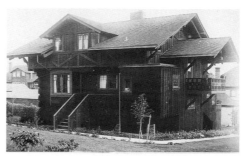

227. *Back of J. B. Elston house, Aberdeen, Washington, 1906–8. The Elston house is a copy of Maybeck's Boke house of 1902.*

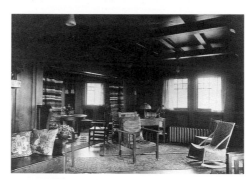

228. *Living room, Elston house, looking toward the dining room*

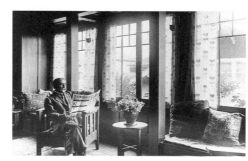

229. *J. B. Elston reading by the window alcove, c. 1910*

1906–9 Telegraph Hill Neighborhood
House
1734 Stockton Street,
San Francisco
Additions by Maybeck, 1913
and 1928

1907 F. M. French house
2236 Summer Street, Berkeley

J. H. Senger house
Bay View Place, Berkeley

Albert C. Kern house
Dormidera Avenue near Pacific
Avenue, Piedmont
Location and condition
unknown

Stebbins house: remodeling
Berkeley
Location unknown

Photographic Studio
Oscar Maurer, client
1772 Le Roy Avenue, Berkeley

230. *Photographic Studio, Berkeley, 1907*

Francis E. Gregory house
1476 Greenwood Terrace,
Berkeley

Unbuilt project: Victor
Robinson house
Burlingame

Albert Schneider house
1325 Arch Street, Berkeley

Andrew C. Lawson house
1515 La Loma Avenue, Berkeley

Dudley Saeltzer house
2100 West Street, Redding
Altered, 1970s

William W. Underhill house,
no. 2
Tamalpais Road, Berkeley
Destroyed in 1923 fire

Hearst Hall bathhouse,
University of California
College Avenue, Berkeley
Demolished, 1922

1908 J. B. Tufts house, no. 2
245 Culloden Street, San Rafael

Eliza R. Roman house
Laurel Place, San Rafael
Altered, n.d.

P. H. Atkinson house
2735 Durant Avenue, Berkeley

Frank C. Havens house
101 Wildwood Gardens,
Piedmont
Altered by Tiffany and Company

R. H. Briggs house: library
addition
Los Gatos

Paul Elder and Co. Bookstore
Grant Street, San Francisco
Demolished

Social Hall, Unity Church
Bancroft Way and Dana Street,
Berkeley
Demolished

c. 1909 Max Raden House
2683 Buena Vista Way, Berkeley
Addition by Maybeck, 1925

Unbuilt project: school
Flora B. Randolph, client
Shattuck Avenue and Berryman
Street, Berkeley
Altered

1909 Unbuilt project: H. P.
Goodman house
Berkeley

Isaac Flagg summer house
Ukiah
Destroyed, 1921

Leon L. Roos house
3500 Jackson Street,
San Francisco
Living room altered, 1913;
garage added, 1916; dressing
room added, 1919; second-floor
study added, 1926—all by
Maybeck
Interior refurbished, 1970s,
kitchen and other service spaces
altered, 1970s–1990s

Randolph School
Flora B. Randolph, client
2700 Belrose Avenue, Berkeley
Now a residence

231. *Randolph School, Berkeley, 1909*

Samuel Goslinsky house
3233 Pacific Avenue, Berkeley

232. *Samuel Goslinsky house, Berkeley, 1909*

Chester N. Rowell house
Fresno
Demolished, 1960s

R. Fry house
Thirty-second Avenue,
San Francisco
Location and condition
unknown

A. W. Thomas house
315 Eldridge Avenue,
Mill Valley
Altered

Bernard Maybeck house, no. 2
2701 Buena Vista Way, Berkeley
Destroyed in 1923 fire

1910 J. W. Thomas studio
Greenwood Terrace, Berkeley
Destroyed in 1923 fire

L. P. Dyer house
Los Gatos
Location unknown

Unbuilt project (drawings only):
Edyth H. Decker house
Buena Vista Way, Berkeley

Unbuilt project: apartment
house
Pine Realty Company,
T.J.C. Jacques, client
San Francisco

E. B. Power house
1526 Masonic Avenue,
San Francisco
Interior altered by Jack Hilmer,
1980s

Percy L. Shuman house
Sycamore Avenue, San Mateo
Location and condition
unknown

Club building, San Francisco
Settlement Association
Folsom Street, San Francisco
Demolished

First Church of Christ, Scientist
Dwight Way and Bowditch
Street, Berkeley

c. 1911 Competition drawings:
Courthouse, Dayton, Nevada

Unbuilt project: Schwartz house
Oakland

1911 Unbuilt project: E. C. Young
house
Green Street, San Francisco

Elsa Jockers house
1709 La Loma Avenue, Berkeley

Unbuilt project: Strawberry
Canyon bathhouse, University
of California
Berkeley

Leigh Towart house
Buena Vista Way and La Loma
Avenue, Berkeley
Destroyed in 1923 fire

Unitarian Church
Washington Street near Polk
Street, San Francisco

Competition drawings, federal
city, Canberra, Australia

1911–13 Field houses, Oakland
Playground Commission
De Fremery Playground, 1911;
Mosswood Park Playground,
1912; Bella Vista Playground,
1913
Demolished

1912 Isaac Flagg house,
no. 2
Shattuck Avenue, Berkeley

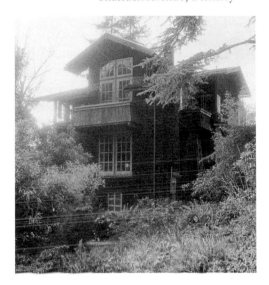

🔲 233. *Isaac Flagg house,
no. 2, Berkeley, 1912*

Unbuilt project: May Runyon
house
Los Molinos

S. C. Irving house
Sonora
Location and condition
unknown

Charles C. Boynton house
("Temple of the Wings")
2800 Buena Vista Way, Berkeley
Maybeck designed a temporary
house for this site in 1911 and a
preliminary design for a perma-
nent house, completed in 1912
by A. Randolph Monro because

of a property dispute between
the Maybecks and the Boyntons.
The house burned in the 1923
fire and was rebuilt using the
original concrete columns, cast
according to Maybeck's design,
which survived the fire.

Unbuilt project: church and
school, Pacific Unitarian School
Dana Street and Allston Way,
Berkeley

Rose Walk
Berkeley
Originally a declared but
unpaved street, which William
Underhill—who owned the lots
on the north side of the right-
of-way—convinced the city
should be a pedestrian way.
Maybeck designed the stairway
branching around the retaining

🔲 234. *Rose Walk,
Berkeley, 1912*

wall and bench on Euclid
Avenue and the lighting stan-
dards. The block-long project
was built with neighborhood
contributions. The property was
later acquired by Mr. and Mrs.
Frank Gray, who hired Henry
Gutterson after the 1923 fire to
design single houses and
duplexes on the north side. The
designs were executed in consul-
tation with Maybeck and are
ingeniously sited to provide pri-
vate spaces and gracious living
on a small scale. The south side
was built up later with buildings
designed by other architects.

Competition drawings:
San Francisco City Hall

1913 Competition drawings: Alameda
County Infirmary

George A. Scott house
Vine Street and Scenic Avenue,
Berkeley
Destroyed in 1923 fire; rebuilt
by another architect around
original chimney

E. C. Young house
51 Sotelo Avenue, San Francisco

Parsons Memorial Lodge
Sierra Club, client
Tuolumne Meadows, Yosemite
National Park
Location and condition
unknown

1913–15 Exposition buildings, Panama-
Pacific International Exposition
San Francisco
Palace of Fine Arts
Reconstructed in 1962
Livestock Pavilion; House of
Hoo Hoo (Pacific Lumbermen's
Association, client)
Both demolished 1915

Town plan, May 1914, with a
hotel (built), and cottages,
YMCA clubhouse, and a school
(all unbuilt)
Brookings Lumber Company,
client
Brookings, Oregon

1914 F. K. McFarlan house
Hawthorne Terrace, Berkeley
Destroyed in 1923 fire

Unbuilt project (drawings only):
Chinese Village and Pagoda
Company
San Francisco

Guy Hyde Chick house
Chabot and Roble roads,
Oakland

Alma S. Kennedy studio
Euclid Avenue and Buena Vista
Way, Berkeley
Destroyed in 1923 fire; rebuilt
with additions, 1923

1915 Thomas F. Hunt house
Spruce Street, Berkeley
Relocated to 53 Domingo
Avenue, Berkeley

R. H. Mathewson house
La Loma Avenue and Buena
Vista Way, Berkeley

C. W. Whitney house
1110 Keith Avenue, Berkeley

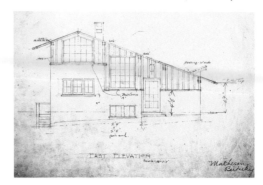

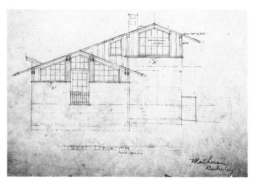

235, 236. *East and west elevations, R. H. Mathewson house, Berkeley, 1915. Documents Collection, College of Environmental Design, University of California, Berkeley*

B. D. Marx Greene house
Chabot Road, Berkeley
Destroyed

1916 S. H. Erlanger house
270 Castaneda Street,
San Francisco

H. F. Jackson house:
remodeling
Orchard Lane, Berkeley
Condition unknown

Arthur E. Bingham house
San Ysidro Road, Montecito
Interiors altered by Douglas
Bartoli, 1980s

J. A. Owens house
1041 Ashmount Avenue,
Oakland
Additions by Maybeck for
J. L. Mears, 1922

1917 Alice Gay house
 2563 Clarendon Avenue,
 San Francisco

 Dahlia Loeb house
 275 Pacheco Street,
 San Francisco

1918 Unbuilt project: Thomas R.
 Hanna houses
 Crockett

 Red Cross temporary building
 Civic Center Plaza,
 San Francisco

 General plan for Mills College
 Phoebe Apperson Hearst,
 sponsor
 Oakland

1918–19 Town plan, hotel, and housing
 Clyde
 George A. Applegarth, architect;
 Bernard Maybeck, supervising
 architect
 Demolished

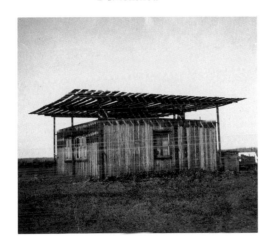

1919 Hazel P. Hincks garage and
 service rooms
 Rancho Lomo, Live Oak
 Location and condition
 unknown

Forest Hill Association building
381 Magellan Avenue,
San Francisco
E. C. Young, associate architect

c. 1920 Unbuilt project (drawing only):
 California branch building,
 National Conservatory of Music
 Planned location unknown

1920 Sidney H. Greeley house:
 additions
 Bakersfield
 Condition unknown

 Unbuilt project: Christine W.
 Stevensen house
 Hollywood

 Unbuilt project: J. F. O'Keefe
 house
 San Jose

 Unbuilt project: Community
 house
 S.F.B. Morse, Del Monte
 Properties, client
 Pebble Beach
 Mark Daniels, associate architect

 James J. Fagan house
 Portola Drive, Woodside
 Remodeled

1921 Cedric Wright house
 2515 Etna Street, Berkeley

 Unbuilt project (drawing only):
 San Carlos de Borromeo
 Mission reconstruction
 Carmel

Unbuilt project: C. E. Floete house
Pebble Beach
Mark Daniels, associate architect

Unbuilt project: J. A. Landsberger house
Carmel

Resort buildings
E. G. Galt, client
Glen Alpine Springs

Robert A. Peers house
Old Truckee Road, Colfax
Altered; condition unknown

J. Wilbur Calkins house
601 Rosemount Avenue, Oakland

Estelle S. Clark house
1408 Hawthorne Terrace, Berkeley

1922 Byington Ford house
Pebble Beach
Altered

Frances Potter Thomas house: additions and remodeling
Pebble Beach
Location and condition unknown

Unbuilt project: school
Del Monte Properties, client
Pebble Beach

Camp Curry: kitchen additions
Yosemite Valley
Condition unknown

Unbuilt project: school building, San Francisco Teachers College
State of California Department of Education, client
Proposal for the site of the 1915 Panama-Pacific International Exposition

Unbuilt project: J. A. Manning house
Pebble Beach

Unbuilt project: Wheeler Beckett house
Berkeley

1923 Ira B. Joralemon house and studio
168 Southampton Avenue, Berkeley

239. *Ira B. Joralemon house and studio, Berkeley, 1923*

Mary D. Loy (W. E. Chamberlain) house
Ellsworth Street, Berkeley
Demolished

Unbuilt project: E. R. Sturm house
E. Orange Grove Avenue, Glendale

Unbuilt project: Laurence J. Kennedy house
Redding

1923–30 Unbuilt project: General plan, Principia College (published in 1927)
East Saint Louis, Illinois

1924 Orin Kip McMurray house
2537 Le Conte Avenue, Berkeley

E. F. Giesler house
Buena Vista Way, Berkeley
Location unknown

J. H. Burnett house
2680 Hilgard Avenue, Berkeley

Bernard R. Maybeck house, no. 3 ("Studio/Sack House")
2711 Buena Vista Way, Berkeley
Later additions

1924–29 Unbuilt project: auditorium, gymnasium, and museum buildings, Phoebe A. Hearst Memorial complex
William Randolph Hearst, donor
University of California, Berkeley

1924–30 Earle C. Anthony studio, gardens, and house, no. 3
Waverly Place, Los Feliz Park, Los Angeles
Mark Daniels, landscaper
Relandscaped by Lutah Maria Riggs for Daniel and Bernardine Donohue, 1960s

1925 Phoebe A. Hearst Memorial Gymnasium for Women
University of California, Berkeley
Julia Morgan, associate architect

🕮 240. *Phoebe A. Hearst Memorial Gymnasium for Women, Berkeley, 1925*

Unbuilt project: office building
Dr. Robert A. Peers, client
Colfax

Charles W. Duncan house
Santa Rosa Avenue, Sausalito
Location and condition unknown

L. F. de Angulo house
2800 block of Buena Vista Way, Berkeley

Unbuilt project: Robert Legge house
Panoramic Way, Berkeley

Unbuilt project: Chevy Chase School library and recreational hall
F. E. Farrington, client
Chevy Chase, Maryland

Earle C. Anthony house, no. 1
3405 Waverly Drive, Los Feliz Park, Los Angeles

Warren P. Staniford house
6130 Ocean View Drive, Oakland
Destroyed in 1991 fire

Unbuilt project: Dr. James Smith house
[San Francisco]

1926 Packard automobile showroom
Earle C. Anthony, client
Van Ness Avenue, San Francisco
Powers and Ahnden, associate architects

Unbuilt project: Hemet Hotel
Hemet

Unbuilt project: Caroline W. Hollis house
La Loma Avenue, Berkeley

1927 Earle C. Anthony house, no. 2
Waverly Dr., Los Feliz Park, Los Angeles

🕮 241. *Associated Charities building, San Francisco, 1927*

Associated Charities building
Gough and Eddy streets, San Francisco

R. I. Woolsey house
20 Sunset Drive, Kensington

1928 Harrison Memorial Library
Carmel

Packard automobile salesroom and office interiors
Earle C. Anthony, client
Los Angeles
John Parkinson and Donald B. Parkinson, associate architects
Demolished

Sunday School building, First Church of Christ, Scientist
Dwight Way, Berkeley
Henry Gutterson, associate architect

Edwin S. Pillsbury house
220 Alvarado Road, Berkeley
Destroyed in 1991 fire

Packard automobile showrooms
Earle C. Anthony, client
Harrison Street, Oakland
Powers and Ahnden, associate
architects
Demolished 1974

1930–38 General Plan and buildings for
Principia College
Elsah, Illinois
Julia Morgan, associate architect

1931 Annie White Maybeck cabin
Twain Harte Mountain, Twain
Harte

J. B. Tufts house, no. 3
2733 Buena Vista Way, Berkeley

c. 1932 Paul Elder and Co. Bookstore
Geary Street, San Francisco
Demolished

1933 Wallen Maybeck house, no. 1
2751 Buena Vista Way, Berkeley

Kerna Maybeck house
2780 Buena Vista Way, Berkeley

1935 House
2786 Buena Vista Way, Berkeley

1935–37 Unbuilt project (drawings only):
Ninth Church of Christ,
Scientist
San Francisco

1936 Wells cabin
Fuller Road, Twain Harte
Location and condition
unknown

Unbuilt project: Cole Chemical
Company
B. L. Cole, client
Saint Louis

1937 Unbuilt project: Paul Staniford
house
Fresno

Mobilized Women of Berkeley
building
University Avenue, Berkeley
Altered

1937–38 Wallen Maybeck house, no. 2
("Hilltop")
Purdue Avenue, Kensington

1940 Charles Aikin house
2750 Buena Vista Way, Berkeley

Unbuilt project: cemetery
(grounds and buildings)
A. H. Darbee, client
[South San Francisco]
Julia Morgan, associate architect

BUILDINGS DESIGNED IN THE OFFICE OF MAYBECK, HOWARD, AND WHITE

c. 1907 R. Y. Hayne office building
Washington and Stockton
streets, San Francisco
Demolished

J.H.P. Howard office building:
addition
Vicinity of Battery and
Commercial, San Francisco
Location and condition
unknown

1907 San Mateo Polo Club building
San Mateo Realty Investment
Company, client
San Mateo
Location and condition
unknown

Unbuilt project: Balfour house
San Mateo

Charles Josselyn house
Kings Mountain Road,
Woodside

SELECTED BIBLIOGRAPHY

ARCHIVAL MATERIAL

Bancroft Library, University of California, Berkeley. Includes Phoebe Apperson Hearst correspondence and papers (with letters from President Benjamin Ide Wheeler about the appointment of John Galen Howard as supervising architect and about the Hearst Memorial Mining Building, and letters from Annie Maybeck written while the Maybecks were in Europe to coordinate the Phoebe Hearst competition); Hillside Club Papers (minutes, pamphlets, and yearbooks); Charles Keeler Papers; and Bernard Maybeck family papers (correspondence and papers related to the property-boundary disputes with the Boynton family).

Berkeley Architectural Heritage Association. Includes the Dimitri Shipounoff Collection (with building files and photographs of Berkeley buildings and of people associated with Charles Keeler).

Documents Collection, College of Environmental Design, University of California, Berkeley. Includes the Bernard Maybeck Papers (drawings, photographs, and specifications of work; office correspondence; scrapbook; tapes of the KPFA interview with Maybeck in February 1953).

BOOKS

Benedict, Burton. *The Anthropology of World's Fairs: San Francisco's Pan-Pacific International Exposition of 1915*. London and Berkeley, Calif.: Lowie Museum of Anthropology and Scolari Press, 1983.

Boutelle, Sarah Holmes. *Julia Morgan, Architect*. New York: Abbeville Press, 1988.

Cardwell, Kenneth H. *Bernard Maybeck: Artisan, Architect, Artist*. Santa Barbara, Calif., and Salt Lake City: Peregrine Smith, 1977.

Drexler, Arthur, ed. *The Architecture of the Ecole des Beaux-Arts*. New York: Museum of Modern Art, 1977.

Egbert, Donald Drew. *The Beaux-Arts Tradition in French Architecture*. Princeton, N.J.: Princeton University Press, 1980.

Freudenheim, Leslie Mandelson and Elisabeth Sacks Sussman. *Building with Nature: Roots of the San Francisco Bay Region Tradition*. Santa Barbara, Calif., and Salt Lake City: Peregrine Smith, 1974.

Gebhard, David. *Lutah Maria Riggs: A Woman in California Architecture*. Santa Barbara, Calif.: Capra Press, 1992.

Herrmann, Wolfgang. *Gottfried Semper: In Search of Architecture*. Cambridge, Mass., and London: MIT Press, 1984.

Jacobs, Stephen W. "California Contemporaries of Frank Lloyd Wright, 1885–1915," in *Problems of the Nineteenth Century*. Studies in Western Art, vol. 4. Princeton, N.J.: Princeton University Press, 1963.

Johnson, Paul C., ed. *The Early Sunset Magazine, 1898-1928*, anthology. San Francisco: California Historical Society, 1974.

Jordy, William H. *American Buildings and Their Architects: Progressive and Academic Ideals at the Turn of the Twentieth Century*. Garden City, N.Y.: Anchor Press/Doubleday, 1976.

Keeler, Charles. *The Simple Home*. San Francisco: Paul Elder and Co., 1904. Reprint. Santa Barbara, Calif., and Salt Lake City: Peregrine Smith, 1979.

Longstreth, Richard. *On the Edge of the World: Four Architects in San Francisco at the Turn of the Century*. New York: Architectural History Foundation; Cambridge, Mass., and London: MIT Press, 1983.

Macomber, Ben. *The Jewel City: Its Planning and Achievement; Its Architecture, Sculpture, Symbolism, and Music; Its Gardens, Palaces, and Exhibits*. San Francisco and Tacoma, Wash.: John H. Williams, 1915.

McCoy, Esther. *Five California Architects*. New York: Reinhold, 1960. Reprint. New York: Frederick A. Praeger, 1975.

McLaren, John. *Gardening in California: Landscape and Flower*. San Francisco: Philopolis Press, 1908 and 1914.

Maybeck, Bernard. Untitled booklet, *Hillside Building*, issued by the Hillside Club, Berkeley. South Berkeley, Calif., [1907].

——— . *Palace of Fine Arts and Lagoon*. Introduction by Frank Morton Todd. San Francisco: Paul Elder and Co., 1915.

——— . *The Principia College Plans*. Saint Louis: Trustees of The Principia, 1927.

Maybeck, Jacomena. *Maybeck: The Family View*. New ed. Berkeley, Calif.: Berkeley Architectural Heritage Association, 1991.

Mullgardt, Louis Christian. *The Architecture and Landscape Gardening of the Exposition*. San Francisco: Paul Elder and Co., 1915.

Mumford, Lewis. *Roots of Contemporary American Architecture*. New York: Reinhold, 1952.

Sargeant, Winthrop. *Geniuses, Goddesses and People*. New York: E. P. Dutton, 1949.

Scully, Vincent. *The Shingle Style and the Stick Style*. New Haven and London: Yale University Press, 1955 and 1971.

Semper, Gottfried. *The Four Elements of Architecture and Other Writings*. Translated by Harry Francis Mallgrave and Wolfgang Herrmann. New York: Cambridge University Press, 1989.

Starr, Kevin. *Americans and the California Dream*. Santa Barbara, Calif., and Salt Lake City: Peregrine Smith, 1981.

Stickley, Gustav. *The Best of Craftsman Homes*. Santa Barbara, Calif., and Salt Lake City: Peregrine Smith, 1979.

Todd, Frank Morton. *The Story of the Exposition: The Panama-Pacific International Exposition*. New York and London: G. P. Putnam's Sons, 1921.

Trustees of the Phoebe Apperson Hearst Architectural Plan for the University of California. *The International Competition for the Phoebe Hearst Architectural Plan for the University of California*. San Francisco, [1899].

Woodbridge, Sally, ed. *Bay Area Houses*. New ed. Salt Lake City: Peregrine Smith, 1988.

ARTICLES AND UNPUBLISHED PAPERS

Banham, Reyner. "The Plot against Bernard Maybeck." *Journal of the Society of Architectural Historians* 43 (March 1984): 33–37.

Bangs, Jean Murray (Mrs. Harwell Hamilton Harris). "Bernard Ralph Maybeck, Architect, Comes into His Own." *Architectural Record*, January 1948, pp. 72–79.

——— . "Bernard Ralph Maybeck." *Journal of the American Institute of Architects*, May 1951, pp. 221–28.

——— . "Maybeck—Medalist." *Architectural Forum*, May 1951, pp. 160–62.

"B. R. Maybeck: Designer of the Palace of Fine Arts—PPIE." *Sunset*, November 1915, pp. 951–52.

Battu, Zoe A. " 'The Man on the Street' Speaks on the Packard Building." *California Arts and Architecture*, July 1927, pp. 32–35.

Bell, Mary. "Hearst Hall." *University of California Magazine*, February 1900, pp. 10–14.

Bessinger, Curtis. "After 50 Years This House Is Newer Than Many Moderns." *House Beautiful* 104 (May 1962): 150–57.

Cardwell, Kenneth H., and William C. Hays. "Fifty Years from Now." *California Monthly*, April 1954, pp. 20–26.

Carroll, Rita. "Bernard R. Maybeck's Bird's Eye View of a University of California Hospital." *University of California, San Francisco Alumni News* 4 (Fall 1985).

Cerny, Susan D. Stern. "Northside." Historical survey. Berkeley, Calif.: Berkeley Architectural Heritage Association, 1990.

Craft, Mable Clare. "A Sermon in Church Building." *House Beautiful,* February 1901, pp. 125–32.

Craig, Robert M. "Bernard Ralph Maybeck and the Principia: Architecture as a Philosophical Expression." *Journal of the Society of Architectural Historians* 31 (October 1972): 234.

Harris, Dianne. "Architecture and the Garden: The Landscape Designs of Bernard Maybeck." Master's thesis, University of California, Berkeley, 1989.

Hays, William C. "Some Interesting Buildings at the University of California: The Work of Bernard Maybeck, Architect." *Indoors and Out*, May 1906, pp. 68–75.

Keeler, Charles. "Friends Bearing Torches." Manuscript, begun c. 1934, Keeler Papers, Bancroft Library, University of California, Berkeley.

McLaren, Donald. "Landscape Gardening at the Exposition." *Western Architect*, September 1915, pp. 13–15.

Maclay, Mira A. "The Maybeck One-Room House." *Sunset*, July 1923, pp. 65–66, 80.

Maybeck, Bernard. "The Planning of a University." *Blue and Gold* (U.C. Berkeley yearbook), 1900, pp. 17–20.

————. "A Dream That Might Be Realized." *Merchant's Association Review* (San Francisco), November 1903, pp. 1–2.

————. "House of Mrs. Phoebe A. Hearst in Siskiyou County, California." *Architectural Review* (Boston), January 1904, pp. 64–66.

————. "The Palace of Fine Arts." *Transactions* (Commonwealth Club of California), August 1915, pp. 369–74.

————. "Fine Arts Palace Will Outlast Present Generation." *Architect and Engineer*, November 1915, p. 53.

Morrow, Irving F. "Earle C. Anthony Packard Building, San Francisco." *Architect and Engineer*, July 1927, pp. 60–67.

————. "The Packard Building at Oakland." *California Arts and Architecture*, February 1929, pp. 54–59.

Nichols, Frederick D. "A Visit with Bernard Maybeck." *Journal of the Society of Architectural Historians* 11 (October 1952): 30.

Polk, Willis J. "Preservation of the Palace of Fine Arts." *Architect and Engineer*, January 1916, pp. 100–103.

"Presentation of Institute's Gold Medal to Bernard Ralph Maybeck." *Journal of the American Institute of Architects*, July 1951, pp. 3–8.

Sargeant, Winthrop. "Bernard Ralph Maybeck." *Life*, May 17, 1948, pp. 141–53.

Smith, Thomas Gordon. "Bernard Maybeck's Wallen II House." *Fine Homebuilding*, April–May 1981, pp. 18–25.

Thompson, Elizabeth K. "The Early Domestic Architecture of the San Francisco Bay Region." *Journal of the Society of Architectural Historians*, October 1951, pp. 15–21.

INDEX

PHOTOGRAPHY CREDITS

Unless otherwise indicated, all color photographs are by Richard Barnes and all plans are drawn by Diana Woodbridge. The photographers and sources of photographic material other than those cited in the captions are as follows:

Aikin family collection: plates 216, 218; Bancroft Library, University of California, Berkeley: plate 52; Richard Barnes: plates 23, 230, 232–34, 238–41; Berkeley Architectural Heritage Association, Dimitri Shipounoff collection: plates 10, 13, 15, 16, 18, 19–22, 24–28, 47, 189, 191, 192, 231; California Historical Society, San Francisco: plate 23; Kenneth H. Cardwell: plate 153; Documents Collection, College of Environmental Design, University of California, Berkeley: plates 1, 2, 6, 62, 63, 65, 67, 68, 74, 75, 97, 102, 117, 120, 138, 165, 166, 168–70, 186, 226–29, 237; Jeremy Kotas: plate 14; Jacomena Maybeck: plates 3, 7, 8, 9, 188, 220–23; Richard B. Rice: plate 187; San Francisco History and Archives Room, San Francisco Main Public Library: plates 86, 87.